Constable, a Master Draughtsman

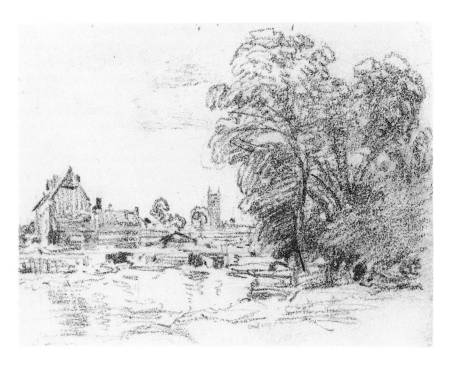

Constable, a Master Draughtsman

Dulwich Picture Gallery

Constable, a Master Draughtsman

Dulwich Picture Gallery, London, England,
13 July – 16 October 1994

Art Gallery of Ontario, Toronto, Canada,
3 May – 9 July 1995

Part of the exhibition is also to be shown at
The Frick Collection, New York, U.S.A.,
15 November 1994 – 12 February 1995

Front Cover: *A Windmill near Colchester* (cat.40)

Catalogue edited by Charles Leggatt
and designed by Barry Viney

© Dulwich Picture Gallery, London, 1994

Printed in England by The Lavenham Press,
Water Street, Lavenham, Sudbury, Suffolk CO10 9RN

ISBN 1 898519 10 2

Contents

Preface

Few artists have so carefully and effectively documented the effects of nature as John Constable. Attention to detail, a constant exploration of the shifting values of light and atmosphere, and a fascination with the subtle nuances of the English landscape mark all of Constable's work. But these qualities are especially apparent in his drawings which reveal the artist's extraordinary draughtsmanship and meticulous hand. The eighty three remarkable drawings in *Constable, a Master Draughtsman* all come from the collection of David Thomson whose interest in Constable is unparalleled and whose generosity and enthusiasm have made the exhibition possible.

Giles Waterfield
Director, Dulwich Picture Gallery

Glenn Lowry
Director, Art Gallery of Ontario

June 1994

Foreword

John Constable knew Dulwich Picture Gallery well. As a Royal Academician, he was involved in the supervision of the Gallery's affairs in its early days, and is recorded as a guest at the annual dinners at Dulwich. He was familiar with the collection, copying Jacob van Ruisdael's *Landscape with Windmills near Haarlem* (his copy, rediscovered during the course of research for this exhibition, is included in the display), and writing in fervent praise of the Watteau *Les Plaisirs du Bal*.

We are delighted that with this exhibition Constable returns to Dulwich. Our first thanks must go to David Thomson, whose Constable drawings provide the focus of the exhibition. His achievement in assembling a collection of such distinction is a remarkable one, especially since his collecting interests range from mediaeval works of art to historic aircraft, and his favoured artists from Constable to Joseph Beuys. Many of these drawings have never previously been exhibited, and we are honoured to be able to show them here at Dulwich.

It has been our good fortune that Ian Fleming-Williams, one of the leading authorities on Constable, felt that Dulwich would be an ideal location to present an examination of the artist as draughtsman – an area of his art needing discussion and presentation. Mr. Fleming-Williams has worked

indefatigably on the preparation of the catalogue for a collection that he knows intimately, and we are greatly in his debt for this and many other matters connected with the exhibition. I am very pleased that Patrick Heron, Anne Lyles and Jane McAusland have contributed valuable essays to this publication.

I would like to thank the Friends of Dulwich Picture Gallery for their financial support of the exhibition and Prudence Cuming Associates Ltd. for their generous help over the photography. Government Indemnity for the exhibition has been arranged by the Museums and Galleries Commission through the kind offices of Bettie Clark and Heather Wilson.

I am most grateful to the lenders of items to the 'Prologue' section of the exhibition. Barry Viney has designed the catalogue with his characteristic flair and sensitivity.

Help in the researching and writing of the book is gratefully acknowledged to R.E. Alton, Revd Norman S. Bedford, Peter Bower, David Blayney Brown, Felicity Butcher, William Drummond, Sir Brinsley Ford, Cyril and Shirley Fry, Judy Crosby Ivy, Dr F.J.G. Jefferiss, R.J. Lancaster, Corinne Miller, W.A. Mitchell, Andrew Moore, Charles Newton, Charles Nugent, Sheila O'Connell, Felicity Owen, Leslie Parris, David Patterson, Michael Pidgley, Jan Piggott, Andrew Clayton-Payne, Graham Reynolds, Kim Sloan, Denis Thomas, Neil Walker, David Wardlaw, Norma Watt, Henry Wemyss, Steven Wildman, Andrew Wilton and Andrew Wyld. Invaluable help has also been received from James Gore Browne, John Bull, Richard Constable, Carol Fitzpatrick, Mark Knight, Paul Mitchell and his staff, Jim Reddaway, Brenda Renwick, Paul Stork and Kate Whiteman.

I wish to thank all the members of my staff, as well as a number of interns, who have in various ways contributed to the preparation of this exhibition, and in particular Victoria Bethell, Kate Bignold, Caroline Eason, Sheila Gair, Kate Goodwin, Emma Hardy, Cathy Houghton, Kate Knowles, Robert Maniura, Tom Proctor, Julian Spicer, Peter Theobald, Trevor Ward, Elizabeth Wedmore and Emma Wigmore. Charles Leggatt, who suggested the idea of the exhibition in the first instance and as exhibition curator has worked indefatigably on every detail, has played an indispensable role and I am particularly pleased to be able to acknowledge his enthusiasm, energy and skill.

Finally, I am delighted that after the exhibition closes at Dulwich it will be seen in both New York and Toronto.

Giles Waterfield

Abbreviations

ABBREVIATIONS: GENERAL

b.l.	bottom left
b.r.	bottom right
t.l.	top left
t.r.	top right
repr.	reproduced
repr., col.	reproduced in colour
< >	deleted word

ABBREVIATIONS: LITERATURE

JCC I — R.B.Beckett (ed.), *John Constable's Correspondence: The Family at East Bergholt 1807–1837*, 1962

JCC II — R.B.Beckett (ed.), *John Constable's Correspondence: Early Friends and Maria Bicknell (Mrs Constable)*, 1964

JCC III — R.B.Beckett (ed.), *John Constable's Correspondence: The Correspondence with C.R.Leslie*, 1965

JCC IV — R.B.Beckett (ed.), *John Constable's Correspondence: Patrons, Dealers and Fellow Artists*, 1966

JCC V — R.B. Beckett (ed.), *John Constable's Correspondence: Various Friends, with Charles Boner and the Artist's Children*, 1967

JCC VI — R.B.Beckett (ed.), *John Constable's Correspondence: The Fishers*, 1968

JCD — R.B.Beckett (ed.), *John Constable's Discourses*, 1970

JC:FDC — Leslie Parris, Conal Shields, and Ian Fleming-Williams: *John Constable; Further Documents and Correspondence*, 1975

Day 1975 — H.A.E.Day, *Constable Drawings*, 1975

Farington — *The Diary of Joseph Farington*, ed. Kenneth Garlick and Angus Macintyre (vols I-VI), Kathryn Cave (vols VII-XVI), 1978-84

Fleming-Williams and Parris 1984 — Ian Fleming-Williams and Leslie Parris, *The Discovery of Constable*, 1984

Fleming-Williams 1990 — Ian Fleming-Williams, *Constable and his Drawings*, 1990

Gadney 1976 — Reg Gadney, *John Constable R.A. 1776-1837: A Catalogue of Drawings and watercolours...in the Fitzwilliam Museum, Cambridge*, 1976

Holmes 1902 — C.J.Holmes, *Constable and His Influence on Landscape Painting*, 1902

Hoozee 1979 — Robert Hoozee, *L'opera completa di Constable*, 1979

Leslie, Life, 1951 — C.R. Leslie, *Memoirs of the Life of John Constable*, ed. Jonathan Mayne, 1951

Parris 1981 — Leslie Parris, *The Tate Gallery Constable Collection*, 1981

Reynolds 1973 — Graham Reynolds, *Victoria and Albert Museum: Catalogue of the Constable Collection*, 2nd ed., 1973

Reynolds 1984 — Graham Reynolds, *The Later Paintings and Drawings of John Constable*, 1984

Shirley 1930 — Andrew Shirley, *The Published Mezzotints of David Lucas after John Constable, R.A.*, 1930

Tate 1976 — Leslie Parris, Ian Fleming-Williams and Conal Shields, *Constable: Paintings, Watercolours and Drawings*, (exhibition catalogue) Tate Gallery, 1976

Tate 1991 — Leslie Parris and Ian Fleming-Williams, *Constable*, (exhibition catalogue), Tate Gallery, 1991

Ian Fleming-Williams

Introduction

Numerically, Constable's drawings far outnumber his oil-sketches and easel paintings. They are, however, the least known of his works. Availability is one of the reasons for this. Few are to be seen permanently on view to the general public, the greater part of the considerable national holdings being only accessible on request. In reproduction or in exhibitions it is generally his watercolours that are chosen to represent his work on paper. This is understandable – we all respond readily to colour – but regrettable nevertheless, for with the most commonplace of all artists' tools, the 'lead' pencil, Constable was able to express many of his feelings for landscape to the full and to produce works, often on a miniature scale, able to bear comparison with landscape drawings by the greatest of Continental masters. In this exhibition we have examples from almost every period of his working life, from his early years to his very last season of sketching. The majority are in pencil; all are monochromatic.

In one of his lectures, when talking about the young aspiring artist, Constable said that the 'art of seeing nature', the *art* it will be noticed, 'is a thing almost as much to be acquired as the art of reading the Egyptian hieroglyphs'[1]. Drawing, with its necessary conventions, like a written language, also has to be learned, and as Constable (unlike Turner) was a slow developer this took time. The first section in this exhibition, the Prologue, is devoted to the graphic work of those artists whose influence during Constable's formative years as a draughtsman may be most clearly seen.

For Constable, as for most young artists, drawing was part of the learning process: acquiring manual skill – a somewhat underrated part of the training – and an understanding of natural appearances. During this formative period and on into his early maturity, drawing or painting appears to have taken the lead alternately: painting out of doors in 1802 giving place to the pencil and watercolour in 1805 – 6; oil-sketching predominating in the period 1809-12, to yield during 1813 and 1814 yet again to the sketchbook and pencil. This period, and in particular these last two years, was largely devoted to collecting, to the gathering of material that would fuel his creative energy for the rest of his working life.

Much of his work with the pencil during this long period of study was essentially of a private nature. Occasionally drawings were made as gifts, or, as was the case in 1815, to be exhibited. Sometimes interested parties must have asked to see some of his drawings: the Whalleys of Fenton (Staffordshire) in 1801, for example, to see his Derbyshire sketches (see nos 3-5); or, in 1806, the Hardens of Brathay, his drawings and watercolours when he rejoined them from Borrowdale (see no.12). But it is only in the spring of 1814 that we have him referring to the contents of his sketchbooks for the first time. 'You once talked to me about a journal', he wrote to his betrothed, Maria Bicknell, 'I have a little one that I <kept> made last summer that might amuse you could you see it – you will then see how I amuse my leisure walks – picking up little scraps of trees – plants – ferns – distances &c'.[2] From this time onwards it is notice-

able that his sketchbooks are filled less with 'scraps' and increasingly with complete compositions sketched on the spot, landscapes scrutinised with great intensity and of a character entirely original. Constable's closest friend, John Fisher, nephew of the Bishop of Salisbury, may have had something to do with this. His sketchbooks contain copies of drawings Constable made in a pocketbook of 1813 and in several of his later books, and it is known that Fisher would attempt to further his friend's cause by showing the sketchbooks around among members of his circle.[3]

For an appreciation of Constable's vision of landscape it is sometimes helpful to remember his origins. A large proportion of the watercolourists were city dwellers. Many, such as Girtin, J.R. Cozens, Linnell, Palmer and, of course, Turner, were Londoners born and bred. For some, the countryside was a pleasant escape from urban life. Mostly, it was sketched while on tour, or, for a fortunate few, when staying with a patron at his country seat. In neither case were the artists part of the life that lived and worked on the land. By birth, Constable belonged to the land and remained essentially a countryman all his life, with a countryman's eye for practical detail – the hang of a gate or the slope of a field – moved neither by Mary Russell Mitford's rosy picture of life in the country,[4] nor by the efforts of those who attempted to raise landscape into the realms of High Art. With his passionate nature, it was his native eye that appears to have given him such a feel for natural phenomena and for the structure of material things, for the sheer weight of an approaching rain-squall (no.29), the crumbling of the earth's crust (no.36), or for the timbers of a patched-up lock-gate (no.60).

It was probably the degree of his familiarity with the country around his home that gave him the feel for what he called 'chiaroscuro', which he defined as 'that power which creates space' that is to be found 'everywhere, and at all times in nature; opposition, union, light, shade, reflection, and refraction, all contribute to it. By this power, the moment we come into a room, we see that the chairs are not standing on the tables, but a glance shows us the relative distances of all the objects from the eye, though the darkest or the lightest may be the furthest off.'[5] This awareness of space, be it within the confines of a room or in the open expanses of the outdoors, stems, of course, from knowledge, from motor experience, moving and touching; in Constable's case from the fact that his native countryside was, for him, so rich in motor memories that he knew it field by field, almost by heart; knew not only the distance of every feature he drew and painted, but how far it lay in time, how soon it could be reached. This feeling for space experienced found expression in sketches of other places he came to know well, Salisbury for instance, most noticeably in a drawing such as his remarkable *Salisbury from the Road to Old Sarum* (no.54), a view of the distant cathedral from beside the road he had just ascended.

Although landscape is the subject of most of the drawings in this exhibition (one portrait only is included), not all are studies direct from nature. There are examples of his curious method of making tracings (nos 22-3) and of his copies of works by other artists (nos 47-9 and 63). There are also drawings made during the development of a major work in oils (nos 50 and 68); sketches for a book illustration (nos 77 A – D); and a mezzotint, so overworked with wash and white heightening that little of the original is visible.

In Constable's early years pen or pencil and wash were the media he most often used (figs.38, nos 3-5); chalk he also adopted for a while (fig.56, no.7). Pencil then became and remained for the rest of his working life the tool he favoured most, though he used pen and wash again in the '20s for a series of Brighton views (nos 65 and 67) and worked with wash, pen and watercolour singly or in combination in the early '30s, both in the open air and in the studio (nos 68, 70 and 73). It was with the pencil, however, that he made the last of his sketches form nature (fig.117, nos 83 and 84).

There has been very little work done on the pencils that were available in the period when Constable was using

them (1796–1837), the graphite for which was being mined in Seathwaite, only a mile or so from where he was sketching in 1806 (see no.12). In his MS 'Observations of Landskipp Drawing' of 1791[6], the Oxford drawing-master, John Malchair, (see no.X1V) wrote thus of 'Lead Pencil':

The thikness of the Lead should be an eight part of an inch at least. The point of it must be blunt as a Glaziers diamond, which form afordes a corner sufficientely sharp for the dilicate lines at the same time that it presents several surfaces of a convenient flatness for the broader stroakes and learge shaddowes which require a force and spirit much too great for a slender point to resist <nor can a broad line bee drawn at all with a fine point>

From this one gathers that there was a choice of pencils available, from an eighth-inch thick lead to a more slender one. In addition, from examination of the drawings themselves, one must conclude that the quality of the mined graphite varied, producing strengths that were subsequently categorised (when mixed with clay) into the familiar degrees of hardness and softness, 'H' and 'B'.

Constable's marked preference for the pencil (only, of course, when not working in oils) is understandable if one takes just two examples from the present exhibition: the drawing he made in East Bergholt churchyard (no.44) and *Dowles Brook* (no.84), one of the last drawings he made from nature. Apart from its practical advantage – its handiness and immediate serviceability (no need to carry ink, water, or colours or to wait for drying) – the graphite point provided a range that neither chalk, pen or brush could equal. Constable exploits this range to the full in these two drawings. In the churchyard scene hardly even in oil-paint could he have achieved such a plethora of textures and touches, ranging from the faintest brushing of graphite in the sky, to the intensely dark and precisely drawn urn-finials on the railing around the tomb. It would not have been easy either, in oils, to equal the textural subtleties he was able to note in the chancel roof and nave end wall. *Dowles Brook* is an entirely different type of drawing, but here too we have an orchestrated range far beyond the capabilities of any other graphic medium – a vibrant gamut of touches.

As Anne Lyles will show in her essay, few of Constable's contemporaries attempted to exploit and enrich the pencil's potential thus far, and none left a comparable number of drawings in this medium of the quality to be seen in the present exhibition.

1 JCD, p.71.

2 JCC II, p.120.

3 John Fisher to Constable, 1 October 1822, '...Captain Forster a gentleman of property near Windsor is an admirer of your art. He is to meet you at Salisbury. He was first caught by a sketch book of yours which I had. Your pencil sketches always take people: both learned and unlearned.' JC:FDC, p.118.

4 Constable, in the journal he kept for his wife, 2 June 1824, '...Mrs. Strutt sent me a book from [?Mrs.] Hopkins – called our Village by Mis Mitford – being sketches by her of character & scenery too childish & unnatural for me – it seems done by a person who <for> had made a visit from London for the first time and like a cockney was astonished and delighted by what she saw.' JCC II, p.323.

5 Given in a lecture to the Royal Institution in 1836, Leslie *Life*, pp.316-7.

6 Unpublished; Private Collection.

Jane McAusland

Some of the Papers and Drawing Materials Available to Artists in the Late Eighteenth and Early Nineteenth Centuries

When John Constable went to purchase his drawing and painting materials he did not have to travel far from either of his London residences, for both Kepple Street and Charlotte Street (where he lived after 1822), were within easy walking distance from a number of new establishments that had recently caught on to the popular demand, from both amateurs and professionals, for an increasingly wide array of goods and services relating to painting, drawing and printing. In Constable's fifty-page sketchbook dated July 13–27, 1835, a label inside the front cover is inscribed: 'S. & I. Fuller, Temple of Fancy, 34 Rathbone Place, London' (a stone's throw away from Charlotte Street). The paper is watermarked: 'J WHATMAN 1832.' (Victoria & Albert Museum) (fig.1). The artist's correspondence gives us no hint or information about how or where he purchased his materials, so this little label tells us that at this time at any rate, he was buying them in London. There were also artists' colourmen in the country towns, as the *Ipswich Journal* of 1781 and 1800 records[1].

Papers, pens, pencils, chalks, inks and graphite were becoming more readily available to artists at the end of the eighteenth century. Stationers and repositories selling these goods were opening or expanding to deal with the enthusiastic demand from schools and private individuals for these products. One such outlet was Ackermann's Repository of the Arts. In 1786 Rudolph Ackermann, born in Saxony, had moved to London, and in 1795 he opened a large emporium at 96, The Strand. Ackermann's also published books on drawing and showed works of art in its own gallery as well as manufacturing its own brand artists'

materials. There is little further documentation about other such enterprises, but there were some noted London traders in artists' materials in existence at that time: Reeves and Blackman, William Dickie in the Strand, Edward Orme of Conduit Street (later New Bond Street), and Winsor & Newton.

Papers

Before 1800 the concept of 'drawing paper' was generally used to describe any papers that had the right surface and size for drawing and watercolour painting. From 1793 England was at war with France for twenty years and the disruption of imported papers and raw material forced the British papermakers to be more productive and inventive than previously, having hitherto relied too much on continental imports. The increasing demand for specialist papers, including drawing papers, was found to be profitable for the manufacturers – a ready market could be identified and catered for.

Linen (flax) or cotton rags were the preferred and most commonly used raw materials for the furnish of paper at the end of the eighteenth century. Linen fibres make the best paper because the fibres are longer and thicker, therefore stronger and more flexible; they are also naturally purer, so need less treatment before use. After the 'furnish' was treated it was cast into sheets on 'moulds'[2] constructed with copper wires to produce either *laid* or *wove* papers. (figs 2 & 3). The former shows a strong pattern of close *'laid lines'* with intersecting *'chain lines'* at intervals. These are

1 A trade card of S. & I. Fuller, 1823. The Temple of Fancy opened in 1809. What appear to be small sketchbooks stack the shelves behind the central display stand area. Board of Trustees of the Victoria and Albert Museum, London.

2 Paper made on a laid mould showing watermark of a Royal Cipher. The Author.

most visible when a sheet is held up to the light. Wove papers have a dense, even translucency, just sometimes showing the woven pattern produced by being made on a fine mesh. The papermakers sewed copper wires to the surface of a mould, in the form of a design, letters, date, a name or both, which slightly thinned the paper on casting, produc-ing what are termed 'watermarks'. Ideally for drawing, papers should be 'sized'. This process gives a sheet a harder or softer surface, depending on the strength of the sizing agent, and a certain amount of waterproofing. A hot solution of gel-atine was generally used for papers in the late eighteenth and early nineteenth centuries. Added alum hardened the gelatine. Finally the surface of paper could be 'finished' either with pressure from a burnisher (a polished stone like agate), or it was put through two wooden rollers like a mangle, called a 'calendar machine'. Later, metal sheets which put pressure on the paper sheets were used in a sandwich with rollers to flatten the paper's surface. Sometimes these metal sheets were heated to produce an even flatter surface. At this time papers with smooth, flat surfaces were known as 'glazed'.

The invention of wove paper in the 1750s is credited to James Whatman senior of Turkey Mill, Maidstone in Kent (fig.4) and was considered a breakthrough, certainly in English and even in European papermaking. James Baskerville the printer had developed a new fount of type with very fine lines and he needed a paper with a smooth surface without bumps, lumps and general unevenness. Full development of wove paper seems to have taken about a decade, but its popularity steadily increased. Later, Thomas Bewick, the wood–engraver of natural history sub-jects, required this remarkable smooth paper for his detailed and often small, exceptionally fine engravings. Other papermakers soon caught on and began making this high quality paper[3].

John Constable's early choice of papers for his drawings may at first have been limited to laid sheets through the lack of available wove papers, which papermakers were slow to perfect. In England in 1800 there were 417 mills licensed to make paper[4].

The watermarks that are easily decipherable in the paper of the drawings in this exhibition are: a posthorn in a car-touche with W beneath, indicating a Whatman paper (*Chalk Church, near Gravesend* 1803, no.6); an 'E & P' 1804, (Edmeads & Pine), (*The River Brathay and the Village of Skel-with Bridge* 1806, no.11); JOHN DICK... 18, (John Dickinson

3 Wove paper showing the watermark, J. Whatman, 1829. The Author.

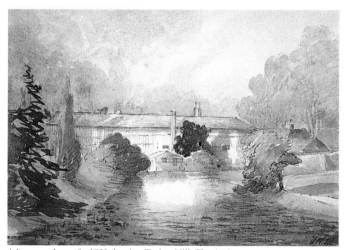

4 A watercolour of c.1830 showing Turkey Mill. The Author.

& Co.), (*Reapers on a Summer Evening* 1817, no.41); FEL-LOWS 1812, (John Fellows), ('*Captain Allen*' 1818, no.42); ...ATMAN 18... (J Whatman), (*Salisbury from the Road to Old Sarum* 1820, no.54) and a fuller J WHATMAN 1833 (*A Sunken Lane at Fittleworth* 1835, no.78).

The majority of Constable's drawings are on wove paper, which leads one to think that he preferred the smooth surface of this type of paper to the finely ridged undulations of laid paper. His drawing style is demonstrably different on the two surfaces and he may have enjoyed experimentation. His small sketchbook of 1815 (nos 29, 30 & 31) is of laid paper and the undulations have stamped their character on the lines of his drawing as the pencil has moved over them (with results similar to a coin rubbed through paper). The drawing style of his wove paper sketchbook of the summer/autumn of 1816 (nos 32 – 39) is very different, the smooth surface of the wove paper imposing no character of its own on the drawings, giving a free rein to the artist.

Constable also occasionally used coloured papers for his drawings. His early figure studies of 1800 (Victoria & Albert Museum) are on brown and grey papers, and on papers with a green (sketchbook, summer 1815) or blue tinge as in no.47 of 1819. The use of these papers is consistent with the tradition of the Old Masters and artists working in the seventeenth and early eighteenth centuries, such as Van Dyck and two of the artists Constable copied, Van de Velde and Ruysdael.

Perhaps with a view to sending them off to his friend John Martin, the bibliographer (1791–1853), Constable drew his series of drawings *Jaques and the wounded Stag* (nos.77 A – D) on writing paper. Alternatively as this paper had shorter fibres than the other papers he was using and was thinner, maybe these drawings were executed with the idea that they should be transferred to a woodblock for publication.

Most of the drawing papers Constable used are well sized, and thereby not soft or waterleaf, ie. without sizeing. It is interesting to note that in his *Compositional Study for 'Stratford Mill'* (no.50) he has either used absorbent paper or worked on a dampened sheet, in an almost oriental fashion. Some of his watercolours also demonstrate this method of execution on dampened paper (V & A cat.no. 92a).

Graphite and Pencils

The first graphite, a form of carbon, was mined in Borrow-

5 Steps in making an early wood-cased pencil from natural graphite. The Author.

6 A nineteenth century stump of tightly rolled paper. The Author.

dale, Cumberland in the middle of the sixteenth century. It soon became the successor to the older, metalpoint drawing stylus, the tool used by late mediaeval and Renaissance artists and tradesmen for drawing or writing on paper, parchment or wood. These early instruments were made of copper, silver, lead, bismuth, tin and alloys of these metals. Gold was also used. Due to its similarity to the metal, it is an accident of terminology stemming from the use of lead (plumbago) in metalpoint that we arrive at the erroneously named 'lead pencil' of today.

The lode of finest graphite (or *wadd*, the traditional local nomenclature) found at Borrowdale was for three centuries the most highly prized European deposit, and was jealously guarded at its source and by severe export restrictions. Originally the natural graphite was used either as a lump, often held in sheepskin, or a stick set into a *port–crayon*. The name 'pencil' derives from the latin *pencillium*, as the stick resembled a brush of that name. Pencils as we would recognise them today were made in Germany at the end of the seventeenth century, but were not of the standard of the later English manufacture as they were composed of inferior graphite dust mixed with gums and tallow. The first edition of *Encyclopaedia Britannica* names George Rowney's factory as the earliest British pencil mill. All records of this factory, its exact date of opening or its whereabouts have been lost; it certainly was not at Keswick, where the pencil industry began circa 1792. At this time in England pencils were made from pieces of natural graphite cut and fashioned to fit into hollow cylinders of wood, usually cedar (fig.5).

The deposit that graphite leaves on paper is in the form of flakes or grains; it is friable and shows a much greater broad tonal range than the earlier metalpoints. Constable's drawings show this range of tones in the natural graphite. In the 1790s in Paris, where English graphite was unavailable (due to the war), Nicolas–Jacques Conté developed a pencil by mixing finely powdered graphite from which impurities had been removed, with potter's clay and water. This wet paste was fashioned in long rectangular moulds, then fired at a high temperature. By this method a broad tonal range of pencils could be developed. It is interesting to note that when Constable was drawing with graphite in Borrowdale (no.12) in 1806 he was only a mile or two from where the first *wadd* was discovered and mined.

Black Chalk

The distinctions between chalks, pastels and crayons, and the terminology used to describe them is confusing. Roughly speaking, they fall into simple categories, although

a browse through colourmen's handbooks of the nineteenth century reveals that all three words were used indiscriminately to describe the three different types of material. First came natural chalk, or the pigmented earths that are found in certain areas of England and Europe. Used since Stone Age man first drew on cave walls, they continued to provide artists of the Renaissance with a material that produced some of the most remarkable drawings ever executed. Natural chalks of uneven consistency provided a harder or softer line for the artist. The unevenness of these chalks led to a demand for smoother, more regular drawing material, and so a second type of fabricated chalk or pastel was composed from pastes of dry pigment and water soluble binding agents, various gums and other substances. These could be made more even, and different tones and colours could also be achieved. Although *Nicholson's British Encyclopaedia* noted in the nineteenth century that: 'natural black chalk with white is constantly preferred in the model room of the Royal Academy, the professors of which consider it the best material for drawing from plaster figures or the life', it is likely that the black chalk or crayon drawings in this exhibition by George Frost (Prologue nos VII, VIII & IX) and Constable (no.7) belong to the third category. These chalks or crayons were made by binding pigments with oily or fatty agents which could include olive oil, tallow, spermaceti, linseed oil, beeswax or even soap. The result was a medium which was less friable than the other chalks or pastel, but with the same possibility for variety of tonal range.

The Uses of Stump and Isinglass

Two other aids relate to Constable's use of graphite and black chalk, one more visible than the other. The first and *visible* tool is a stump. This was tightly rolled paper or leather which formed a cylinder about 1.5 cm diameter and about 15 cm long (fig.6). Both ends were sanded to form rounded points and a piece of smoother paper or leather surrounded the centre to provide a holder. The equivalent of a graphite or black chalk wash was achieved by blurring the lines with the point of this instrument. Constable has used this method in his black chalk drawing of *Washbrook* (no.7) to achieve a misty horizon in the distance.

The *invisible* aid is Constable's use of a fixative to fix or hold the graphite to the paper surface. In his *Memoirs of the Life of John Constable, R.A.,* C. R. Leslie notes that in 1834 during a visit to Lord Egremont at Petworth:

> I had an opportunity of witnessing his habits. He rose early, and had often made some beautiful sketch in the park before breakfast. On going into his room one morning, not aware that he had yet been out of it, I found him setting some of these sketches with isinglass.

This fixative is a high grade glue made from the swimming bladders of fish, (the sturgeon providing the highest quality), which does not discolour or darken with age. An observant eye will see that on Constable's drawing of 1806, *Glaramara from Borrowdale* (no.12) there is a triangle in the centre of the tree on the left where the fixative has not been applied, leaving a lighter area. Artists at this time also used egg white and milk as fixatives for friable surfaces. The latter discolours badly.

Black Carbon and Iron Gall Inks, Reeds and Quills

In 1796, when staying with relations in Edmonton, John Constable met J. T. Smith, a professional artist who, as he was involved with topography, had developed a careful, detailed style of drawing. He became an informal tutor to Constable, visiting him at East Bergholt in 1798, and influencing his drawing at this stage (see Prologue nos I & II). *A Farmhouse by a River,* 1798 (no.1) is an example of this influence, showing fine lines of black carbon ink. These inks were prepared and used by the ancient Egyptians and Chinese, so the history of their use is long and the ink is very stable. They were first imported into Europe from the Orient and were highly regarded for the fine lines that could be achieved with this black liquid. The ink is made from a variety of soot, some resinous and made from different woods, and fruit stones bound with gums or animal

glue. The oriental version is in the form of small black cakes which have to be rubbed on a wetted rough stone to produce the liquid. Europeans experimented with various mixtures, also producing liquid versions and later *Indian* inks that were both liquid and sometimes waterproof. It is impossible to say exactly what type of black carbon ink Constable used in his drawing of 1798.

We cannot be certain about the instrument Constable used in his series of ink drawings of *Jaques and the wounded Stag* (77 A – D), but it is either a quill or a reed pen. It is unlikely to be of steel, as this type of pen was not fully developed until after the third decade of the nineteenth century. A brush has been used for the ink wash. The ink is not bistre (tar, soot and gum) or sepia (cuttlefish ink), but 'iron gall' ink, made from oak galls (containing tannic and gallic acids) and ferrous sulphate. Primarily made for writing, these inks are acidic and corrosive to paper, so in the darker areas of these drawings the paper is brittle and weak. Iron gall ink darkens on drying and with exposure to the air. It is interesting to note that these ink drawings are on writing paper; perhaps the artist was poised to write a letter, but, changing his mind, he produced the first *Jaques,* liked the results and continued.

The combination of different papers, drawing materials and instruments, gave Constable and his contemporaries a much greater freedom of choice than earlier artists had enjoyed. Constable felt least constricted with the pencil; the instant graphite line, with all its tonal potential, on the new smooth Whatman paper, eventually provided him with just the results he sought. The sketchbooks and small notebooks sold at the new London emporia, that could be slipped easily into the pocket, were also just what he needed for the drawings he made on his walks in the countryside.

1 *The Ipswich Journal* of June 1781 lists an artist colourman, Kendall of Bury St. Edmunds, selling 'Watercolours, books and Reeves new patents as well as canvas'. In May 1800 the same journal lists R. Clamp (Engraver) who advertised every article in the 'Fancy drawing line'.

2 'Furnish': the mixture of various materials that are blended in the stock suspension from which paper is made. The chief constituents are the fibrous material (pulp; at this time linen in the form of rags), sizing materials, and dyes. A paper 'mould' is a frame over which is stretched a porous fabric, usually a wire screen, on which fibres are separated from a fluid suspension to form a sheet.

3 Of these James Newman is perhaps the most important, he worked very closely with papermakers to develop very paricular watercolour and drawing papers. All the 'Whatman' paper made for Newman, to his specificications, by the Hollingworths at Turkey Mill, contain, besides the normal J WHATMAN/TURKEY MILL etc watermark, a copperplate N in the watermark. After 1859 when the Hollingworths stopped making 'Whatman' paper, these marks also sometimes contain an additional B to indicate that they were made by Balston at Springfield.

4 The following mill and paper makers are identified from watermarks in the papers of some of Constable's drawings: Basted Mill, J. Buttanshaw, John Dickinson & Co., Portal & Co., S. Lay, J. Wickwar, J. Whatman, Edmeads & Pine, J. Rump, Skeats, J. Ruse, John Fellows, Gilling & Alford, and Joseph Coles.

BIBLIOGRAPHY

Doerner, Max, *The Materials of the Artist,* London, 1970

Mayer, Ralph, *A Dictionary of Art Terms & Techniques,* New York, 1969

Petroski, Henry, *The Pencil: a History,* London, 1989

Watrous, James, *The Craft of Old-Master Drawings,* Wisconsin, 1957

The Dictionary of Paper, American Paper and Pulp Association, New York, 1965

Hunter, Dard, *Papermaking: The History and Technique of an Ancient Craft,* New York, 1967

Hills, Richard L., *Papermaking in Britain 1488 – 1988,* London, 1988

Churchill, W.A., *Watermarks in Paper in Holland, France, England, etc. in the XV11 Centuries and their Interconnection,* Amsterdam, 1967

Krill, John, *English Artists Paper,* London, 1987

Paper – Art & Technology, Paulette Long, Ed., San Francisco, 1979

Bower, Peter, *Turner's Papers: A Study of the Manufacture, Selection and Use of his Drawing Papers 1787 – 1820,* London, 1991

Anne Lyles

The Landscape Drawings of Constable's Contemporaries: British Draughtsmanship c. 1790–1850

When transcribing the three-dimensional world onto a flat surface, we instinctively tend to describe form using outline rather than tone. Yet it is a fundamental truth that, as the late eighteenth-century Oxford drawing master John Baptist Malchair put it, 'natural objects have, strictly speaking, no outline.'[1] 'Remember always', wrote John Ruskin in *The Elements of Drawing* (1857), 'that everything you can see in Nature is seen only so far as it is lighter or darker than the things about it, or of a different colour from them.'[2] Thus 'a good artist habitually sees masses, not edges'; an artist who 'restricts himself to outline', he advised, was 'a bad draughtsman'.[3]

However, the basic tools of the draughtsman's trade are the humble pencil (which both Malchair and Ruskin recommended) and chalk, both of which are essentially linear in character. This paradox was acknowledged by the water-colourist James Duffield Harding, one of Ruskin's early mentors, in his popular treatise *Elementary Art; or, the Use of the Lead Pencil* (1834). Since the operations of the pencil, he explained, were 'carried on by lines', it was on those grounds 'ill adapted to the purposes of Art'.[4] Not only, then, did the artist first need to be taught how to see the world for what it really was, a sequence of 'masses' rather than contours. He also had to be trained to cajole an apparently unsuitable instrument into producing areas of tone.

One method of creating tone with pencil or chalk, was to rub or smudge the lines, either with a finger (as Malchair advised) or with a tool known as a 'stump', usually made of rolled paper or leather. But the most common method was by shading or hatching, a method of laying lines together

'uniformly by going up and down with the pencil ... with a certain steady and rapid motion of the hand'.[5] Shading had the advantage of making a drawing more 'expressive', as Ruskin recognised.[6] But it was also a vital means of representing shadow, and therefore creating the impression of volume. Constable on one occasion defined 'Chiaroscuro' (light and shade) as 'that power which creates space'.[7]

Constable seems from an early age to have had an almost instinctive feeling for the importance of tone and the value of tonal contrasts. His early chalk drawings made at the Royal Academy from the living model were admired for 'their breadth of light and shade', and at the same time criticised for 'sometimes being defective in outline'.[8] He brought the same tonal bias to the study of landscape, but it took a number of years to develop his own personal, 'tonal', response to the natural world.

This essay investigates the extent to which Constable's contemporaries shared a similar tonal approach in their landscape drawings. The study of Nature being Constable's chief concern, the essay concentrates on pure landscape (hills, fields and open countryside) rather than topography (the representation of a specific place, usually an urban view). Since most of Constable's landscape drawings were made with the pencil, the emphasis is placed on the use of that tool. However, chalk is also considered in so far as it was the obvious alternative for an artist when drawing in monochrome, and because Constable himself occasionally used it. Of course, artists could also create tone in their landscape drawings by using pen and ink with monochrome washes, and indeed British artists working in the late eigh-

teenth century had often favoured this method.[9] However, by the early nineteenth century artists were tending to prefer colour (that is watercolour) when working in washes; so although Constable himself sometimes employed pen and ink and monochrome washes, especially in his early and later career (see nos 1, 50, 60–1, 65, 70–1, 73 and 77),[10] the use of this technique by his contemporaries will not be discussed here.

Whilst numerous publications are available on the history of watercolour painting during this period, little has been published on the subject of British pencil draughtsmanship,[11] and in a short essay it will not always prove possible to analyse an individual drawing at length. It is therefore suggested that some of the following questions should be borne in mind as to why, and under what circumstances, any given drawing was made (although, of course, motives often overlap and are not always easy to disentangle).

Was the drawing made for its own sake, purely as a means of expression, or as a record intended for future use (for working up into a more elaborate watercolour or oil, for example)? Is it simply a sketch, or a finished composition: was it made on the spot or in the studio; did the artist intend that only he should see it, or did he plan to circulate it amongst his friends, or send it to a public exhibition? Was it drawn rapidly, possibly on the move, or was it carefully laboured over during a long period? Is it drawn in a 'language' that is recognisably the artist's own, or does it seem dependent on the style and methods of others, perhaps the drawing master or, as is more often the case, those of well-known landscape artists who preceded him?

Wilson, Gainsborough and the Early Watercolourists: the Eighteenth-Century Background

When in the 1790's Nicholas Jacques Conté and Joseph Hardtmuth invented a process of mixing graphite with clay, it became possible for the first time to produce pencils of predictable degrees of varying hardness;[12] the pencils produced by this method were the forerunners of the versatile tool we know today. Before that date, the pure graphite pencil was a limited instrument of variable quality, and in the eighteenth century it remained for most artists a functional rather than an expressive tool.

Pencil, of course, produces much finer, sharper lines than chalk, and does not wear down so quickly. It was first used in the sixteenth century, when it inherited the role of the old 'lead' point (or metalpoint).[13] At that time it was often employed for under-drawing, and it continued to be used in this way well beyond the eighteenth century. The early watercolourists in particular, such as Paul Sandby (1730–1809), almost invariably employed pencil for defining preliminary outlines (especially the contours of buildings) in their 'topographical' drawings;[14] the outlines were then superimposed with layers of differing shades of grey wash to define light and shadow, as well as with a little local colour – hence the expression 'tinted drawing'. Pencil was also an invaluable tool for the artist when on tour, the ideal medium for recording new information which might serve in later years as the raw material for a more elaborate composition. When travelling in Italy with William Beckford of Fonthill, for example, in 1782–3, the watercolourist John Robert Cozens (1752–1797) filled seven sketchbooks with small outline landscape studies in pencil, to which he later added (perhaps whilst still on tour) areas of grey wash to indicate light and shade.[15] Many of these studies were subsequently used as the basis for evocative landscape watercolours of the sort Constable had in mind when he commented that 'Cousins was all poetry'.[16]

The oil painters Richard Wilson (1713/4–1782) and Thomas Gainsborough (1727–1788), by contrast, only rarely made watercolours, preferring to work in monochrome, and then usually in chalks rather than pencil. Wilson worked exclusively in chalks, usually in combination with coloured papers, and instructed his pupils to do likewise so that they might be 'ground ... in the principles of Light and Shade without being dazzled and misled by the flutter of Colours'.[17] Although Gainsborough used pencil with remarkable virtuosity in his early career (see Prologue nos XI – XII), he later abandoned it for chalk because, his

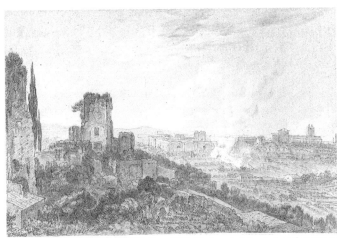

7 Richard Wilson, *The Palatine Hill, Rome*, 1754, black and white chalk and stump on blue-grey paper, 283 x 424mm. Whitworth Art Gallery, University of Manchester

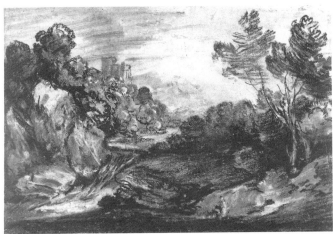

8 Thomas Gainsborough, *Landscape Composition*, c.1780, black chalk and stump heightened with white on prepared paper, 225 x 319mm. British Museum, London

daughter explained, 'He cd. not with sufficient expedition make out his effects'.[18] The rapidity with which chalk could be handled certainly seemed better suited to his aims and temperament in his later years.[19]

Chalk, of course, produces softer and broader effects than pencil (qualities, perhaps, of particular appeal to an oil painter). Chalks are especially effective when used, as they were by Gainsborough as well as by Wilson, in combination with coloured papers of a middle tint. The coloured paper (usually blue, blue-grey, grey or brown) could be left to stand for the mid tones (and to give some notion of local colour[20]); the darker and lighter tones ranging from velvety blacks to pearly white highlights (applied in chalk or liquid lead white) would then be built up around them. By this method, a richer variety of tones could be obtained than by using chalk (or pencil) on white paper, and a greater subtlety in the description of light and shade.[21] Presumably this explains why it was widely adopted at this date in teaching academies, including the Royal Academy Schools, for making studies from plaster casts and from the life.[22]

However, the two artists may also have had their own, more personal reasons for adopting this combination of media. Wilson seems first to have used chalks on coloured papers when, in the 1750s, he came across similar drawings made by French students working in Rome.[23] Meanwhile, one nineteenth-century critic thought that Gainsborough had adopted the technique under the influence of the French drawing masters active in London at this date – although it seems just as likely that he was inspired by the landscape drawings of the Old Masters, particularly the Dutch and Flemish landscape painters, and the French artist Gaspard Dughet on whose work Gainsborough based many of his later compositions.[24] Wilson and Gainsborough used the combination to equally impressive effect: Wilson especially in his 'Dartmouth' drawings, elaborate studio compositions of classical Rome made c.1753 for William Legge, second Earl of Dartmouth (fig.7);[25] and Gainsborough in his later, imaginary landscapes, apparently made up from models of objects arranged in the studio (fig.8).[26] Constable hung drawings by Gainsborough similar to these in his parlour in later life.[27]

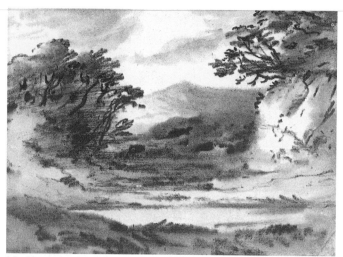

9 Dr Thomas Monro, *Landscape with a Cliff*, ?c.1800, india ink stick and stump, 142 x 195mm. British Museum, London

The drawings of Wilson and especially Gainsborough were much imitated in the late eighteenth century. Wilson's studies mainly influenced his pupils, such as Joseph Farington, and artists (often amateurs) in the circle of Sir George Beaumont.[28] Gainsborough's chalk drawings were imitated by the portrait painter John Hoppner (1758– 1810) and by the drawing master and painter of bodycolour landscapes John Laporte (1761–1839). In collaboration with W.F. Wells, Laporte also produced a series of soft-ground etchings after a selection of Gainsborough's sketches in private collections (1802–5).[29] The doctor, collector and amateur artist Thomas Monro (1759–1833) also made 'pasticci' of Gainsborough's drawings with an india ink stick, stump and washes on dampened paper (fig.9).[30] Thus the influence of Wilson's and Gainsborough's late drawings was transmitted well into the nineteenth century.

Monro and the 'Monro School': Thomas Girtin and his Circle

In late 1793 or early 1794, Dr Thomas Monro moved to new premises at 8 Adelphi Terrace, the Strand.[31] Within the year Farington recorded that the house was 'like an Academy in the evenings', where young artists were 'employed in tracing [the] outlines' of various landscapes given to them to copy.[32] Some of these were supplied by Monro himself from his own extensive collection of drawings by other artists, whilst others came from the collection of his friend and neighbour John Henderson.[33] We know that the topographer Thomas Hearne lent his work, and that in 1798 Thomas Girtin and J.M.W. Turner, Monro's most famous students, were 'employed in copying the outlines or unfinished drawings of Cozens', and then 'washing in the effects'.[34]

During his mental illness, John Robert Cozens had been placed in Monro's care.[35] At about that time (and apparently for a period after Cozens's death in 1797), Monro obtained 'temporary possession' of many of his drawings; giving them to Girtin and Turner to copy was, perhaps, his way of adding examples of Cozens's work to his collection at a time when it was not readily available on the market.[36] Yet even if Monro's motives were not entirely disinterested, his informal 'Academy' offered young artists an immensely valuable training in landscape drawing which was not easy to come by elsewhere (certainly not at the Royal Academy Schools, where the emphasis was on drawing from life and the antique). Not only Girtin and Turner, but many of the most promising talents of the next generation were to benefit from Monro's patronage, such as the brothers John and Cornelius Varley, John Sell Cotman, William Alexander, Henry Edridge, William Henry Hunt and John Linnell. Constable never became a member of the 'Monro School', although he later became friendly with Monro's artist son, Henry, and visited him at Adelphi Terrace.[37]

These artists working, often together, under Monro's tutelage, developed something of a 'house style' of drawing, characterised by the use of short, cursive strokes, even of dots and dashes, and of lines which are alternately thick or thin depending on the pressure exerted by the drawing instrument (usually pencil, but sometimes pen and ink). This method of drawing ultimately derives from Canaletto,

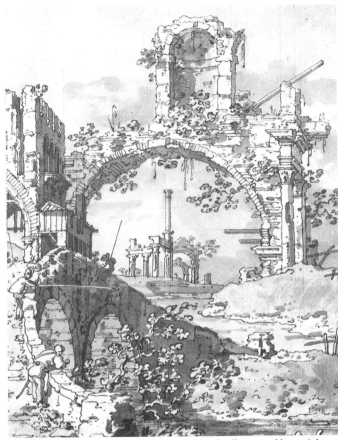

10 Canaletto (1697-1768), *Arch and Gateway Caprice* (detail), pen and brown ink over pencil with grey washes, 241 x 389mm (whole image). British Museum, London

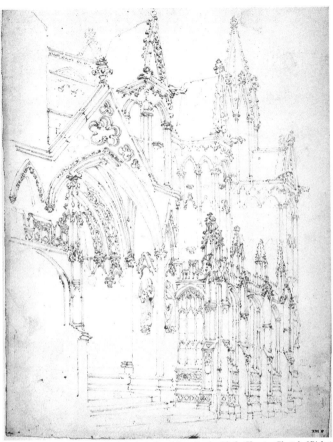

11 J.M.W. Turner, *Lincoln Cathedral: the South-East Porch with the Chantry Chapel of Bishop Russell,* 1794, pencil, 275 x 214mm. Tate Gallery, London, Turner Bequest XXI-P

whose pen drawings (fig.10) Monro and Henderson both owned (they also seem to have possessed examples of Canaletto's etchings, which have a similar cursive calligraphy).[38] To some extent, however, the style was transmitted through copies, and the work of imitators such as Farington. Constable, for example, once seems to have taken it up through the intermediary of Farington, although it is not always clear whether Farington's source was Canaletto or his own teacher, Richard Wilson, whose use of line is often similar (see Prologue VI and no.6).

The 'Canaletto' style of drawing is particularly well-suited to the description of variations in surface texture, and was thus ideal for recording buildings, and in particular the intricate details of an architectural façade.[39] With a hard pencil and taut, economical strokes, Turner, for example, brilliantly captures the knobbly encrustations of a cathedral's gothic porch (fig.11). Girtin uses the technique with similar precision in his impressive drawings of Paris,[40]

23

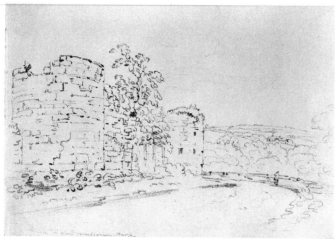

12 Thomas Girtin, *Ruins in Lord Mulgrave's Park* (from the 'Shepherd sketchbook'), c.1800, pencil, 143 x 213mm. Whitworth Art Gallery, University of Manchester

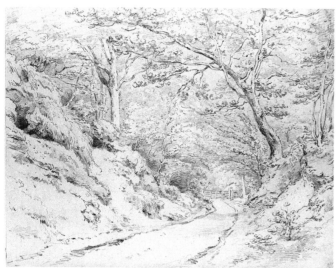

13 Henry Edridge, *A Country Lane among Trees, ? at Bushey*, c.1811, pencil, 260 x 343mm. Private Collection, photo courtesy Mellon Centre, London

but he often adopts a softer pencil, and looser, broader strokes which are, in fact, closer to Canaletto. The example by Girtin (fig.12), from the 'Shepherd sketchbook', shows how much less suited the style was for pure landscape – especially when used without shading, thereby forcing the artist to rely on accurate perspective (in this case, the receding road and the diminishing scale of the ruins) to help define the different planes. This drawing, like others in the sketchbook, is probably a 'record' of a composition rather than a nature study.[41]

This linear and rather decorative style of drawing frequently served as the supporting structure for topographical watercolours and landscapes, mostly executed in a limited range of coloured washes, often just blue and grey.[42] Yet for all its apparent studio mannerisms, the drawing style may well have facilitated the process of sketching from the motif. When reaching a point of firm pressure (sometimes indicated as a dot), the artist, whilst still holding his position with the pencil, would have been able to look back up at his subject without losing his place on the sheet.[43] Certainly a more naturalistic version of the style emerged amongst a slightly later generation of artists working alongside Monro at his country retreats near Fetcham in Surrey and Bushey in Hertfordshire. In the country lanes round Bushey, in particular, Henry Edridge (1769–1821) perfected a version of this technique with shading (see fig.13), which seems to owe something to Hearne, and was closely imitated by Amelia Long (1772–1837), one of Girtin's former pupils, in her pencil studies made in the vicinity of Bromley.[44]

J.M.W. Turner: the Study of Nature and the Influence of 'High Art'

J.M.W. Turner (1775–1851) continued to use the 'Canaletto' style of draughtsmanship for making topographical drawings throughout the greater part of the 1790s. During that decade, however, he was also experimenting with the use of coloured papers, both integrally coloured (that is coloured during manufacture) and those

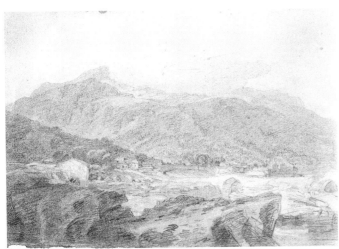

14 J.M.W. Turner, *Tummel Bridge*, 1801, pencil heightened with white on buff prepared paper, 292 x 432mm. Tate Gallery, London, Turner Bequest LVIII-42

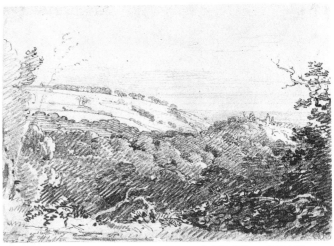

15 Thomas Girtin, *Brough, Westmorland*, c.1801, pencil, 143 x 198mm. British Museum, London

he coloured himself with a wash of his own choosing. In 1796, the year he took up oil painting, he prepared the pages of an entire sketchbook with dark washes (for use with watercolour and bodycolour rather than pencil) in imitation of the dark ground of an oil painting:[45] throughout his career, indeed, there was for Turner as much as for Constable a constant 'dialogue' between work in oil paint and that in watercolour, pencil or chalks. But the first large body of drawings Turner made on prepared surfaces are the sixty monochrome studies he made on a visit to Scotland in 1801, dubbed by Ruskin the 'Scottish Pencils' since they are executed almost entirely in that medium.[46]

Knowing, presumably, that he was on this occasion intending to work exclusively in monochrome, Turner prepared his paper with a mid-tint of brown composed, he told Farington, out of 'Indian ink and Tobacco water'.[47] He sometimes reinforced the darker areas of his pencilwork in these drawings (areas of the foreground, for example) with black chalk, whilst highlights were added 'with liquid white of his own preparing'.[48] Otherwise the pencilwork is 'made to accomplish everything that washes of colour would [nor-mally] do';[49] that is provide tone and articulate space in addition to defining form.

The impressive range of tonal modulation which Turner achieves in the series can readily be appreciated by comparing any of them (fig.14) with a pencil study of *Brough* made by Girtin in the same year (fig.15). Here, Turner's rival attempts to transpose to paper the conventional recessionary methods used by the classical landscape painters in oil, such as Wilson or Claude. Yet Girtin's summarily rendered planes – the dark foreground, middle distance of mid-tone and brightly-lit horizon – are not entirely plausible here; the tone does not successfully define the planes or achieve a convincing sense of distance or space.

Ruskin described the Scottish pencils as 'scientific in the extreme', and they seem to have been at least partly executed from nature.[50] They are, nevertheless, rather formal drawings, with a pictorial 'completeness', grandeur even, which suggests that Turner, as was so often the case, may have been looking at the landscape through the filter of 'high art'. On this occasion he may have been thinking of Richard Wilson's Dartmouth drawings (ill.7).[51]

We know Turner had been imitating Wilson's work in the later 1790s.[52] It seems more than likely, then, that he would have tried to see the Dartmouth drawings, either at the family seat, Patshull House in Staffordshire (drawn by Cornelius Varley in 1820, see ill.21), or at the London residence on Blackheath. Certainly other artists, and members of the gentry, managed to examine the series, as entries in Farington's *Diary* between 1801 and 1811 testify.[53] The Longs, for example, spoke enthusiastically about them to Henry Edridge, whose drawing in chalks, *Floods at Eton* (fig.16), surely reflects his own admiration for the series – as to a lesser extent do Amelia Long's own chalk drawings of Bromley Hill.[54] If Turner did see the Dartmouth drawings, he has more thoroughly integrated their impact, characteristically responding in his own, more personal way. It is interesting to reflect that whilst Turner, then, was apparently absorbing into his study of nature the influence of the formal statements of a painter steeped in the classical tradition, Constable, by contrast, was at around the same date responding to the more modest nature studies of his fellow East Anglian, Thomas Gainsborough, often transmitted through George Frost (see Prologue VII-XII, and no.7).

Turner again took up the method of working in monochrome which he evolved in the Scottish mountains in 1801 when travelling in Switzerland the following year. One sketchbook used on this tour, the *Grenoble* sketchbook, was filled with similarly pictorial alpine studies and executed in a similar combination of media, although the pencilwork was now more extensively worked over with black chalk.[55] Uncharacteristically, Turner later mounted up these studies in a special album.[56] But the pencil sketches made by him on future tours were rarely conceived in the same tonal terms (except, to a lesser extent, on his trip to Italy in 1819[57]). In his later career Turner travelled even more extensively throughout Europe (especially after 1815, which saw an end to the wars with France); and, often working on commission, he now needed above all to gather as much information as economically as possible. Nothing could be further from Constable's aims at any stage of his career.

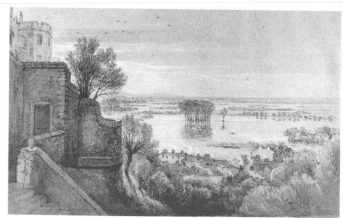

16 Henry Edridge, *Floods at Eton, from Windsor Castle*, c.1810, pencil and black chalk with grey wash and white heightening on blue-grey paper, 336 x 545mm. British Museum, London

To this end, Turner devised his own personal 'shorthand', a rapid notation he could use, if necessary, whilst on the move (he often made studies out of a carriage window). His sketchbooks would be filled with tiny outline studies in pencil, often several to a page, perhaps recording the scenery from different angles, and sometimes annotated with colour notes, even with compass bearings (fig.17). He knew full well that his powerful visual memory would enable him to add tone and colour when back home. Turner's interest in tone did not cease. It simply shifted from his drawings to other aspects of his output, particularly to the many monochrome engravings made from his work in his later career, in which his chief concern was to ensure the correct balance of light and shade – and in correcting proofs he could prove as daunting a taskmaster as Constable.[58] Increasingly Turner also became interested in the relationship between colour values and their tonal equivalents in black and white which, as Malchair pointed out (see under Prologue XIV), was not at all the same thing as the tonal expression of light and shade.[59]

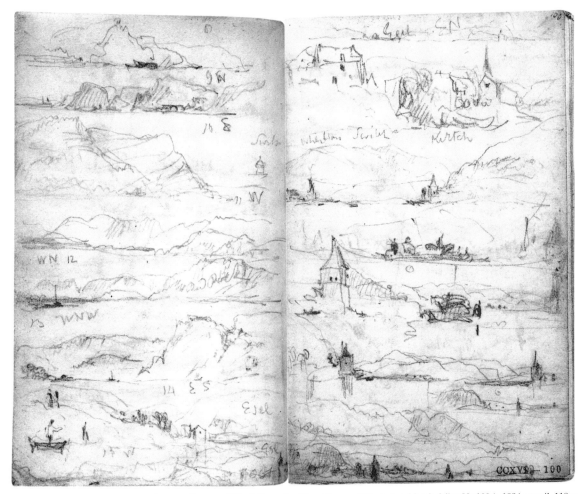

17 J.M.W. Turner, *Sketches of the Mosel between Ehrang and Kirsch* (from the *Rivers Meuse and Moselle* sketchbook, folios 99v-100r), 1824, pencil, 118 x 78mm (page size). Tate Gallery,London, Turner Bequest CCXVI

Turner, unlike Constable, made many watercolours on commission specifically for translation by engravers into black and white. Watercolour always played a significantly more important role in Turner's art – he used it throughout his career, whilst Constable only took it up intermittently. Neither became a member of the Society which the watercolourists established in 1804 in a desire to be independent of the Royal Academy on whose walls, they believed, their work was shown at a disadvantage. Yet it was partly the large, impressive watercolours that Turner had been exhibiting in the early 1800s that had fuelled the watercolourists' ambitions.[60]

The establishment of the Old Watercolour Society, of which the Varley brothers were founder members, led to an increase in the popularity and prestige of watercolour. Sir George Beaumont feared its detrimental impact on the course of landscape painting, as artists might be encouraged to take up the new medium in preference to oil.[61] Indeed, many of the most talented landscape painters of the early nineteenth century did devote themselves almost exclusively to the practice of watercolour. Girtin and the Varley brothers very rarely painted in oil, and although Cotman, David Cox and Peter de Wint used it more frequently, they are still much better known as watercolourists. From this date watercolours also became larger, technically more sophisticated, and more ambitious in content, often appropriating the traditional subject-matter of oils – indeed they were frequently framed to look like oil paintings.[62]

Yet if watercolour could take on the aspirations and appearance of finished oils, to what extent might it also appropriate the more intimate role of the sketch (and especially the plein-air sketch) which until this date had almost always been tackled in oil or in monochrome drawings? By the turn of the century Turner, Girtin and Cornelius Varley were all using watercolour with an unprecedented rapidity and spontaneity for recording transient atmospheric effects.[63] Whilst Constable, influenced in part by his knowledge of Girtin's and possibly Cornelius Varley's watercolours, was employing coloured washes with a similar boldness and freedom in the Lake District in 1806.[64]

In fact, at this date at least, just as many landscapists were turning to monochrome when working from nature, and as often to chalks as to pencil. Around 1806 to 1807, for example, about the time (or shortly after) their apprenticeship to the watercolourist John Varley, the young artists John Linnell (1792–1882), William Henry Hunt (1790–1864) and William Turner 'of Oxford' (1789–1862) were using chalks on coloured (usually blue) papers for making plein-air transcripts of the rather featureless stretch of the Thames at Millbank.[65] Linnell was also using this technique

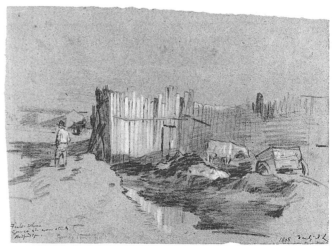

18 John Linnell, *Fields Where Gower Street Now Stands, Bedford Square*, 1808, black and white chalk on blue-grey paper, 161 x 222mm. British Museum, London

for sketching other unassuming corners of the urban scene – at Russell Square, Covent Garden and near Bedford Square (fig.18) – Bloomsbury, like Millbank, being still semi-rural at that date.[66] Linnell continued using chalks until at least 1820 (though by that date often in combination with washes); no doubt it was he who inspired his friend William Collins (1788–1847) to take up the technique as well.[67] Constable himself was experimenting at intervals in his early career with black and white chalks on mid-toned papers for sketching from nature (see fig.90).[68]

Linnell would have been using chalks on coloured papers from about 1805, when he entered the Royal Academy Schools as a probationer – the combination was regularly used there for making studies from plaster casts and the life. However, it was presumably Varley who promoted its use amongst his pupils for making landscape sketches in the open air, although he did not often favour the method himself; he had, after all, encouraged them to make oil sketches on millboard along the riverbanks at Twickenham without making similar studies himself.[69] Certainly other pupils of Varley used chalks on coloured papers for plein-

air sketching at various stages of their careers – William Mulready (1786–1863), David Cox, and especially Peter de Wint (1784–1849) who employed it regularly, perhaps because it approximated more closely than pencil to the richnesses of tone he was able to achieve in watercolour.[70]

In Linnell's case there may have been a further source of encouragement, for he and Hunt are the only members of the 'Monro Academy' who are specifically recorded as having copied Gainsborough's drawings at Adelphi Terrace, eighty of which Monro purchased in 1801.[71] Monro no doubt impressed on his young protégés that Gainsborough himself had used this combination for sketching from nature as well as for making finished drawings (some sources would have us believe that Monro had actually known Gainsborough and accompanied him on sketching expeditions[72]). By 1809 the method was being recommended for making 'studies of light and shade in the open air' in a drawing manual issued by Ackermann's, the celebrated London publisher and suppliers of artists' materials situated on the Strand.[73]

John Varley and the Role of the Drawing Master

Such drawing manuals were intended mainly for amateurs, who by this date represented an important and growing section of the market for the teaching of drawing and, especially, watercolour. For many artists, John Varley (1778–1842), Cotman and Cox for example, teaching was a financial necessity on which they relied throughout their careers. Other artists, such as J.M.W. Turner, took pupils only until they could manage without them – not long in the case of an artist as successful as Turner.[74] In his early career, Constable considered a formal teaching post at the Royal Military College in High Wycombe but rejected it on the advice of colleagues; shortly afterwards he wrote to a friend that accepting the position 'would have been a death-blow to all my prospects of perfection in the art I love'.[75] In later life Constable did occasionally take pupils. The best-known, Dorothea Fisher, was the elder daughter of one of his most important patrons, Bishop Fisher, so in this case at least remuneration can hardly have been uppermost in his mind.[76]

Although teaching was a necessity for many landscape artists, it was not always associated with drudgery. John Varley, for example, was a born teacher, for whom the role of drawing master was both a pleasure and a mission. Ever enthusiastic to preach his methods of 'cooking nature', it was not just amateurs he sought to convert into 'Michael Angelos' of landscape drawing.[77] On 22 August 1831, Constable wrote to C.R. Leslie:

> Varley, the astrologer, has just called on me, and I have bought a little drawing of him. He told me how to '*do* landscape', and was so kind as to point out all my defects. The price of the drawing was 'a guinea and a half *to a gentleman,* and a guinea only to an *artist*', but I insisted on his taking the larger sum, as he had clearly proved to me that I was no artist.[78]

To Constable, of course, the very idea of reducing nature to a sequence of formulae was anathema.

Varley was probably demonstrating to Constable the use of washes rather than pencil (the terms 'watercolour' and 'drawing' are interchangeable). However, a pencil drawing by him would not necessarily have looked very different, so dependent had Varley's work now become on those very rules of composition he espoused in his drawing manuals.[79] He had for many years been making 'copy drawings' in pencil specifically for the benefit of pupils – drawings which betray their pedestrian function in their simple compositions (assembled from such stock ingredients as a cottage, trees, water, bridge, a boat, a few weeds and so on) and the use of 'dead', repetitive lines (fig.19).[80] In the late eighteenth century, Malchair's students in Oxford had been trained to dispense with outlines and to achieve with the pencil a complete tonal landscape (colour was rarely employed by those in his circle, and then only for the most part over extensive pencilwork, see fig.44). By Varley's time, pencil was still regarded as an essential tool for the beginner when learning how to define form, even how to indicate light and shade, but most pupils were eager to progress

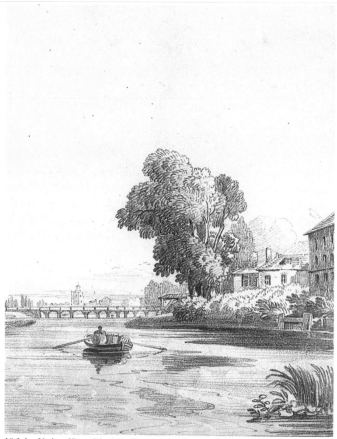

19 John Varley, *View of the River Thames with Battersea Bridge and Chelsea 'Old' Church*, pencil, 220 x 195mm. Photo courtesy of Sotheby's

Varley's copy drawings than by his watercolours (although he might have admired Varley's later, looser Claudean compositions in pencil, chalk or brown washes which resembled those Constable himself made in later life[83]). In his capacity as a teacher, Cotman also made many 'copy drawings' in pencil, especially for the large circulating library of drawings he created on his return to Norwich in 1809.[84] Yet, to a much greater extent than Varley, Cotman was able to separate his teaching activities from the rest of his creative output.

Cornelius Varley and the Patent Graphic Telescope

Like his brother John, Cornelius Varley (1781–1873) exhibited at the Old Watercolour Society, especially in his early career. But his output was never subjected to the application of didactic formulae, nor was Cornelius as prolific an artist as John, being equally interested in scientific pursuits.

Thanks, in part, perhaps, to this scientific bent, Cornelius Varley brought to the study of nature a more analytical eye than most of his contemporaries at the Old Watercolour Society, and one often as penetrating as Constable's. When travelling in Wales in 1805, he wrote that he wished to 'observe and understand' what he saw, and his close scrutiny of nature on that trip bore fruit in a sequence of remarkable watercolour sketches in particular.[85] Two years earlier, when touring North Wales with the artist Joshua Cristall, Varley also made some impressive pencil studies of mountain landscapes (fig.20) which invite comparison with drawings made by Constable in the Lake District in 1806 (nos 11-12).[86] But whereas Constable achieves tone in his drawings using pencil alone, Varley creates it by adding washes and stumpwork to a design conceived originally in terms of line.

Varley's linear approach to drawing became if anything more marked as the years progressed, accentuated no doubt by his use of mechanical drawing instruments, in particular the one he invented himself in 1809 known as the 'Graphic Telescope'.[87] Patented in 1811, the Telescope was used to project the image of an object or scene onto a sheet

to the more 'challenging' task of taking instruction in watercolour.[81] Pencil, for the amateur at least, was now just the means to an end.

Although Constable was capable of using pencil with remarkable physical control, he nevertheless had a deep dislike of any kind of 'repetitive movement'; he instinctively felt that every touch or stroke of the pencil should be different.[82] So he would have been no more impressed by

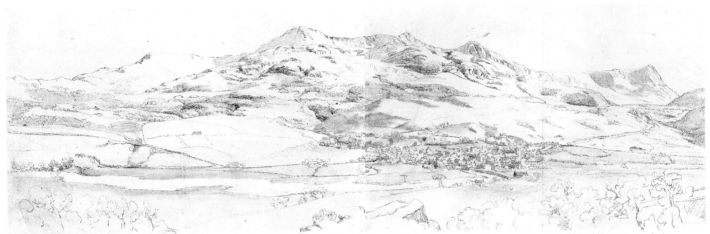

20 Cornelius Varley, *Panorama of Cader Idris and Dolgelly* (from the *North Wales* sketchbook, folios 10v-11r), 1803, pencil and stump with washes, 230 x 369mm (page size). Pierpont Morgan Library, New York. 1973.7.

of paper so that it could be traced. Artists had been using drawing aids like this for many years. The earliest and best-known was the camera obscura (originally a room, but from the seventeenth century a portable closed box). Then in 1807 a version was patented – the camera lucida – which could be used in full daylight.[88]

Varley's Telescope was a modification of the camera lucida with a more compact shape, and a greater facility for adjustment (some of the drawings he made with it are inscribed with the power of magnification, power 2, 5, 10, and so on); the original patent stressed its capacity for 'viewing Distant Objects' in particular.[89] It is likely that Varley was using both the camera obscura and camera lucida for making landscape drawings (perhaps even in Wales in 1803, see fig.20) before he had invented his Telescope; he could hardly have known what refinements were required without understanding the drawbacks of the older models. But only those drawings by him made with the Graphic Telescope are so credited, inscribed with the power of magnification or, more often, simply with the letters 'PGT' (fig.21).

As one might expect, Varley's drawings made with the Graphic Telescope are characterised by rather heavy, mech-

anical lines, very similar to those of Constable's 'tracings' made by means of a different process using a sheet of glass (see nos 22-24). In his tracing of *East Bergholt House* (no.24), Constable, like Varley in his view of Patshull (fig.21), has filled in some of the contours with shading, as if to counter-act their 'dead' weight. Yet despite their lack of spontaneity, such drawings were clearly valued as accurate records of the view. Varley seems to have invented his telescope specifically to facilitate the faithful recording of landscape (although it was also used for drawing portrait heads, for architecture, and for making tracings or reductions of images for the engraver).[90] Like Constable, he wanted to 'sketch the view correctly' – record objects at true distances and in correct relationship to each other, but also in accurate perspective (camera lucidas were recommended for the latter purpose in particular[91]). Our familiarity nowadays with photographic images perhaps makes it difficult for us to realise how far from everyday optical cognition two-dimensional concepts of landscape then were.[92]

With his customary precision in annotating his drawings, Constable has indicated that the tracing of East Bergholt House was made at half past eight in the morning – the

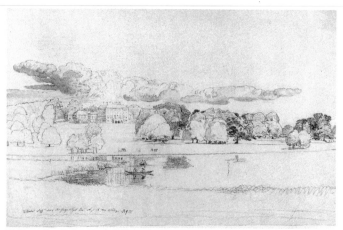

21 Cornelius Varley, *Patshull House, Staffordshire*, 1820, pencil and grey washes, 343 x 539mm. British Museum, London

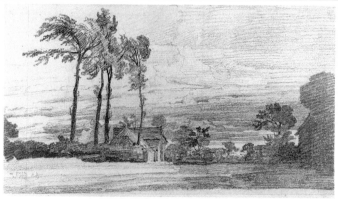

22 James Ward, *Buildings at Dusk: A Wind Getting Up*, ?c.1820, pencil, 180 x 320mm. Photo courtesy of Sotheby's

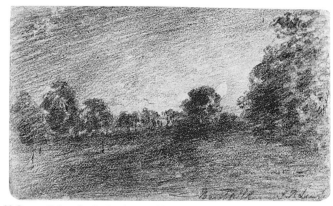

23 George Robert Lewis, *Landscape at Moonlight (? 'Bardhill')*, ? c.1815, pencil, 70 x 119mm. British Museum, London

long shadow cast by the tree in the right-hand foreground testifies to the early hour. In Varley's drawing of Patshull, however, shadows are short and few, and the light bright and strong, suggesting that it was made around midday, the very time when it was recommended that camera obscuras should be used.[93] Intriguingly, John Linnell made similar sharply-lit landscape drawings and watercolours in his early career which similarly focus on features in the middle distance and which have correspondingly empty foregrounds; and Linnell is known to have acquired various drawing instruments from Cornelius Varley.[94]

However, if the bright light of midday was apparently ideal for making tracings with the telescope, then for opposite reasons, dusk was the period for making more 'tonal' drawings; for, at this time, as George Field had experienced when out walking with Constable, 'all colour of the landscape had disappeared and objects were seen only as skeletons and masses'.[95] It was in conditions of twilight and moonlight that Constable's contemporaries James Ward (1769–1859) and G.R. Lewis (1782–1871) made pencil drawings (figs 22 and 23) which seem closer than almost anything else produced in this period to Con-

stable's own (and Lewis's sketch, like many of Constable's, is on a very small scale). Yet such drawings are by no means typical, having been produced in untypical circumstances. Constable's tonal response to nature was not, of course, conditional on seeing the landscape in exaggeratedly tonal terms, and in fact he did not often produce drawings at times of dusk or moonlight either (but see nos 24 and 53; and fig.68).

In his early career John Sell Cotman (1782–1842) had studied alongside the Varley brothers, both at the 'Monro Academy' and, from about 1802, at an artist's drawing club known as the 'Sketching Society' where members would meet to draw designs illustrating 'poetick passages' (designs which often incorporated a strong landscape element as well).[96] Some of his most impressive early drawings are elaborate pencil studies of the facades of ruined abbeys in Yorkshire made between 1803 and 1804, which in their confident handling of perspective anticipate the large body of architectural work he was to produce for the Norfolk antiquarian, Dawson Turner. On two trips he made to Normandy in 1817 and 1818 in connection with a proposed publication for the latter on the architectural antiquities of the region, Cotman took with him an example of Cornelius Varley's Graphic Telescope, which he seems to have found rather difficult to operate.[97] There is no indication, however, that Cotman ever used drawing instruments for landscape.

Comparison between two studies by Cotman of Rievaulx and of Fountains Abbey made in 1803 and 1804 reveal a subtle shift in his drawing style from a crisp, decorative manner learned at the 'Monro Academy' to a slightly looser, more tonal approach achieved with a softer pencil.[98] By 1804 to 1805 Cotman was using soft pencil for pure landscape, as is indicated by a group of studies of woodlands and parkland in Yorkshire drawn on a very small scale.[99] One of these subjects (fig. 24) is of particular interest in having been executed on paper prepared by Cotman with a buff wash. The highlights have been created by scratching through the wash to reveal the white of the paper beneath in a manner very similar to that adopted by J.M.W. Turner for a sequence of monochrome studies made in Rome in 1819.[100]

However, it was on the banks of the river Greta near the border between Yorkshire and Durham that Cotman was inspired to produce some of the most evocative drawings of his career: a small group of rich, tonal studies in black and

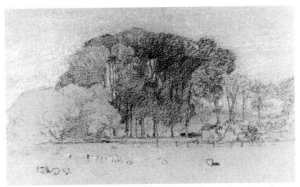

24 John Sell Cotman, *Parkland*, c.1804-5, pencil with scraping out on brown prepared paper, 95 x 159mm. Norwich Castle Museum

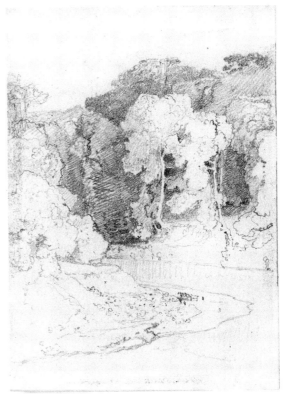

25 John Sell Cotman, *On the River Greta, Yorkshire*, 1805, pencil, 186 x 133mm. Leeds City Art Gallery

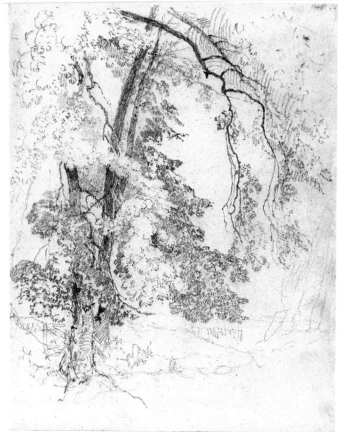

26 John Sell Cotman, *Tree Study*, pencil, ? c.1810, 303 x 242mm. British Museum, London

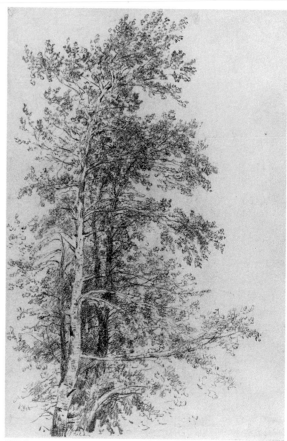

27 John Constable, *Study of a Birch Tree*, c.1820, pencil, 231 x 159mm. British Museum, London

white chalks on bluish-grey paper (a technique familiar to him from his days at the Sketching Society)[101]; and other, lyrical drawings in pencil, whose delicate touch has been described as 'of almost rococo lightness and playfulness' (fig.25).[102] Most of these studies share that sense of almost hypnotic stillness which is evident in Cotman's more famous watercolours of the Greta; indeed many of the latter are directly based on them.[103]

The Greta watercolours above all revealed Cotman's instinctive tendency to interpret nature in terms of rhythmic pattern and subtle pictorial design (a very different approach from John Varley's manipulation of the landscape according to a book of rules). Cotman's tendency to view nature in 'formal' terms can be seen in his drawings as much as his watercolours, although it is less apparent in his monochrome work as shapes are rarely 'flattened' out to the same degree.

A tree study, for example, made by Cotman probably

after his return to Norwich (he was apparently 'black-balled' from joining the Old Watercolour Society in London[104]), is at first sight impressively naturalistic (fig.26). But on comparing it with a tree study by Constable (fig.27; see also no.46), one notices the extent to which Cotman has thought of his subject in terms of its effective pictorial arrangement on a sheet of paper. Constable, one observes, draws a birch from a high viewpoint, so that he can scrutinize it in isolation and at close quarters, and he has brilliantly described the characteristic way its upper branches sway in a gentle breeze. He leaves us in no doubt that we are looking at a particular specimen, belonging to a distinctive species, at a specific moment. Cotman, on the other hand, selects a low viewpoint, which ensures that his tree is seen in relation to the surrounding landscape (and he has already begun to sketch in the rest of the composition). It also enables him to include the decorative overhanging branches of another tree nearby, and we are so mesmerised by the shapes and patterns of the foliage and branches that we barely stop to enquire what species he has drawn.

Cotman's formal approach to his subject tends, then, to produce drawings which appear rather static compared with those of Constable. What Cotman and Constable have in common, however, is their sheer commitment to drawing, particularly in pencil; the numerous surviving drawings by Cotman bear witness to the wide range of responses he brought to his subject throughout his career.[105] The same cannot be said of David Cox, although no-one else came closer to Constable than Cox in the use of a rapid, expressive line.

David Cox and the Animated Line

David Cox (1783–1859) left his native Birmingham for London in 1804. At an early date he began to work in black and white chalks on coloured papers perhaps, it has been seen, at the suggestion of John Varley; he used blue papers at intervals throughout his career, although in later years more usually with black chalk (or charcoal) alone.[106] Like Varley, Cox soon began to take pupils himself, impressing

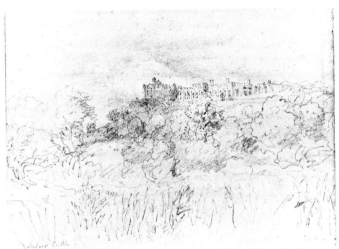

28 David Cox, *Bolsover Castle, Derbyshire*, c.1834, pencil, 200 x 278mm. City Museums and Art Gallery, Birmingham

on them the value of the preliminary drawing and of accurate draughtsmanship.[107] The drawing style he evolved for himself by the 1820s, especially for his architectural subjects, was nevertheless conspicuous for its freedom and bravura, albeit usually functioning as the linear framework for works in colour – tone and especially light and shade being provided by washes at a later stage.[108]

Cox's landscape sketches from nature in pencil or chalks are often similarly linear in character and at times quite slight, for the most part conveying the essential topography of the scene rather than weather or light.[109] A vigorous plein-air sketch by him of *Bolsover* made around 1834 is more elaborate than many, the addition of shading in the sky and elsewhere contributing extra animation to this blustery scene (fig.28). This sketch illustrates many of the hallmarks of Cox's mature drawing style as so tellingly described by Martin Hardie, in particular his use of a flickering, jerky line (which in even later drawings is distinctly angular) to suggest movement and vibration and the flutter of light and shade.[110]

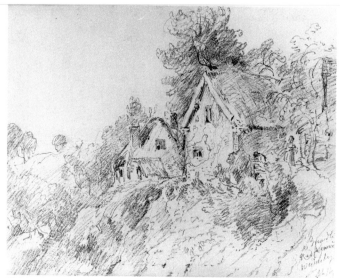

29 John Constable, *Cottages near Bewdley*, 1835, pencil, 216 x 284mm. City Museums and Art Gallery, Birmingham

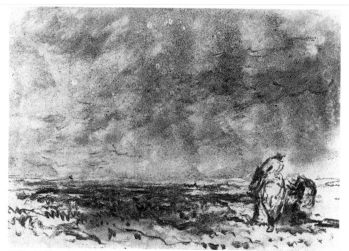

30 David Cox, *Crossing the Moor*, c.1850, charcoal and stump with some washes, 170 x 245mm. City Museums and Art Gallery, Birmingham

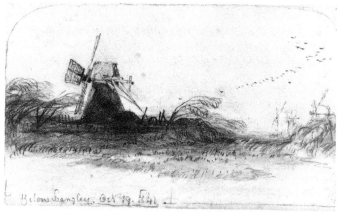

31 John Sell Cotman, *Below Langley*, 1841, black and white chalk on grey-brown paper, 187 x 317mm. British Museum, London

In drawings such as these, Cox comes close to Constable and to the 'restless shorthand' of his later years. One might, for example, compare Cox's sketch of Bolsover with a late drawing by Constable of *Bewdley* (fig.29), both being views looking up a steep incline from a low viewpoint. Constable appears to have articulated the foreground space more convincingly – his rapid strokes have succeeded in describing the slope, Cox's animated calligraphy has merely suggested it. Nevertheless, there is in Cox's drawing as a whole that same sense of spaciousness, achieved mainly through aerial perspective, which is characteristic of the rest of his output at this later stage of his career.

Cox's drawing style was so spontaneous by this date, and he so effectively suggests the palpitation of light or the movement of wind, that we are left with the impression that his sketches were made in the open air. However, this was not always the case. In later life, Cox often preferred to work indoors, in the winter evenings by lamplight, mapping out the rough charcoal outlines or broad colour lay-ins he called his 'cartoons', which he would complete in daylight on some future occasion.[111]

It was surely under studio conditions that Cox also produced his more elaborate late works in charcoal or chalks which are complete tonal statements in their own right – vigorous evocations of windswept moorland with, perhaps,

a figure on horseback, the main subject being the atmospheric and turbulent sky, in this example rendered using a stump (fig.30). Some of the chalk drawings made by Cotman on a two-month tour to Norfolk in 1841 (the year before he died), look rather similar to Cox's late work, albeit for the most part clearly drawn from the motif (fig.31).[112] They show an unusual degree of movement and animation which makes one wonder to what extent Cotman may by this date have been familiar with Cox's work. Certainly, the two artists knew each other in their late careers, for in 1838 they had planned a sketching tour together.[113]

Epilogue: Continental Topography and the Ascendancy of the Drawing Master

To a greater extent than any of the artists considered so far, Cotman and Cox are associated, like Constable, with specific landscapes in Britain they lived near or came to love – Cotman is identified with North Yorkshire and Norfolk, Cox with the Midlands, Herefordshire, Lancashire and North Wales. However, unlike Constable, both artists made occasional tours abroad, mostly to Northern France.[114] Following the reopening of the Continent after the end of the Napoleonic Wars, indeed, journeys abroad were to become commonplace for artists as they came under increasing pressure to record new destinations for an expanding middle class now travelling for change or pleasure.[115] Initially they turned to the unfamiliar picturesque corners closest to home, in Normandy, the Low Countries and the Rhineland.

One of the first artists to travel in Normandy after the end of the wars was Henry Edridge, who in 1817 and 1819 made numerous pencil sketches of views in and around its colourful towns, as well as some finished watercolours for exhibition and sale back home.[116] Edridge was still using the 'Canaletto' style of linear drawing he had learned in the Monro circle, which proved as suitable for recording picturesque buildings abroad as it had for those at home. Inspired by Edridge, the watercolourist Samuel Prout (1783 – 1853) adopted the technique for drawings of Normandy

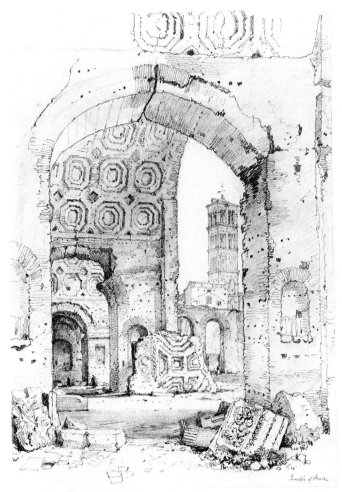

32 Samuel Prout, *In the Temple of Peace, Rome*, c.1824, pencil and stump, 357 x 253mm. British Museum, London

and other continental destinations (fig.32). The style was even transmitted to Richard Parkes Bonington (1802–1828) who may have had access in Paris to drawings by Edridge or Prout.[117]

In 1821, some of Prout's Normandy subjects were published as lithographs,[118] a new type of print made using a

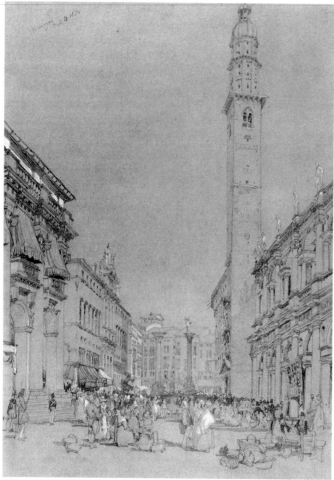

33 James Duffield Harding, *Vicenza*, 1834, pencil heightened with white on grey paper, 375 x 264mm. Tate Gallery, London

mid-toned coloured papers for his continental views together with pencil or black chalk and white bodycolour highlights (fig.33);[120] the tint-stone effectively imitated this combination by making it possible to print a neutral buff background tone from which highlights could then be reserved by scraping or etching down the stone's surface.[121] Artists' suppliers responded by adding to their range a specially-coloured paper which the draughtsman could scrape down to reveal the white paper below, achieving his highlights in direct imitation of the lithographic process.[122]

Harding had once been a pupil of Prout's, but now the two artists became rivals in the race to see their continental drawings published in lithographic form. They were also important teachers (the young Ruskin had lessons from them both), and took advantage of lithography to reproduce in their instruction manuals for amateurs the sort of 'copy drawings' which had once been made in pencil (or more recently in soft-ground etching, which lithography now replaced). However, Harding, 'the prince' of art-instructors,[123] was the more influential teacher, and his popular manual, *Elementary Art: or, the Use of the Lead Pencil* (1834), did much to reaffirm the importance and status of drawing. In his 'rush' to adopt colour too soon, argued Harding, the amateur had involved himself in 'inextricable difficulties'; to avoid these, he should first receive a thorough grounding in 'the use of some such simple instrument as the lead pencil'. By 1846 the manual was reissued to include the use of chalk, which artists were increasingly preferring to pencil when working on the better-quality coloured papers then available on the market.[124] Harding's own continental landscapes and rather uninspired English cottage scenes were made either in chalk or in soft, rich pencil – his linear, rather slick drawing style often complemented with areas of tone produced with the stump. It was, perhaps, these sorts of drawings as much as his water-colours which led one nineteenth-century biographer to comment that Harding had 'a tendency to a meretricious style'.[125]

This latter aspect of Harding's work was closely imitated by Henry Bright (1810–1873), a member of the Norwich

stone (rather than a metal plate) which could produce a particularly effective imitation of a pencil or chalk drawing. They were printed by Charles Joseph Hullmandel, who pioneered most of the early technical refinements of the lithographic process, including that of the tint-stone developed from 1835 in collaboration with James Duffield Harding (1797 – 1863).[119] From 1830 Harding had begun to use

34 Henry Bright, *A Ruined Castle*, c.1850, pencil, 247 x 352mm. British Museum, London

School who was for many years based in London. Bright was an important drawing master who seems at one stage to have inherited most of Harding's pupils.[126] Like Harding, he used chalks or pencil (sometimes such a dark, rich pencil that it might almost pass for chalk). His landscapes may at first seem free and spontaneous, but on closer inspection they reveal all the tricks of the drawing master – especially the presentation of the scene rather like a vignette (where the image fades out at the corners) so that it mimics the appearance of a sketch, and the inclusion of a rhetorical signature (in this example at lower left) so similar to the calligraphy of the drawing itself that it is virtually indistinguishable from it (ill.34). Geoffrey Grigson once wrote that 'the language of drawing is one of ... expressive feeling', and that 'to draw well is to be deeply concerned'.[127] The products of the drawing masters, certainly, show that technical proficiency alone does not make a truly gifted draughtsman.

Who, then, if anyone, in this period, came close in their landscape drawings to those of Constable, either in the intensity of their response to the natural world, or in their ability to describe the landscape in tonal terms? While the dedicated drawing masters of the period certainly had little

in common with Constable, many other artists considered in this essay were attempting like him to scrutinise nature more closely than those who had gone before them, and in the process to forge a more personal language of drawing.

Inevitably, however, each artist brought to the task his own artistic bias and temperament, and these tended to militate against the more truthful, unaffected response to nature that Constable was able to achieve. Turner, for example, tended to see nature in pictorial terms or through the eyes of previous artists, whilst Cotman's instinct was to interpret nature in terms of pattern and design. Nor were these artists as committed as Constable to working directly and continuously from nature, Constable's own 'Primitive Source'.[128] Cox retreated to the studio in later life, and although Cotman continued to draw from the motif until the end of his career, his teaching commitments must have prevented him from sketching as often as he would have liked. Cornelius Varley's interests in later years turned increasingly to the invention of scientific instruments, and in any case his drawings made with the Patent Graphic Telescope had proved, as had Constable's tracings, that spontaneity was just as important for the landscape sketcher as objectivity and precision.[129]

Furthermore, whilst many of these artists had shown themselves well capable of producing drawings with minimal outline, the majority were watercolourists as well as monochrome draughtsmen, and watercolour offered an alternative and, in many ways, more suitable language for expressing landscape in tonal terms (this was particularly true for Turner). Few of them, in any case, had either the motivation or the sheer determination that Constable showed in persistently re-evaluating the landscape (and in Constable's case, of course, often the same landscape); and as a result they rarely achieved the same degree of insight or perception in their monochrome drawings. It is curious to think that Ruskin once said he had never seen any work by Constable which showed signs of 'his being able to draw'.[130] At least Ruskin was eventually to come round to the belief – one Constable would have taken for granted – that 'the best drawing-masters are the woods and hills'.[131]

(for abbreviated footnotes referring to Constable, see 'Abbreviations: Literature')

1 'Observations on Landskipp drawing with Many and Various Examples Intended for the use of beginners 1791'; see under Prologue XIV. Malchair's role as a drawing master is discussed in P.Bicknell and J.Munro, *Gilpin to Ruskin: Drawing Masters and their Manuals, 1800–1860*, exh.cat., Fitzwilliam Museum, Cambridge, and Dove Cottage and the Wordsworth Museum, Grasmere, 1987-8, pp.24-5.

2 J.Ruskin, *The Elements of Drawing; in Three Letters to Beginners*, London, 1857, pp.47-8.

3 Ibid., p.107.

4 J.D.Harding, *Elementary Art; or the use of the Lead Pencil advocated and explained*, London, 1834, p.14.

5 William Varley, *Observations on Colouring and Sketching from Nature*, London 1820, p.6.

6 Ruskin, *op.cit.*, p.107.

7 Third Lecture at the Royal Institution, 1836 (JCD, p.62).

8 C.R.Leslie, *Memoirs of the Life of John Constable*, London, 1951, ed. Jonathan Mayne, p.9. Examples of drawings made by Constable at the Royal Academy Schools are repr. in I. Bignamini and M. Postle, *The Artist's Model; Its Role in British Art from Lely to Etty*, exh.cat., University Art Gallery, Nottingham and the Iveagh Bequest, Kenwood, London, 1991, nos 26 and 61.

9 See A.Wilton and A.Lyles, *The Great Age of British Watercolours 1750–1880*, exh.cat., Royal Academy of Arts, London and National Gallery of Art, Washington, pp.36-77.

10 In this sense, then, Constable's use of pen and monochrome washes, although not extensive, was rather unusual for the period. The fact that he did not use the method more frequently (given his tendency to work in monochrome) can probably be put down quite simply to his preference for the pencil. Constable's adoption of pen and wash in his later career may to some extent have been influenced by his knowledge of Claude's drawings in the same medium: in 1825, for example, he made a painstaking copy of a Claude study of trees, and at some stage in the 1830s produced two very vigorous 'blot-like drawings' in brown wash which recall Claude (see I. Fleming-Williams, *Constable and his Drawings*, London 1990, pp.278-81); his famous dismissal of Claude's drawings as 'like papers used and otherwise mauled – & purloined from a Water Closet' should not, it seems, be taken at face value, having been prompted by Richard Payne-Knight's expensive purchase of an album of Claude's drawings shortly after failing to buy any of Constable's own work (Fleming-Williams, ibid.). Certainly, the use of pen and wash can be associated with a continental precedent in the case of Constable's contemporary, David Wilkie, whose 'tonal' studies of the human figure in this medium were to a large extent prompted by his admiration for Rembrandt's drawings (see D.B. Brown,'"The True Spirit of Observ-ation": Wilkie as draftsman', essay in *Sir David Wilkie of Scotland 1785–1841*, exh.cat., North Carolina Museum of Art, Raleigh, 1987, pp.59-72).

11 The general literature on British drawings (though not confined to a discussion of pencil) is mostly in the form of anthologies, for example: M.T.Ritchie, *English Drawings*, London 1935; H. Rietlinger, *From Hogarth to Keene*, London 1938; H. Hubbard, *Some Victorian Draughtsmen*, Cambridge 1944 and G. Grigson, *English Drawing*, London 1955. There is also an exh.cat. covering the earlier period by L.Stainton and C.White, *Drawing in England from Hilliard to Hogarth*, 1987, British Museum, and of course these are catalogues of drawings in permanent collections.

12 See H. Petroski, *The Pencil: a History*, London, 1989, pp.71 and 84, and P.Bower, *Turner's Papers*, exh.cat., Tate Gallery, London, 1990-1, p.62.

13 See S.Lambert, *Drawing: Technique and Purpose*, Victoria and Albert Museum, London, 1984 (revised version of catalogue pub. to accompany exh. held in 1981), p.33.

14 Good examples of drawings made by Sandby with the graphite pencil (and characterised by rather hard, silvery lines) are in the British Museum.

15 See *Catalogue of Seven Sketch-Books by John Robert Cozens (formerly in the Collection of William Beckford)*, Sotheby's 29 November 1973.

16 Letter to Fisher, 4 August 1821 (JCC VI, p.72).

17 *The Memoirs of Thomas Jones*; quoted B.Ford, *The Drawings of Richard Wilson*, London, 1951, p.41.

18 Farington, *Diary*, 29 January, 1799: quoted J.Hayes, *The Drawings of Thomas Gainsborough*, London, 1970, 2 vols, pp.22-3 in text volume.

19 Hayes, *op.cit.*, p.14.

20 See J.D.Harding, *op.cit.*, p.78.

21 B. Ford, *op.cit.*, p.26; and D.H.Solkin, *Richard Wilson: The Landscape of Reaction*, exh.cat., Tate Gallery, London, 1982-3, pp.152–3.

22 See, for example, I.Bignamini and M.Postle, *op.cit*, although they do not specifically discuss the suitability of this technique over other methods.

23 B. Ford, *op.cit.*, draws attention to the similarity of Wilson's drawings with those of L.G. Blanchet (1705–1772) and C.M. Challe (1718–1788), who studied at the French Academy in Rome. For Blanchet, see also M. Kitson, *The Art of Claude Lorrain*, exh.cat., Hayward Gallery, London, 1969, no.167.

24 W.H. Pyne, *Arnold's Library of the Fine Arts*, 1, London, 1832, pp.118–9 (see P. Walton, *The Drawings of John Ruskin*, London 1972, p.2); for the possible influence of Dutch and Flemish drawings, especially by

A.Waterloo and D.Teniers, see Hayes, *op.cit.*, p.61; see also L.Stainton, *British Landscape Watercolours 1600–1860*, exh.cat., British Museum, 1985, p.23.

25 See B. Ford, 'The Dartmouth Collection of Drawings by Richard Wilson', *The Burlington Magazine*, vol.90, Dec. 1948, pp.33–45; Farington records that there were originally 69 drawings in the series, but only 25 are known today.

26 Edward Edwards (*Anecdotes of Painters*, London, 1808, p.135) spoke of Gainsborough's 'habit of making what might be called models for landscapes, which he effected by laying together stones, bits of looking glass, small boughs of trees and other suitable objects, which he contrived to arrange, so as to furnish him with ideas and subjects for his rural pictures'.

27 C.R.Leslie, *op.cit.*, p.270; J.Hayes, *op.cit.*, p.74, explains that Constable appreciated them, erroneously, as examples of Gainsborough's reference to nature, studies done at a particular time of day, when sundown had reduced the landscape to nothing more than skeletons and masses.

28 For Wilson's pupils in general, see B. Ford, *op.cit.* 1951, pp.39–44. Hayes, *op.cit.*, reproduces a drawing by Farington (pl.419) in black and white chalks on blue paper, and there is a sketchbook executed by him in similar media in the Oppé collection (2567). For Wilson's influence on Beaumont, see F. Owen and D. B. Brown, *Collector of Genius; A Life of Sir George Beaumont*, New Haven and London, 1988, pp.49–50; and for his influence on Oldfield Bowles, see M. Hardie, *Watercolour Painting in Britain*, 3 vols, London 1966–8, volume 3, p.261.

29 See Hayes, *op.cit.*, pp.79–81 and p.83.

30 It is W.H.Pyne writing in 1824 (*Somerset House Gazette*, vol.2, London 1824, p.8) who referred to Monro's imitations as 'pasticci' (quoted Hayes, *op.cit.*, p.81); 'pasticcio', of course, is the Italian word for a copy, imitation or pastiche, but also a pie, muddle or mess.

31 See F.J.G. Jefferiss, *Dr Thomas Monro (1759–1833) and the Monro Academy*, exh. leaflet, Victoria and Albert Museum, London, 1976, n.p..

32 Farington, *Diary*, 30 December 1794.

33 Monro's large collection of drawings was sold at Christie's between 26 June and 1 July 1833 (for his prints, see n. 38). The collection formed by John Henderson (1764–1843) seems to have been inherited by his son, John Henderson the younger (1797–1878). The latter was an important collector in his own right, and made many bequests to museums and art galleries, including the British Museum, to which he left 4 drawings by Canaletto, 27 by Girtin and 13 by Turner – the majority of these probably inherited from his father. Other pictures, watercolours and prints from the younger

Henderson's estate were dispersed at Christies, 16–18 February, 1882.

34 Farington, *Diary*, 30 December 1794 and 12 November 1798.

35 Monro specialised in mental illness, inheriting his father's post as principal (consultant) physician to Bethlem Hospital in 1792 (see Jefferis, *op.cit.*).

36 See Jefferis, *op.cit.*, and A. Wilton, *The Art of Alexander and John Robert Cozens*, exh.cat., Yale Center for British Art, New Haven, 1980, pp.59–60; Monro had few if any Cozens drawings of his own before 1805, when he acquired a number at the Beckford sale.

37 The (unpublished) diaries of E.T.Monro, Dr Thomas Monro's eldest son, record that Constable visited Adelphi Terrace on 15 January 1809 and 21 December 1813; and that 'Henry [Monro] breakfasted at Mr Constables' on 13 November 1808. Henry was popular at the Academy schools, and was made 'president' of the students. I am grateful to Dr F.J.G.Jefferis for this information.

38 See M. Liversidge and J. Farrington ed., *Canaletto and England*, exh.cat., Birmingham Museums and Art Gallery, 1993–4, pp.106–9 and pp.170–1. Liversidge suggests that the calligraphy of Canaletto's etchings was also influential on the drawing style of Girtin and Turner (and others) in the 1790s. Monro's collection of prints was sold at Christie's on 3 July and 4 July 1833; the first day's sale included nineteen large engravings by Canaletto (lot 12) and a set of 'Canaletti vedute' (lot 161). The collection of John Henderson the younger (partly inherited from his father, see n. 33) also included prints by Canaletto (see Christie's, 16 February 1878, lot nos 4–5).

39 S.Lambert, *op.cit.*, p.36.

40 Girtin's Paris drawings, made in 1802, are in the British Museum (see T. Girtin and D. Loshak, *The Art of Thomas Girtin*, London, 1954, cat.nos. 459–78).

41 Girtin and Loshak (*op.cit.*, pp.39–40) describe the 'Shepherd sketchbook' (the only Girtin sketchbook known to survive practically intact) as 'a kind of sample-book which Girtin carried with him to show prospective clients, from which they might select compositions to be worked up as studio watercolours'. Other drawings from the sketchbook are repr. in M. Hardie, 'A Sketch-book of Thomas Girtin', *Walpole Society*, vol. XXVIII, 1938-9, pp.89–95ff.

42 See A.Wilton, 'The "Monro School" Question: Some Answers', *Turner Studies*, Winter 1984, vol.4, no.2, pp.8–23.

43 I am grateful to Ian Fleming-Williams for this suggestion.

44 Compare, for example, similar drawings by Hearne, especially *Trees in Ashtead Park, Surrey*, c.1795–6, repr. D. Morris, *Thomas Hearne and his Landscape*, London 1989, plate 106; see also T. Sidey, *Amelia Long, Lady Farnborough (1772–1837)*, exh.cat., Dundee Art Gallery, 1980, no.46 repr.

45 The *Wilson* sketchbook (Tate Gallery, Turner Bequest XXXVII), pub. in facsimile by the Tate Gallery, 1988, with an introduction by Andrew Wilton.

46 P. Bower, *op.cit.*, p.64, lists other works by Turner on prepared papers prior to the execution of the 'Scottish Pencils'.

47 Farington, *Diary*, 6 February 1802.

48 Ibid.

49 A. Wilton, 'Turner in Scotland: the Early Tours', essay in *Turner in Scotland*, exh.cat., Aberdeen Art Gallery and Museum, 1982, pp. 11–20; see p.16.

50 Ibid., p.17.

51 Wilton argues (ibid., p.16) that 'the weight, the disposition of graded tones of grey and black, the warmth of atmosphere and effect, within an apparently austere form, all suggest Wilson, and it is difficult to believe that Turner did not have the Dartmouth series in mind when he created his own set'. One might also add that the sheer number of drawings by Turner in the series (about 60) also suggest a parallel with the Dartmouth set (originally about 68, see n. 25). It may also be significant that Turner showed his drawings to Farington (a former pupil of Wilson's).

52 See n. 45, and also D.B. Brown, *From Turner's Studio: Paintings and Oil Sketches from the Turner Bequest*, Tate Gallery, 1991.

53 See B. Ford, *op.cit.* 1948, pp.338–41. The Patshull estate was later purchased by George Pigot (1719–1777); Cornelius Varley's inscription on the drawing refers to Pigot's nephew, George (see *Dictionary of National Biography*, 1909, vol.XV, pp.1166 and 1168).

54 Farington and Edridge visited the Longs at Bromley Hill on 24 June 1809, when Charles Long reported to them his opinion that the Dartmouth drawings were 'admirable' (see B. Ford, ibid.). Amelia Long's chalk drawings made in the vicinity of Bromley and elsewhere have the same sense of pictorial completeness as Wilson's Dartmouth set (see, for example, *Bromley Hill, Kent*, signed and dated 1814, and repr.p.93, C. Nugent, *From View to Vision: British Watercolours from Sandby to Turner in the Whitworth Art Gallery*, exh.cat., Whitworth Art Gallery, Manchester 1993).

55 Tate Gallery, Turner Bequest, LXXIV. The sketchbook is extensively reproduced and discussed in the exh.cat. ed. by N. Alfrey et al., *Turner en France*, Centre Culturel du Marais, Paris 1982: see especially an essay by A.Wilton 'Turner's first visit to France – 1802', pp.25–39; and subsequent catalogue entries, pp.40–68.

56 Ruskin even thought that Turner might have sold the album and then bought it back, but this suggestion is dismissed by Wilton, ibid., p.29. David Blayney Brown, who is preparing a revised catalogue of A.J.Finberg's 1909 Inventory of the Turner Bequest covering the decade from 1802, believes that Turner may have mounted his Swiss studies in a special album so as to show them to patrons, and thus hopefully obtain commissions for finished watercolours from them.

57 Many of the monochrome studies made by Turner on this trip (in Rome, in particular) are executed on papers prepared by him with a grey wash, which is subsequently scratched down to achieve white highlights; see especially the *Rome: C. Studies* sketchbook (Turner Bequest CLXXXIX) and the *Small Roman C. Studies* (Turner Bequest CXC). Inevitably, the drawings therefore have a wider tonal range than Turner would have achieved on white paper alone, but this is not exploited by him to the same extent as in the 1801 and 1802 drawings; pencil is used in a much more linear fashion, and chalk not at all. Turner's adoption of grey prepared papers on this trip may have been prompted by his association of Rome with Wilson and the Dartmouth drawings; and, indeed, this time the influence of Wilson is more noticeable (C. Powell, *Turner in the South: Rome, Naples, Florence*, New Haven and London, 1987, pp.46-8, argues for it on the strength not only of technique and the size of the drawings, but also 'similar angles of vision and tricks of composition'). Turner's *Naples, Rome C. Studies* sketchbook (Turner Bequest CLXXVII) also has some pages prepared with a grey wash, which makes one wonder whether the 'C' in Turner's titles for all three sketchbooks might indeed stand for 'Chiaroscuro' as Finberg first argued in his 1909 Inventory of the Bequest, rather than 'composition' or 'colour' sketches as some recent Turner scholars believe.

58 See A. Lyles and D. Perkins, *Colour into Line: Turner and the Art of Engraving*, exh.cat., Tate Gallery, 1989–90, *passim*. On one occasion Turner (recalling Constable) was so concerned to introduce 'sparkle' into a mezzotint that in Ruskin's opinion he even began to 'spoil' the print through retouching (ibid., p.57).

59 Some of these complex ideas are discussed in J.Gage, *Colour in Turner: Poetry and Truth*, London, 1969, pp.50-1.

60 See Wilton and Lyles, *op.cit.*, p.176.

61 Owen and Brown, *op.cit.*, p.151.

62 Wilton and Lyles, *op.cit.*, p.260.

63 Ibid., p.133.

64 M. Pidgley suggests that Constable may have been influenced by the watercolours Varley exhibited at the Old Watercolour Society in 1805; see 'Cornelius Varley, Cotman and the Graphic Telescope', *The Burlington Magazine*, CXIV, 1972, p.782. For examples of Constable's Lake District watercolours, see L. Parris and I. Fleming-Williams, *Constable*, exh.cat., Tate Gallery, London, 1991, nos 233, 237 and 239.

65 For Linnell, see C. White, *English Landscape 1630–1850: Drawings, Prints and Books*, exh.cat., Yale Center for British Art, New Haven, 1977, no.195, and also *A Loan Exhibition of Drawings, Watercolours, and Paintings by John Linnell and his Circle*, exh.cat., Colnaghi, London, 1973, nos 7 and 8; for Hunt see Sotheby's 19 March 1981, lot 70; and for a riverside view by Turner of Oxford, perhaps of Millbank, see C. M. Kauffmann, *John Varley (1778–1842)*, exh.cat., Victoria and Albert Museum, 1984, p.36, repr.

66 See K. Crouan, *John Linnell: A Centennial Exhibition*, exh.cat., Fitzwilliam Museum, Cambridge and Yale Center for British Art, New Haven 1982-3, nos 5–6, 8 and 11.

67 See album of drawings by William Collins, with John F. C. Phillips and Thomas A. Deans, The Gallery Downstairs, London, 1993.

68 Up until about 1813 (Parris and Fleming-Williams, *op.cit.*, p.407), although in 1819 he also made a sequence of sky studies in coloured chalks on blue paper (G. Reynolds, *The Later Paintings and Drawings*

of *John Constable*, New Haven and London, 1984, 2 vols, nos.19.11–19.16). One possible source of inspiration for Constable's adoption of chalks on coloured papers would have been Farington, see n. 28.

69 However, a small group of chalk studies on blue and grey papers by Varley in the V & A may include views executed near Millbank (see Kauffmann, *op.cit.*, cat.no.24, see example repr.). For the oil studies by Linnell and Hunt at Twickenham, see D. B. Brown, *Oil Sketches from Nature: Turner and his Contemporaries*, exh.cat., Tate Gallery, 1991, pp.62–3.

70 For Mulready, see A. Rorimer, *Drawings by William Mulready*, exh.cat., Victoria and Albert Museum, London, 1972, nos 136–8 and 141–3; for Cox, see n. 106 below; for Peter de Wint, see D. Scrase, *Drawings and Watercolours by Peter de Wint*, exh.cat., Fitzwilliam Museum, Cambridge, 1979, *passim*, and also a sketchbook in the V & A (E 709-1922) interleaved with brown and buff papers, worked on by the artist mainly in black and white chalks.

71 Purchased from Margaret Gainsborough (Farington, *Diary*, 11 April 1801; see Hayes, *op.cit.*, p.81). J.T. Storey (*The Life of John Linnell*, London, 1829, 2 vols; see vol.1, p.41) records that Linnell and Hunt were set to made copies 'from studies by Gainsborough and Constable (in charcoal)' from Monro's collection. The reference here to Constable is rather surprising, since no drawings by Constable are recorded in Monro's sale catalogue of 1833 (see n. 33).

72 Hayes, ibid.

73 *New Drawing Book of Light and Shadow, in imitation of Indian Ink*, Ackermann, 1809, n.p.

74 Turner was mainly taking pupils between 1794 and 1798, in which year he told Farington he was 'determined not to give any more lessons in drawing' – though he probably continued to take occasional pupils thereafter (see A.Wilton, *Turner in his Time*, London, 1987, pp.46–7). The Tate Gallery has recently acquired an interesting letter from one of Turner's pupils, The Rev. Robert Nixon, dated 1798, and afterwards annotated by Turner with his advice (and an illustration) on how to apply washes to indicate light and shadow (TGA 941.1).

75 The year in question was 1802, and Constable consulted Farington and Benjamin West in particular; he wrote to John Dunthorne soon afterwards (see JCC VI, pp.6–7).

76 See I. Fleming-Williams and L. Parris, *The Discovery of Constable*, London, 1984, p.266 for a list of Constable's pupils; and pp. 192–4 for a discussion of Dorothea Fisher. Constable was also asked to comment on watercolours made by the amateur artist General Sir George Bulteel Fisher, Bishop Fisher's brother, a task he found rather tiresome (see M. Hardie, *op.cit.* 1966–8, vol.3, p.264).

77 Elizabeth Turner, daughter of the Yarmouth banker Dawson Turner, took lessons from Varley in October 1822, and wrote of his enthusiasm for turning all the family into 'Michael Angelos' (see Kauffmann, *op.cit.*, pp.38-9).

78 Leslie, *op.cit.*, p.194. Varley was a keen astrologer, and his 'pockets were always crammed with old almanacks' so that he sould cast people's horoscopes (see Kauffmann, *op.cit.*, pp.39-45).

79 The most important of these is Varley's *Treatise on the Principles of Landscape Design* (1816–1821), passages from which are quoted in A. Lyles, 'John Varley's Thames: Varieties of Picturesque Landscape c.1805–1835', *Old Watercolour Society's Club Journal*, vol.63, 1994, pp.1–37; see also Kauffmann, *op.cit.*, pp.51-3.

80 The example illustrated here is from an album of drawings by John Varley and a pupil called A.Shaw (see Sotheby's, 9 April, 1992). Other 'copy drawings' by Varley are catalogued by Kauffmann, *op.cit.*, nos 43-4.

81 See Bicknell and Munro, *op.cit.*, *passim*.

82 I.Fleming-Williams, *op.cit.* 1990, p.19.

83 See Kauffmann, *op.cit.*, pp.164-5; see also under n. 10.

84 An advertisement for Cotman's circulating library (from *The Norfolk Chronicle*, 22 July 1809) is quoted by S. D. Kitson, *The Life of John Sell Cotman*, London 1937, p.130.

85 *Cornelius Varley's Narrative Written by Himself*, quoted by M. Pidgley in Introduction to *Exhibition of Drawings and Watercolours by Cornelius Varley*, Colnaghi, London 1973, n.p. Watercolours made in Wales in 1805 are repr. in that catalogue, and in Wilton and Lyles, *op.cit.*, pls.113 and 115.

86 Varley's mountain studies are in a sketchbook discussed by C. Ryskamp, 'A Cornelius Varley Sketchbook in the Morgan Library', *Master Drawings*, Autumn 1990, XXVIII, no.3, pp.344–59. Pencil studies produced by Cristall on the same trip are rather similar (see B. Taylor, *Joshua Cristall (1768–1847)*, exh.cat., V & A, London, 1975, no.70, repr.p.62).

87 For the best discussion of the telescope, see M.Pidgley, *op.cit.* n. 64.

88 See S.Lambert, *op.cit.*, pp.41-2.

89 For drawings inscribed with the power of magnification, see *Exhibition of Drawings and Watercolours by Cornelius Varley*, *op.cit.* n. 85, cat.nos. 8a and b, 71 and 102. The patent (no.3430), registered on 4 June 1811, reads: 'Patent of a New Construction of a Telescope or Optical Instrument for Viewing Distant Objects and for other Useful Purposes, with a suitable Table or Stand for the same' (quoted Kauffmann, *op.cit.*,p.135).

90 In the original version of the catalogue published in 1981 to accompany the exhibition *Drawing: Technique and Purpose* at the Victoria and Albert Museum, London (cited n. 13), Lambert claims (p.22) that the telescope was 'originally designed for landscapes'; and Kauffmann similarly argues that it enabled 'the artist to depict a more true and precise apprehension of nature' (*op.cit.*, p.135). The fact that the telescope was capable of viewing objects at a far distance certainly meant it was ideal for recording landscapes, as Samuel Prout pointed out in his *Rudiments of Landscape* (1813), referring to it as 'this most ingenious instrument, by which views of objects at a considerable distance may be drawn, which affords a vast scope for the study of landscape composition' (quoted by M. Pidgley in Introduction to *Exhibition of Drawings and Watercolours by Cornelius Varley*, *op.cit* n. 85.). With regard to the Telescope's other uses, see Pidgely, *op.cit.* n. 64; Kauffmann, *op.cit.*, pp.13–5; S. D. Kitson, 'Notes on a Collection of Portrait Drawings formed by Dawson Turner', *The Walpole Society*,

XXI, 1932-3, pp.67–104; and M. Butlin, *William Blake 1757–1827*, Tate Gallery, London, 1990, pp. 153–64.

91 S.Lambert, *The Image Multiplied*, exh.cat., V & A, London, 1987, p.47.

92 Fleming-Williams, *op.cit.*1990, p.122.

93 I am grateful to Dr Michael Pidgley for this information.

94 See Wilton and Lyles, *op.cit.*, p.134. Linnell purchased from Varley a camera obscura in 1811, a camera lucida in 1820, and a Graphic Telescope in 1848.

95 C. R. Leslie, *op.cit.*, p.270.

96 See J. Hamilton, *The Sketching Society 1799–1851*, exh.cat., V & A, London, 1971, no.32.

97 See Pidgley, *op.cit.* n.64, pp. 785–6.

98 *Rievaulx Abbey*, 1803, pencil, 371 x 270mm (Tate Gallery T00973) and *Fountains Abbey, Yorkshire*, 1804, pencil, 362 x 267mm (Norwich Castle Museum, 482.235.951; repr. M. Rajnai and M. Allthorpe-Guyton, *John Sell Cotman 1782–1842: Early Drawings (1798–1812) in the Norwich Castle Museum*, Norfolk Museums Service, plate 16).

99 Rajnai and Allthorpe-Guyton, *ibid.*, nos 38-41, repr. plates 21 and 22.

100 See n. 57.

101 Rajnai and Allthorpe-Guyton, *op.cit.*, nos.52-3 and 55 (plates 33 and 35), where they are mistakenly described as executed in pencil and white chalk.

102 Illustration 19 and also *Brignall Banks on the Greta, Yorkshire* in Leeds City Art Gallery, both from Sydney Kitson's collection (see D. Boswell and C. Miller, *Cotmania & Mr Kitson*, exh.cat., Leeds City Art Galleries, 1992, nos 14 and 17a). The description of the pencilwork as showing a 'rococo lightness' is in Rajnai and Allthorpe-Guyton, *op.cit.*, p.19.

103 *Ibid*, nos 54 and 56; and D. Boswell and C. Miller, *op.cit.*, no.17b.

104 *John Sell Cotman (1782–1842); a touring exhibition arranged by the Arts Council of Great Britain*, exh.cat., V&A, London, and other venues, 1982–3, p.13.

105 The most extensive collection of Cotman's work in pencil is in the Norwich Castle Museum, and comprises nature studies, topographical drawings (especially of East Anglian and Normandy subjects) and 'copy drawings'; the British Museum also has a good collection, a selection of which was published in A.H. Holcomb, *John Sell Cotman*, London, British Museum, 1978.

106 Examples of earlier drawings of this type are in the Birmingham Museum and Art Gallery. Others are repr. in A.J. Finberg, *Drawings of David Cox*, London [1906].

107 See T.Cox, *David Cox*, London 1947, pp.43–5, who quotes passages from Cox's important drawing manual, *Treatise of Landscape Painting and Effect in Water-Colours*, 1813–4 (the latter was reprinted for a special edition of *The Studio*, 1922, with preface by A. L. Baldry).

108 See, for example, *Rouen: Tour d'Horloge*, 1829, Tate Gallery (T 00977), repr. Wilton and Lyles, *op.cit.*, plate 101.

109 *David Cox: drawings and paintings*, London, Anthony Reed and New York, Davis and Langdale, 1976, with introduction by Anthony Reed.

110 M.Hardie, *op.cit.* 1966-8, vol.2, p.200.

111 N.Solly, *Memoir of the Life of David Cox*, 1873; facsimile reprint, 1973, p.226.

112 A number of them are extensively inscribed with colour notes, see for example, A.Holcomb, *op.cit.*, plate no.89 (and for other drawings made on this tour, see her plate nos 90 and 92-102).

113 T.Cox, *op.cit.*, p.86 and Solly, *op.cit.*, p.87.

114 Cotman visited Normandy in 1817, 1818 and 1820; Cox travelled to Belgium in 1826, and to Northern France in 1829 and 1832.

115 M.Hardie, *op.cit.* 1966-8, vol.3, pp.1–2.

116 Examples of Edridge's pencil drawings (including a sketchbook) made on these visits to Northern France are in the British Museum.

117 P.Noon, *Richard Parkes Bonington: 'On the Pleasure of Painting'*, exh.cat., Yale Center for British Art, New Haven and Petit Palais, Paris, 1991–2, p.90.

118 *Picturesque Buildings in Normandy*, 8 plates, London, Rodwell and Martin, 1821.

119 R.T.Godfrey, *Printmaking in Britain*, Oxford, 1978, p.91.

120 J.L.Roget (*History of the 'Old Watercolour' Society*, 2 vols, 1891; vol.1, p.513) records that Harding started to use coloured papers in Italy in 1830, and that the drawings from this tour 'being much admired on his return to England, brought that material into vogue as the more efficient means of producing an effect'.

121 Godfrey, *op.cit.*, p.91.

122 The papers sold by Winsor and Newton in 1851, for example, described as 'graduated scraping tinted tablets' and 'prepared vellum tints', were in fact 'printed on drawing paper, in lithography' (1851 Winsor and Newton Trade Catalogue, quoted P.Bower, *op.cit.*, pp.86–7).

123 Colonel M.H. Grant, *The Old English Landscape Painters* Leigh-on-Sea, 8 vols, 1957–1961; see vol.8, p.684 (quoted C. Skilton, 'James Duffield Harding 1797–1863: A Centenary Memoir', *Old Watercolour Society's Club Journal*, 1963, XXXVIII, p.37).

124 J.D.Harding, *Elementary Art, or the Use of the Chalk and Lead Pencil advocated and explained*, London, 1854 (4th edition), preface.

125 S.Redgrave, *A Dictionary of Artists of the English School*, 2nd edition, 1878, p.197.

126 M. Allthorpe-Guyton, *Henry Bright 1810–1873: Paintings and Drawings in Norwich Castle Museum*, Norfolk Museums Service, 1986, p.15.

127 Grigson, *op.cit.* n. 11, p.xii.

128 Introduction to *English Landscape*, JCD, p.10.

129 J.Gage, *A Decade of English Naturalism, 1810–1820*, exh.cat., Norwich Castle Museum and Victoria and Albert Museum, London, 1969–70, p.16.

130 J.Ruskin, *Modern Painters*, vol.I (1843),, pt.II, Section I, chapter VII, ss18; Ruskin for the most part would only have known Constable's oil paintings, but the comment is still interesting nevertheless.

131 J.Ruskin, *The Elements of Drawing*, cited n. 2, p.xxii.

Patrick Heron

Constable: Spatial Colour in the Drawings

The Tate's great Constable show of 1991 seemed to me to present the occasion for placing this supreme painter in his correct position as the single most revolutionary influence on western painting in the last hundred and seventy years. So I wrote to *The Times* saying, among other things, that 'one is more aware than ever of the colossal influence Constable's incredibly varied and totally undisguised brush-movements exerted on virtually every major French master in the subsequent mainstream of European painting – Delacroix (who famously acknowledged it), Courbet, Corot, Manet, early Pissarro, Monet, Sisley, Cézanne (look at the "Cézannesque" foliage in Constable's poplars and elms), even Matisse and Derain. Again and again one could cut out a two-inch-square detail from a tiny "sketch" – e.g. Willy Lott's House. If one blew it up we should have a Matisse of identically simplified trees! Indeed, the Tate's private-view card shows a beach and fishing boat which is so free in its calligraphic brush-work that, at first glance, one thought immediately of Matisse at Etretat, on the Channel coast.'

The discovery, in Constable, which proved so spectacularly potent and lastingly revolutionary was, very simply, *the broken surface*. Briefly, the major part of the picture-surface, in all Constable's greatest forerunners, consisted of continuous and virtually unbroken skins or veils of pigment which were welded together on the canvas by means of brush-work which was itself almost invisible. One has to look very closely to become aware of the weavings of the brush-work in Poussin, for instance. But with Constable, suddenly there is the discovery that the evocation of a form or a plane in the subject can be totally definite without the pictorial definition, there on the picture plane, being *continuous*. In other words, *separate* strokes, quite unconnected to each other, like islands in an archipelago, can evoke and define the continuous surfaces in the subject with a power even greater than that achieved by those continuous skins of pigment which were the plastic language employed by all Constable's greatest predecessors. Of course, nothing could be more obvious than that this broken surface itself became the very means of the Impressionists. But also late Cézanne; the broken hatch-strokes of analytical cubism; the calligraphic dots and dashes of the Fauves – all are descended from the unprecedentedly free scribbles of Constable's brush.

But Constable's *pencil* was equally miraculous as an instrument for the profoundly informative investigation of visual reality. As is the case in all the greatest figurative art, our apprehension is two-fold at every instant – as our eyes journey back and forth across the surfaces of his drawings. In every square millimetre there is the double experience for the eye – it savours the design of marks at the surface at the same instant that it sinks through and beyond the grey of pencil and the white of paper to the depths of the outdoor spaces so miraculously evoked. It is one of the greatest thrills of the greatest figurative art, this immediate and total identification of marks at the surface with physical spaces and with a multitude of forms inhabiting, and defining, those spaces, *through and behind* those very marks. The illusion is total: that lopsided stab of a pencil point, itself a mere square millimetre in extent, is a great tree in full leaf, up on the horizon, that proclaims itself to be precisely half a mile distant from the beholder's eye. Throughout the

composition the dance of marks, the pure music of their infinitely complex relationships, right the way through and across the surface of the drawing, is an experience of a profoundly certain and definite visual harmony, a harmony which the eyes feed on as they are unconsciously propelled and sucked, this way and that. But the process is one of the unending *conscious* absorption of relationships – of our conscious registration of the unbelievably varied intervals between the thousand and one marks of an incredible design – a design, however, whose structure not only fascinates the eye in its own right but which also *simultaneously* pulls and pushes it back and forth through all the thousands of yards of the illusionistic aerial depth of 'the subject'. The profound satisfactions of a Constable drawing thus include the rhythmic experience of a counterpoint that is a counterpoint in spatial depth. By this I mean that at every stage in our contemplation of a drawing we are measuring the various depths to which our eyes sink into the illusionistic space the drawing evokes: thirty yards to that tree – seventy yards to that bank – two hundred yards to that hedge – eighty-five yards to that gable-end – five miles to that cloud – stop; stop; stop; the eye plunges straight ahead through the illusionistic space of the drawing, down a hundred lines of vision to a 'stop'. I have always felt that our immensely rapid successive penetrations of these related depths constitutes an experience of a sort of contrapuntal harmony.

However, as I write this, I am looking at *A Windmill near Colchester*: 9 August 1817 (no.40). In the very centre of the bottom edge a small animal stands looking half left, in strong sunlight – the near side of its back is white paper i.e. it's well lit; and two roughly horizontal soft pencil strokes proclaim its shadow on the ground. Your eye goes up left towards the cottages and it extracts the sensation of a patch of sunlit slightly rising ground up the middle of which some scattered dots create the conviction of a ragged pathway. On its way up to the shadowed near end of the first cottage your eye encounters some unidentifiable objects which exist in this drawing as some heavy scribbles, darker in tone than that shadowed cottage-end above. It doesn't in the

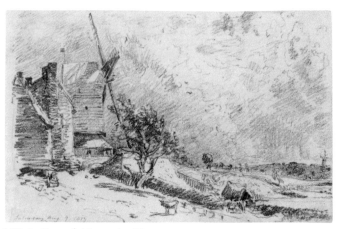

A Windmill near Colchester (no.40)

least matter that we cannot identify real objects in this dark scribble (it might be a discarded trestle of some sort with a bank of nettles behind it?). All that does matter is that we know with total certainty how this bank of whatever it was lay in relation to the absolutely vertical flat end-wall, in deep shadow, which the cottage presents to us in the space, in the drawing, immediately above. The almost horizontal and very rapid scribble, with the flat worn side of a soft lead pencil, not only places this wall of the cottage at roughly eighty-five yards from our eyes, it also evokes its precise angle in relation to the artist's physical position in this landscape. Also, I sense *colour* in this grey-to-black horizontal scribble: isn't there the warmth of red brick there? In fact, *colour* is present in all that *light* which this drawing radiates from end to end – and it was colour which I once described being generated out of grey-and-white in the drawings of Bonnard. Next, however, a channel of white paper rises vertically up the right hand side of this scribble and meets a black knot of a much tighter scribble (the eaves of the cottage roof), jumps over it and goes diagonally on up towards the left. Of course what we are looking at, in this vertical strip of white paper, is the front wall and then the roof of

46

the cottage, both of which face the sun. And notice the sheer perspectival accuracy of the presentation of these architectural geometric facts: the enormously fore-shortened wall and roof which face the sun are evoked with breathtaking precision – but they are created not by perspectival lines of definition but by the termination of areas of scribble, on either side! Beyond them (beyond this lit roof of the first cottage) the equally shadowed end of the second cottage is created in even heavier pencil scribbles, rotund and very dark on the shadowed wall on the gabled end of the wall to the left of the chimney; and these scribbles meet the sky along a complex profile above, which is virtually black – but which therefore makes the sky *light*. Beyond, again, the much larger box-like tower of the windmill itself, whose strangely shaped cap is angled to catch the sunlight. And angled diagonal shadows from the windmill sails fall across this cap, and could so easily have rendered its physical volume and structure unintelligible. But no: this whole passage is lucidity itself. Again, the shadowed side of the windmill tower is created by thirteen very wide horizontal strokes, which are both loose and firm in the same instant (as, indeed, is every single gesture from this master's pencil or brush) and which register the light, rapid pressure from the flattened side of a worn pencil, superimposed over a very soft grey diagonal tonal scribble. All this adds up to a windmill tower which was obviously made of horizontal pale wood planks.

These three buildings clustered together, overlapped and receding one behind another, present three vertical planes each of which is evoked or defined or created and given substance as a separate visual reality by roughly speaking one means only: each has come into existence, and taken up its position in space in relation to the others, and to the spectator, as the result of soft, broad *horizontal* pencil strokes ranged up and down each building. On the windmill these horizontal strokes are independent of each other in the sense that the pencil came off the paper at the beginning and end of each stroke, which are therefore unconnected: also, the spaces between these horizontal strokes are wider than the strokes themselves. Moving left, to the

house between the windmill and the nearest smaller cottage, we find the end of that house itself dividing into three vertical areas, each created by a differing system of horizontal 'stripe' scribbles. The right-hand section is the lightest and has only a very loose spiralling scribble, to give it a light tone and push it back into the required position. Next is the chimney, which reaches from the very top down to the ground, whose frontal plane is created by a much heavier ladder of horizontal scribbled strokes. And then jumping across the narrow white passage which is the foreshortened sunlit roof and wall of the nearest cottage, already described, there are the heaviest, darkest, broadest horizontal strokes in the entire work, which so plastically (as Fry would have said), and so emphatically place that nearest cottage wall in space – an absolutely definite and finite and utterly measurable physical space!

The bunching of these broad vertical planes, (which *are* these buildings), hard up against the centre of the left-hand edge of the picture leaves the right-hand two-thirds of the picture empty of near incident. Pale meadows and a darker low ridge stretch horizontally right out along the bottom quarter of the drawing's height to the far right-hand edge with nothing to 'balance' the mass of buildings to the left (except perhaps the minute distant second windmill virtually on the picture's right edge). And the genius of Constable expressed itself *compositionally* all the time. The equilibrium arrived at in every single sketch was always utterly novel in its checks and balances. In this drawing the 'emptiness' of the right-hand half (or two-thirds) of the picture is perfectly counterbalanced by what anyone else would have thought was the over-crowded bunching of the complex of the buildings huddled up to – and even unceremoniously cut off by – the left-hand edge of the picture. Unlike Turner, whose classically ovoid and 'complete' compositional organisations tend to repeat themselves, Constable's moving eye, swivelling this way and that as he walked the meadows, would invariably suddenly freeze the rectangular picture-frame around features whose relationship had never been previously seen and captured. But another word about that 'emptiness', which is of course not

empty at all: in this windmill drawing more than half of the right-hand half of the drawing is packed solid with sensation, sensation of a high, cloudy, windy sky where the sun is penetrating here and there and has, of course, burst down, like a great and quickly moving and very temporary spotlight, onto everything in the scene except the further rim of the shallow valley. The temporary brilliance of the sun through high clouds on a windy day – this is that familiar and very English moment which this drawing captures totally. No other painter has been gifted with quite such instantaneous accuracy, quite such candour of recorded vision of things seen, in landscape at any rate. The lightning speed of his notation, as the visual data flooded in on his retina, was responsible for the myriad unforeseeable intervals his composing faculty seized upon and made into the compositional structures of his works – so revolutionary, so far removed from all hitherto dominant conventions of composition.

I myself believe that the modernity of Constable can never be overstressed. In, for instance, *The Schooner 'Malta' on Brighton Beach* (no.67) we have the sawn-off rump plus sail of a beached fishing boat obtruding from the left-hand edge of the composition, and a semi-distant schooner in full sail practically falling off the right-hand edge of the picture, while in the middle a horizontal oblong of empty open sea, full of white light, pushes towards our eyes past the schooner 'Malta', which it elbows off to the right, and past the beached boat which leans steeply over from the left – which it elbows still further to the left. The 'empty middle' format, where objects cluster towards or along the picture's edges, was a great compositional feature in Bonnard, as I long ago pointed out. There is also, I think, an example here of the sort of near-awkwardness we so often find Matisse, upon *further* acquaintance, has totally resolved – and in such a way that its resolution (of a threatened awkwardness into a perfect harmony) has become, for that very reason, the high point of our satisfaction. I'm thinking, in this case, of the wonderful tensions generated between the downward pointing corners of the white sail as they spike into the hulls of the two boats on the left, whose forms these

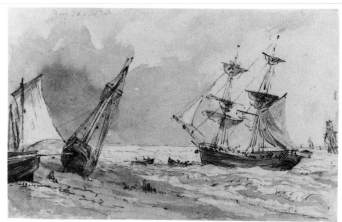

The Schooner Malta on Brighton Beach (no.67)

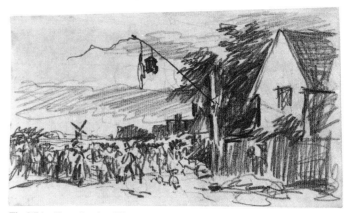

The White Horse Inn (no.20)

spiky corners barely reach. Constable's well-mannered contemporaries (Turner included) would never have perpetrated such risky cubist-fauve triangulations!

And while we've Matisse in mind let's notice that *The White Horse Inn*, of 1812, (no.20) is exactly a hundred years earlier than those apparently summary, those fluid, heavy-pencilled, and wonderfully minimally descriptive drawings

which Matisse scribbled among the pines and olives and rocks at Collioure. In this demonstrably spontaneous black-leaded scramble of rapidly scribbled lines, whose soft furry thickness of stroke co-exists everywhere with the shaped areas of white paper in which they sit to give us sunlight, we have a linear network which is as plastically evocative as thick oil paint. As in Matisse, this drawing abounds in apparent 'corrections' and changes of mind, all of which, however, again as in Matisse, have welded themselves into an immaculately unified compositional image which conveys, in every square millimetre of its surface, a mass of purely visual information about a particular terrain, an exactly identifiable location. It possesses, in its apparent abandon, exactly the same sort of authority, in the almost crude plastic power of its three-dimensional statements, that we find sixty, seventy and a hundred years later on in French master after French master.

It's impossible in this short note even to hint at the truly immense variety of Constable's invention. So far I have been mentioning drawings for the most part constructed of separate strokes, each and all of which could be said to be floating in the white of the paper (and despite its washes this is still the case with the schooner at Brighton). But the drawings of Constable are not limited to anything you could call calligraphic. Sometimes the communicative power of a drawing lies as much in the *tone*, the granularity, the precise degree of speckledness within soft, broad strokes of a flattened black-lead pencil tip as in any *line* as such. In fact there are no lines at all in countless Constable drawings, in the sense of a fine linear gesture more than half an inch in length. Take *Dedham Lock and Mill*, 22 July 1816 (no.32). This minute registration of a view celebrated in one or two of his greatest oil paintings shows a miraculous accuracy of definition. The great originality – again – of a drawing divided into two halves (sky, village and pool to the left; the single great mass of the trees to the right) apart, the greatest thrill is reading the soft, granular tones of the tiny handful of vertical or horizontal parallel strokes which block in the near end of the mill, the outbuildings and – with breathtakingly accurate scale – the slightly paler vertical rectangle

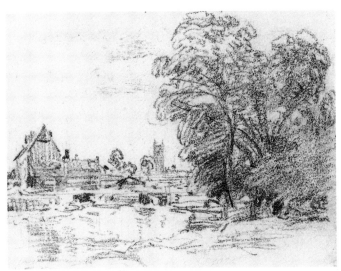

Dedham Lock and Mill (no.32)

of the more distant church tower. The underlying rectilinear severity of the overall composition is thrilling: all the rotund scribbles which create the mass of the trees to the right can be circumscribed in a square which reaches from the exact centre point of the drawing's horizontal length to the right-hand edge, then up almost to the top of the drawing, and down below the trees to the foreground white, which occupies a horizontal oblong one-quarter as deep as the trees' height: the left-hand half of the picture resolves into a square of sky reaching down to the horizontal band occupied by the village, underneath which the second, wider horizontal band is the surface of the pool. But the very great pleasure, for me, is in the contemplation of all those squarish furry pale marks, punctuated by much fewer darker ones, which are strung out along invisible horizontal lines, but into which we read the spatial layout of the lock, the rushes, the water reflections and then the outhouses, the field walls, the three or four rotund trees which fill out this band between church and mill. Not only has

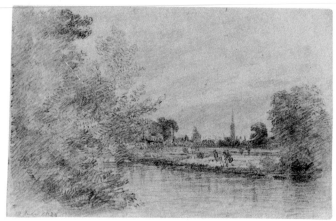

Salisbury Cathedral beside the River Nadder (no.53)

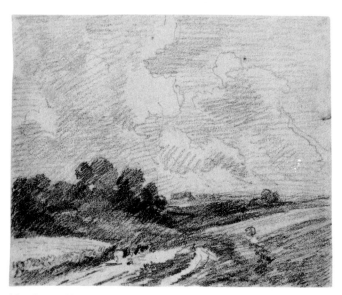

A Landscape with a Cornfield, after J van Ruisdael (no.49)

each of these squarish marks a spatial tone – each has its own *colour*. The light which sparkles off and out of the surfaces of these great drawings itself generates *colour* – and the variety of colour throughout the drawings of Constable is infinitely varied.

At the core of Constable's great genius there seems to have been an attitude which rescued him, all the time, from slipping towards formula of any kind whatsoever. Each and every start seems to have been a completely new beginning in which everything the scene offered to his eyes was registered and translated afresh. The result is that the three-dimensional reality of that scene always overwhelms all memories of previous paintings, previous discoveries or devices – in fact, there seem to be *no devices* in Constable. The featheriness of the willows which fill the left-hand half of *Salisbury Cathedral beside the River Nadder*, 18 July 1820, (no.53) is as unrepeatably organic, as infinitely varied in its suggested construction, as the tree itself. Penetrating across the river, and over and across and through the meadows opposite, Constable's eye proved over and over again to be the most accurate eye in the history of painting for *recording recession*. Yet always the deep distances and horizons are perfectly accommodated to the picture surface. Never in Constable was profound spatial accuracy disruptive of the most delectably organised surface-design. In the successful pursuit of this great unity the nature of the marks he made on the surface changed all the time – sometimes the insistent diagonal hatch-stroke (in which *we* cannot but see Cézanne); sometimes an immensely decorative, loose looping line over-ridden with the lightest of parallel hatchings (clouds in a sky in which *we* cannot but see fauve Matisse). Both these features co-exist with total naturalness in *A Landscape with a Cornfield, after Jacob van Ruisdael*, 1819 (no.49). Only the greatest of all European painters are Constable's peers.

Prologue

It is not unusual to find artists of genius deeply versed in the work of their forerunners. In this respect, Constable was no exception. He learned his craft by copying, and stylistic borrowing is a feature of his work on paper until he began to respond to landscape in a way entirely his own in the summers of 1813 and 1814.

This first section is given to the graphic work of the artists, professional and amateur, whose manner he adopted for a time, or whose vision of landscape appears to have influenced his development as a draughtsman in his formative years.

John Thomas 'Antiquity' Smith 1766 – 1833

I *An Artist sketching beside a Mill Pool*

Pen and wash on wove paper 273 x 191mm (10³/₄ x 7¹/₂ in)

Charles E. Mather 111 and Mary MacGregor Mather

II *A Well on the Road to Ipswich,*
 copy by John Constable after J.T.Smith

Pen and wash on wove paper 190 x 156mm (7¹/₂ x 6¹/₈ in);
inscribed 'Well on the Road from/ E.B. to Ips^ch done in/ a gig by
J.T.S. & / this my copy from it'

Courtauld Institute Galleries, London (Witt Collection)

It was largely the help and encouragement Constable received
from J.T.Smith that enabled him to make his final choice of a
career. They met when Constable was staying with relations, the
Allens, at Edmonton in 1796. Thomas Allen, his uncle by mar-
riage, was a member of a cultured circle with interests in antiqui-
ties, literature and the fine arts. Smith, a local drawing-master with
a growing reputation as an engraver and recorder of ancient
buildings, was about to publish his *Remarks on Rural Scenery*, illus-
trated with etchings of picturesque, tumbledown cottages,and had
already begun on his *Antiquities of London and its Environs*, a work
he completed in 1800. Constable became his pupil in all but
name, while still remaining in the family business – working in the
mills and as a clerk in the counting-house. Smith supplied him
with books, plaster casts of anatomical and classical figures, sent
him drawings to copy and instructed him in the art of etching. At
one stage, maybe because Constable was showing no great
promise as an artist, we find Smith advising him to attend to his
father's business. However, it is perhaps significant that it was soon
after Smith's visit to East Bergholt in the autumn of 1798 – when
he must have made the drawing of the well-head (no.I) – that
Golding Constable agreed to support his son in London while he
studied to become an artist.[1]

Outside the volumes of Antiquities in the British Museum,
extra-illustrated with Smith's originals, examples of his drawings
are few and far between, but their number is sufficient to establish
a style that is recognisably his. Pen and wash was his preferred
medium (fig.35), often with some tinting. In all his drawings the

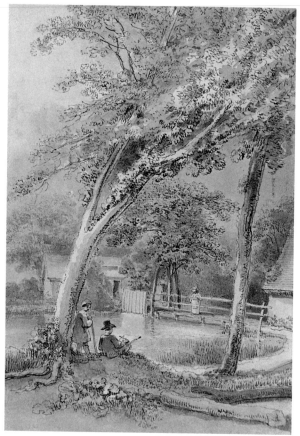

I

pen, used somewhat like an etcher's needle, played a pri-
mary role, not necessarily, though, for outlining. His
touch was delicate and tentative. Where possible – when
profiling the main tree-trunk in no.I, for instance – he
would use the faintest of broken touches to sharpen tonal
edges and elsewhere employ swarms of little dots and
squiggles to suggest texture and details. Constable learnt
to draw thus, and for his future development it was
fortunate that he did so. A bolder, linear calligraphy
would have limited his vision and been far less
productive.

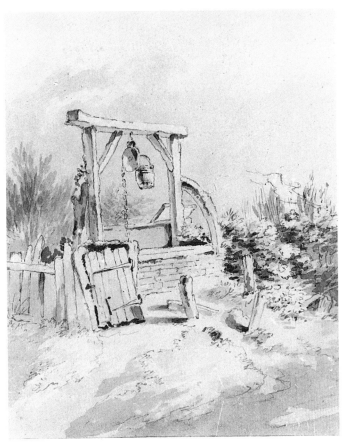

II

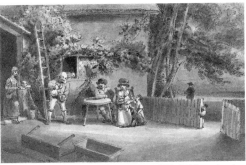

35 J.T.Smith, *Outside an Alehouse*, pen and black ink, and water-colour on thin card 155 x 251mm ($6\,^1/_8$ x $9\,^7/_8$ in). Fitzwilliam Museum, Cambridge

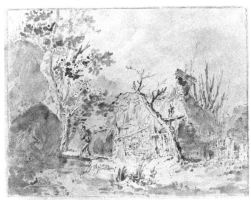

36 John Constable, *A Figure Crossing a Brook beside a Thatched Cottage*, pen and wash on wove paper 168 x 210mm ($6\,^5/_8$ x $8\,^1/_4$ in). Private Collection

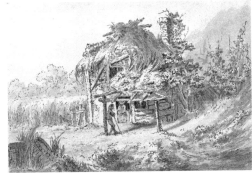

37 John Constable, *A ruined Dwelling with Figures near a Cornfield*, pen and grey wash 140 x 200mm ($5\,^1/_2$ x $7\,^7/_8$ in). Courtesy of Andrew Wyld

Smith had an eye for the quaint and the rural picturesque. Constable eagerly drew every dilapidated dwelling he could find and appears to have invented when the supply ran out. Figs.36 and 37 illustrate two stages in his development while under Smith's influence .

1 Constable's first London friend, Ramsay Richard Reinagle (1775-1862), son of Philip Reinagle, R.A., was a guest at East Bergholt the following year. Their friendship was short-lived and Constable was only briefly influenced by Reinagle's bravura style of drawing. See Fleming-Williams and Parris 1984, pp.154-8.

Sir George Howland Beaumont, Bart. 1753 – 1827

III *Dedham from Langham*

Pencil and wash on laid paper 320 x 467mm (12⅝ x 18⅞ in); inscribed in pencil 'w' three times on the river[1]; 'Langham Sept: 13th 1796' below, in ink on the sheet on which it is mounted; on the back in pencil 'Langham $\frac{Wednesday}{\langle Tuesday \rangle}$ Sept: 13 1796'

E.J. Burstal

IV *View of Dedham*

Pencil and wash on laid paper 165 x 229mm (6½ x 9 in); inscribed 'Dedham Friday July 25 1794'

Sir George Beaumont, Bart.

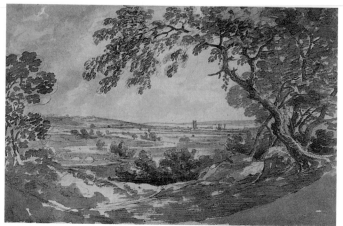

III

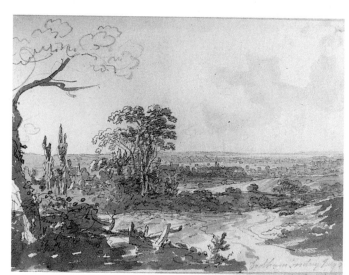

IV

Beaumont, connoisseur and collector, a pupil of Alexander Cozens at Eton and of Malchair at Oxford, was the most distinguished amateur artist of his day. A regular exhibitor at the Royal Academy between 1794 and 1825[2], Constable said of him in a letter to Wordsworth 'I feel that I am indebted to him for what I am as an artist.'[3] Although this was perhaps a little generous, Constable did owe him a great deal. It was from Beaumont that Constable, then aged nineteen, received his first encouraging words, when all he had to show were some copies of engravings after Raphael. Beaumont introduced him to the landscapes of Claude and other Old Masters as well as to the works of Wilson and the young Girtin. Constable was given the run of the collection in the Beaumont's Grosvenor Square house when a student so that he could study and copy[4]. For a time he greatly benefited from Beaumont's fatherly care. Later, he was a guest for six weeks at Coleorton, Sir George and Lady Beaumont's country house in Leicestershire (see nos.63 and 64). Beaumont's influence as an artist is to be seen in some of the drawings made during his Derbyshire tour of 1801 – in the free handling of pencil and wash in his Chatsworth view, for instance (fig.38) – and, of much greater importance, in the oil-sketches Constable made in 1809, which seem to derive directly from the *alla prima* sketches in oils that Beaumont made in the Lake District in 1807.[5]

For a number of years Beaumont's mother, the Dowager, lived at Dedham, and it was on one of his visits to her, probably in 1795, that Mrs Constable, in C.R.Leslie's words, 'procured for her son

an introduction to Sir George Beaumont'.[6] The previous year Beaumont must have paid a lengthy visit to his mother, for his drawing of Dedham, no.IV, is dated 25 July, and on 5 September he and Lady Beaumont were joined by his friend the Academician, Joseph Farington. They were unlucky with the weather and had to spend several days indoors, painting. On the 15th Beaumont walked his friend up to Langham so that he could sketch the view there; '...we then', Farington continued in his Diary, 'went in the Carriage to Mistley, and the village of Thorn, and crossing a Bridge returned through Bergholt [where they must have driven past Constable's home] and Stratford.

The country about Dedham presents a rich English Landscape, the distance towards Harwich particularly beautiful.'

It seems likely that Farington was referring to the view he had drawn from Langham, which Beaumont sketched two years later (no.III) and which Constable subsequently drew and painted so many times (see fig.104). Beaumont's other drawing may have been taken from 'the grounds above the Revd. Mr Hurlochs'[7], where Farington said he had made a drawing.

It is interesting that the view from Langham had also been drawn by another of Constable's early mentors (fig.39), by Dr Fisher, then Canon of Windsor, but later, as Bishop of Salisbury, to play such an important part in Constable's life. In his unpublished memoirs, Fisher talks of having passed 'some time upon my living at Langham with the Hurlocks' in the autumn of 1788, and notes having revisited Langham 'as usual' at the same time of the year in 1794, '96, '97 and '98. It was his nephew, also John Fisher, who became Constable's closest friend.

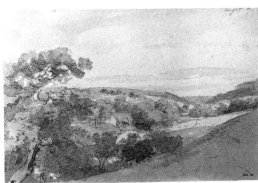
38 John Constable, *Chatsworth Park*, 1801, pencil and brown wash on wove paper 171 x 257mm (6 3/4 x 10 1/8 in). Board of Trustees of the Victoria and Albert Museum, London

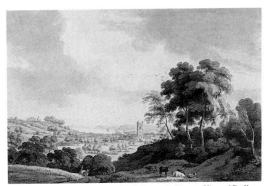
39 Dr John Fisher, Bishop of Salisbury, *A Distant View of Dedham*, pencil and watercolour on wove paper 344 x 512mm (13 1/2 x 20 1/8 in). Whitworth Art Gallery, University of Manchester

1 Presumably to remind himself which was water and which was land when he came to paint in the grey washes.

2 He first exhibited in 1779. Between 1794 and 1825 he showed a total of thirty-five works, almost all landscapes.

3 15 June 1836, Wordsworth Trust, Dove Cottage, Grasmere.

4 In his diary for 25 May 1799, Farington notes that 'Constable called. Has just finished a Kitcat picture [a 36 x 28 inch canvas], painted by memory as an experiment, from Sir George Beaumont's picture by Wilson, of Mecanas's Villa'. On 29 May the following year Farington called on Beaumont and found 'Constable copying small upright Claude.' This was probably Beaumont's favourite, *Hagar and the Angel*, now in the National Gallery.

5 In Tate 1991, pp.146–7, Beaumont's *Keswick Lake* (fig.42) is compared with two of Constable's important early sketches of 1809, *View at Epsom* (no.67) and *Malvern Hall from the North-West* (no.68).

6 Leslie, *Life*, 1951 p.5. 'Sir George' Leslie continues, 'had seen and expressed himself pleased with some copies made by Constable in pen and ink from Dorigny's engravings of the Cartoons of Raphael; and at the house of the Dowager Lady beaumont the young artist first saw a picture by Claude, the "Hagar", which Sir George often carried with him when he travelled.'

7 The Revd Brooke Hurlock was rector of Lamarsh, nearby, but was currently obliging Dr John Fisher, by acting as his curate, as he found it more convenient to employ his own curate at Lamarsh and live at Dedham, where he could educate his sons. His daughter, Lucy, was a friend of Constable's, who, in 1800, as a wedding present, gave her four large drawings of Dedham Vale. It was through the Hurlocks that Constable first met Dr Fisher. One of Constable's earliest paintings is a view of the Hurlock Lamarsh residence, *Lamarsh House*, see Tate 1976 no.20, p.43.

Joseph Farington, R.A. 1747-1821

V *Barnes Elms*

Pen and grey ink over pencil on wove paper 306 x 455mm (12 x 17³⁄₄ in); inscribed in pencil 'Octr 16 –' below trees in centre, and in ink 'Barns Elms' b.l.

Ashmolean Museum, Oxford

Today, Joseph Farington is best remembered for his *Diary*, which is our main, and sometimes our only source of information on the London Art World in the period 1793–1821. But in his day he earned a respectable place for himself as a landscape painter and topographer and, although he did not exhibit again after 1813, as a Senior Academician he played an important role in the inner workings of the Royal Academy. A pupil of Richard Wilson from the age of sixteen, Farington ever after revered the name and work of his master. He certainly owned some of his sketchbooks as well as two of his paintings, *Maecenas's Villa* and *Adrian's Villa* (both of which Constable bought after his death)[1]. Among bibliophiles, Farington is known for his collections of the engraved views of the Lakes, published in 1789 and 1816; for his *Views of Cities and Towns in England* (1790) and for the monumental *History of the River Thames* containing 76 aquatints in two volumes, which the Boydells published in 1794-6. *Barnes Elms*, no.V, was engraved for the plate facing p.59 in vol.II.

The first Constable entries in the *Diary* run as follows:

[25 February 1799] Mr. J. Constable of Ipswich calld. with letter from Mrs. W[akefield][2] devoted to art therefore not necessary to profess it.[3] – Knows Sir G[eorge] B[eaumont] – thinks first pictures of Gainsborough his best, latter so wide of nature.

[26 February] Constable calld. and brot. his sketches of Landscape in neighbourhood of Dedham – Father a Merc[han]t who has now consented that C. shall devote his time to the study of Art. Wishes to be in Academy – I told him he must prepare a figure[4].

Farington subsequently had a considerable influence on the course of Constable's career as an artist and was also a wise counsellor on the management of his affairs – his money problems, his relationships with other artists and his pre-marital tribulations. Only in a few of his early drawings, however, such as the *Extensive Landscape* (see no.2) do we see much evidence of Farington's

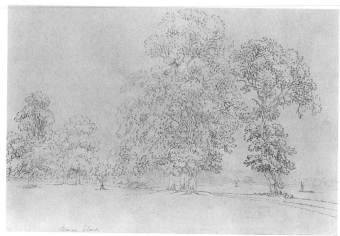

V

stylistic influence. When sketching it was Farington's practice to make a careful outline drawing in pencil in front of the scene and to ink it in and paint the monochrome or colour washes in later.[5] It seems to have been after his meeting with Farington in Dovedale in 1801 and seeing him in the act of sketching, that Constable temporarily adopted his friend's manner (see no.2, *An Extensive Wooded Landscape*).

1 Farington died on 30 September 1821. Constable was then living nearby in Keppel Street. The following year he took over the lease of Farington's house, 35 Charlotte Street and moved there with his family in June. In February he had written to a friend 'I have been with my wife to look over Mr. Farington's house, which has left a deep impression on us both. I can scarcely beleive that I was not to meet the elegant and dignified figure of our departed friend, where I have been so long used to see him, or hear again the wisdom that always attended his advice, which I do indeed miss greatly' (JCC IV, p.247). A notebook in the family collection lists '£80 – 2 -' as the purchase price of the two Wilsons from the executors (JC:FDC, p.215).

2 See no.10, *Markfield*.

3 From this, one gathers that Constable was presenting his aims to Farington more as those of a gentleman amateur, than a professional artist-to-be.

4 Those wishing to enter the Academy Schools were expected to submit a study from the antique as a proof of competence before they were accepted as students.

5 When staying with Sir George Beaumont at Dedham in 1794, Faring-
ton noted in his diary for 6 September 'The weather rainy, employed
myself in washing the river views [for the *History of the Thames*] while Sir
George was painting.' And on the 8th, 'the weather still very wet. I
employed on my River subjects. Sir George painting the sky of Chep-
stow composition.'

Richard Wilson R.A. 1713/4 – 1782

VI *Arch of Augustus at Rimini*

Red chalk on laid paper 280 x 197mm (11 x 7³/₄ in); inscribed
'Rimini' t.r.

Sir Brinsley Ford, C.B.E., Hon.F.R.A., F.S.A.

Wilson is included in this short review of some of Constable's
stylistic progenitors in an attempt to explain a phase in the latter's
development when, for a short while, he adopted a manner that
seems to have derived, if indirectly, from the Venetian, Canaletto.
During Canaletto's years in England (1746 – 55) and for a long
time afterwards, his idiosyncratic way of drawing – his dots, dashes
and squiggles for outlining (see fig.10) – continued to be imitated
and adopted by artists in this country.

No.VI is one of a group Richard Wilson made in 1751 while
travelling from Venice to Rome. Canaletto had been back in
Venice again for a short time when Wilson was there and it has
been suggested that they may have met.[1] Wilson certainly knew
Consul Smith and would have seen his considerable collection of
drawings and paintings by Canaletto.[2] Since Wilson had only
recently turned from portraiture to landscape, it would have been
surprising if the sketches he made on his way south had not
reflected something of Canaletto's calligraphy. This is to be seen
in Wilson's rendering of the masonry in his sketch of the *Arch of
Augustus*, in his broken, wiggly line and the general scatter of
touches and sudden pressures.

In Farington's early work he, too, adopted Canaletto's accom-
plished but imitable manner, combining the Venetian's brown ink
outlines with the cool, grey-washed shadows.[3] Both Constable's
pencil sketch of Chalk Church (no.6) and the pen and wash draw-
ing he made from it (fig.55) appear to be Canaletto derivatives,
but to have been differently routed: the latter through a study of

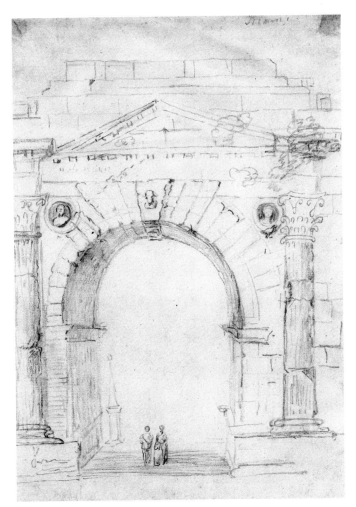

VI

Farington's reed pen and wash drawings; the former after looking
at Wilson's Canaletto-styled drawings. A couple of weeks before
making the pencil sketch of Chalk Church Constable had called
on Farington, who lent him Wilson's *Maecenas's Villa*, presumably
to copy.[4] Farington also owned a couple of drawings by Canaletto
and two volumes of sketches by Wilson.[5] If Constable had also seen
these, which seems very likely, then this could well account for the

markedly Wilsonian manner in which he worked while he was in Kent and aboard the *Coutts*, that is, the manner in which Wilson was drawing when Canaletto was freshest in his mind.

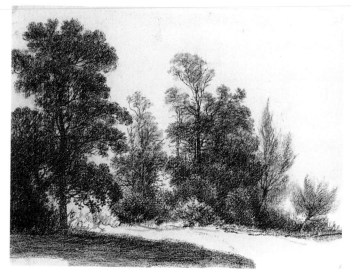

VII

1 M.Liversidge and J.Farrington, *Canaletto in England*, exhibition catalogue, Birmingham, 1993, p.129.
2 The collection, which Joseph Smith eventually sold to George III, included over one hundred and forty drawings.
3 This resemblance is commented upon and well illustrated in the above catalogue, pp.149-50.
4 Farington *Diary*, 1 April 1803.
5 See no.6, n.5.

George Frost 1743 – 1821

VII *Trees in Shadow*

Black chalk on laid paper 277 x 363mm ($10^1/_2$ x $14^3/_{16}$ in); Esdaile monogram 'WE' b.r.

Private Collection

VIII *Wooded Landscape with Pigs grazing*

Pencil on laid paper 335 x 290mm ($13^1/_8$ x $11^7/_{10}$ in); Esdaile monogram 'WE' b.r.

The Trustees of Gainsborough's House, Sudbury, Suffolk

IX *On the Banks of the Orwell*

Black chalk on laid paper 197 x 254mm ($7^3/_4$ x 10 in); a companion drawing is on paper water-marked '1802'

Mr. & Mrs. Denis Thomas

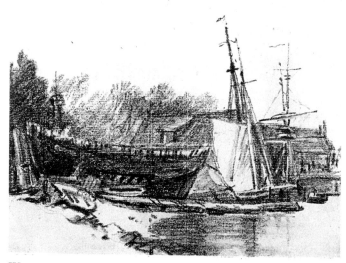

IX

After J.T.Smith, George Frost, and through Frost, Gainsborough were the most important influences on Constable's early development as a landscape draughtsman. It is not known exactly when they became acquainted, but the earliest dated drawing to show

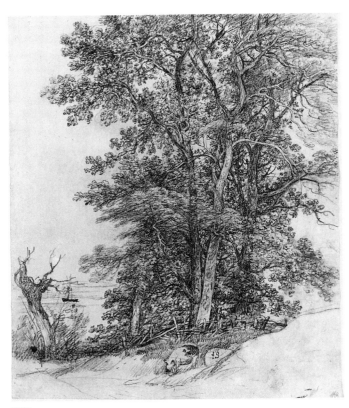

VIII

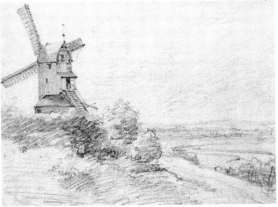

40 John Constable, *A Windmill at Stoke, near Ipswich*, c.1805, pencil on wove paper 118 x 168mm (4$^5/_8$ x 6$^5/_8$ in). Courtesy of the Leger Galleries

the influence of Frost is the remarkable *Mill on the Banks of the River Stour* in the Victoria and Albert Museum (see no.7 fig.56) which is inscribed 'Octr. Noon 1802.'. A dated drawing by Constable of shipping at Ipswich that pairs with one by Frost, shows that they were working side by side by October 1803.[1] In a letter written in 1814,[2] Constable recalls another of their expeditions 'many years ago', when Frost, John Dunthorne (his sketching crony from East Bergholt) and he were drawing a windmill together at Stoke, just outside Ipswich (fig.40).[3]

Outside working hours, Frost, a clerk at the Ipswich Blue Coach office, was an enthusiastic amateur artist with a passionate admiration for his one-time fellow townsman, Thomas Gainsborough. His output was considerable[4] and consequently the quality of his work varied considerably. At its conventional best, as in no.VIII, it can only command respect. For a time many of his drawings were attributed to Constable, occasionally for no other reason than that they 'were too good for Frost'. Gainsborough, whose early work he both collected[5] and copied, had been his model. But, one of those figures whose very isolation from the mainstream makes for independence, he was an original, particularly in his use of black chalk for dramatic tonal effect – nos VII and IX.

1 See Tate 1976, nos 38 and 39, p.53.
2 To John Dunthorne 22 February, JCC I, p.101.
3 Fig.40, a drawing of Stoke Mill that has recently come to light. This was probably the sketch Constable made when in company with Frost and Dunthorne. From this drawing Constable made a watercolour which was engraved by John Landseer to illustrate a poem, *The Social Day*, by Peter Coxe, brother of William Coxe whom Constable had met at Stourhead in 1811 (see no.20).
4 Over 400 of his drawings appeared on the market some years ago, 165 of which had belonged to the collector, William Esdaile.
5 See no.X for a Gainsborough once owned by Frost.

Thomas Gainsborough R.A. 1727 – 1788

X *Wooded Landscape with River, Footbridge, Figure and Buildings*

Pencil and watercolour with some bodycolour on wove paper 299 x 368mm (11 $^3/_4$ x 14 $^1/_2$ in); the drawing enclosed by brown ink double ruled lines; Edaile monogram 'WE' b.r.; inscribed on the back by Esdaile 'G-Frost's colln N50+' b.l.

The Board of Trustees of the Victoria and Albert Museum

XI *Study of Trees*

Pencil on laid paper 152 x 190mm (6 x 7 $^1/_2$ in)

Private Collection

XII *Study of Trees*

Pencil on laid paper 180 x 135mm (7 x 5 $^1/_4$ in)

Mr and Mrs David Thomson

On his first meeting with Joseph Farington in February 1799, Constable expressed the opinion that Gainsborough's early pictures were his best, the later being 'so wide of nature'. After a term as a student at the Academy Schools, while staying with his friends the Cobbolds in Ipswich, Constable discovered how delightful was the surrounding country 'for a landscape painter.' 'I fancy', he said, 'I see Gainsborough in every hedge and hollow tree.'[1] In this formative period, at first it was the paintings of Gainsborough's Suffolk years that influenced Constable most strongly. One of his earliest pictures, *The Harvest Field* (fig.41), could almost be mistaken for a copy of an early Gainsborough original. It was not until he met George Frost that Constable came under the spell of Gainsborough's drawings.

Frost owned a number of the drawings. They were described in 1820 as 'a pleasing collection of valuable specimens executed in different ways, but chiefly with black chalk and lead pencil, in the best style of Gainsborough's earlier manner.'[2] It is possible that some of these Gainsboroughs passed on to Constable after Frost's death and were sold, along with forty-eight 'Drawings in imitation of Gainsborough, in black chalk, by Frost', and ten 'Studies of

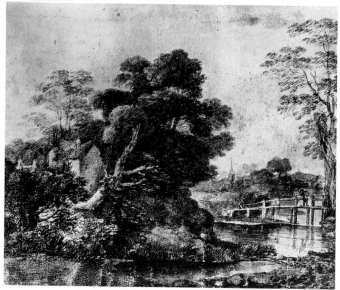

X

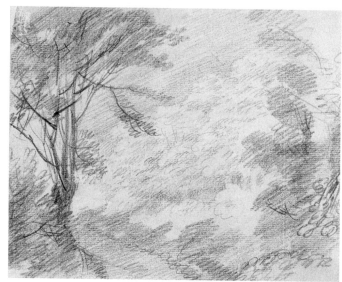

XI

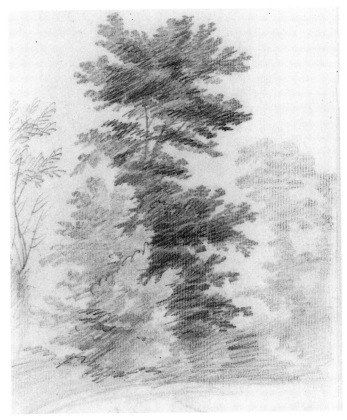

XII

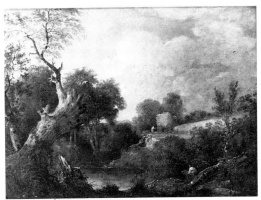

41 John Constable, *A Harvest Field*, c.1797, oil on paper laid on canvas 490 x 670mm (19 1/4 x 26 1/4 in). Private Collection

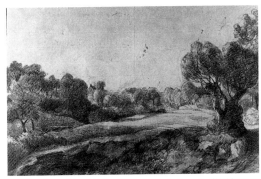

42 John Constable, *A Dell*, c.1805, black chalk on buff laid paper 335 x 492mm (13 1/8 x 19 3/8 in). Private Collection

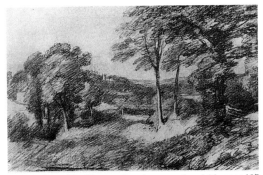

43 John Constable, *View near Langham*, pencil on laid paper 197 x 306mm (7 3/4 x 12 in), Private Collection

Trees, in black chalk' by Constable, in the sale of the contents of his studio at Fosters in 1838.

No.X was one of the Gainsboroughs owned by Frost and would therefore almost certainly have been seen by Constable. Its influence, or that of other similar works, is to be seen in drawings such as the black chalk studies *A Dell* (fig.42) and the *View near Langham* (fig.43). The drawing of the Dell reflects Gainsborough's bold massing of forms and, besides a similar breadth of treatment, in the Langham view we have Constable almost imitating Gainsborough's treatment of foliage. There was one type of Gainsborough drawing, however, to which Constable paid particular attention, a type exemplified by the two studies of trees, nos. XI and XII, sketches 'washed' with areas of rapid diagonal shading,

varied in pressure, in which the pencil is used somewhat like a brush and in which outline plays little or no part. Constable's adoption of this manner was to last several years.

Among collectors, this has sometimes caused confusion. In 1813, No.XII was acquired by H.W.Underdown and was subsequently passed on to the next owner as a Constable. Underdown (1864-1944), a solicitor, who ended his life as a Brother in Old Charterhouse, was a somewhat hopeful collector of Constables. Fourteen drawings from his collection (including the *Dell*, fig.42) were published in 1921 as Constables by Sir Charles Holmes in a slender volume, *Constable, Gainsborough and Lucas: Brief Notes on some early Drawings by John Constable*. Four of the drawings discussed and illustrated in this work are now recognisable as Frosts.

1 In a letter to J.T.Smith, 18 August, JCC II, p.16.
2 This is from J.R.Hobbes, *Picture Collectors' Manual*, 1849, quoted by Denis Thomas in his pioneer article on Frost in the *Connoisseur*, Vol.178, October 1971, pp.108-13.

Dr William Crotch 1775 – 1847

XIII *Magdalen Tower and Merton Fields 1802*

Black chalk and grey wash on wove paper 289 x 471mm (11 $^3/_8$ x 18 $^9/_{16}$ in); inscribed on the back in pencil 'N° – 43 – Magdalen Tower Wm Crotch Merton fields Oxford – / Aug 3rd 1802 5 to 6 PM – races -'; lower down inscribed in grey wash with a brush 'I had drawn this subject twice before – Mr Malchair has a fine drawing of it -'

Private Collection

One of the most precocious musical infant prodigies of all time, with a subsequently succesful career as an organist, composer[1], chorus-master and teacher, William Crotch was also a talented artist, and, for a time, taught drawing in Oxford.[2] His extraordinary talent for music declared itself when he was two years old. At the age of three he was performing in towns around the country and had appeared before the royal family.[3] In 1790, aged fifteen, he became organist at Christ Church, Oxford; in 1797,

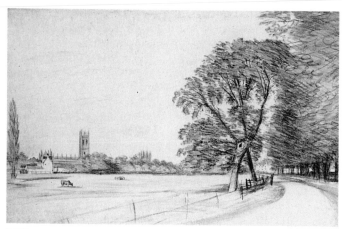

XIII

Professor of Music; and in 1822 was appointed the first Principal of the Royal Academy of Music. 'My love of drawing', he wrote in his *Memoirs*, 'seems to have made its appearance in less than a twelvemonth after that I showed for ye sister art. I have ever found it a source of amusement after the fatigue of professional duties so that I cannot tell which I love best of these 2 sisters.' Though initially self-taught, it was under the guidance of Malchair at Oxford (no.XIV) that he was able to develop his own individual responses to landscape. They became close friends and founded what they only half-jokingly called *The Great School*, recruiting members from artist friends and pupils sympathetic to their views on art; these were Members of the Great School (MGS); Malchair was first President (PGS) and after his death Crotch succeeded him. In the *Memoirs*, Constable is listed as a Member.[4]

Two drawings by Constable are pasted into the pages of the *Memoirs*. The first is a portrait of Crotch in profile inscribed by the sitter 'W.CROTCH playing Mozart – drawn by John Constable R A M G S about 1806'[5]; the second, of Crotch's daughter Isabella, is dated 1809. They remained friends and are variously recorded together. Constable painted some scenery for a small stage production of *Henry V* in which Crotch played the lead; a drawing of the 'Colissium & ye Priory near Regents Park' by Crotch (Private Collection) is also inscribed 'John Constable R.A. told me he should be proud to own this as his & told me to write it here'. Con-

stable gave Crotch a little oil painting and a watercolour and, in 1836, sent him a copy of his *English Landscape* (see no.70).[6]

When they first met, Constable was still endeavouring to articulate more fully his feelings about the tonality of landscape and to find a solution to the problems of representing forms – trees, etc. – in space. From Malchair (fig.46) Crotch had learnt to see landscape tonally, without outline, and his work (fig.44) must have encouraged Constable to continue in the direction he was already taking towards a more naturalistic view of nature. Crotch's method of diagonal shading (left-handed in no.XIII, it will be observed)[7] without outline, would also have provided encouragement. In addition, Constable seems to have made the fullest use of Crotch's suggestions for drawing trees initially as ovoid forms (fig.45).[8] In his drawings of 1805-6, the view of Glaramara for example (no.12) by reducing many of the trees to sculptural, dumpling-like forms he creates space around them and achieves a three-dimensionality that, in less schematic terms, he retained throughout the rest of his working life.

1 Four of his compositions are now recorded on CD: his symphonies in F and E flat; his organ concerto No. 2 in A; and an overture in G.

2 'At this time there were four drawg masters at Oxford (besides myself) Neill, Shetky, Jones & Taylor', entry for March 1805 by Crotch in his *Memoirs of William Crotch extracted by himself and for himself from old letters etc.*, Norfolk Central Library, MS 11244.

3 *Op.cit.*, and 'Account of the Musical Phaenomenon', *The London Magazine* April 1779, pp. 7-9.

4 Other Members included W.H.Callcott, the composer (brother of A.W.Callcott, R.A.), William Delamotte, James Roberts and, besides other amateurs, Sir George Beaumont.

5 Repr. JC:FDC facing p.234.

6 W.Crotch to Constable 28 February 1836; JC:FDC p.l54.

7 Crotch was ambidexterous, but usually drew with his left hand.

8 This is a page from a pocket book of 1803, Norfolk Central Library, MS 11073.

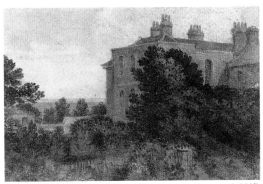

44 Dr William Crotch, *Behind Wetherall Place, Hampstead*, 1807, pencil and watercolour on wove paper 115 x 178mm (4 1/2 x 7 in). Private Collection.

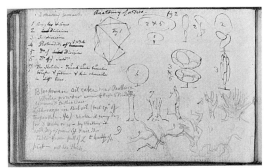

45 Dr William Crotch, *Anatomy of a Tree*, 1803, pen and ink on p.100 of a pocket book. Norfolk Record Office, MS1103

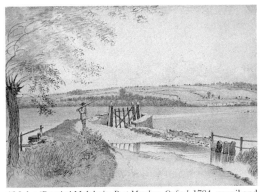

46 John 'Baptist' Malchair, *Port Meadow, Oxford*, 1784, pencil and wash on wove paper 210 x 299mm (8 1/2 x 11 3/4 in). Visitors of Ashmolean Museum, Oxford

John 'Baptist' Malchair 1729 – 1812

X1V *Moel-y-ffrydd* 1795

Pencil and wash on heavy wove paper 415 x 552mm (16³/₁₆ x 21³/₄ in), trimmed; inscribed on the back in wash with a brush over pencil 'Moel y Frydd – Near Llanummowddy in Merioneth Shire/met with Mʳ Richards [and in pencil] the Clargeman of the place' along the bottom; above, in pencil, in William Crotch's hand 'Wales'

Private Collection

Constable had no direct contact with Malchair, but as a co-opted Member of the Great School (see no. XIII) he must have heard a lot about him and also seen many examples of his work, in particular the drawings owned by Crotch that Malchair made during a tour of Wales in 1795 (e.g. no. XIV). Best known as the founder of the Oxford School, like his pupil Crotch, Malchair was both musician and artist.

Born in Cologne, Malchair came to England via Nancy, in France, in 1754. It was as a violinist that, partly through the patronage of Robert Price of Foxley (father of the better known Uvedale Price), he was appointed leader of the Music Room Band at Oxford in 1759[1]; the 'band' being a small orchestra that gave regular subscription concerts. This he led until 1792. He had taught drawing for a while in London and, with time to spare from his duties as leader of the orchestra, by the later '60s he had built up a succesful practice as a drawing master – the only one in Oxford at that time. About forty of his pupils are known by name, some, such as Sir George Beaumont and Lord Aylesford, distinguished themselves in later life as amateurs. Malchair's method of teaching is to be found in a treatise he wrote that has survived in manuscript: *Observations on Landskipp drawing with Many and Various Examples Intended for the use of beginners. 1791.*[2] On outline and 'Complexion', ie: colour, he has this to say:

> The natural objects have strictely[3] speaking no outline, and may bee imitated without the help of line in painting, but in drawing the Artist is _{rather}_{<often>} obliged to use them in order to marke out the form and demension of the Several objects, before he discriminates the Mass by shaddow and complexion, but he must make his outline so, as to disappear in a greate measure when the discriminating powers of Shade and complexion take place.

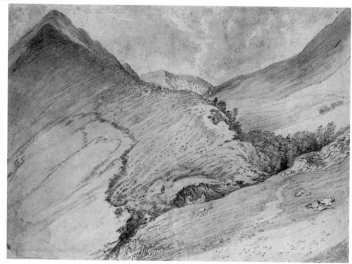

XIV

> Complexion is the colour of an object, and tho' the artist should not use colours, he may yet in some _{measure}_{<degree>} express the complexion by the different degrees and strentht of the materials he draws with, this effect is totaly distinct from that of light and shade.

Outline plays little part in the dramatic Welsh view (no.XIV) or in Malchair's gentler drawing of Portmeadow Gate (fig.46).[4] In the latter there is hardly a shadow to be seen, yet by the subtlest of pale washes and stronger touches of brush and pencil every part is clearly, as he says, discriminated – the path in the foreground from the water, the gate-posts from the distant woods. Constable did not take to the Oxford combination of pencil and wash, but, eventually, in what might be called his middle period, in drawings such as the *Farmhouse at East Bergholt* of 1814 (no.25) and the study of his parents' tomb in East Bergholt churchyard (no.44), he managed to achieve similar results with the pencil alone. It is possible, however, that his meeting with Crotch in 1806 had more immediate results. Malchair's Welsh drawings that Crotch owned were all on relatively large sheets of paper, many, such as no.XIV, were of mountain scenery executed boldly with almost explosive force.[5] If Constable had been shown these powerful images, which seems very likely, it might explain some of the equally vigorous drawings that he made later that year, also on large sheets of paper, when

confronted by hills of comparable magnitude in the Lake District (see no.12).

1 The opening concert in the newly built Music Room in Holywell, was performed in July 1748; see, John H.Mee, *The Oldest Music Room in Europe*, 1911.
2 Private Collection. This title is written on the outer, vellum cover. A sub-title is given on the first page: 'Rules and Examples In the drawing of Landskipp according to the practice at Oxford'.
3 Malchair never lost his German accent – cherubs in the sky of a painting were 'papies in the clouts' – and never mastered English spelling.
4 A flat expanse of pasture of some 400 acres on the north-west side of Oxford, Portmeadow, known as such since 1285, is mentioned in the Domesday Book and could therefore claim to be Oxford's oldest monument.
5 Crotch appears to have numbered each of the 1795 Welsh drawings on the back in red chalk and in some cases to have added his own comments. On the back of a view of Barmouth in a storm, for example, he has written 'this was a thunderstorm which took three days to cross the kingdom – It was probably Aug 6 that it struck St Mary's Spire Oxford'.

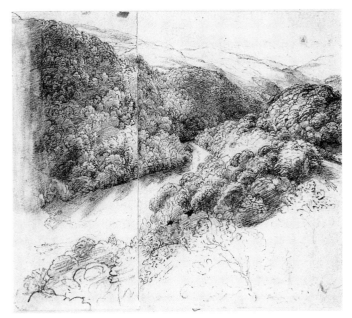

XV

Thomas Stothard R.A. 1755 – 1834

XV *View near Hafod*

Pencil on two sheets of wove paper 210 x 244mm (8 1/4 x 9 5/8 in)

The Trustees of the British Museum, London

Thomas Stothard is remembered now mainly for his work as an illustrator – some two thousand of his designs were engraved. A regular exhibitor at the Royal Academy from 1778, he was elected Academician in 1794 and became Librarian in 1810. A happily married man with a large family, his life-long friendship with Constable is recorded first in Farington's *Diary*,[1] when he apparently advised him (somewhat prematurely, in Farington's opinion) to put his name down as a candidate for election as an Associate. Stothard makes his first appearance in the Correspondence in November 1811, when Constable told Maria Bicknell that the Academician had been encouraging him to paint a view of Salisbury

'of a respectable size.'.[2] Stothard was a great walker and, being deaf, preferred the company of a single companion. 'Constable', Leslie tells us in his *Life*, 'had, for some time, been the chosen companion of Stothard's long walks, the chief relaxation of that admirable artist from the drudgery of working for the publishers. These walks lengthened with the lengthening days'.[3] One such walk is commemorated in an account Constable gave Maria in a letter of 6 June 1812:

> Yesterday I took a long walk with Mr Stothard – I left my door about 6 of the morning – we breakfasted at putney – went over Wimbledon Common – & passed three hours at least in Coomb Wood – (Stothard is a butterfly catcher) where we dined by a Spring – then to Richmond by the park – and enjoyed the view – and home by the River – all this on foot and I do not feel tired now though I was a little in the morning.[4]

Two of the drawings Constable made on this excursion have survived, a pencil sketch of Coombe Wood (fig.47) and a drawing of the famous view from Richmond Hill (fig.48).[5]

C.R.Leslie became another close friend of Stothard's and often

spent an evening with him looking through his sketchbooks.

They were filled,'he says, in his *Autobiographical Recollections* 'with every variety of subject; landscape, architecture, groups of figures and flowers, all drawn with exquisite taste...Many of the sketches were made from the windows of inns where he had halted while travelling; and to judge from the materials which filled his books, he did not appear to have ever gone in search of the picturesque, but to have sketched whatever his leisure permitted, and chance presented to him.[6]

None of these sketchbooks has survived and the whereabouts of all too few of Stothard's landscapes is known, so the nature of Stothard's influence on Constable is by no means clear. But in 1813, the year after their long walk together, Constable filled a small sketchbook in quite a new way, with just the sort of scraps that Leslie had seen in Stothard's books – cattle, old posts, water-lilies, men at work in the fields, boats, windmills, etc.[7] There is a change also in the character of the dozens of small landscapes he drew in this sketchbook, a change that may have resulted from watching Stothard at work on a drawing such as his sketch of open farmland (fig.49). With many of his customary 'washes' of diagonal shading there is a much more meticulous use of the pencil and we see evidence of a closer, more enquiring scrutiny in front of the motifs (see figs 50 & 51).

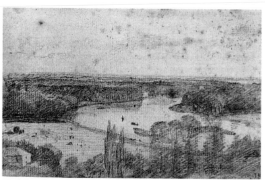

48 John Constable, *Richmond Hill*, pencil on laid paper 92 x 155mm (3 5/8 x 6 1/8 in). City Museum and Art Gallery, Birmingham

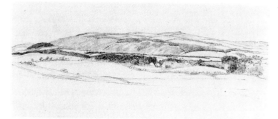

49 Thomas Stothard, *Farms in a Wooded Landscape*, pencil on wove paper 99 x 228mm (3 15/16 x 9 in). Henry E. Huntington Library and Art Gallery, San Marino

47 John Constable, *Combe Wood*, pencil on laid paper 86 x 128mm (3 3/8 x 5 1/16 in). Private Collection

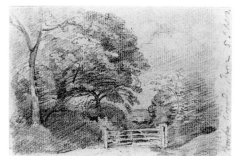

1 6 July 1807.
2 JCC II, p.54.
3 Leslie, *Life*, p.32.
4 JCC II, p.72.
5 According to Leslie, the excursion is also recorded by a third drawing of a shady lane into which Constable introduced Stothard with his butterfly nets.
6 C.R.Leslie, *Autobiographical Recollections*, 1860, vo.I, p.131.
7 The pages of this sketchbook are reproduced in Reynolds 1973, pls76-93.

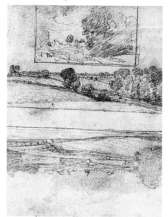

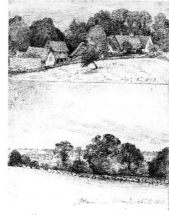

50 John Constable, *Landscape Studies*, pencil on wove paper 89 x 120mm (3 1/2 x 4 3/4 in), p.48 in an intact sketchbook. Board of Trustees of the Victoria and Albert Museum, London. Right: 51 John Constable, *View towards Dedham and A Farmhouse among Trees*, pencil on wove paper 89 x 120mm (3 1/2 x 4 3/4 in), p.63 in an intact sketchbook. Board of Trustees of the Victoria and Albert Museum, London

John Constable: a Chronology

1776 June, born at East Bergholt, Suffolk, fourth child of Golding Constable and his wife Ann. His father a corn and coal merchant with farming interests, windmills and watermills.
Attends schools at Fordstreet, Lavenham and Dedham. c.1792 enters the family business.

1795 Is introduced to Sir George Beaumont.

1796 Meets J. T. Smith at Edmonton while staying with relatives.

1798 Smith stays with the Constables at East Bergholt.

1799 Introduces himself to Joseph Farington. March, admitted a probationer at the Royal Academy Schools.

1801 July-November stays with sister's in-laws at Fenton, Staffordshire. August, tours Derbyshire.

1802 Exhibits for first time at the Royal Academy – 'A Landscape'.

1806 September–October, a tour of the Lake District.

1809 August, a guest at Malvern Hall, Warwickshire.

1811 While staying with Bishop Fisher at Salisbury, visits Stourhead, Wiltshire.

1815 Exhibits three drawings as well as paintings at the R. A.

1816 October, marries Maria Bicknell after a long courtship. They spend their honey-moon at Salisbury, Osmington (Dorset) and Binfield (Berkshire).

1817 A three month stay at East Bergholt with his wife.

1819 Elected Associate of the Academy.

1820 A long stay with his friend John Fisher at Leadenhall, Salisbury Close.

1821 Accompanies John Fisher on his Berkshire Visitation.

1823 A long stay with the Beaumonts at Coleorton, Warwickshire.

1824 Takes his wife and family to Brighton, the first of several visits.

1828 Maria dies after a final visit to Brighton.

1829 Elected an Academician. Visits Salisbury twice.

1830-2 Publishes his *English Landscape* in five parts, four mezzotints in each of the first four parts; six in the last.

1834 A fortnight's stay with George Constable (no relation) at Arundel, Sussex. Later, spends two weeks at Petworth.

1835 A second visit to Arundel. October, lectures at Worcester.

1837 March, dies at his home in Charlotte Street, London.

Colour Plates

Plate 1 *Farmhouse by a River* 1798
Pencil, pen and ink, and green wash on wove paper 295 x 449mm (11 $^5/_8$ x 17 $^{11}/_{16}$ in) ; see no.1

Plate 2 *A Lane near East Bergholt* c.1803
Pencil on wove paper 229 x 190mm (9 x 7 $^1/_2$ in) ; see no.9

Plate 3 *Glaramara from Borrowdale* 1806
Pencil on wove paper 409 x 343mm (16 $^1/_8$ x 13 $^1/_2$ in) ; see no.12

Plate 4 *Redcliffe Point* 1816
Pencil on wove paper 87 x 114mm (3 $^7/_{16}$ x 4 $^1/_2$ in) ; see no.36

Plate 5 *Captain Allen* 1818
Pencil on wove paper 320 x 202mm (12 $^5/_8$ x 8 in) ; see no.42

Plate 6 *A States Yacht under Sail Off-shore,* after W. van de Velde 1819
Pencil on wove paper 93 x 116mm (3 $^5/_8$ x 4 $^9/_{16}$ in) ; see no.47

Plate 7 *The Mound of Old Sarum from the South-East* 1820
Pencil on wove paper 154 x 230mm (6 $^1/_{16}$ x 9 $^1/_{16}$ in) ; see no.55

Plate 8 *Greenham Lock* 1821
Pencil on wove paper 175 x 248mm (6 $^7/_8$ x 9 $^3/_4$ in) ; see no.59

Plate 9 *Worthing* 1824
Pencil, pen and wash on wove paper 178 x 259mm (7 x 10 $^3/_{16}$ in) ; see no.65

Plate 10 *Colliers on Brighton Beach* 1825
Pencil on wove paper 114 x 184mm (4 $^1/_2$ x 7 $^1/_4$ in) ; see no.66

Plate 11 *The Small Salisbury* 1832
Mezzotint with grey wash and white heightening on wove paper 225 x 284mm (8 $^7/_8$ x 11 $^3/_8$ in) ; see no.72

Plate 12 *Stoke-by-Nayland* c.1830-35
Pencil and ink wash with white heightening on wove paper 122 x 165mm (4 $^{13}/_{16}$ x 6 $^1/_4$ in) ; see no.70

Plate 13 *On the Arun* 1834
Pencil on wove paper 136 x 230mm (5 $^3/_8$ x 9 in) ; see no. 75

Plate 14 *Study for Jaques and the Wounded Stag* 1835
Pen and ink with white heightening on writing paper 228 x 185mm (9 x 7 $^1/_2$ in) ; see no.77 A

Plate 15 *A Sunken Lane at Fittleworth* 1835
Pencil on wove paper 222 x 285mm (8 $^3/_4$ x 11 $^3/_{16}$ in) ; see no.78

Plate 16 John Linnell, *Fields where Gower Street now Stands* 1808
Black and white chalk on blue-grey paper 161 x 222mm (6 $^3/_8$ x 8 $^5/_8$ in); British Museum, London

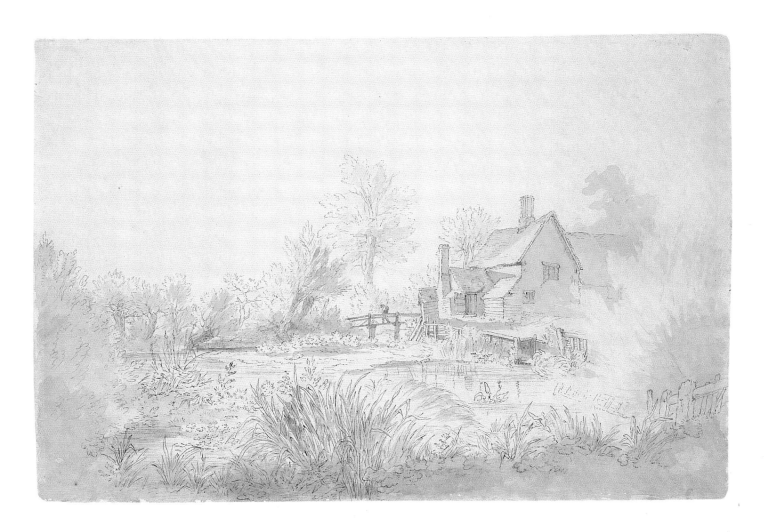

Plate 1

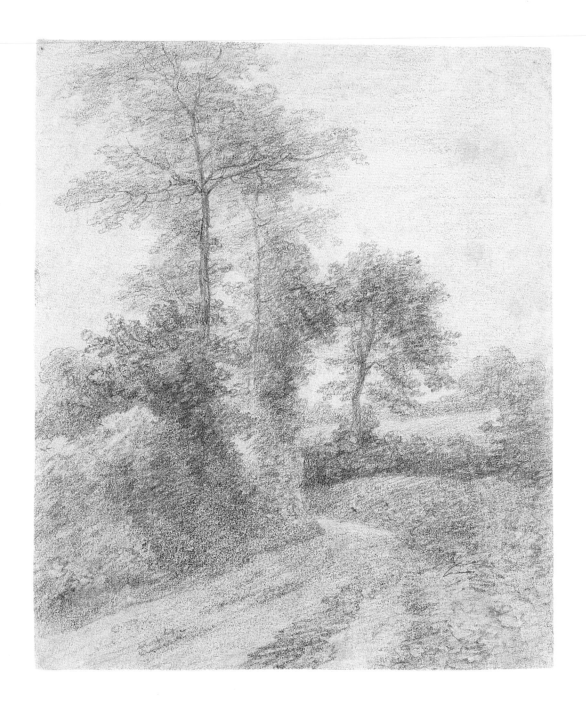

Plate 2

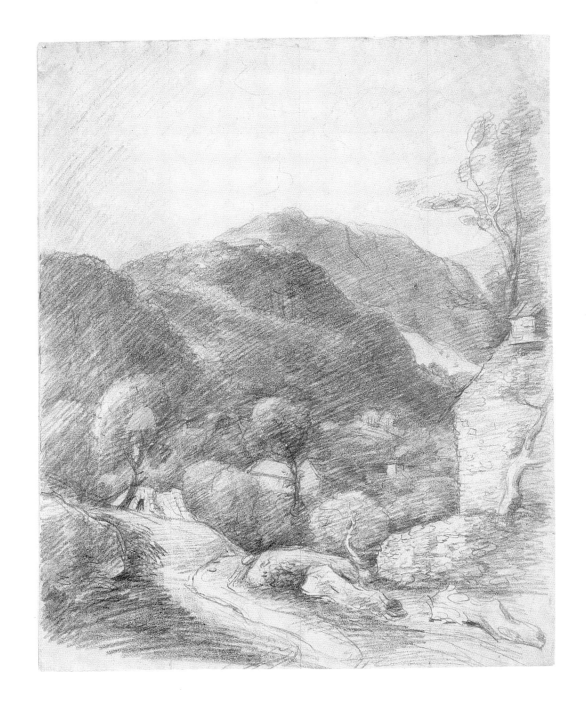

Plate 3

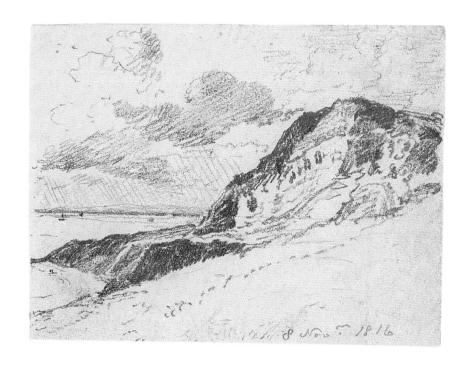

Plate 4

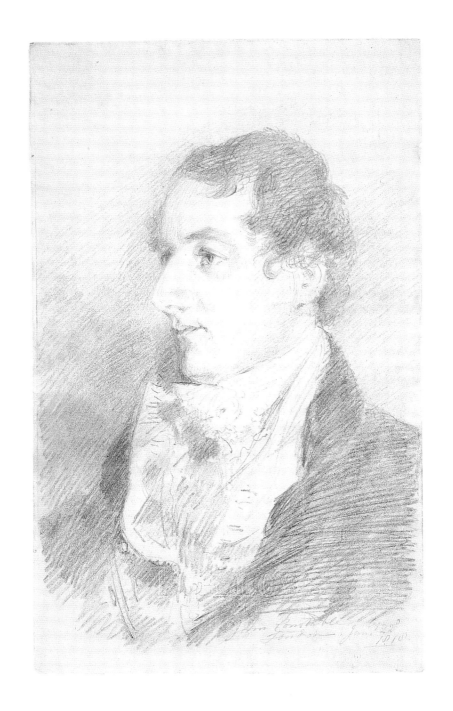

Plate 5

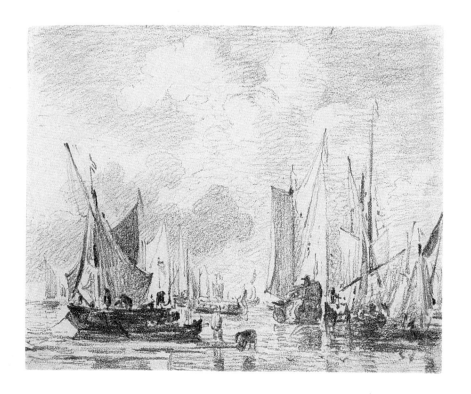

Plate 6

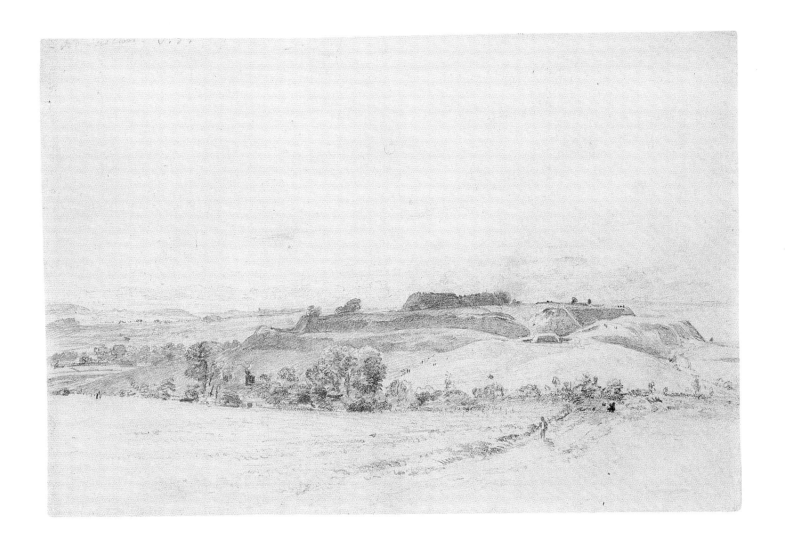

Plate 7

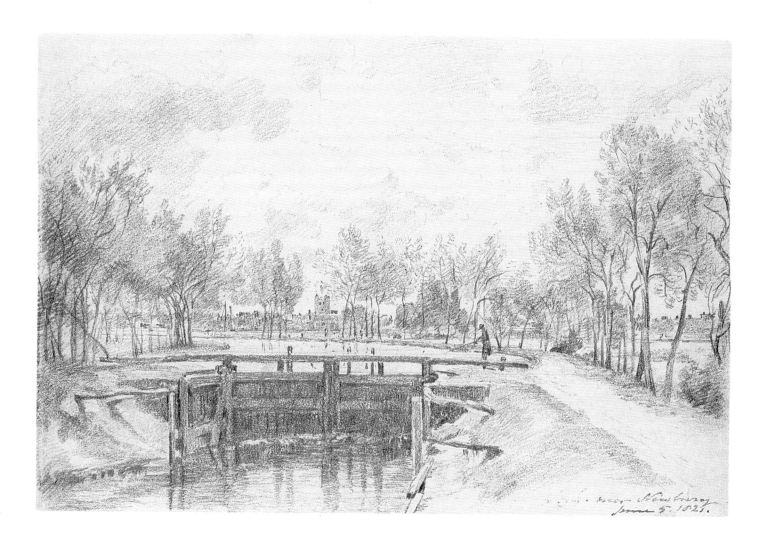

Plate 8

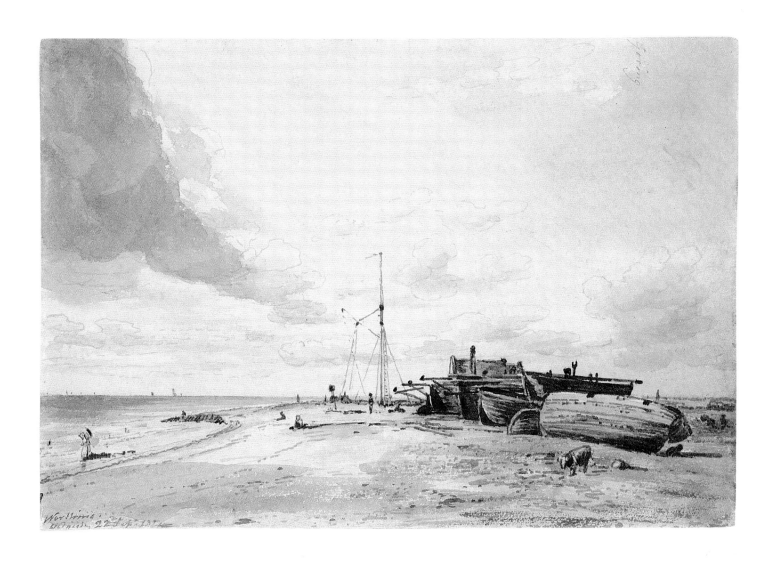

Plate 9

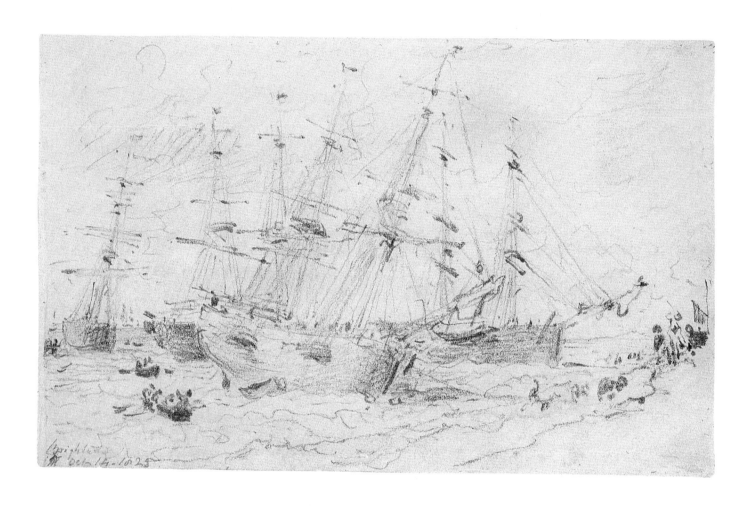

Plate 10

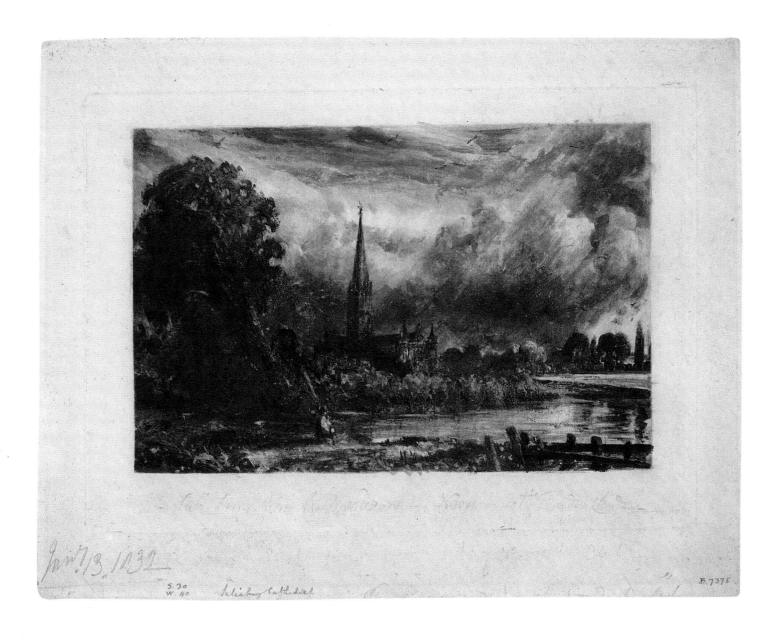

Plate 11

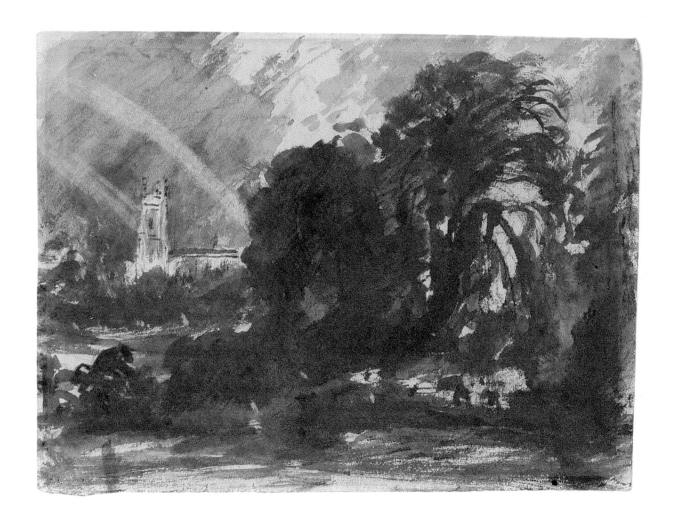

Plate 12

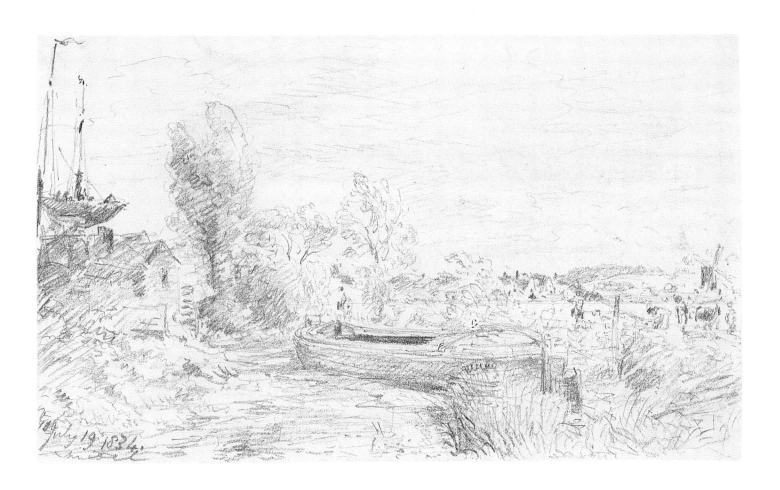

Plate 13

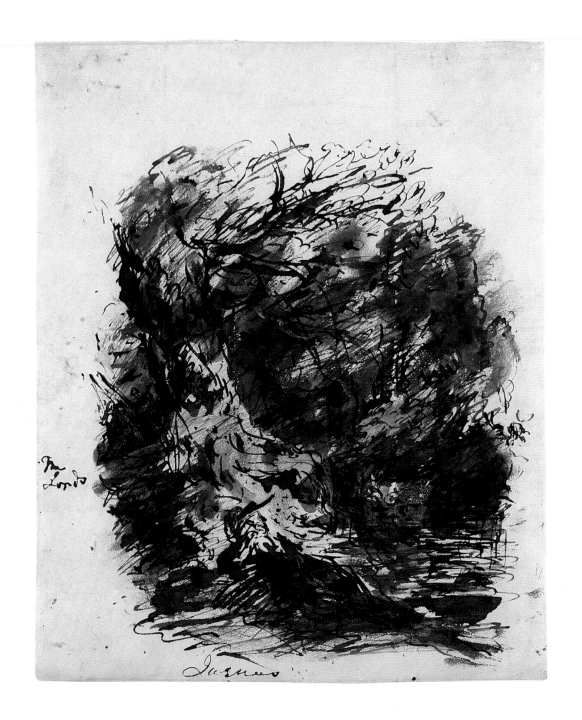

Plate 14

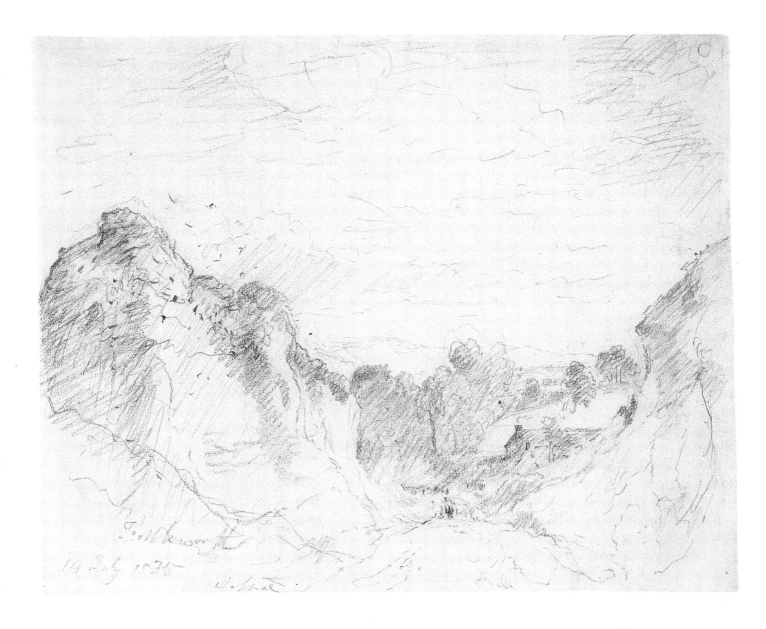

Plate 15

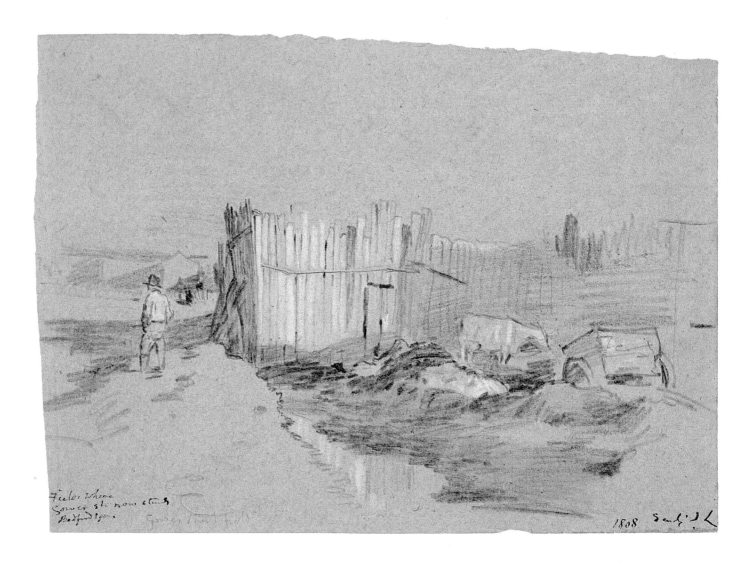

Plate 16

The Catalogue

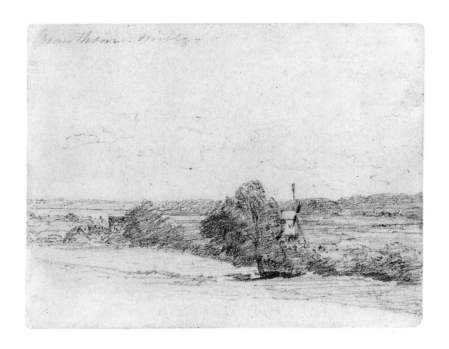

A Farmhouse by a River 1798

Pencil, pen and black ink with green wash on wove paper with a deckled edge 295 x 449mm (11 5/8 x 17 11/16 in); watermark fleur-de-lis in shield, crown above, 'GR' below; inscribed in pencil '1798' t.r. and on the back 'Hadley/1798'

PROVENANCE:...; Private Collection, New York; Colnaghi; acquired 1984

For two years after their first meeting in 1796, J.T. Smith was Constable's only tutor (see Prologue no.I). Figs 36 and 37 are early attempts by the younger man to emulate his friend's style of draughtsmanship. In the autumn of 1798 Smith was a guest at East Bergholt House. During his stay Constable introduced him to his circle of friends, and it was while Smith was being driven around the countryside in the gig that he stopped to make his drawing of a picturesque well-head (Prologue no.II). It seems unlikely that this would have been the only sketch he made during the visit and, in view of Constable's enthusiastic discipleship, equally unlikely that they did not spend some time sketching together, but, so far, Constable's copy of the well-head drawing is our only graphic record of Smith's stay in Suffolk.

No.1, a view probably on the River Brett, that runs down from Hadleigh[1] to join the Stour at Higham, is one of three securely dated drawings of that year, 1798. The second is of a tomb in a local church, Little Wenham, the exterior of which Constable also made a sketch, in pen and watercolour, much in Smith's manner.[2] The third, a pencil and wash drawing inscribed 'Autumn 98', is of a man resting beside a track in a wooded landscape (fig.52). In this work, as in no.1, we see Constable adapting Smith's rather

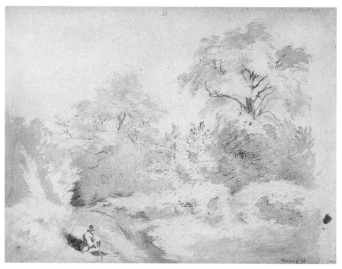

52 John Constable, *A Figure resting beside a Track*, 1798, pencil and grey wash on wove paper 292 x 413mm (11 1/2 x 16 1/2 in). Private Collection

finicky calligraphy to suit his own developing, more open approach to landscape. It seems unlikely that he would have worked thus if his tutor had been present. Both no.1 and this last drawing (likewise two others of the same period[3]) are on unusually large sheets of paper, but no.1 is also unusual both for its delicate grey-green washes and, at this early stage, for its representation of early morning or evening light.

1 This Suffolk Hadleigh is not be confused with Hadleigh and its castle in Essex, which Constable sketched in 1816 and of which he painted one of his six-footers in 1829 (see no.68).
2 See Tate 1976, nos.16 and 17, p.41.
3 See Charles Rhyne, 'Constable Drawings and Watercolours in the Collections of Mr. and Mrs. Paul Mellon and the Yale Center for British Art. Part 1, Authentic Works', *Master Drawings*, Vol.XIX, no.2, Summer 1981, no.2 *A Rural Cot*, Pl.1; and Fleming-Williams, 1990, fig.37, p.45, *Cottage among Trees*.

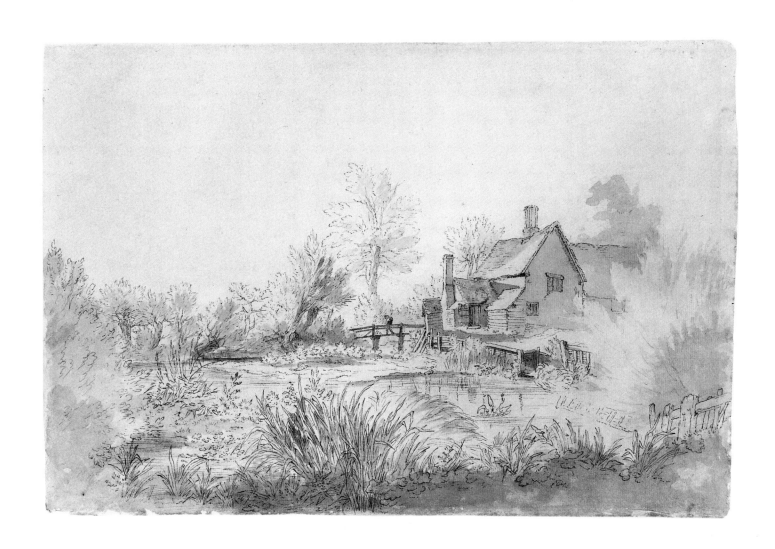

2

An Extensive Wooded Landscape ?1801

Pencil on wove paper 255 x 362mm (10 11/16 x 14 1/6 in); inscribed in pencil on the back 'Drawn by JC'

PROVENANCE:...; Private Collection; Christie's 12 July 1988 (lot 3, repr.)

In the summer of 1801, with a break of some three weeks for a tour of Derbyshire, Constable spent nearly four months in Staffordshire with his sister Martha's in-laws, the Whalleys. The Derbyshire tour, in August, is well recorded by drawings, but apart from the likelihood that no.2 is a Staffordshire view, there is no evidence of his having sketched at all during the weeks he spent with Daniel Whalley, senior, and his family at Great Fenton, then a village just outside Stoke-on-Trent.

No. 2 first came to light when a large group of Constable drawings from a private collection appeared on the market in 1988 (see nos. 4, 13, 14, 17, etc). Topographically, the densely wooded but otherwise featureless scene depicted here is quite unlike Constable's native agricultural landscape with its windmills, church towers and waterways. Clearly, it is of some other part of the country and much the most likely area, judging by the terrain, is one of the low-lying stretches of country to the east of Stoke-on-Trent. There are other unusual features in this drawing. A few of the Derbyshire sketches were drawn with chalk on blue paper, but the rest were in pencil and wash, almost all done in a six by ten inch sketchbook. The *Extensive Landscape* is in pencil only and also larger than any other drawing attributable to 1801. Can this have been the only occasion during his long, twelve-week stay at Great Fenton when he set pencil to paper? It seems improbable, since

there appear to have been plenty of opportunities for sketching. The entries in the diary kept by Daniel Whalley, senior, only briefly record his family's doings[1], but 'Mr J Constable' is often mentioned as a member of one or another of the various excursions undertaken – to 'Mr Spodes Manufactory', for instance, to Trentham's 'Gardens & Pleasure Grounds'or, the diary tells us, on 11 September, '.....Daughters wth Mr J Constable rode to Cellar-head & Watley rock &c'. It was an ideal summer for sketching, too. 'Finish'd our Corn', Whalley noted for 29 August, 'In 17 days the finest Harvest ever known – wthout rain & fine crops.....Gave a supper to all our harvest People – fine day'.

While on his Derbyshire tour, apparently quite by chance, Constable had come upon his mentor, Joseph Farington, R.A., engaged in sketching the entrance to Dove Dale (see entry for nos 3, 4 & 5). Farington's sketching style was dry, pedantic and essentially linear (see Prologue no.V). During these experimental years of self-discovery, Constable was highly susceptible to stylistic influences. It has been noted more than once[2] that many of his freer pencil and wash Derbyshire sketches bear a strong resemblance to those of his other mentor at this time, the well-known amateur and patron of the arts, Sir George Beaumont. It is therefore likely that Constable had Farington in mind when making this panoramic sketch, and found himself best able to describe the scene that lay before him as his friend the Academician would have drawn it, in terms of outline. If this is the case, then no.2 may have been drawn soon after 20 August, when he and his companion Daniel Whalley, junior, returned from their tour.[3]

1 See JC:FDC, pp.67-72.
2 See Reynolds 1973, p.44.
3 H.A.E.Day, illustrates a pencil and wash drawing of a similar panoramic subject to no.2 in his *John Constable R.A. 1776 – 1837 Drawings The Golden Age* , pl.10. Formerly in the collection of Walter C. Baker, neither the present whereabouts nor the dimensions of the drawing are known.

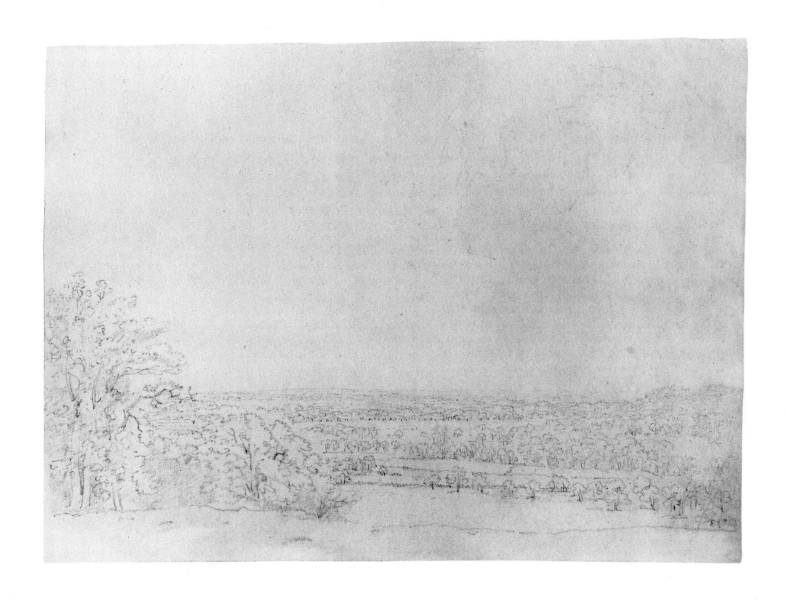

3

The Valley of the Derwent, with Chatsworth in the Distance 1801

Pencil and grey wash on wove paper 215 x 320mm (8 $\frac{1}{2}$ x 12 $\frac{1}{2}$ in); inscribed in pencil t.r. 'Chatsworth/Augst 7/1801' and in pencil on the back 'August 7 1801'

PROVENANCE:...; Christie's 9 April 1991 (lot 110, repr.)

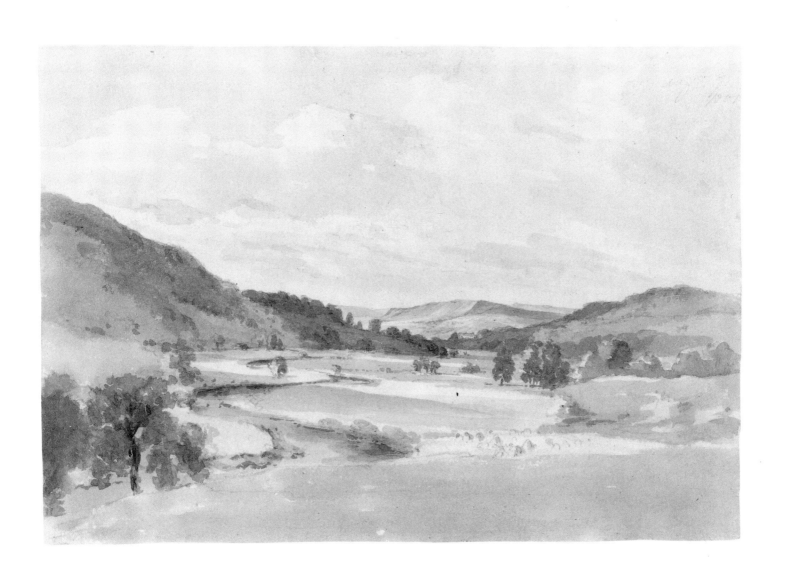

Dove Dale, Derbyshire 1801

Pencil and grey wash on wove paper 171 x 264mm (6$^3/_4$ x 10$^1/_2$ in); inscribed in pencil t.r. '22 Dove Dale/Augst 19'

PROVENANCE:...; Christie's 12 July 1988 (lot 2); Salander O'Reilly Galleries, Inc., New York

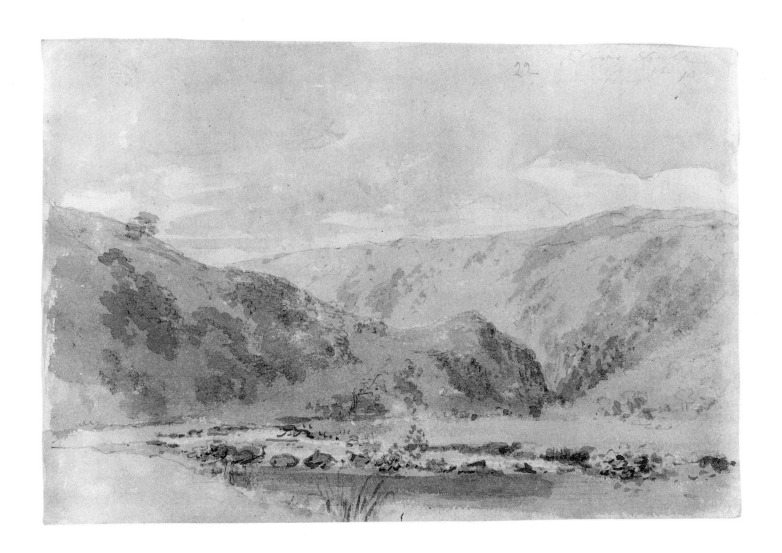

93

5

Dove Dale, Derbyshire 1801

Pencil and grey wash on wove paper 171 x 260mm (6 3/4 x 10 1/4 in); inscribed in pencil t.r. '23 Augst 19' and in ink on the back 'Dove Dale/Aug 19 1801/J. Constable R A'

PROVENANCE:...; acquired by vendor's family c.1930; Sotheby's 16 November 1989 (lot 21)

'Abt 9 this morning', Daniel Whalley, senior, wrote in his diary for 31 July 1801, 'Son Daniel & Mr John Constable, set out on a Tour into the Peake in Derby=shire'. Mr Whalley was writing at his home at Great Fenton, Staffordshire, where Constable had arrived from London on the evening of the 23rd. 'Son Dl & Mr John Constable return'd from their 3 weeks Tour into Derbyshire abt Ten in the Ev'ning', the entry for 20 August records, '- a very fine & excessive hot harvest day.'[1]

It is not yet possible to work out the precise route Constable and young Daniel Whalley took on their tour, but they were in the Matlock area well to the east on 5 August; at Chatsworth on the 6th and 7th; on the 8th at East Moor and in Derwent Dale; at Castleton (their most northerly point) and on the Dove near Buxton on the 12th; back east at Baslow on the 14th; at Chatsworth again and at Haddon Hall on the 17th; on the 18th, nearby at Edensor; and on the penultimate day of the tour, the 19th, in Dovedale. It was here that Constable and Joseph Farington had their chance meeting. This is described by Farington in the entry in his Diary for 19 August: 'At 9 oClock we entered Dovedale [he was touring with friends] – I made a sketch of the first appearance of the entrance, & while I was so employed Mr. Constable came up to me. He having come a 2d time to make Studies here. He was accompanied by a Mr Whaley who lives near Newcastle in Staffordshire.' Farington made three drawings while he and his party were in the Dale. In his entry for that day we have a fair description of one of the scenes Constable drew (fig.53) '....the weather was excessively hot and I suffered much...The Dale is 2 miles long, in some parts very narrow & about the middle there is a beautiful picturesque pass where the River flows, between high rocks that form side screens, and intersecting each other so as to prevent all distant views.'

Nos 4 and 5, both from the six-by-ten inch sketchbook, are numbered '22' and '23'. Most of the other sketches from the book seem to have been similarly incribed. A fairly elaborate wash drawing of Derwent Dale in the Whitworth Art Gallery is dated 8 August and numbered '3', while '28' is of an unidentified view of a river and hills in the Victoria and Albert Museum. If there were twenty-eight drawings originally in the sketchbook, then rather more than half have so far been located. No.3, the Chatsworth view, drawn on a larger sheet of paper, is not so numbered.

In the slighter sketches made on this tour, such as the *Chatsworth Park* in the Victoria and Albert Museum (fig.38), the vigorous initial pencilling provides a summary of the main forms that the wash merely supplements. It is in works such as these that, as Iolo Williams first noted,[2] the influence of Sir George Beaumont is to be most clearly seen. At least twice during the tour Constable spent rather longer on a drawing; on 8 August in Derwent Dale[3] and on the 7th, on our view of the Derwent valley, no.3, both being almost entirely the work of the brush with only some of the details – such as the field-workers among the hay stooks in no.3 – left to the pencil. It is in drawings such as these that we find Constable moving towards a new, more complex tonality.

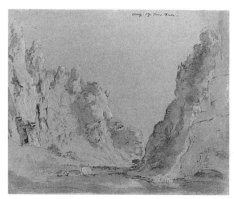

53 John Constable, *Dove Dale*, 1801, black and white chalk and wash on blue paper 288 x 355mm (11 3/8 x 13 3/4 in). Department of Prints and Drawings, The Royal Museum of Fine Arts, Copenhagen

1 JC:FDC, p.71.
2 The *Times*, 1 May 1953.
3 *View of Derwent Dale, Derbyshire*, Whitworth Art Gallery, repr. Tate 1976, no.29, p.48.

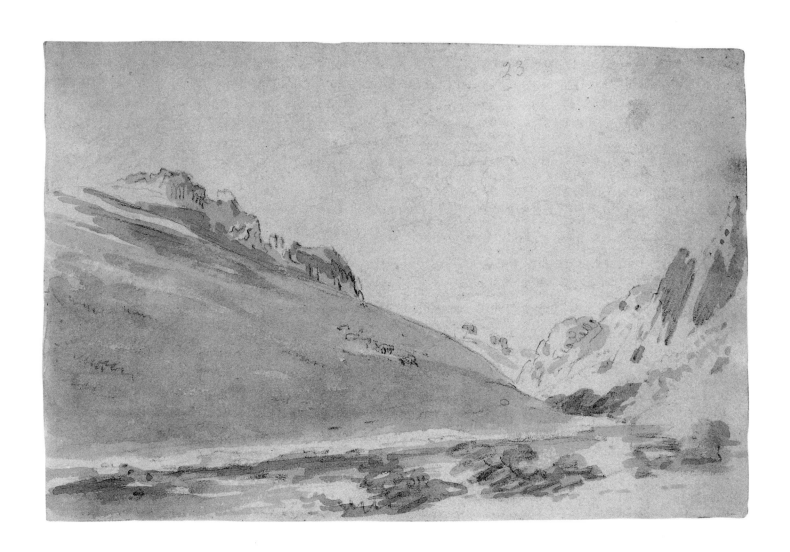

Chalk Church, near Gravesend 1803

Pencil on laid paper, squared for transfer 210 x 253mm (8^1/$_4$ x 10in); watermarked '[...] W' below a hunting-horn in a cartouche[1], inscribed, faintly, 'AP 18' t.l., on the back 'April 18. noon 1803' and, in another hand, 'Nr Gravesend/Chalk Kent'

PROVENANCE:...; R.Dunthorne 1936; H.W.Wolifson; Christie's 26 July 1957 (lot 4); Leger Galleries; P.G.Scarisbrick January 1959; Sotheby's 15 March 1984 (lot 130)

In the late spring of 1803, Constable spent nearly a month on board the *Coutts* , an East Indiaman captained by an old friend of his father's, Robert Torin (1760-1824). A full account of the trip is to be found in a long letter Constable sent to his East Bergholt painting crony, John Dunthorne, on 23 May.[2] 'I was', he wrote, 'much employed in making drawings of ships in all situations ... When the ship was at Gravesend, I took a walk on shore to Rochester and Chatham ... At Chatham I hired a boat to see the men of war, which are there in great numbers. I sketched the "Victory" in three views. She was the flower of the flock[3], a three decker of (some say) 112 guns. She looked very beautifull, fresh out of Dock and newly painted. When I saw her they were bending the sails – which circumstance, added to a very fine evening, made a charming effect. On my return to Rochester, I made a drawing of the Cathedral, which is in some parts very picturesque, and is of Saxon Architecture.'

With Constable on board, the *Coutts* sailed from Gravesend for China between the 28th and 30th of April. They were delayed by a storm for three days when they reached the Downs. Here Constable witnessed 'some very grand effects of stormy clouds'. When he left the ship at Deal on 6 May it was in such a state of confusion that he forgot his precious parcel of drawings. 'When I found, on landing, that I had left them, and saw the ship out of reach, I was ready to faint.' From Leslie we learn that the drawings, some 130 or so, were subsequently recovered.

Chalk village is about a mile on the Rochester road from Gravesend, where Constable had joined the *Coutts* , and he may have made his sketch of the church while on his way to Rochester. But he also sketched Tilbury Fort and Gravesend church[4], so it is probable that he made more than one excursion ashore. If no.6 was drawn at noon, as inscribed, there would hardly have been

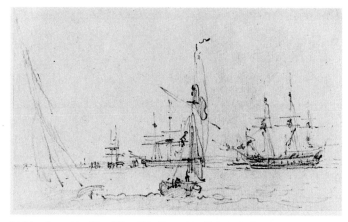

54 John Constable, *Three Ships off the Coast with a Yacht in the Foreground*, 1803, pencil on laid paper 125 x 200mm (4^7/$_8$ x 7^7/$_8$ in). Private Collection

enough of the day left for an eight mile walk to the Medway and for all the drawings he made from his hired boat as well as his sketch of Rochester Cathedral. None of the Medway sketches is dated, but it seems unlikely that both they and *Chalk Church* were drawn on 18 April.

Quite a number of Constable's drawings of the Thames shipping and of the fleet at Chatham have been listed. Overall, there is a marked stylistic consistency. Some have been given a few tonal washes, but the majority are in pencil only (see fig.54) and the handling, with the strokes of the pencil so frequently beginning and ending with an affirmative pressure, is characteristic of the work he did on this trip. A certain similarity between these marine studies and those of the van de Veldes – primarily in the subject-matter – has frequently been remarked upon. However, possibly rather more to the point is their likeness to some of Richard Wilson's less studied drawings. This is noticeable if we compare the pencil-movements in *Chalk Church* with those in a drawing such as Wilson's *Arch of Augustus at Rimini* (Prologue no.V1). In both we have the varying pressures – firm at either end of the stroke – and even the wriggling along the line to denote the worn edges of the masonry. Farington, it may be remembered, had been Wilson's pupil and remained all his life an ardent disciple . Only a week or so before the *Coutts* trip he had lent Constable Wilson's *Maecenas's Villa*, presumably for him to copy. As he had

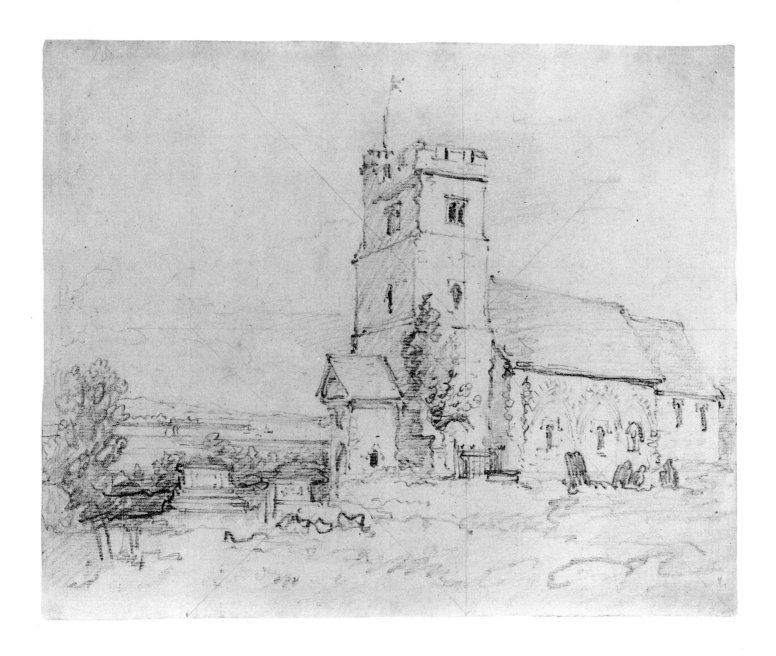

6 been on several sketching tours with Wilson in his youth, it seems likely that he would also have been able to show Constable some of his revered master's chalk drawings and that it was the calligraphy Constable had seen in these that he had been emulating at Chalk and when he was afloat.[5] From his drawing of the little church, with the Thames in the distance, Constable made a careful pen and wash study which he signed and dated 1803. This is only known from an old photograph (fig.55).

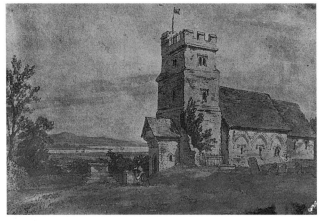

55 John Constable, *Chalk Church*, ?1803, reed pen and wash on wove paper, whereabouts not known

1 *A Ship under Sail* in the V.& A. (Reynolds 1973 no.41, pl.24) appears to have been drawn on paper similarly marked, i.e. 'H & W' below a horn in a cartouche.

2 JCC II, pp.33-5.

3 This quaint expression is also noted by Robert Gittings in his *The Young Thomas Hardy*, p.119.

4 Christie's 20 July 1957 (lot 3).

5 In this context, Sir Brinsley Ford has recently brought to my notice the following entry in Farington's *Diary* for 17 July 1817: 'Lady Mary Lowther called soon after 3 oClock & staid more than an Hour. I shewed Her my two Volumes of sketches by Wilson, & some of my own sketches in Chalk, & She made a selection including the two Vols, by Wilson, to take to Lowther. – I also shewed Her black & white chalk in *wood pencils*, & gave Her some as specimens.'

7

Washbrook 1803

Black chalk on wove paper 333 x 243mm (13$^1/_8$ x 19$^9/_{16}$ in); watermark '17[?9]4/WHATMAN'; pin-holes in all four corners, paper at some time folded across middle; inscribed on the back ' 5 Octr. 1803/noon. Wash brook' b. l.; inscribed on an original backing 'This very beautiful study/was given by Constable to his friend Mr Dunthorne/of Bergholt 1815'

PROVENANCE: Given by the artist to John Dunthorne senior;....; Dr. Denis J. Drake; Mrs Gordon Drake; given by her to Mrs A.F. Bodkin 1963 or 4; Christie's 12 July 1988 (lot 170, repr.)

Still in search of his own artistic identity and ready to imitate and adapt the work of others, it was through his friendship with George Frost that Constable became familiar with Gainsborough's drawings and with Frost's own interpretation of landscape in the manner of Gainsborough.

Black and white chalk on coloured paper was a standard medium used in the life-classes at the Royal Academy Schools at this time, and a number of Constable's figure studies made when a student are in this medium[1]. Some of the Derbyshire drawings were drawn in chalk, but it was not until the following year, 1802, when Constable presumably became acquainted with Frost, that he is found making a drawing in his Ipswich friend's Gainsborough manner,that is, with much stronger darks and with the chalk blurred in places with a stump (fig. 56).

Washbrook is one of two sketches Constable made on 5 October 1803. The other, a dated watercolour of the quays, warehouses and shipping at Ipswich, was done when he and Frost were sketching together, almost side by side.[2] Washbrook is on the road from East Bergholt to Ipswich, and he would almost certainly have taken that route when on his way to join Frost.

In some of the other chalk drawings of 1805 Constable has used the stump to soften the gritty texture of the chalk and to blur the forms. But in no.7, he appears to have confined its use to the distant trees and fields, to lighten the tones and achieve depth and an effect of aerial perspective.

1 See Reynolds 1973, nos. 17 – 20, pls 8 and 9.

2 See Tate 1976, nos. 38 and39, p.53.

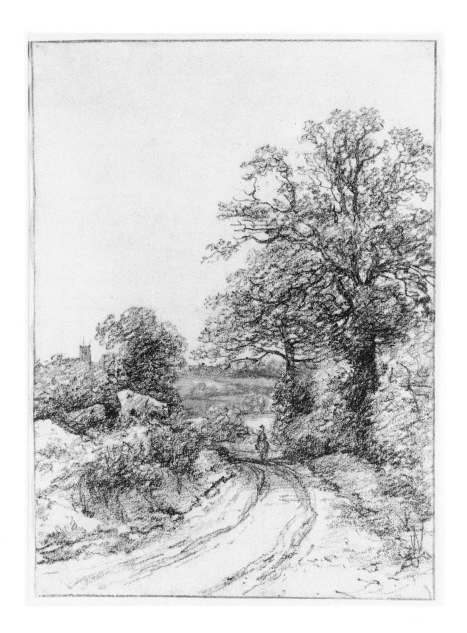

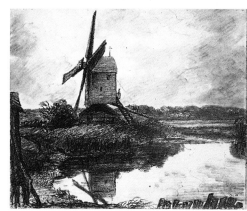

56 John Constable, *The Windmill at Brantham*, 1802, black chalk, ?charcoal and red chalk on wove paper 240 x 298mm (9 ¹/₂ x 11 ³/₄ in). Board of Trustees of the Victoria and Albert Museum, London

Dedham from the South-East 1803

Pencil on wove paper 237 x 328mm (9 3/8 x 12 7/8 in); the centre lightly squared; inscribed on the back in pencil '1803' and in another hand, 'Lecture House Dedham Essex'

PROVENANCE:...; Leggatt Brothers 1899;...; Christie's 1959; H.A.E. Day; Christie's 14 November 1989 (lot 118, repr.)

When this drawing was lifted off its backing for conservation, the date on the back came as a surprise. Stylistically, such delicate and sensitive pencilling was more readily associated with the beautiful little drawings in the 1813 sketchbook[1].

No. 8 is clearly a purposeful study – not just a sketch made in passing – a study on which Constable has spent much time and a great deal of care. It is therefore to be expected that the rhythms of notation should change and that here there should be evidence of a tempo slower than in a sketch such as *Washbrook*. In that drawing an effect of depth was achieved by blurring the distant trees and lightening them tonally. Here, in this remarkable drawing of Dedham, we have spatial recession organised in a more subtle and complex fashion.

It is perhaps significant that the strongest of the squaring-up lines in the centre is an horizontal, to be seen on a level with the eaves of the lower of the two houses. Throughout his working life it was Constable's practice, from time to time, when drawing from nature, to rule such lines across his paper, lines sometimes, as in the present case, unrelated to the level of the eye or the horizon. We cannot be certain about his reasons for making these lines, but when the judging of angles is acute, as it is here in the foreground, a basic horizontal, imagined or ruled, can be a useful aid. Having established a spatial linear framework with the daringly fore-shortened road and the receding fence sliding away down into the middle distance, Constable fills the scene with a gentle light and creates a secondary, an aerial perspective.

Centrally, just to the right of the tower of St Mary's, we see what was known as the Lecture house[2]. This was identified by the late Col. Attfield Brooks who lived in the present Lecture House, a nineteenth-century replacement built near the site of the old one. Col. Brooks also identified the house below in the valley as Brook

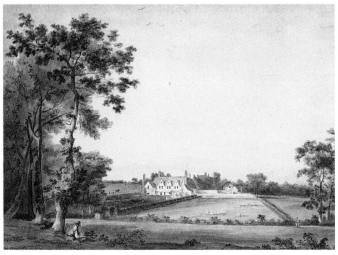

57 John Constable, *The Old Lecture House, Dedham*, 1800, pen and brown ink and watercolour with white heightening on wove paper 328 x 458mm (12 15/16 x 18 1/16 in). Private Collection

Farm House and the nearer building as the coach-house of the Grove.

This was the second time Constable had made a careful, finished study of the Lecture House. The first was in 1800, when he presented a watercolour[3] of the house (fig.57) to Maria Sophia, daughter of the Revd Samuel Newman, Vicar and Lecturer, who had died in 1780. He was succeeded by the Revd Dr Thomas Lechmere Grimwood (1740-1809), Headmaster of Dedham Grammar School, where Constable completed his schooling. C.R.Leslie, the artist's friend and biographer, re-telling what Constable must have told him, describes Grimwood as a sympathetic and indulgent master. Constable, Leslie says, 'was at this time sixteen or seventeen and had become devotedly fond of painting. The readiness with which the eye and mind, by nature formed for such a pursuit, are attracted to every surrounding object, may render it more than usually difficult to fix the attention on studies not immediately connected with the favourite art. During his

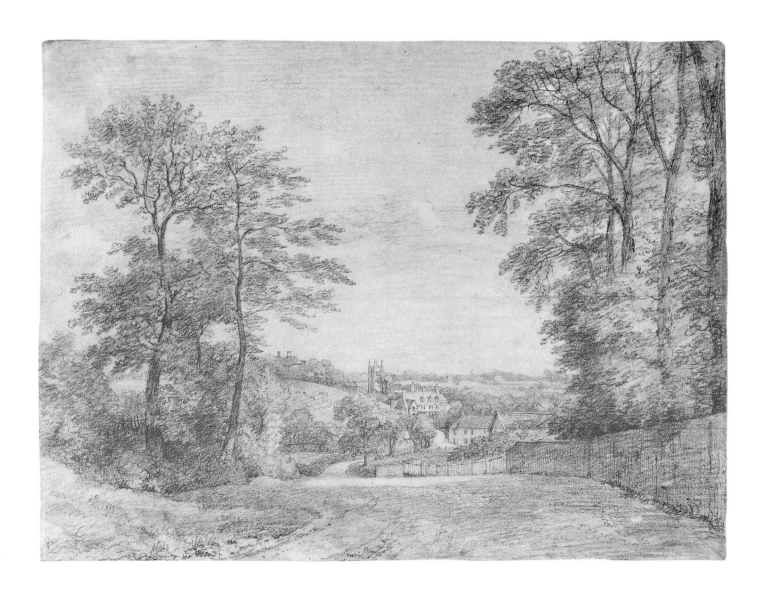

101

A Lane near East Bergholt c.1803

Pencil on wove paper 229 x 190mm (9 x 7 $\frac{1}{2}$ in), all four sides of which have been trimmed up to enclosing, ruled pencil lines; two pin-holes are in each of the top corners; part of what appears to be a thumb-print is visible just above the middle of the left-hand side

PROVENANCE:...; Christie's 12 November 1991 (lot 83, repr.)

From the little-used road between East Bergholt and Flatford, with its views across the valley of the Stour towards Dedham and Langham, Constable found subjects for many of his paintings. About halfway along, there is a bend in the road, just where it starts to descend into the little Ryber Vale. Here, in the period of his historic breakthrough (1809–12) he made several oil-sketches[1] and to this spot he again returned with his little sketch-book in 1813[2].

No.9 appears to be of this same bend, but this time from below, from the Flatford side. It is undated, but although his use of a kind of graphite dusting is new, parts of the pencilling, especially the rendering of the branches and twigs in the nearest tree, are very close to the handling to be seen in the study of the Lecture House, no.8. So, until we know more of the relatively sparse output of these first years of the new century, c.1803 may be regarded as an acceptable working date.

8 French lessons a long pause would frequently occur, which his master would be the first to break, saying, "Go on, I am not asleep: Oh! now I see you are in your painting room'".[4] Grimwood retired from schoolmastering in 1798 and was succeeded to the Lectureship by his nephew the Revd T.G. Taylor. No.8, the second drawing of the Lecture House, must surely relate to Dr Grimwood's retirement as Lecturer. The squaring-up suggests that Constable was contemplating a painting of the house, possibly to be a present to his old headmaster, but no such painting has been recorded. Sometime between 1800 and 1806 he did, however, paint a portrait of Grimwood, a life-size, half-length oil, now the property of Colchester Borough Council[4]. Perhaps this was painted in lieu of a planned house portrait.

1 Reynolds 1973, no.121.

2 The Lecturer was a preacher usually chosen by the parish, whose duties consisted chiefly in delivering afternoon or evening 'lectures'.

3 See, Tate 1991, no.233, p.390. A label on the back of this drawing reads: 'This picture of DEDHAM, ESSEX, was painted by John Constable as a present to my Great Grandmother, Maria Sophia Newman, daughter of the Rev. Samuel Newman, Rector of Dedham, on her marriage, on 6th March 1800, to my Great Grandfather, Lieut.-Col. Harcourt Master, 52nd Regiment. John Constable was the son of the Miller of Dedham... (Signed) Edward T.Master, Melrose, Weybridge."

4 C.R.Leslie, *Memoirs of the Life of John Constable Esq. R.A.*, 1843, p.2. Some of this passage was re-written by Leslie for the second edition of 1845.

5 Hoozee 1979, no.51, p.92.

1 See Tate 1991, nos 40-44, pp.109-12. The earliest, of c.1809, includes the Stour valley and Langham hills to the west; in the others we are looking eastwards towards Flatford. No.41 is dated 17 May 1811 (V&A.); no. 43, 9 July 1812 (Museo Lazaro Galdiano, Madrid).

2 Dated 16 July, this is on p.32 of the sketchbook (Reynolds 1973, no.121, pl.82).

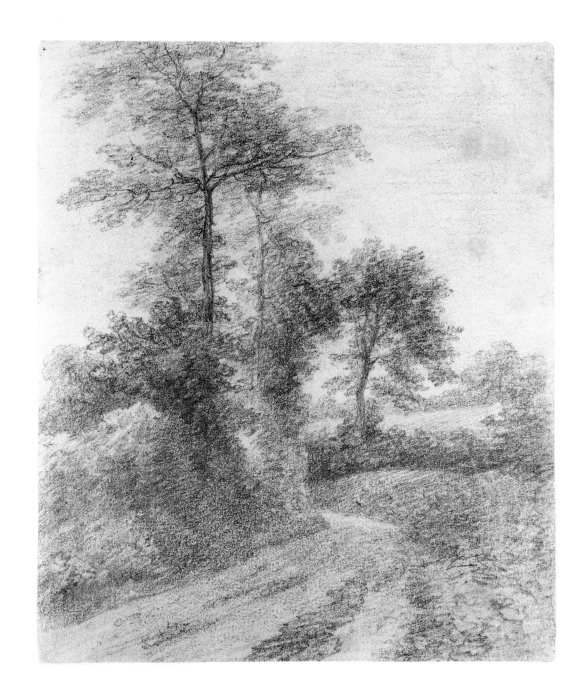

Markfield 1806

Pencil on laid paper 92 x 146mm ($3\,^5/_8$ x $5\,^3/_4$ in), trimmed l.; inscribed in ink 'Markfield' b.l., 'Mr Constable' b.r.

PROVENANCE: Mrs Batty (from whose album of her travels this was removed);...; Christie's 9 November 1993 (lot 42, repr.)

In terms of numbers of drawings produced, 1806 was the most prolific year of Constable's working life. Well over 150 are recorded, of which nearly fifty are dated. A considerable number are of young women. In June he sketched some of the Cobbold daughters[1] in Ipswich; in June and July the daughters of William Hobson of Markfield, Tottenham; and in August , before setting out on a tour of the Lake District (see nos 11 and 12), his Gubbins cousins and their friends[2].

William Hobson, originally of Quaker stock, was a prosperous building contractor who had built Markfield for himself, but had only recently moved there. Both being inclined towards a more liberal way of life, Hobson and his wife had severally been disowned by the Quakers, he for 'encouraging diversions' – he rode to hounds, had a box at the opera, and played billiards – she for encouraging their children to learn music. Of these, there were sixteen, three boys and thirteen girls, five of whom, when Constable stayed at Markfield, were between the ages of fourteen and twenty.[3]

It is not known for certain why Constable was staying at Markfield, but he was probably given an introduction to the Hobsons by the author and philanthropist Priscilla Wakefield, a resident of Tottenham and herself a Quaker, whom he had first met at the Cobbolds in 1799. She had then described him in her diary as 'a pleasing modest young man – who had a remarkable genius for painting'.[4] In April of that year he had called on her at Tottenham. 'Mr Constable', she wrote in her diary, 'paid me an unexpected visit to dinner & tea – Painting the fine arts literature & their effects upon society were the subjects that beguiled the time & displayed the abilities of this diffident & virtuous young man so superior & contrary to the man of fashion the world admires.' There are many gaps in the diary, but in our context it is significant that Mrs Hobson is mentioned several times; in May, for instance '....spent an hour with Mrs Hobson – domestic happiness seems to flourish in her family.'

It is also not known why Constable spent at least two weeks at Markfield. It may signify a 'nuptual flight' directed at one of the thirteen young daughters, as has been suggested[5], but the year before he had completed his most ambitious work to date, a six-foot group of the Bridges family, the parents with their eight children[6], and it would seem more likely to have been the prospect of another such commission that brought him to Markfield. Mrs Wakefield had already helped him with an introduction to an Academician, Joseph Farington[7]. Perhaps she thought she might further his cause by introducing him to her friends the Hobsons.

Constable made many drawings of the Hobson family. Mostly, they are to be found in two sketchbooks (now in the Louvre) that he used while at Markfield[8]. The majority are sketches, slight in character, of the daughters, singly and in small groups. Many of the drawings are inscribed with their names. Of one, Laura, he later painted a portrait[9].

No.10 came from an album, the contents of which recorded a journey from Scotland to France and Switzerland via London, a journey taken by a Mrs Batty who presumably was a fellow guest of Constable's at Markfield and must have asked him as a favour for a souvenir of her stay. Though a miniature, this was not the first of his portraits of country houses, nor by any means was it to be his last.[10]

1 Daughters of John and Elizabeth Cobbold, of the Cliff Brewery, Ipswich. She was a close friend of the Constable family and took a great interest in the early stages of the young artist's career. It was when he was staying with the Cobbolds in 1799 that he enthused in a letter to J.T.Smith: 'Tis a most delightfull country for a landscape painter, I fancy I see Gainsborough in every hedgerow and hollow tree.'

2 Who lived with their parents at Epsom.

3 See Graham Reynolds, *Constable with his Friends in 1806*, 1981, introductory volume to four facsimile sketchbooks, for a fully researched account of the Hobson family and Constable's stay at Markfield.

4 From the Priscilla Wakefield unpublished papers. Private Collection.

5 See above, n.3.

6 See Leslie Parris, 1981, no.l., pp.26-9.

7 See Farington, 25 February 1799.

8 Musée du Louvre, R.F.1870, 08701 and R.F.1870, 08700.

9 A profile on a $13\,^3/_4$ x $9\,^3/_4$ inch canvas, Christie's 12 July 1991 (lot 34, repr.col.).

10 He had already painted Lamarsh House, Old Hall, East Bergholt; and, in watercolour, Gifford's Hall. See Tate, 1976, nos 20, 25 and 27, pp. 43, 45 and 47.

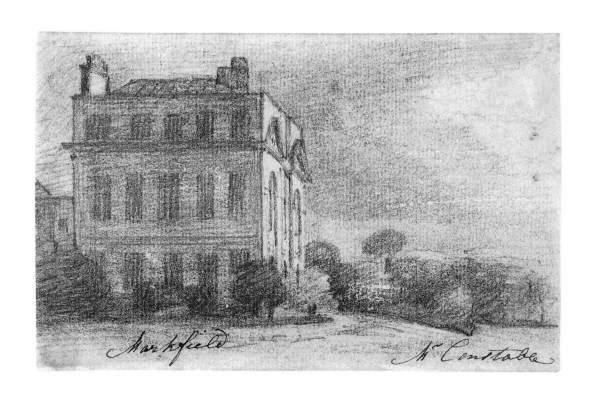

Markfield Mr Constable

11

The River Brathay and the Village of Skelwith Bridge 1806

Pencil on wove paper 246 x 373mm (9 $^{11}/_{16}$ x 14 $^{11}/_{16}$ in); squared for transfer (?); watermark 'E & P/1804' (i.e., Edmeads & Pine); inscribed in pencil '7 Septr. 1806', b.l.

PROVENANCE: By descent to Charles Golding Constable;...; Christie's 11 March 1960 (lot 15); Spink & Son Ltd.;...; the Clonterbrook Trust;...; John Richards; Christie's 20 March 1984 (lot 88, repr.)

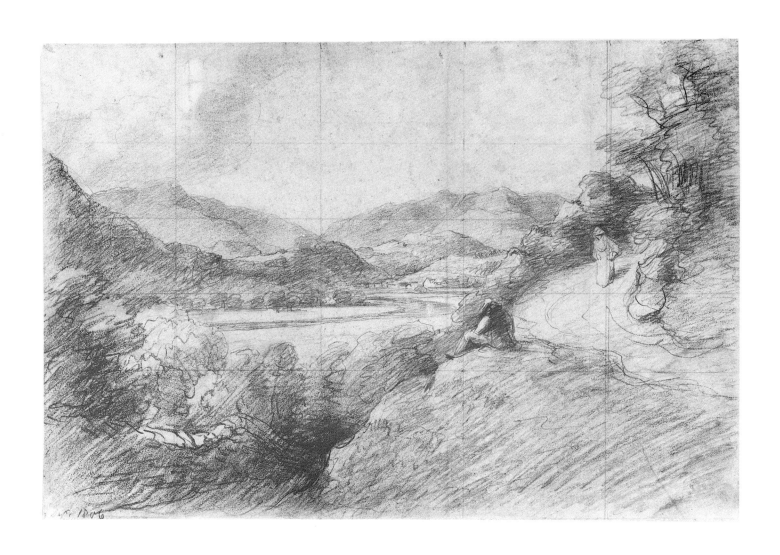

Glaramara from Borrowdale 1806

Pencil on untrimmed wove paper 409 x 343mm (16 1/8 x 13 1/8 in); squared for transfer (?); a small triangular area of fixative missing on the tree to the left; inscribed faintly on the back in pencil, 'Will you Sup with me at 9 o clock/to [?night].../.../Wed Morn^g'

PROVENANCE:...; Sir John and Lady Witt; Sotheby's 19 February 1987 (lot 110, repr.)

Constable drew and painted in many parts of the country, but almost always because family, friends or business had taken him there. Unlike so many of his contemporaries, only twice did he embark on a tour for the opportunities it might afford to sketch: in 1801 to Derbyshire and in 1806 to Westmoreland and Cumberland, this last mainly because a well-to-do uncle, D.P.Watts, recommended it and paid his expenses. The tour lasted seven weeks, from 1 September to 19 October. The precise number of sketches he made in that time is not yet known, as hitherto unrecorded drawings continue to come to light, but so far about ninety have been listed. The first two weeks were spent with friends, at Storrs on the east side of Lake Windermere and with the Hardens at Brathay, at the head of the lake. Constable then set out northwards with a companion, George Gardner. They ended up in Borrowdale, a little-visited valley, where, after some days, Gardner 'got tired of looking on' and returned to Brathay, leaving Constable 'drawing away at no allowance'[1].

In the summer of 1805, inspired apparently by the first major exhibition of watercolours in London, Constable seems to have worked almost exclusively in that medium. Although he made half a dozen pencil studies such as nos 11 & 12 and a few pencil and wash drawings, most of his ninety sketches of the lakeland scenery were also in watercolour. Unfortunately, some of the colours he used were fugitive and only three or four have not seriously faded.

The view of the Brathay from the road to Langdale (no.11) is now obscured by trees, although the wall on the left is still visible, running down beside a track. The spot from which Constable drew the valley is about a mile from Brathay Hall, where Jessie Harden, his hostess, wrote of him in her journal the following day, 8 September, 'He is the keenest at the employment [i.e. sketching] I ever saw & makes a very good hand of it...He is a genteel handsome youth.'[2] Youth? they were the same age – 30 years.

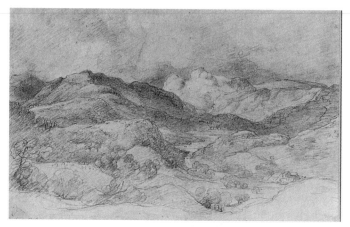

58 John Constable, *Langdale Pykes from above Skelwith Fold*, 1806, pencil on wove paper 239 x 380mm (9 7/16 x 14 15/16 in). Wordsworth Trust, Dove Cottage, Grasmere

A few days before making this drawing he had walked up on to the hillside near the entrance to the Brathay valley and on paper of a similar size to no.11 had drawn a splendid panoramic view, with Langdale Pykes in the distance (fig.58). This, probably his first response to the mountain scenery, is outlined with powerful, flowing strokes of the pencil and modelled with rapid zig-zag shading and the fine 'dusting' of graphite to be seen in the sketch of the bend in the road of 1803 (no.9). In no.11, of another bend in a road, this time with two figures, the pencil has moved over the paper with a veritable surge of strength, rhythmically shaping the larger forms and hardly pausing over details. One feels that his pulse had quickened in this landscape of vast geological upheavals and that he was discovering deep within himself forces of which, hitherto, he had been almost totally unaware, forces that would gather momentum and eventually carry him on towards the great six-foot canvases of his mature years.

Constable spent nearly three weeks towards the end of his tour in Borrowdale, a deep valley with massive hills on every side, rising up from an alluvial floor. Here he made some of the finest drawings of the tour. Mostly he worked in watercolour, but the largest three were in pencil: a view up the valley from near Peathow[3]; another, of Folly Bridge and the surrounding hills[4]; and no.12 with its so far unidentified yet typical hump-backed bridge.

In some of his watercolours and chalk drawings of the previous year, by simplifying his trees and bushes into sculptural, rounded

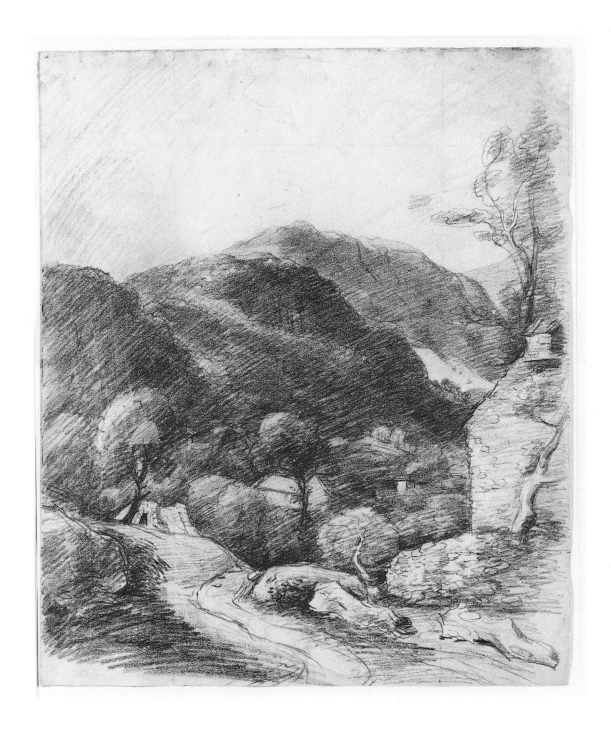

Twyford, Bridge House (?) 1809

Black chalk on laid paper 91 x 151mm ($3\,^{7}/_{16}$ x $5\,^{15}/_{16}$ in); inscribed in pencil 'Twyford June 25. 1809' b.l., partially cut

PROVENANCE:...; Sir J.C. Robinson; Christie's 21 April 1902 (lot 83, with another view of the house); Reynolds;...; Christie's 12 July 1988 (lot 9, repr.)

The technique of shading Constable employed in the two 1806 drawings (nos.11 & 12) was almost certainly derived from early Gainsborough pencil studies such as the tree study (Prologue no.X11), perhaps from examples in George Frost's own collection. In the very few drawings by Constable known to be of 1808 he is to be seen occasionally *making shapes* with areas of shading, not, as had been standard contemporary practice, shading within or around previously established outlines. This technique he developed still further, until, as in the Twyford sketch, outlining is minimalised, and he begins to draw and see tonally. The importance of this new way of 'seeing' landscape can hardly be overstressed, for it was in this year, 1809, that he began to paint in oils with finely judged areas of tone, as in the historic oil-sketch of Epsom in the Tate[1], and thus to make his great breakthrough towards an entirely new naturalism. Having begun to see landscape thus, he of course could find a closer approximation to his new vision of landscape in colour rather than in black and white. For the next year or two, therefore, sketching in oils takes precedence and fewer advances are made in chalk or with the graphite pencil.

There are seven Twyfords in the gazetteers and there is no known reason why Constable should have visited any of them. At Twyford in Berkshire, however, there is a house of a rather later date, Bridge House, beside an unusually long, straight mill-stream – as in no.13 – and formerly there stood a mill nearby, presumably the building to the right of the house in our drawing[2]. Though it is not known what could have brought Constable to the area, these conjunctions make it seem likely that it was the Berkshire Twyford he visited in 1809[3].

1 Tate 1991, no.67, pl. 146.
2 This may be seen more clearly as a mill in a drawing in the Courtauld Institute, repr. Day 1976, pl.27.
3 In the same Christie's sale in which no.13 first appeared, there were two more views of Bridge House (repr. Tate 1991, no.240, p.405 and Christie's catalogue for the sale of 12 July, lot 10, p.21).

12 forms, Constable found a means of expressing them three-dimensionally as volumes in space. This schema may have derived from talks with a new friend, William Crotch (see Prologue no.X111), Professor of Music at Oxford, who moved to London before gaving a series of lectures in January 1805 at the Royal Institution. In *Glaramara* (no.12) the rounded tree forms, such a feature of this drawing, represent an extension of this phase of Constable's experimentation[5]. Crotch owned a group of fifty drawings that his old Oxford friend, Malchair had made during a tour of Wales in 1795. *Moel-y-ffrydd* (Prologue no.X1V) is one of the better-known drawings from this group. Larger than any Constable made during his tour of the Lakes, it is a work of extraordinary power and, with the other Welsh drawings, may have prepared Constable in some way for the exhilarating experience of mountain scenery, for the awesome scale of great land masses. Though drawn with explosive force, a remarkable degree of control has been exercised in the making of Constable's *Glaramara*; control of pencil pressure – to convey a sense of depth – and of the wide-ranging movements of the pencil over the paper, from flowing, expressive rhythms to most delicate touches such as the three hardly noticeable marks to represent scrubby trees on the slope of the most distant hill.

1 Daphne Foskett, *John Harden of Brathay Hall.* 1974, p.29.
2 Ibid.
3 See Tate 1976, no.76, p.66.
4 See Tate 1991, no. 238, p. 403.
5 For a full discussion of Constable and William Crotch, see Fleming-Williams, 1990, pp. 56-60.

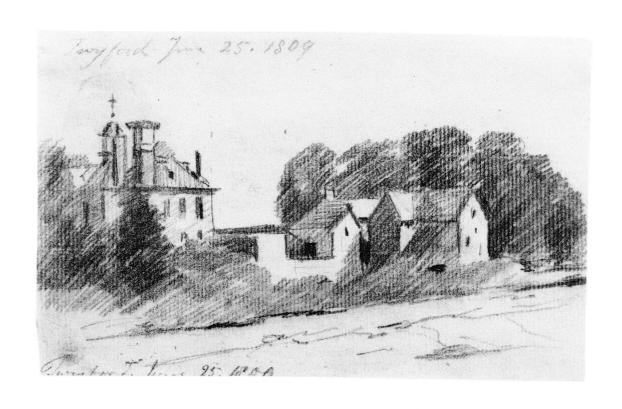

Malvern Hall, Warwickshire 1809

Black chalk on laid paper 96 x 154mm ($3^3/_4$ x $6^1/_{16}$in), trimmed; inscribed on the back in pencil '2/August the first made the/picture of the House from the/great pool'

PROVENANCE:...; Sir J.C. Robinson; Christie's 21 April 1902 (lot 83, with another view of Malvern Hall); Reynolds;...; Christie's 12 July 1988 (lot 13, repr.)

An inscription on the back of another chalk sketch of Malvern Hall establishes the date of Constable's departure from London for Warwickshire, 'Left Town for Malvern Saturday July 15 1809'[1]. A sketch of Warwick from Hatton Hill dated 7 August was probably done on his way home[2]. The purpose of his visit was to paint a portrait of Mary Freer, the ward of Henry Greswolde Lewis (1754-1829), the owner of Malvern Hall, whom Constable had met through the Dysarts of Helmingham Hall, Suffolk, Lewis being the brother of the Countess of Dysart. During his stay at Malvern Hall Constable painted three views of the house and grounds, the Tate painting (fig. 59) being the most familiar. If the inscription on the back of no.14 refers to this picture, which seems most probable, then the painting was the work of one day; 'a remarkable feat', as Leslie Parris has remarked[3].

Besides the portrait of Mary Freer, aged thirteen, and the other three paintings, about twenty drawings Constable made during his stay in Warwickshire have so far come to light, the majority only in 1988. Four are of the Hall: this drawing, no.14, a view from the south-west; a sketch of the west side seen above a narrow iron gate[4]; another of the entrance front with Solihull church beyond[5]; and lastly, the house from the north-east, with a figure of a woman on the path that ran along the south side, facing the deer park[6].

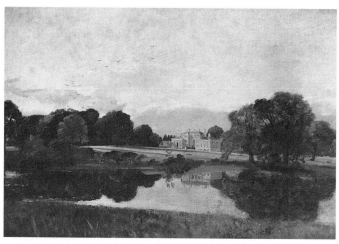

59 John Constable, *Malvern Hall*, 1809, oil on canvas 515 x 769mm ($20^1/_4$ x $30^1/_4$ in). Tate Gallery, London

There is also a figure, it will be noticed, in the present drawing (no.14), seemingly a man in a black hat, touched in carefully but firmly. Perhaps this represents his host, whose portrait Constable later painted and from whom over the next twenty years (as well as from his sister the Countess) the artist received a number of commissions, including further pictures of the Hall, a painting of a Norman ancestor in full armour, a design for an inn sign, *The Mermaid,* and, most bizarre of all, a painting on ivory of Mary Freer's eye, for a shirt-pin.

1 See Tate 1976, no.89, p.72.
2 Sotheby's 16 July 1987 (lot 38, repr.).
3 Tate 1991, p.149.
4 Christie's 12 July 1988 (lot 14, repr.).
5 See above, n.1.
6 Sotheby's 16 July 1987 (lot 80, repr.).

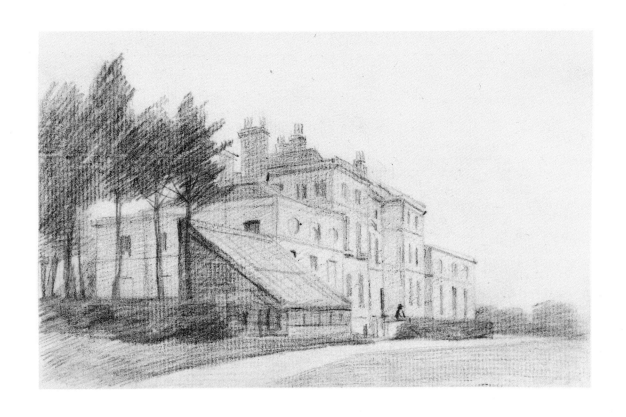

15

The Doric Barn, Malvern Hall, and Sandals Bridge 1809

Pencil on laid paper 92 x 154mm ($3\,^5/_8$ x $6\,^1/_{16}$ in)

PROVENANCE:...; Sotheby's 19 November 1987 (lot 24, *Study of a Cottage by a Bridge*, repr.)

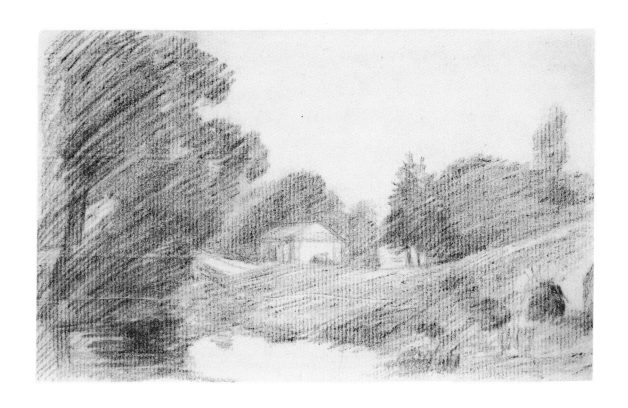

A Tabby asleep 1809

Black chalk on laid paper 90 x 150mm ($3\,^5/_8$ x $5\,^7/_8$ in); VERSO: *A Country House among Trees*

PROVENANCE:...; Sotheby's 19 November 1987 (lot 26)

No.15 was drawn from a viewpoint beside the River Blythe. Beyond is a gatehouse to the grounds of Malvern Hall known as the 'Barn à la Paestum', after the primitive Doric Order it features. This, and much else at Malvern Hall, was designed by Sir John Soane. Soane had worked for H.G. Lewis in the 1780's, when wings were added to the Hall and the rest modernised, all to his designs. Much of these improvements Lewis subsequently regretted. In a long letter to Constable of 18 April 1819, Lewis said he would value the artist's opinion 'in forming the Landscape of the park by cutting glades & shearing timber & tree so as to give a forest scenery. I have brought the house', he continued, 'to nearly what it was 60 years ago – before that *Modern Goth*, Mr. Soane, spoilt a handsome house by shaving clean every ornament, architraves, coins, keystones, string courses, & ballustrade, the latter I could not replace, all the rest I have accomplished"[1].

Constable is now drawing almost entirely with so-called shading; roughing out and describing the tree masses with the rapid zig-zagging of the point of his pencil over the surface of the paper, pressing harder for the darker areas and resorting to outline only for the delineation of the Barn. But it will be noticed that the vertical wire-lines of the laid paper produce a somewhat distracting grain, obviating any chances of obtaining tonal subtlety. See nos 29–31.

Constable was very fond of animals. In his letters from his family home in East Bergholt he often mentions his walks with the dogs. His favourite was Yorick, the pug. 'I took a walk this morning', he told Maria Bicknell, his future wife, in 1812, 'attended with three

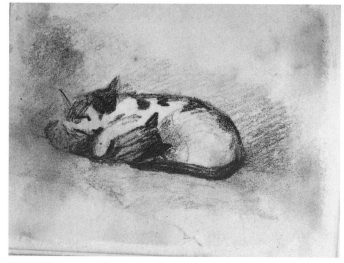

60 John Constable, *Sleeping Cat and Kitten*, 1819, pencil on wove paper 67 x 93mm ($2\,^5/_8$ x $3\,^5/_8$ in), p.48 in an intact sketchbook. British Museum, London

little mates – As to Yorick His behaviour is quite ridiculous – he seemd to promise himself so much pleasure'[2]. His letters to his wife from their Charlotte Street home when she was in Brighton in 1824-5 are full of news about their pets; especially the cats, one which had her kittens among his paintings stored away in the back yard, under his studio. Nothing is known, however, of either the charming tabby he drew, presumably at Malvern Hall (no.16) or the mother cat and her kitten sleeping together that he sketched in his little 1819 sketchbook (fig. 60).

1 JCC IV, p.62.
2 JCC II, p.78.

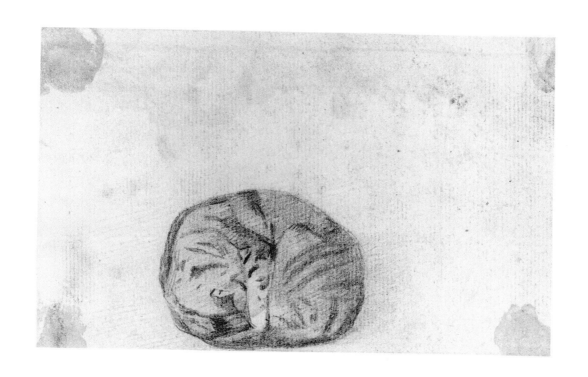

St. Alphege's, Solihull, from the East 1809

Black chalk on laid paper 96 x 154mm ($3\,^3/_4$ x $6\,^1/_{16}$ in), trimmed; watermark '06'; indistinctly inscribed '13 August' t.l. and '5'; VERSO: *Copt Heath*, a distant windmill with a tree; black chalk

PROVENANCE:...; Sir J.C. Robinson; Christie's 21 April 1902 (lot 84, with no.18, both described as *Views of Salisbury*); Reynolds;...; Christie's 12 July 1988 (lot 12 *A Church Spire among Trees;* verso: *An open Landscape with a Windmill,* etc.)

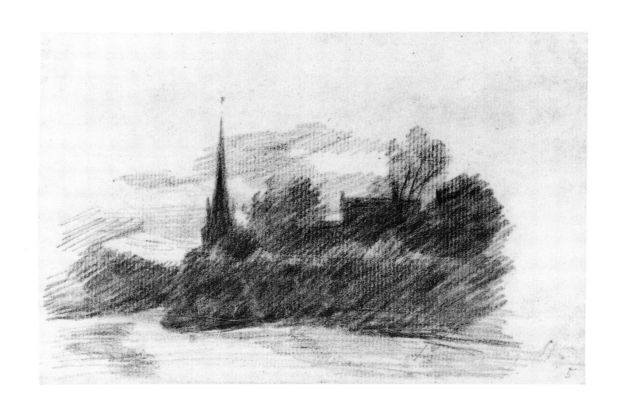

119

St Alphege's, from the Deer Park, Malvern Hall 1809

Black chalk on laid paper 96 x 154mm ($3\,^3/_4$ x $6\,^1/_{16}$ in); trimmed; watermark '06'; VERSO: *Temple Balsall Church and Templars' Hall*; black chalk

PROVENANCE:...; Sir J.C. Robinson, sold Christie's 21 April 1902 (lot 82, with no.17 of Solihull church); Reynolds;...; Christie's 12 July 1988 (lot 11, *An extensive wooded Landscape with a distant church*; VERSO: *A House beside a Church with a Tower*)

No.17, of Solihull church from the path to Malvern Hall, must have been drawn towards the end of the day when it appeared, with the surrounding hedges, trees and buildings, silhouetted against the evening sky. In the case of this drawing, outline has played no part. The entire scene is described with sensitively controlled shading, mostly diagonal, as that direction comes more naturally for the right hand.

 The view looking north, with Solihull church on the skyline (no.18), was drawn from a spot only a few yards away from the viewpoint where Constable painted an oil-sketch of the house, *Malvern Hall from the South-West* (fig.61). The rising line of the open field in the foreground of the drawing runs across to the right and almost continues with the equivalent line of the field in the painting. In the drawing, however, Constable has zoomed in a little on the church, so that it appears to be nearer than the house in the painting. He has again used the point of the pencil as if it

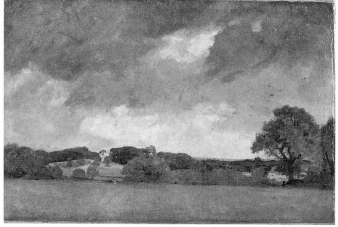

61 John Constable, *Malvern Hall from the South-West*, 1809, oil on canvas 317 x 495mm ($12\,^1/_2$ x $19\,^1/_2$ in). Bristol Museums and Art Gallery

was a brush, drawing now with 'washes' of chalk, eschewing line almost entirely, much as he used paint in *Malvern Hall from the South-West*.

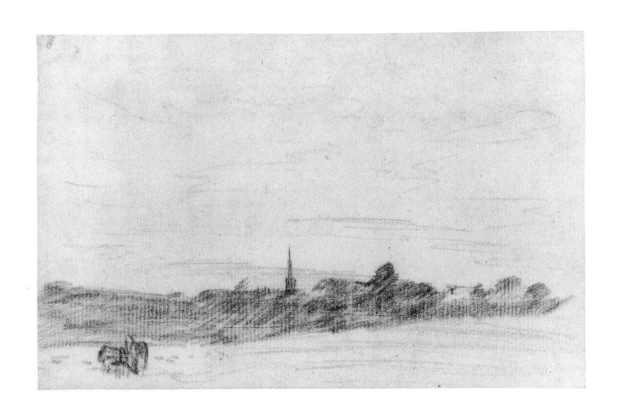

19

Dedham Lock and Mill c.1809

Pencil on laid paper 96 x 153mm ($3^3/_4$ x 6 in); trimmed on left
edge; watermark Britannia in an oval

PROVENANCE:...; Christie's 16 November 1982 (lot 49, repr.)

In August 1788 it was announced that Dedham Mill was to be sold
by auction on 17 September.[1] The following December Golding
Constable, the artist's father, advertised for a 'diligent, sober, hon-
est' Journeyman miller for 'a place in a water-mill'.[2] Golding Con-
stable, with his experience of milling at Flatford, may have been
the leading member, but for some years after the sale of 1788 Ded-
ham Mill was owned by a body of some twelve proprietors, with the
Dedham solicitor, Peter Firmin, as spokesman.[3] By 1809, however,
Golding appears to have bought the others out and to be the sole
proprietor. Evidence to support this is to be found in the Family
Correspondence. In March Mrs Constable told her son John, then
in London, that his father 'has in Contemplation – a great repair
& alteration of Dedham Mill – which as it must be for the benefit

of *Succeeders* – cannot be disapproved – tho the expenses *there* must
cause Privations elsewhere'[4]; and in April she reports again that
his father 'has it in Contemplation; a large repair & improvement
at Dedham Mill – for the benefit of Posterity....but it will take all
running Cash – for the present leaving no superfluity'.[5]

It is possible that Constable's drawing, no.19, may be connected
with his father's purchase of the mill and the improvements that
were contemplated. He was in Suffolk, we know, in October of that
year.[6] The drawing is certainly the first indication that Constable
was thinking of the mill and lock at Dedham as possible material
for a picture. In this sketch he includes rather more to left and
right than he will eventually, when composing his three paintings
of the subject.[7] See no.32 for later drawings of the scene.

1 *Ipswich Journal* 30 August 1788, no.3032.
2 Ibid., 13 December 1788, no.3047. 'A married man', the advertisement
 continues, 'if not too large a family, will be prefer'd.'
3 Essex Record Office D/P26/5. I am grateful to Michael Rosenthal for
 this reference.
4 JCC I, letter postmarked 4 March 1809.
5 Ibid., letter dated 16 April 1809. In a letter of 17 July (p.42) she tells
 her son that his father 'begins his great job at Dedham Mill on Monday,
 how glad I shall be when it is finished.' Perhaps she meant the
 following Monday, the 24th.
6 On 13 October he painted the view from the top of Fen Lane known
 as *A Lane near East Bergholt with a Man Resting*, on the back of an oil
 sketch of the Malvern Hall stables. See Tate 1976, between pp.48-9 and
 Tate 1991, no.68, p.147.
7 See Tate 1991, nos 94-6, pp.188-91.

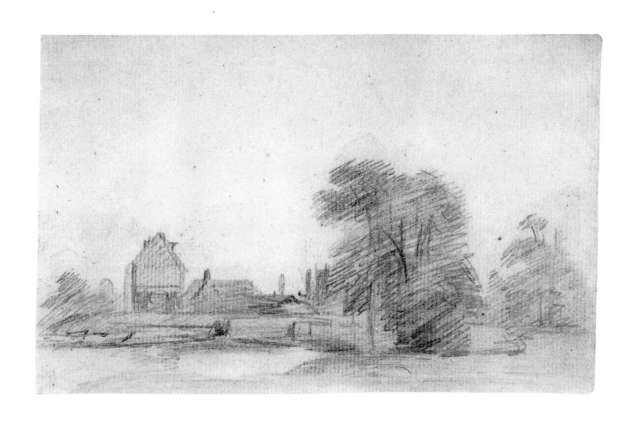

The White Horse Inn 1811

Soft pencil on laid paper 109 x 186mm (4 1/4 x 7 5/16 in); trimmed with scissors at left; watermark part of a crown; VERSO: a rapid pencil sketch of trees and bushes with a distant cottage

PROVENANCE:...; 1886, W. Booth Pearsall, by descent to his granddaughter Mrs E. Pearsall; Sotheby's 21 November 1984 (lot 84)

The 'toy' fair at East Bergholt (so called to distinguish it from the larger fairs where livestock as well as the lighter, consumer goods were sold) had been held annually for many centuries. An early record in the reign of Henry VI ordered the bailiff to collect rates and profits from the stalls 'next the graveyard of EstBergholt church'.[1] As it took place in the centre of the village, that is, immediately in front of East Bergholt House, the Constable family home, for Mrs Constable it was a most wretched fair[2]. Her son, John, however, rather enjoyed it. 'I am writing all this', he told Maria Bicknell in a letter of 1 August 1816, 'amid a tumult of drums & trumpets & buffooning of all sorts it is a lovely afternoon & the fair is realy very pretty'.[3] Of the fair as seen from their house, he painted two oil-sketches, one by day[4], the other at night-time.[5] He also made five drawings; three of the stalls and crowds on the 'Green' in front of the house and two of scenes outside The White Horse, an inn half a mile from the centre of the village on the edge of the common land, known as the Heath.

It is by no means clear what exactly is going on outside the White Horse in no.20. In the other, the Huntington sketch [6], a view looking in the opposite direction, a rather more orderly crowd has gathered round the finish of a donkey race. In this scene, as in no.20, from the inn-sign a long pole has been hoisted high above the assembly, at the end of which a pennant flutters and there hang two tantalisingly indeterminate objects. It has been suggested that there has been a ploughing match, a popular event in many parts of the country, and that one of the suspended objects is the prize for the winner, a pair of breeches.[7] Arthur Young, in his *General View of the Agriculture of the County of Suffolk*, of 1813, praising the straight furrows ploughed by the Suffolk men, adds that 'a favourite amusement is ploughing [straight] furrows, as candidates for a hat, or a pair of breeches'. It has also been suggested that Constable was witnessing a match of another kind – wrestling or fisticuffs – and that the two lines sloping up at the feet

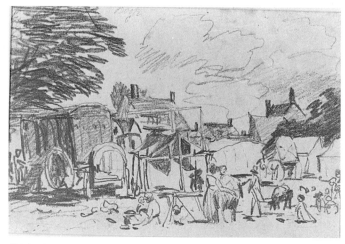

62 John Constable, *East Bergholt Fair*, 1812, pencil on wove paper 110 x 164mm (4 3/4 x 6 1/4 in). Private Collection

of the crowd from immediately below the windmill are the sides of a ring. With these two sketches of the White Horse Inn and the three of the quieter scenes around the stalls and booths of the Green, we have a group of drawings of a character unique in the artist's oeuvre. On only three other occasions is he to be found mixing with a crowd, sketchbook in hand: in 1813, when he drew the fair again, in his 3 by 4 inch sketchbook[8]; in 1814, when he made a pencil and an oil-sketch of the feast for eight hundred given on the Green to celebrate the Peace[9]; and finally, in 1828, when, in a sadder mood, he joined the crowds around a vessel driven ashore in a storm (see no.67).

The closer one studies the works of this remarkable artist, the more surprises there prove to be in store. Having been able to trace a reasonably logical line of development to date, from a linear to a more tonal series of responses to visual experience, we suddenly find him reverting to a fierce linear mode, in which the finer tonal values are exchanged for strong contrasts. To sketch a constantly shifting crowd the pencil has to move with great rapidity, it is true, but even in two of the sketches of the fair on the Green, where there are fewer figures and less movement (fig.62), we are still faced with the same stylistic autonomy, the same heavy

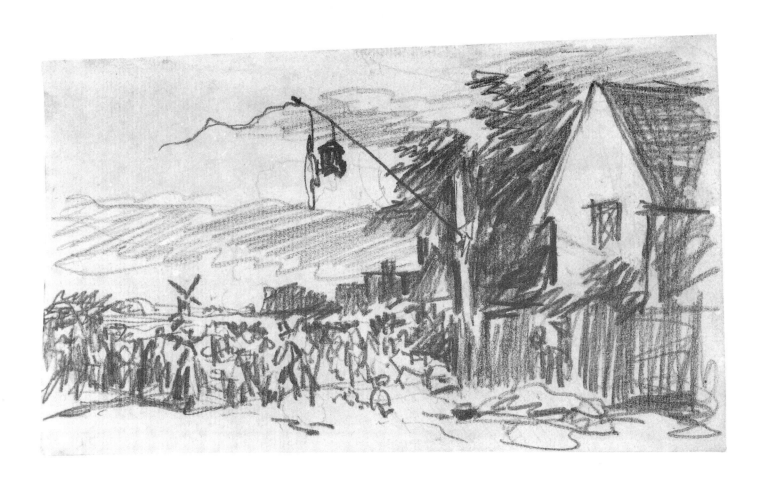

20 line and deep darks, as if the scene were lit by a flash of lightning.

The fair took place, as always, on the last Wednesday and Thursday in July. The following Sunday Constable was out in the fields, drawing the family home from the land at the back, owned and farmed by his father. Nothing could be more tranquil than this scene, drawn in finely judged areas of tone, with only the rounded forms of the passing clouds faintly outlined (fig. 63).

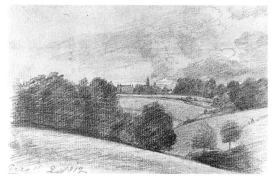

63 John Constable, *The Artist's Birthplace*, 1812, pencil on laid paper 91 x 155mm (3⁵/₈ x 6¹/₈ in). John Day

1 T.F.Patterson, *East Bergholt in Suffolk*, 1923, p.37.
2 JCC I, p.47.
3 JCC II, p.191.
4 Reynolds 1973, no.101, pl.60.
5 Private Collection.
6 See Fleming-Williams, 1990, fig.101, p.103.
7 Information from Norman Scarfe.
8 Reynolds 1973, no.121, pp.85 and 87, pls 92 & 93.
9 Ibid. no.132, p.13, pl.103 and Hoozee 1979, no.216, p.108

White Sheet Hill and Zeal's Knoll, from Stourhead 1811

Pencil on 'Pro Patria' laid paper 90 x 143mm (3⁹/₁₆ x 5⁵/₈ in); watermark lower segment of oval with Britannia's shield; inscribed 'Stourhead – Oct^r 3^d 1811 – 't.r.

PROVENANCE: said to have been given by the artist to a 'Mr Shires', thence by descent; Sotheby's 30 March 1983 (lot 141, repr.)

Constable made four drawings while staying at Stourhead, in Wiltshire, as the guest of Sir Richard Colt Hoare. Three, as might be expected, were of the lake with its temples and wooded slopes, a landscape designed for pleasure, rich with classical allusions (see figs.64 & 65)[1]. The fourth, no.21 was a view looking out eastwards, possibly from the steps in front of the house. For us, this may seem a less obvious subject to have chosen; not necessarily so, however, for his host.

Stourhead, in the words of Colt Hoare's great work *The Ancient History of Wiltshire*, 'is situated at one extremity of the county where the line of chalk hills terminates...Immediately on ascending the hill called Whitesheet', the writer continues, 'we find ourselves surrounded by British antiquities'. Here, we are told, were four barrows, one containing a double interment, burned bones in an urn and above, a skeleton with its head laid towards the south, its mouth wide open and grinning 'horribly a ghastly smile', a singularity 'never before met with[2].

The first of three parts of Hoare's *History*, published the previous year, with its account of innumerable excavations, had been handsomely reviewed in *The Quarterly Review* [3]. When Constable was at Stourhead the second two parts of the work were in preparation, and as another antiquarian, the Revd William Coxe[4], was of the company, the Ancient Britons and Hoare's excavations must have been a frequent topic of conversation. Constable, the antiquarian, has received little attention. But from the days of his first meeting with a cultured circle, with J.T. Smith and his friends at Edmonton in 1796, evidence of the past for Constable always proved an unfailing attraction. It is not surprising, therefore, that he should have wished to draw White Sheet Hill, so recently revealed as a store of archeological finds. There was an additional attraction to be seen from this viewpoint, a feature that had made its appearance on the sky-line above White Sheet Hill only a few years before, the 300-foot tower of Beckford's already notorious

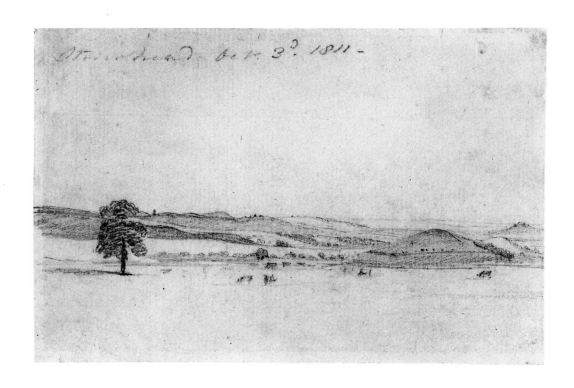

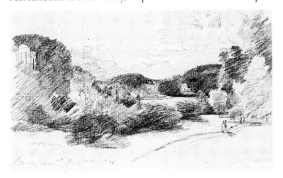

64 John Constable, *The Lake at Stourhead, with the Temple of Apollo*, 1811, pencil on laid paper 84 x 149mm (3 3/8 x 6 7/8 in). Fogg Art Museum, Harvard University, Bequest of Granville L. Winthrop

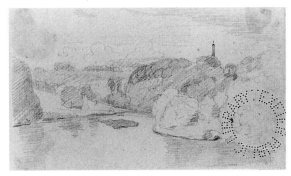

65 John Constable, *The Lake at Stourhead, with the Obelisk*, 1811, pencil on laid paper 86 x 149mm (3 3/8 x 6 7/8 in). Royal Albert Memorial Museum, Exeter City Museum and Art Gallery

127

21 Fonthill Abbey ten miles to the east, the top of which is clearly visible in Constable's drawing just to the right of the tree.

It was during his first visit to Salisbury in October 1811, a stay of some three weeks with the Bishop and his wife, that Constable was taken by the Fishers to Stourhead for a few days. He described the visit in his first letter to Maria Bicknell, his future wife:

> I have much to tell them in Suffolk about my visit to Salisbury – The great kindness (I may almost say affection <of the>) that the good Bishop and Mrs. Fisher have so long shown me was now exerted in an unusual degree <to me> to make every thing agreeable to me – During my stay his Lordship & Mrs F made a visit for a few days to Sir Richard Hoare – at Stourhead – (a most beautiful spot) – and took me with them – we were not fortunate in the weather but the inside of the House made ample recompense – Sir Richard is no inconsiderable artist himself – [5]

The botanist, A.B.Lambert (1761-1842), a founder member of the Linnean Society, was also of the company at Stourhead, and in a letter to his friend J.E. (later Sir James) Smith, written on the day Constable made his drawing of White Sheet Hill, we have a brief account of his fellow guests:

> ...we have now here a large party staying among whom are the Bishop of Salisbury & Mrs Fisher. & a young Artist whom the B patronises & who he brought with him he says he is well acquainted with you & has dined at your house at Norwich *Constable* by Name. he is making Views of this beautiful place.

The letter continues with Lambert recruiting the Bishop as a Fellow of the Linnean Society, ...'his certificate now lies before me signed by the Revd Mr Coxe & myself'.[6]

This reference to Constable having dined with J.E.Smith (1759-1828), Founder and first President of the Linnean Society, is of particular interest as there was no previous record of his having been to Norwich. At the age of eighteen he went on a sketching tour of Norfolk with one of his father's clerks, but Smith did not return to Norwich, his birthplace, until after his marriage in 1796. So it must have been sometime later that Constable was his guest.

The three paintings of *Yarmouth Pier* [7] have long required an explanation as until now, after the 1794 tour, there was no later record of Constable having been in Norfolk.

Compared with the Warwickshire sketches of 1809 and the large black and white chalk drawings he had recently been making of Salisbury and Old Sarum while staying with the Fishers (see no.56, fig.90), Constable's three views of the lake at Stourhead and his little panorama of White Sheet Hill seem relatively tame, polite performances – which is exactly what they may have been. Though 'no inconsiderable artist', as Constable himself observed, Colt Hoare was a member of the older, outline-and-wash school of draughtsmanship and a patron of some considerable standing, who may have seemed a somewhat intimidating figure. Constable was his guest as the Bishop of Salisbury's protégé (as Lambert had remarked), but in which capacity, as young gentleman or artist? If this ambivalence had been a problem, it might explain the relatively tentative character of the Stourhead drawings.

1 The third, a view looking north from the Temple of Apollo, was sold at Sotheby's 19 March 1981 (lot 9, repr.).

2 R.Colt Hoare, *The Ancient History of Wiltshire*, 1812, Vol.I, p.42.

3 *The Quarterly Review*, V, p.9

4 Archdeacon William Coxe (1747 – 1828), Rector of Stourton until 1811, was the brother of the poet Peter Coxe, for an engraving of whose *Social Day* Constable was commissioned in 1814 to make a drawing (see, Reynolds 1973, pp.92-3). Constable told Farington about his visit to Stourhead on 17 December 1811; Coxe, he said, was 'remarkable for his love of great eating. on His leaving Stourhead, Sir Richd. Hoare said "He is gone away well fill'd, as I have given Him Venison every day" '.

5 JCC II, p.50.

6 Linnean Society, Smith/Lambert Correspondence, MS 301 vol.6. pp.l39-41.

7 See Reynolds, 1984, 22.36 – 38, pls 362 – 4.

22

Flatford Lock from Downstream 1813

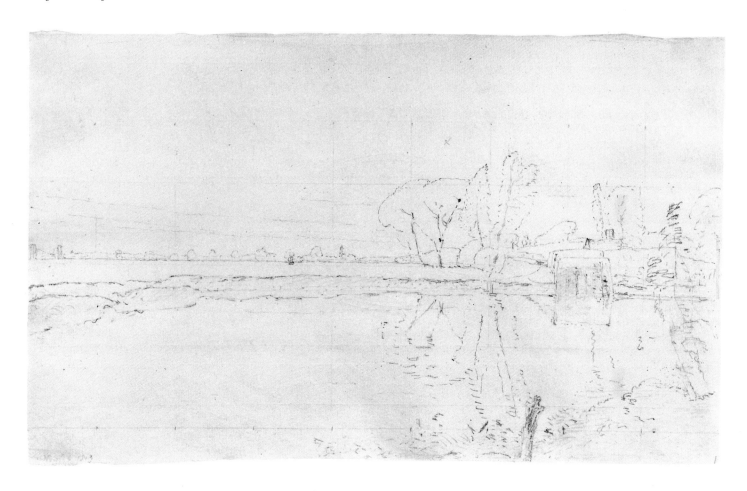

Pencil on wove paper irregularly trimmed 183 x 306mm (7³/₈ x
12 in) at greatest; lightly squared; watermark the Royal Arms;
inscribed in pencil 'Nov 6 1813' b.l.

PROVENANCE:...; Christie's 12 July 1988 (lot 27, repr.)

23

Flatford Lock from Downstream 1813

Pencil on wove paper 228 x 305mm (9 x 12 in); watermark '1808'; inscribed in pencil 'Nov[r] 14th 1813 Flatford Lock' t.r. and in pencil 'Nov[r].24th. 1813. Flatford Lock' b.l.; VERSO, an off-print in printers' ink

PROVENANCE:...; Christie' s 12 July 1988 (lot 26, repr.)

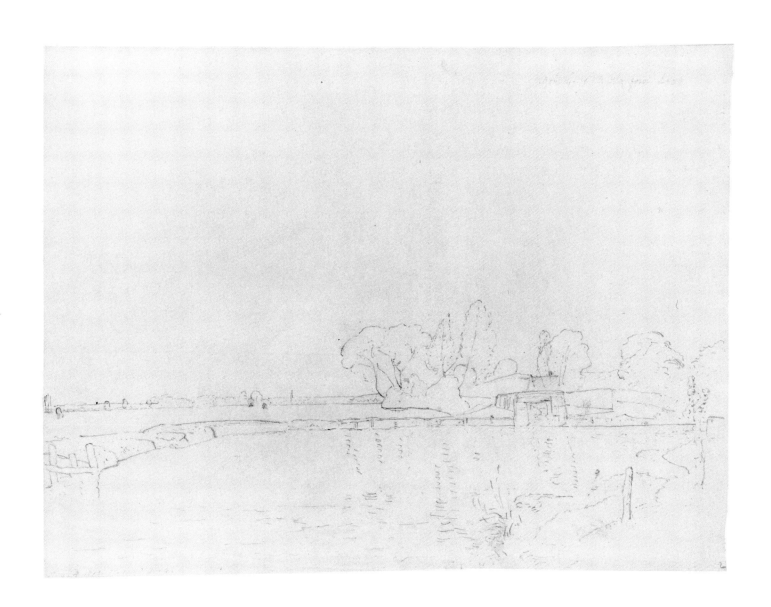

East Bergholt House 1814

Pencil on laid paper 190 x 298mm (7$\frac{1}{2}$ x 11$\frac{3}{4}$ in) trimmed; watermark 'F HAYES 1795'; inscribed 'Octr 5. 1814. $\frac{1}{2}$ past 8 i morning -' b.l.; VERSO, a faint ink off-print and a pencil outlining of a landscape

PROVENANCE:...; Dr H.A.C Gregory Sotheby's 20 July 1949 (lot 84); ...; Sotheby's 16 July 1987 (lot 59, repr.)

These drawings of Flatford Lock and East Bergholt House are attempts, by a method partly of Constable's own devising that he used on a number of occasions, to establish as objectively and as accurately as possible the main outlines of the views that confronted him. He obtained the idea for an apparatus that would enable him to make such outlines from a new edition of Leonardo da Vinci's *Treatise on Painting* that he bought in 1796. On page 40 of this edition a marginal heading 'How to design a landscape from the life' etc., introduces the following:

> Take a square piece of glass, about the size of a quarter of a sheet of royal paper, and fixing it directly between your eyes, and the objects you would design, remove yourself two-thirds of your arm's-length, that is, a foot and a half backwards. Having then fixed your head, by means of some contrivance, so firm as not to move or shake a jot, shut one of your eyes, and with the point of a pencil, trace every thing upon the glass, that you see through it. When your eyes are at liberty, you may transfer this design from the glass upon paper, and chalking the paper, make a fair copy from it.

Constable's solution to the problem of fixing his head 'by some contrivance' is described in a book on perspective by an eccentric miniaturist, Alfred Parsey (fl.1824-40).[1] Writing after Constable's death, Parsey says that the artist told him:

> that when he was studying the art of painting in his native place, unaided by others, that he might not introduce too much foreground, and that he might sketch the view correctly, he had attached to the upper part of his easel a frame with a pane of glass in it; this frame was attached by two screw

nuts by the two upper corners; to the four corners he attached four strings, which he brought to his mouth in such a manner as to bring the centre of the glass perpendicular *to his eye*. On this glass, thus held and secured from shifting by fixing the screw nuts, he traced with colour the outline of his painting and of course his drawing must have been true.

Parsey stops short of the next stage. Having drawn his outlines of the scene with a brush and printer's ink (probably diluted), Constable laid a sheet of paper on it and, often while the ink was still wet, retraced the outline on the glass on to the paper with pencil, presumably with glass and paper held up to the light. It was the off-prints of the wet ink on the backs of these tracings that enabled this stage of the process to be deduced. Barely a dozen have come to light at present and it is not known whether this process was part of Constable's normal working practice or whether he only resorted to it occasionally. The first to be seen were in a collection, some of which was little better than studio detritus[2]. If Constable regarded his tracings as such, then many could have been swept away and destroyed. Only three are known to have related directly to existing paintings[3]. The tracing of East Bergholt House, however, may have been preparatory work for a drawing and the Flatford outlines preliminary studies for an intended painting of this view.

These Flatford views appear to have been taken from the north bank, just below the Mill House, that is from the bank against which a barge is to be seen in the painting exhibited in 1812, *Flatford Mill from the Lock* (fig.66). In the tracings, the roof of the thatched cottage, further upstream by the footbridge, appears just above the lock-lintels, and to the left the familiar tree-group Constable drew and painted so often. It is not clear why he set up his tracing apparatus twice within a few days from viewpoints so near to each other, the only compositional gains being the inclusion of more of the opposite bank to the left in the second drawing and all of the post in the foreground. It is not clear either why, having made an oil-sketch (fig.67), two tracings and, the following year, three pencil sketches of the view,[4] Constable seems to have made no attempt to develop the subject further.

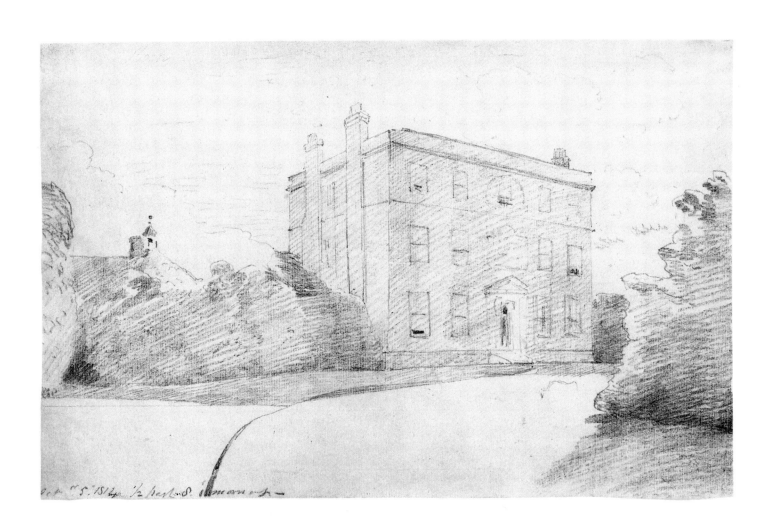

Oct. r 5 1814p ½ bef. 8. morn. +

133

24 East Bergholt House stood in the centre of the village. Built by the artist's father in the '70s, tall, square, of plain red brick with little ornamentation, in a sense it faithfully reflected Golding Constable's own forthright character. Constable made many drawings and paintings of the house and also of the views at the back from the upper windows. On a page of the little 1813 sketchbook that has been preserved intact he sketched it from front and back, marking the former view with an 'x' and inscribing it below '19 July 1813 House in which I was born x.'[5]

On a page from the small sketchbook of the following year, 1814, that has otherwise remained intact, there are again two drawings of the house: one dated 2 October, of the front silhouetted against a rising moon; the other of the house from the same viewpoint as no.24 and likewise drawn early in the morning, but on 3 October, the day after the moonlight sketch (fig.68). Why, one wonders, three views of the house within four days, the third a large tracing of the second? Had Constable in mind a portrait of his birthplace? He had already that year made two preliminary drawings for a house-portrait, a small pencil study and a larger, more detailed one (see no.26 *Feering Parsonage*) that had long been promised for an old family friend. When Constable made the three sketches of his home, his recently widowed aunt, Mary Gubbins and her two daughters had been at East Bergholt House for some weeks and were nearing the end of their stay. There had been hopes that he would find time to make a portrait sketch of the younger girl, but (he told Maria Bicknell) it was many years since he had been able to work so uninterruptedly and calmly at his painting[6] and, to his mother's regret, the portrait 'could not be taken' of his cousin 'as she anxiously hoped would have been the case.'[7] It is possible, however, that he found time to make a drawing of the house, like his Feering study (which the Gubbinses would surely have been shown) and which may even have been intended for them.

The following year he exhibited five oils and three drawings at the Academy. Two of the drawings have been identified with some degree of certainty[8]. One of these is a close-up pencil study of East

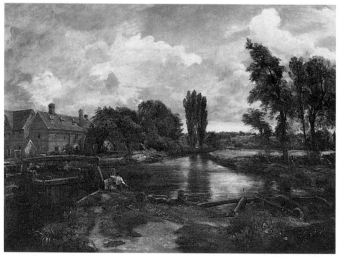

66 John Constable, *Flatford Mill*, 1811-12, oil on canvas 635 x 902mm (25 x 35 1/2 in). Mr and Mrs David Thomson

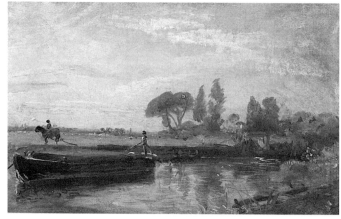

67 John Constable, *A Barge below Flatford*, ?1810, oil on (?paper laid on) canvas 197 x 324mm (7 3/4 x 12 3/4 in). Paul Mellon Collection, Virginia

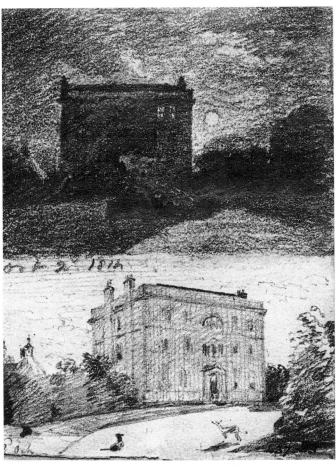

68 John Constable, *East Bergholt House by Day and by Night*, 1814, pencil on wove paper 108 x 81mm (4 $\frac{1}{4}$ x 3 $\frac{3}{16}$ in). Board of Trustees of the Victoria and Albert Museum, London

Bergholt church tower. Could not the third drawing have been a view of his own home, of which he was not a little proud? Years later, he chose a view of the back of the house as the Frontispiece to his book of mezzotints, the *English Landscape*, and to express his sentiments chose a Latin verse, which, freely translated by his friend John Fisher, runs:

> This spot saw the day spring of my Life,
>
> Hours of Joy, and years of Happiness,
>
> This place first tinged my boyish fance with a love of the art,
>
> This place was the origin of my Fame.

1 A.Parsey, *The Science of Vision, or Natural Perspective! Containing the True Language of the Eye, Necessary in Common Observation, Education, Art and Science*, 1840. In his instruction to students learning perspective, John Ruskin, in *Elements of Drawing*, 1857, pp.XX-XX1, describes a similar method for making a tracing of a landscape on 'a pane of glass, fixed in a frame', drawing, 'with a brush on the end of a stick, and a little body-colour'. But he does not specify how the eye should be 'placed at some fixed point.' This reference noted by Anne Lyles.

2 The Ridley-Colborne Album, Sotheby's 18 November 1971 (lot 50), see no.39 n.1.

3 a. A tracing of Willy Lott's House (see Fleming-Williams 1990, fig.111, p.119) almost matches an oil-sketch of 1816 (see Tate 1991, no.62, p.138); b. a tracing of Flatford Mill, plainly a study for the Tate *Scene on a Navigable River* of 1817 (see Tate 1991, no.89, p.181, figs. 60-1); c. *Watermeadows near Salisbury* (repr. Christie's catalogue 12 July 1988, lot 30, p.49), a puzzling outline drawing of the painting of the same name in the V.& A. (Reynolds 1973, no.321, pl.232).

4 Reynolds 1973, no.132, p.25 (pl.104); p.48 (pl.108); p.51 (pl.109).

5 Ibid. no.121, p.34, pl.82.

6 JCC II, p.133.

7 JCC I, pp.107–8.

8 *View over Golding Constable's Gardens* and *East Bergholt Church; South Archway of the Tower*, Reynolds 1973 nos 176 and 177, pls 140-1.

A Farmhouse at East Bergholt 1814

Pencil on wove paper 81 x 109mm (3³/₁₆ x 4⁵/₈ in); indistinctly inscribed '........House – E.Bergholt' t.l.; VERSO, two compositional studies of the valley west of East Bergholt

PROVENANCE:...; J.P.Heseltine; Sotheby's 25 March 1920 (lot 122b, mounted with no.29); Meatyard;.....; Guy Bellingam-Smith;.....; Sir Robert Witt;....; Christie's 17 November 1981 (lot 26, repr.)

In the ninety pages of the 3 by 4 inch sketchbook that Constable used in 1813, he made eighty or so pencil drawings of landscape (some hardly bigger than a postage stamp), a great many brief studies of country folk, farm carts, cattle, ploughmen and their teams, as well as little memoranda of river-side timbers, water-lilies, etc. It was here, in the pages of this tiny sketchbook, that he achieved artistic independence, leaving behind all thoughts of the work of others and, with the visual vocabulary that he was creating for himself, was able to respond fully with the most elementary of artists' tools, the graphite pencil, to whatever he saw about him (see Prologue no.XV, figs 50 & 51).

Only one of the two sketchbooks he used the next year has survived intact; the other, of a similar size, that is even smaller than the 1813 book, was broken up. Presumably, this dismembered sketchbook originally contained about the same number of pages, eighty, but only a dozen can at present be listed. In Constable's drawings of this year (1814) he seems to be working with ever-increasing confidence, often rather more consciously with possible paintings in mind. The 1813 sketchbook, now in the Victoria and Albert Museum[1], provided him with material for three of his later paintings. Five of his major works – *Boatbuilding, The Stour Valley and Dedham Village* (both exhibited in 1815) *Flatford Mill* (1817), *The White Horse* (1817, his first six-footer) and *View on the Stour* (1822) – all originated in the pages of the intact 1814 sketchbook, also in the V.& A.[2]

The first and last dated drawings from the dismembered sketchbook were made on the17th[3] and 28th[4] of June. The other, the V.& A. book, was in use by 9 July and the last dated drawing, a view of Stoke-by-Nayland, is inscribed 'Stoke Oct.23ᵈ 1814. Saturday noon'. In a letter Constable wrote to Maria Bicknell two days later, he said that the studies he had made that summer were better liked than any he had yet done, 'but I would rather have your opinion,' he continued, 'than that of all the others put together.'[5]

The drawing Constable made on 17 June, at Stratford St Mary, near East Bergholt, was done the day before he went to spend some two weeks with an old family friend, the Revd W.W. Driffield, at Feering in Essex (see *Feering Parsonage* no.26). Neither the *Farmhouse at East Bergholt* nor *Brantham Mills* (no.27) is dated.

He was in Suffolk early in June (when he told Maria that the village was in great beauty and he had never seen the foliage so promising)[6], so these two drawings could have been done either before or after his trip into Essex.

Unlike most of the houses in East Bergholt that Constable drew and painted, the farmhouse in no.25 has not yet been identified – regretfully, as he drew and painted it four times, altogether. In 1832, from our drawing (no.25), he made one of his rather formal watercolours.[7] This, which he gave to a friend in Bergholt, was probably either the *Farm-house* he exhibited at the Academy in 1832, or *An old farm-house* shown the following year. The other two works are of the farm from a viewpoint a little nearer and slightly to the left. The drawing, a pencil study of about 8 by 7 inches, is slight in character and, as there are traces of an off-print on the back, may at one stage have been a tracing (fig.69). From this drawing Constable painted an oil, only known from a reproduction in Carlos Peacock's *John Constable, the Man and and His Work* (1965), where, as pl.26, it is mistakenly called a sketch for *The Valley Farm*.

Almost every drawing in the two 1814 sketchbooks was drawn on the spot, or, as must have been the case of the moonlit views (of which there are several), while the scenes were fresh in Constable's memory. The pair of drawings on the back of no.25 are unusual in that they are compositions, recollections of a scene he knew well, as it was only a few hundred yards from the cottage in the village where he had his studio. He had already painted an oil-sketch of the scene with crows flighting towards the setting sun[8], and the previous year (1813) he had drawn it when the corn, standing almost head-high in the foreground field, was bisected by the path to Stratford St Mary[9]. Many years later, in 1832, corn stooks were added at a late stage to the mezzotint that David Lucas

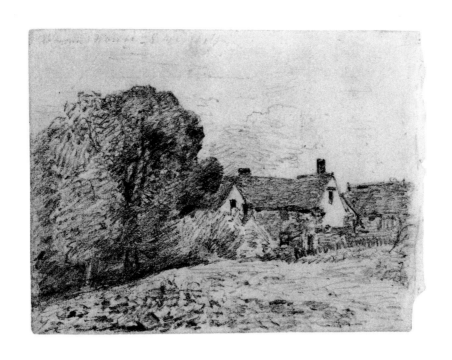

25 was making from the early oil-sketch of the subject .[10] In the foreground of the pencil compositions Constable has touched in what appear to be haycocks or corn-stooks. He frequently searched through his early sketchbooks for ideas that might help him with current problems. It may have been evidence of harvesting in the little compositions that gave him the idea of introducing stooks into the mezzotint, *Autumnal Sun Set.*

69 John Constable, *A Farmhouse*, 1809-14, pencil on wove paper 201 x 189mm (8 1/4 x 7 7/16 in). Royal Albert Memorial Museum, Exeter City Museum and Art Gallery

1 Reynolds 1973, no.121, pls 76-93
2 Ibid., no.132, pls. 102-116
3 R.Gadney, John Constable R.A., *A Catalogue of Drawings and Watercolours.... in the Fitzwilliam Museum, Cambridge.* no.11, *House and Tree by a Pond: Stratford St. Mary.*
4 Reynolds 1973, no.125, pl.101, *Porch of Feering Church.*
5 JCC II, p.135.
6 Ibid., p.125.
7 See Tate 1991, no.328, p.475.
8 Reynolds 1973, no.120, pl.71.
9 Ibid., no.121, p.21, pl.79.
10 See, Tate 1991, 182-4, pp.333-35.

Feering Parsonage 1814

Pencil on wove paper 80 x 110mm (3 1/4 x 4 1/4 in), untrimmed; inscribed in pencil 'Vicarage Feering. Essex/June 24th[?] 1814/Revd W.Driffield' t.l.; VERSO, inscribed in pencil 'Tolleshunt...' [1]

PROVENANCE:...; J.P.Heseltine; ...; Sir Robert Witt; ...; Sotheby's 10 March 1988 (lot 8, repr.)

Constable gave Maria Bicknell quite a lengthy account of his two weeks' stay at Feering with the Revd W.W.Driffield in a letter of 3 July 1814. '...he is a very old friend of my fathers and once lived in this parish – he has remembered me for a very long time as he says he christened me one night in great haste about eleven [o]clock'.[2] The purpose of the visit was to make a drawing of the vicarage and church, but for a few days Driffield took Constable with him on a visit to one of his parishes near Southend. 'I have filled as usual a little book of hasty memorandums of the places I saw,' Constable told Maria, 'my companion though a more than seventy is a most active and restless creature and I could never get him to stop long at a place – as he could outwalk and outrun me on any occasion – but he was so very kind and good tempered'.[3] One of Constable's 'hasty memorandums', of Hadleigh Castle, was subsequently developed into one of his major works (see no.65).

No.26, drawn the day after they returned from their trip, was the first of three Constable made of this view of the vicarage. The second, a large pencil study which he worked on until late in the evening and then again in the early morning, is dated 30 June[4]. In the third, a twelve by fifteen inch pen and watercolour drawing, [5] Constable depicted his host rolling the lawn, but, as Driffield later pointed out, incorrectly dressed, '...*I* never roll my garden in *black* breeches.'[6]

Besides these, Constable made several other drawings while at Feering, including a view of the vicarage and church from across the fields – one of his finest watercolours.[7]

1 'Tolleshunt' – probably Tolleshunt D'Arcy, a village through which Driffield and Constable would have passed en route for Malden and South Essex.

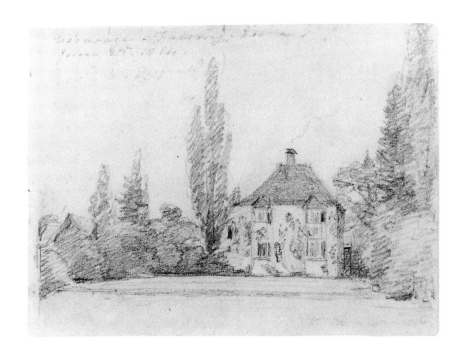

2 JCC II, p.127. In an earlier letter (ibid.p.85), we learn a little more about Driffield and the emergency christening. '..he had to go in the night over the Heath to make a christian of me at a Cottage where I was dying – when I was an infant.' Presumably, as an infant he had been put out to a wet-nurse.

3 Ibid., p.127.

4 See Tate 1976, 2nd ed. no.125a, p.197.

5 See Tate 1991, no.250, p.414.

6 JCC I, p.129.

7 See Tate 1991, no.251, p.415.

Brantham Mills 1814

Pencil on wove paper 81 x 108mm ($3^3/_{16}$ x $4^1/_2$ in), left side slightly trimmed; inscribed in pencil 'Brantham Mills' t.l.

PROVENANCE: By descent to Hugh Constable; ... ; Guy Bellingham Smith;...; H.A.E.Day; Sotheby's November 1983 (lot 77, repr.)

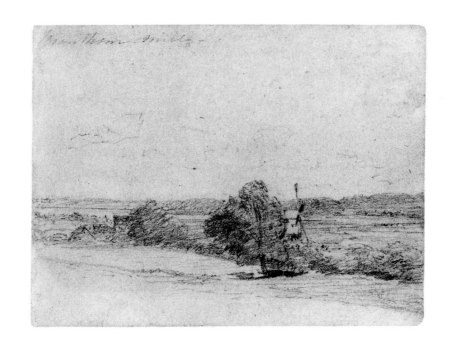

A Barn and Road 1814

Pencil on wove paper 83 x 110mm ($3\,^1/_4$ x $4\,^5/_{16}$ in), left side trimmed

PROVENANCE: By descent from the artist; acquired August 1992

Brantham Mills is undated but the season and time of day – high summer and an early afternoon – may be guessed at by the shadow of one of the sails on the body of the windmill. With a few dark accents in an otherwise pale tonality, Constable has well suggested the ambient light, often to be seen at that time of year in Suffolk and its neighbouring counties. He is now using the pencil almost as if he were just brushing the graphite on to the surface of the paper.

One of the mills owned by Constable's father for a time, Brantham is to be seen more fully described in his early chalk drawing (fig.56). Nearby was the tidal water-mill alongside the first of the locks the Stour traffic would have encountered on its way upstream from the wharves at Mistley; Flatford came next.

No.28 appears to be a page from a sketchbook, a leaf that has been slightly trimmed to remove the stitch-marks along the left edge. There is a small discrepency in its vertical measurement –

83 mm instead of a consistent 81mm – for which it is hard to find an explanation, but stylistically and in every other respect it appears to be yet another page from the dismembered sketchbook of 1814, along with nos. 25, 26 and 27. In the next sketchbook Constable used that summer his handling became much bolder.

So far it has not been possible to identify the barn in no.28. Though similar, it is plainly not the one he drew one Sunday afternoon the following year (see no.31).

Constable's friend, John Fisher (of whom we shall be hearing more shortly) was one of the first to recognise what he was achieving in the pages of his sketchbooks. Fisher made numerous copies of the pencil drawings of the years 1813 to 1817. A few of Constable's drawings are only known from these copies[1]. Not long ago, Fisher's copy of no.28 was mistakenly shown in a London gallery as an original Constable[2].

1 See Fleming-Williams and Parris 1984 pls. 104-6, pp.188-9.
2 Ibid., p.190 for a comparison of Fisher's copy with the original.

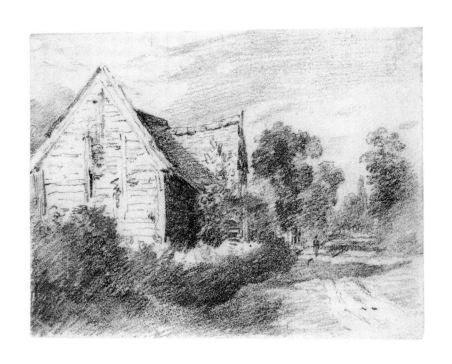

29

East Bergholt; Looking Towards Stoke-by-Nayland 1815

Pencil on laid paper 79 x 102mm (3 1/8 x 4 in), trimmed; inscribed in pencil in another hand on the previous mount 'East Bergholt looking towards Stoke. Aug. 23.1815'

PROVENANCE:...; J.P.Heseltine; Sotheby's 20 March 1920 (lot 122A, mounted with no.25 *A Farmhouse at East Bergholt*); Meatyard;...; Guy Bellingham-Smith;...; Sir John and Lady Witt; Sotheby's 19 February 1987 (lot 116, repr.)

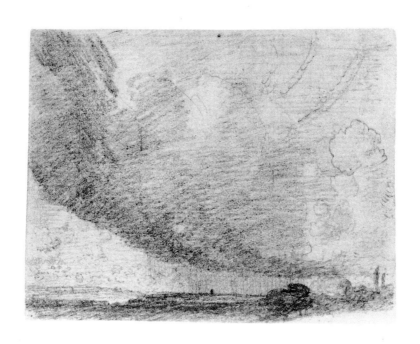

30

The Lane from East Bergholt to Flatford 1815

Pencil on laid paper 96 x 70mm (3 $\frac{1}{4}$ x 2 $\frac{3}{4}$ in) trimmed; inscribed in pencil '30 Augt 8 morning' b.l.

PROVENANCE:...; Dr H.A.C.Gregory; Sotheby's 20 July 1949 (lot 83); R.F.Bradley;...; Phillips, London 27 January 1992 (lot 4, repr.)

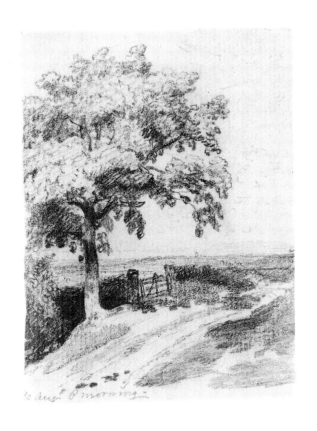

10 Aug^t 8 morning –

147

A Suffolk Barn 1815

Pencil on laid paper 99 x 76mm ($3\,^7/_8$ x 3in), trimmed; inscribed in pencil '3 o clock/1st Octr 1815 – Sunday aftn-' b.

PROVENANCE:...; Christie's 21 March 1989 (lot 48, repr.)

Barely a dozen drawings have survived from Constable's pocket sketchbook of 1815. Unlike the ones he used in 1813 and 1814, the pages of this book were of laid paper, that is, paper with a pronounced grain of close, parallel lines made by the wires of the vatman's mould[1]. There is a marked difference between the drawings made on this paper and those on the wove pages in the previous books. With the 'chatter' of the laid lines tending to show through in the lighter areas of shading – as in the drawing of the barn, no.31 – and the consequent difficulty of obtaining subtle tonal gradation, Constable seems to have resorted to a mode in which forms are outlined (clouds, in particular) and a simpler scale of tones is laid down. To eliminate 'chatter', some of the darks are more heavily loaded with graphite than was usual – for example, the hedge in shadow under the tree in the *Lane*, no.30. It is not possible to say whether Constable acquired this book by choice or by chance, but it is perhaps significant that the pages of his later pocket sketchbooks were always of the smoother, wove paper.

Nos 29 and 30 were drawn within a few hundred yards of each other and, curiously enough, on successive Wednesdays. In both, the distinctive tower of Stoke-by-Nayland church is to be seen, carefully touched in on the distant sky-line. No.29, with the threatening squall-line of clouds, is taken from the field beside Fen Lane where he had already worked a number of times, the field with the two oaks that feature (with the two poplars) in the important oil-sketch of 1809, *Lane near East Bergholt with a Man Resting*,[2] and also in Constable's main exhibit of 1811, *Dedham Vale: Morning*.[3] On the Sunday after making this drawing he wrote to Maria Bicknell, 'I live almost wholly in the feilds and see nobody but the harvest men – the weather has been uncommonly fine though we have had some very high winds.'[4] It was the harvesting that year in this same field that he chose as the subject for a major painting, the work he exhibited at the Academy the following year as *A harvest field; Reapers and Gleaners* (fig.70). Pencil studies for some of the gleaners and workers in the field have survived (fig.71). The pages of laid paper are torn but their dimensions, such as they are, agree

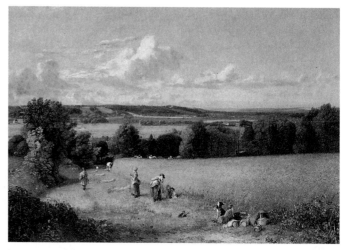

70 John Constable, *The Wheatfield*, 1815-16, oil on canvas 537 x 772mm ($11\,^1/_8$ x $30\,^3/_8$ in). Private Collection

with those of the sketchbook we have been discussing. Constable had already made a sketch of some wheatsheaves in this pocket-book[5] and it seems likely that on 23 August, while he was again with 'the harvest men' (perhaps even at work *in situ* on the painting) that he turned to a page in the little book and sketched no.29, the dramatic sweep of the oncoming squall.

Constable's adoption of a more decorative, almost Cotman-like style, with rounded shadow-shapes and outlines and a bolder tonal scheme, is well illustrated by his sketch of the tree by the gate, no.30. Similar blocks of tonal 'colour' were employed in two drawings of Framlingham Castle that he made in a larger sketchbook of wove paper.[6] So, the new decorative style may not have resulted only from the need to counteract the effect of wire-line chatter.

'I have as you guess been much out of doors', Constable wrote to Maria on 14 September, 'indeed could you see me you would not want to be told that – I am so perfectly bronzed – but to make Amends for <that> loss of BEAUTY one way I have got it (I hope) in other [i.e.another] which I like myself much better.'[7] On

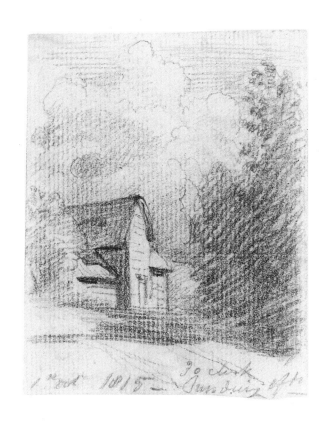

31 Sunday 1 October, the day he made the drawing of the barn, no.31, he wrote again, telling her that he could not help regretting the departure of the delightful summer, 'but', he went on, 'I still continue to work as much in the feilds as possible – as my mind is never so calm and comfortable as at these times.'[8] That long and fruitful season of sketching and painting ended only when he returned to London on 6 November.

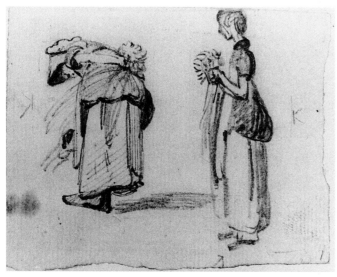

71 John Constable, *Gleaners*, 1815, pencil on laid paper 75 x 92mm (2 $^{15}/_{16}$ x 3 $^{5}/_{8}$ in). Musée du Louvre

1 See Jane McAusland's Essay, p15.

2 See Tate 1976, between pages 48 and 49.

3 For a detail of the 1811 *Dedham Vale*, showing the two oak trees, ibid., between pages 64 and 65. The oaks are still standing, elderly-looking and somewhat battered by storms, but undoubtedly the same pair.

4 JCC II, p.149.

5 Inscribed '15 Augst 1815 East Bergholt', Reynolds 1973, no.140, pl.118.

6 Gadney 1976, nos 14 and 15.

7 JCC II, p.152.

8 Ibid., p.153.

Dedham Lock and Mill 1816

Pencil on wove paper 86 x 114mm (3 $^{3}/_{8}$ x 4 $^{1}/_{2}$ in), trimmed; inscribed indistinctly with a hard pencil '22 July 1816', b.centre

PROVENANCE:...; J.P.Heseltine; Sotheby's 25 March 1920 (lot 123a); W.S.Corder;...; 20 September 1984, Neale's of Nottingham (lot 808, 'two, Dedham Lock and Mill; Salisbury (?) from the river [see no.51]'); Anthony Reed

The following group of drawings (nos.32 to 39) is from a dismembered sketchbook used during the summer and autumn of 1816. About half of the drawings in the book were made in the months leading up to his marriage in October. The remainder were done on his honeymoon.

When writing to Maria about his 1813 sketchbook, Constable said that could he show it to her, she would be able to see how he amused himself on his 'leisure walks – picking up little scraps of trees – plants – ferns – distances &c &c.' In 1816, no longer was he picking up little scraps. Instead, in this small 4 inch book, mixed up with a few briefly noted views, we have page after page of colourful pictorial miniatures, drawn, one imagines, chiefly for his own satisfaction, but also apparently – and increasingly – for the enjoyment of his small circle of admiring friends.

About three dozen drawings from this book have been identified so far. The majority are dated; of these, *Dedham Lock and Mill* is the earliest. He had sketched the view before, as we have seen (no.19). But now, from nearer to, there was a gain in pictorial value; from here he was better able to bring together the mill, sluice, lock, church tower and mass of trees into a coherent design. From a reference in a letter Maria wrote him after he had had a wet journey into Suffolk – 'You must lament this rain very much, there can be no going on with Dedham'[1] – it seems that Constable had already discussed the subject with her and that a sketch of the view had been pre-planned. The following year, when they were on holiday together he made a larger drawing of the scene[2] and after sketching the subject in oil, painted a picture of it, which, in the Academy catalogue of 1818 he called *Landscape: Breaking up of a shower*.[3] From none of the other drawings in this 'Honeymoon Sketchbook' did Constable develop a major painting.

1 JCC II, p.188.

2 See Tate 1991, fig.65, p.186.

3 Ibid., no.93, p.188.

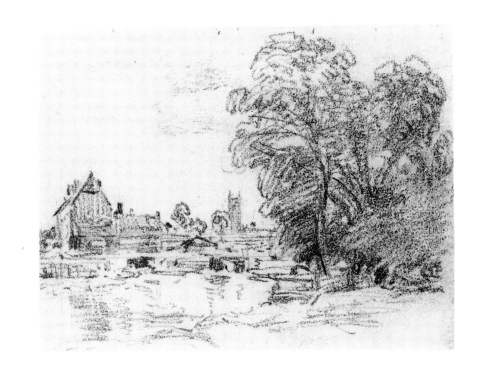

33

The Horizontal Mill, Battersea 1816

Pencil on wove paper 86 x 116mm ($3\,^1/_8$ x $4\,^9/_{16}$ in), trimmed t . &
l.; inscribed in pencil 'Battersea/Aug.6. 1816' b.r.

PROVENANCE:...; Mary Christina, wife of Hugh Frederick Hornby[1];
by descent from Mrs Hugh Vaux née Hornby; Lawrence Fine Art,
Crewkerne 19 April 1979 (lot HA 5, repr.); A.Wyld;.....; Sotheby's
19 March 1981 (lot 162, repr.) bt in

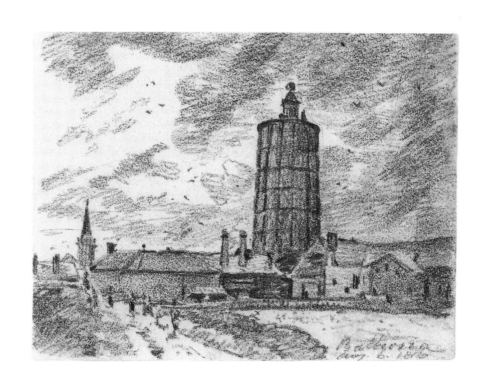

View Across a Wood 1816

Pencil on wove paper 85 x 115 mm (3³/₈ x 4¹/₂ in) trimmed

PROVENANCE:...; Mary Christina, wife of Hugh Frederick Hornby;
by descent from Mrs Hugh Vaux née Hornby; Lawrence Fine Art,
Crewkerne 19 April 1979 (lot HA 4, repr.); ...; Sotheby's 11 July
1991 (lot 162, repr.)

On 1 August 1816 (a Thursday), Constable wrote to tell Maria that
he would be coming to London on Saturday with a present, a
puppy for her and her sister Louisa. 'You cannot imagine what a
real beauty the spaniel puppy is', he had written, 'we call him
"dash" because he is like a charming fellow we once had of that
name – but let me know if you have any name you like to have him
called better – "John" you said you did not like – for a *dog*'.[2] Maria
and her sister were then living in their father's little country
house, one of a terrace, on Putney Heath. A meeting with Mr Bick-
nell was to be avoided – 'I doubt I cannot see you on sunday if your
father should be with you'[3] – so, judging by the dates on no.33 and
the sketch of *The Octagonal House* (fig.72),[4] it appears to have been
on Tuesday 6th that Constable saw Maria and delivered Dash to his
new home. From the shadows in *The Octagonal House* and the
westering light in the Battersea drawing, the former appears to
have been drawn in the morning, the latter towards evening;
perhaps when Constable was on his way back to his lodgings in
Charlotte Street.

The Horizontal Mill at Battersea was the best-known of four
windmills built to this unusual design[5]. Originally intended for
grinding linseed, it had been put to work for nearby distilleries.
Around it, in the drawing, are the gloomy-looking bullock-houses,
where six hundred animals were kept (anticipating modern inten-
sive farming), fed on the grain and meal from the distilleries. The
mill had featured in Thames-side views by other artists, most mem-
orably in Thomas Girtin's *The White House*,[6] but none had por-
trayed it thus, dark against a wild windy sky, echoing possibly the
strength of Constable's feelings after another all-too-brief day with
his beloved Maria.

The undated *View across a Wood* is coupled here with the two
drawings done on 6 August, as the bold use of the soft, blunt point
brings it stylistically very close. Topographically, the scene is also
more like the thickly wooded Putney or Wimbledon landscape of
those days than any of the other areas where Constable is known
to have sketched that year.

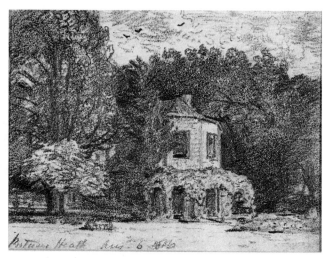

72 John Constable, *The Octagonal House*, 1816, pencil on wove paper 88 x 117mm
(3¹/₂ x 4⁵/₈ in). Private Collection

1 No. 33 with nos 34, 35, 36, 38, 39, 45, 74 & 75, are all from a single
 album of drawings and watercolours which came to light in 1979. The
 gilt initials on the cover of the album, 'M.C.H.', are those of Mary
 Christina, wife of Hugh Frederick Hornby (1829-99), a merchant of
 Liverpool who bequeathed a fine library of books, prints and auto-
 graphs to the city. In all, the album contained ninety-three drawings
 and watercolours. There were examples by Albert Goodwin, John
 Coney etc., and among other amateur hands a number of watercolours
 by Hornby himself. It also contained eighteen previously unrecorded
 drawings by Constable, eight of which were from the 'Honeymoon'
 sketchbook.
2 JCC II, p.187.
3 Ibid., p.191.
4 The building here referred to as the Octagonal House was almost cer-
 tainly Bowling Green House, which was only a short distance from the
 Bicknell's house in Bristol House Terrace. Bowling Green House was
 the residence of William Pitt, the Prime Minister until his death in
 1806.
5 Captain Stephen Hooper's designs for the Battersea and Margate hori-
 zontal windmills had been preceded by two of a similar type designed
 and built by the father of John Mortimer, the artist. The Battersea mill,
 acting somewhat like a turbine, with ninety-six 80 ft vertical vanes
 driving six pairs of stones, was enclosed by a casing of slats that could
 be turned like venetian blinds to admit or restrict the wind. 140 feet in
 height, the structure tapered from 54 to 45 ft.
6 See *The Great Age of British Watercolours*, Royal Academy of Arts, 1993,
 no.143, pl.168.

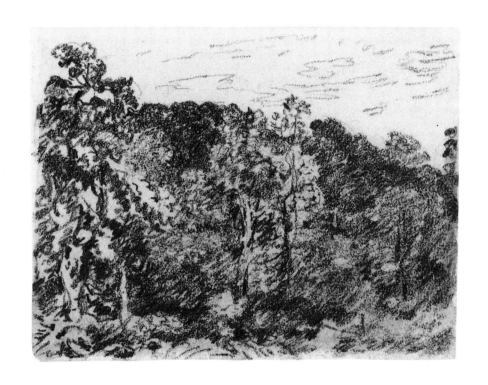

Salisbury Cathedral and the Bishop's Palace 1816

Pencil on wove paper 87 x 113mm trimmed ($3^7/_{16}$ x $4^7/_{16}$ in); inscribed in pencil 'Salisbury 8. Octr. 1816' b.l.; verso 'S [or L] G'

PROVENANCE:...; Mary Christina, wife of Hugh Frederick Hornby; by descent from Mrs Hugh Vaux née Hornby; acquired January 1982

After a courtship lasting seven years and many painful and humiliating situations, Constable and Maria Bicknell were married in St Martin-in-the-Fields on 2 October by the artist's closest friend, Revd John Fisher, nephew of the Bishop of Salisbury. There had been 'warm words' between Maria and her father the day before and two neighbours, the Mannings, were the only witnesses at the wedding. The following day Constable and his wife set off on their honeymoon; first to stay at Salisbury with the kindly Bishop and his wife in their Palace; next, with relations in Southampton and then for several weeks with the recently married John and Mary Fisher in the vicarage at Osmington, near the Dorset coast.

As the shadows show in fig.73 Constable was out with his pencil by mid-morning the day after his arrival at Salisbury to make the first of three drawings of the Cathedral in his sketchbook. No. 35, the second dated drawing, is taken from across the little stretch of water to the south of the palace, known as The Canal, at which the cattle are drinking in the picture Constable later painted for Dr Fisher, *Salisbury Cathedral from the Bishop's Grounds*.[1] From this southern aspect the palace is surprisingly domestic in character; on the north side it presents a somewhat grander, castellated set of elevations to the visitor.[2]

Something of the tension of the weeks preceding his marriage seem to have found its way into Constable's powerful drawings of 6 August – the *Horizontal Mill*, no.33 and the *Octagonal House* – and the study of trees, no.34. The drawings from the rest of the sketchbook are very different. This is partly due to the narrower gauge of pencil he used – the width of the graphite rod – and , in the case of the cathedral sketches, possibly to the presence of his host and mentor, the Bishop, who would have approved of the fine architectural detailing. But it is surely not only hindsight that enables us to find evidence of a deeper change in the drawings he made that autumn. For years he had longed to be able to share his love of landscape with Maria, 'when I think what would be my hap-

piness could I have this enjoyment with You – then indeed would my mind be calm to contemplate the endless beauties of this happy country – In Your society I am freed from the natural reserve of my mind – tis to You alone that I can impart every sensation of my heart.'[3] In this drawing of the cathedral, bright in the sunlight, the firm yet tender handling surely reflects something of that calm enjoyment of beauty for which he had yearned for so long.

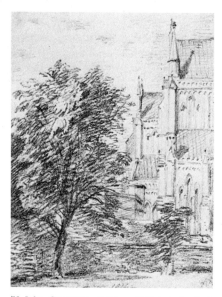

73 John Constable, *Salisbury Cathedral, the South Transept*, 1816, pencil on wove paper 114 x 87mm ($4^1/_2$ x $3^7/_{16}$ in). Stanford University Museum of Art, 1981.264, purchased with funds given in honour of Robert E. and Mary B.P. Grass

1 See Tate 1991, no.140, p.259.
2 A glimpse of the entrance front of the palace may be obtained in an oil of 1820, *Salisbury Cathedral and the Close* (Reynolds 1973, no.196, pl.156). More of the building is to be seen in a drawing, the present whereabouts of which is unknown (Reynolds 1984, 20.60, pl.181).
3 JCC II, p.81.

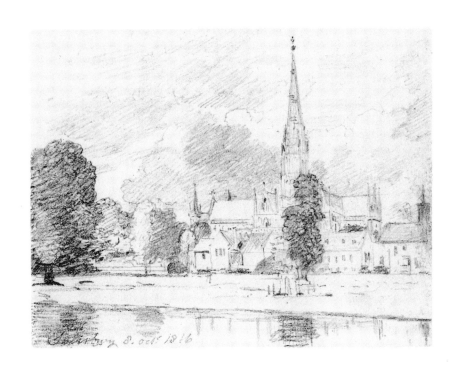

Salisbury 8. octr 1816

157

Redcliffe Point 1816

Pencil on wove paper 87 x 114mm ($3\,^7/_{16}$ x $4\,^1/_4$ in), trimmed l. & b.; inscribed in pencil '8 Novr 1816' b.r.; VERSO, in another hand 'Weymouth'

PROVENANCE:...; Mary Christina, wife of Hugh Frederick Hornby, by descent from Mrs Hugh Vaux née Hornby; Lawrence Fine Art, Crewkerne 19 April 1979 (lot HA 9, repr.)

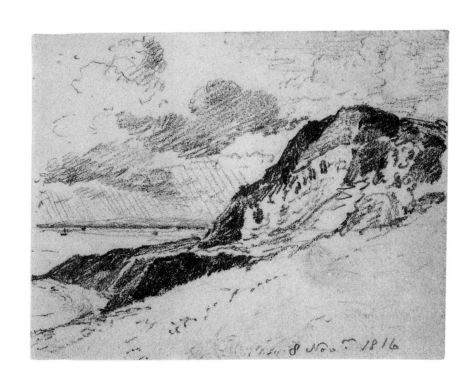

Osmington Church and Vicarage 1816

Pencil on wove paper 88 x 110mm ($3\,^7/_{16}$ x $4\,^3/_8$ in), trimmed b.t. & l.; inscribed in pencil 'Novr. 16. 1816' b. l.

PROVENANCE:...; Louise Burke Wren, South Carolina, 1978; Dr Robert O. Lipe; Christie's 29 March 1983 (lot 11, repr.)

The foundations for Constable's deep friendship with John Fisher were laid down when he was at Salisbury, staying with the Bishop in 1811. Their friendship came to mean much to both men. In his first long letter to Constable (8 May 1812) Fisher tells him how pleased he was with a landscape he, Fisher, had just drawn and coloured on the spot, 'I owe this pleasure to you', he continues, 'you fairly coached me & taught me to look at nature with clearer eyes than I before possessed.'[1] Their correspondence only ceased with Fisher's death in 1832. Some of the most moving passages in the literature of art are to be found in the letters Constable wrote to his friend. He frequently acknowledged his indebtedness to Fisher: 'Beleive – my very dear Fisher', he wrote in 1821, 'I should almost faint by the way when I am standing before my large canvasses was I not cheered and encouraged by your friendship and approbation.'[2]

Fisher included an invitation to come and stay with him and his wife at Osmington in the letter of 27 August in which he urged Constable, 'instead of blundering out long sentences about ye "hymeneal altar"', to ask Maria to name the day. 'My house', he went on, 'commands a singularly beautiful view: & you may study from my very window...we never see company: & I have brushes paints & canvas in abundance. My wife is quiet & silent & sits & reads without disturbing a soul & MrsConstable may follow her example. Of an evening we will sit over an autumnal fireside read a sensible book perhaps a Sermon, & after prayers get us to bed at peace with ourselves & all th world.'[3] This is perhaps not a picture of domestic bliss a modern bride would envisage, but expectations then were of a different order. Subsequently, memories of Osmington always remained dear to Constable and his wife.

During the six weeks they spent at Osmington, Constable painted several oils, including Boston's panoramic *Osmington and Weymouth Bays* (fig.74) and made twenty or so drawings. This was his first real experience of a coastline of character, of cliffs, the workings of the sea and the life of the shore. He had always had in innate feel for land structure. This he had forcefully expressed in his drawings of the hills and deep dales of the Lake District. The bays and cliffs along the shores of the greater Weymouth Bay and the rolling chalk downs gave him a new insight into the geological dynamics of landscape. Redcliffe Point, aptly named, presents a striking exposure of the earth's crust; the upper slab of orange-coloured, friable rock eroding away faster than the dark grey, more resistant clay on which it rests. This story was fully understood and graphically told by Constable in no.36.

Osmington, like several of the villages in that part of the country, lies low, sheltering in a valley between the coastal ridge and the higher downs inland. Constable walked eastwards out of the village, up a track known as The Roman Road to obtain his view of the vicarage (to left of centre, with the smoking chimney) and his friend's church. From this drawing he painted a small picture which he later gave to Fisher and which remained in the family for many years.[4]

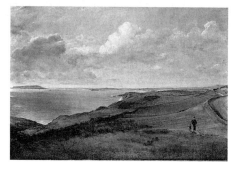

74 John Constable, *Weymouth Bay*, 1816, oil on canvas 560 x 773mm ($22\,^1/_{16}$ x $30\,^7/_{16}$ ins). Museum of Fine Arts, Boston, Bequest of Mr and Mrs William Caleb Loring

1 JCC VI, p.15.
2 Ibid., p.63.
3 Ibid., p.29.
4 See Tate 1991, no.80, p.169.

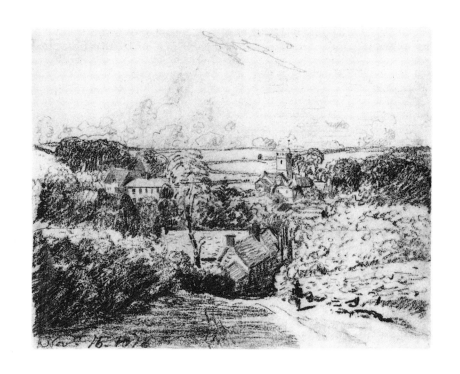

38

The Watersplash, Ryehurst Lane, Binfield 1816

Pencil on wove paper 87 x 111mm ($3\,^3/_8$ x $4\,^3/_8$ in), trimmed t.l. & b.; inscribed in pencil 'Binfield 6 Decr. 1816'. t.l.

PROVENANCE:...; Mary Christina, wife of Hugh Frederick Hornby; by descent from Mrs Hugh Vaux née Hornby; acquired September 1981

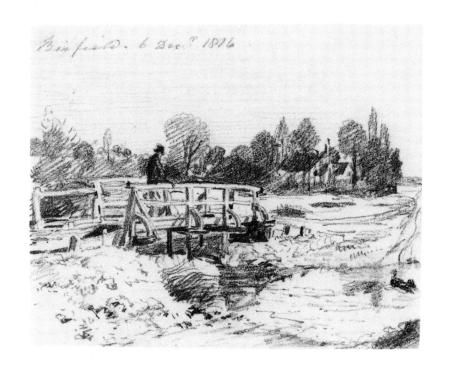

39

Shottesbrooke 1816

Pencil on a double-page of wove paper
Left-hand sheet 75 x 112mm ($2^{15}/_{16}$ x $4^{3}/_{8}$ in), trimmed; inscribed in pencil 'Shottesbrook Berks. /Decr. 7. 1816;' VERSO, *The East Window of Shottesbrooke Church,* inscribed in pencil along left-hand edge 'East Window. Shottesbrook Church. Berks /Decr. 1816'

PROVENANCE:...; Ridley-Colborne;....; Sotheby's 18 November 1971, 'A Volume of Landscape and Figure Studies'[1](lot 50); William Darby; acquired April 1987

Right-hand sheet 87 x 113mm ($3^{3}/_{8}$ x $4^{7}/_{16}$ in), trimmed t. & l.; inscribed in pencil on the back 'S [or 'L'] G/4'

PROVENANCE:...; Mary Christina, wife of Hugh Frederick Hornby; by descent from Mrs Hugh Vaux née Hornby; acquired January 1982

Constable's last dated drawing of his stay with the Fishers, a double-page panorama of Osmington from the fields behind the church, is dated 3 December.[2] On their way back to London, he and his wife broke their journey to spend a few days with Mary Fisher's parents at Binfield, in Berkshire, where her father, Canon Cookson, was the incumbent. It is not known if the Fishers accompanied them, but Mary may have wished to see her parents after her marriage in July. If they were at Binfield too, it would probably explain the top-hatted figure on the Ryehurst Lane footbridge[3] and the dog in the watersplash. Dogs were with the party on the beach in one of Constable's oil sketches[4], and some years later he made a watercolour of Fisher and his dogs at Salisbury and inscribed it so.[5] It would therefore be reasonable to suppose that it was Fisher on the footbridge whom Constable snapped as his friend paused, with his stick resting on the handrail, while his dog splashed about in the stream. Constable's understanding of land-formation, as we have seen in his drawing of *Redcliffe Point,* was only part of a deep-seated feeling for structure of every kind – natural or man-made. Some of his enjoyment in sketching this little scene appears to have derived from the opportunity it afforded to make a construct with the point of his pencil of the bridge itself, with its four arch-braces.

The following day, at Shottesbrooke, only a few miles away, Con-
stable spent some time in the church, drawing the curvilinear tracery and the images in the glass of the East window.[6] On the back of that drawing, on a right-hand page, he began to make a brief outline sketch of the church and nearby house, with its park and lake, no.39. Feeling the need to extend the composition, Constable continued on to the left-hand page and there noted the place and date. Probably separated when the sketchbook was broken up, it was not until 1987 that the two sheets were brought together again as they appear here.

1 Little is known of the history of this volume and the only evidence of previous ownership is an invitation to Mrs Ridley-Colborne from the Royal Academy dated 11 April 1826 which was pasted on the first page. In all, it contained 109 drawings by several hands, many of them small scraps, five or six to a page. Quite a number were by Constable's sons, but as their drawings are much alike it was not possible to attribute any individually to Charles, Alfred or Lionel. Forty-five of the drawings were exhibited by William Darby in 1972; in the catalogue, all were illustrated. Although several were very slight, thirty-seven were undoubtedly by Constable. This total included twenty-two figure studies. Constable mentions an engraving of a portrait by Jackson of Nicholas William Ridley-Colborne, M.P. (1779 -1854), later Lord Colborne, in a letter to David Lucas of 28 September 1835 (JCC IV, p.423). Ridley-Colborne married Charlotte, daughter of the Rt.Hon. Thomas Steele, in 1808 and bequeathed a group of paintings to the National Gallery in 1854, a group that included works by or attributed to Berchem, van der Neer, Rembrandt, Ribera, Teniers and Weenix.

2 No.6 in the Darby, Ridley-Colborne catalogue; Christie's 16 March 1982 (lot 104a).

3 After helpful information from Sir Christopher Lever and Mr R. Mosses, the site was visited in July, 1993. There are two bridges over the stretch of the stream (now know as *The Cut,* formerly named *The Forest Stream*) nearest to the Rectory, where Constable stayed in 1816. Both, of plain concrete, have replaced a watersplash. Beside the lower, Ryehurst bridge, there is now also a concrete footbridge. Immediately below these, the stream bears round to the right, as indicated by the line of trees in Constable's drawing. Beyond – before it was replaced by a modern building – stood a black and white, half-timbered farmhouse known, in true Cold Comfort style, as Gatherum Farm.

4 See Tate 1991 no.84, p. 173.

5 Reynolds 1973, no.313, pl.234.

6 The original glass that Constable drew, with an angel and censer in one pane, was replaced by Hardman & Co., church furnishers, in 1863. The incumbent at this time was the Revd Henry Dodwell. There may have been a connection here with the Fishers and/or the Cooksons. Dodwell's father, William, had been Archdeacon of Berkshire and was buried in Salisbury Cathedral in 1785. John Fisher succeeded William Dodwell's successor, Arthur Onslow, as Archdeacon of Berkshire in December 1817.

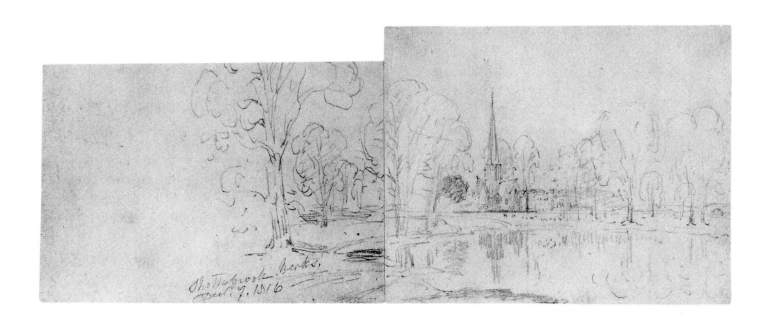

A Windmill near Colchester 1817

Pencil on wove paper 115 x 178mm (4 $^1/_2$ x 7in), trimmed;
inscribed in pencil 'Saturday Aug 9 1817' b.l.

PROVENANCE: By descent from the artist; acquired August 1992

Although the majority of pencil sketches over the last few years
were made in the small pocket sketchbooks, from time to time
Constable had also been drawing on larger sheets of paper. There
are several of 1815 (the year he exhibited three drawings at the
Academy) from a 4 $^1/_2$ x 7 inch sketchbook and while at Osming-
ton he had made a splendid 6 by 12 inch drawing of Weymouth
Bay from high up on the downs.[1] After 1816, however, he is more
often to be found working on a larger scale and when he went
away nearly always took with him one of his bigger sketchbooks.
From the book he used in 1817, nearly two dozen drawings may be
listed, most of which were made during a long holiday he spent
with Maria in Suffolk.

Altogether, they spent some three months with his family – their
first and, as it was to prove, their last visit to East Bergholt together.
As a girl, Maria used to stay in the village with her grandfather, Dr
Rhudde, the rector, but her betrothal to Constable had not been
well received by her family and since then she had not been back.
Their first child was born in December of this year, 1817. There-
after, except for an occasional short holiday with two of his child-
ren, it was only business or family matters which took Constable
down into Suffolk, and Maria always stayed behind with their
young family. During this stay in the summer of 1817 Constable
visited many of his old haunts. There were also visits to various
friends and relations: to his kind patrons the Rebows at Wivenhoe;
to see Walter Driffield[2] at Feering; and to Colchester, probably to
call on his cousin, Anne Mason.[3] On that day, 9 August, Constable
made three drawings. Two were of a church in the town, St Mary-
ad-Murum,[4] the third, no. 40, was of a windmill he had already
drawn the year before in his 'Honeymoon' sketchbook.

This was one of three drawings he had made of windmills on 26
and 27 July (1816). The first, of Copford mill, is of the upper part
of a mill appearing above a house on the main London road.[5] The
second, also dated the 26th, is of a post-mill that stood at Green-
stead, the other side of Colchester.[6] In the third (fig.75), drawn on
the 27th, from the same viewpoint as no.40, the windmill (another

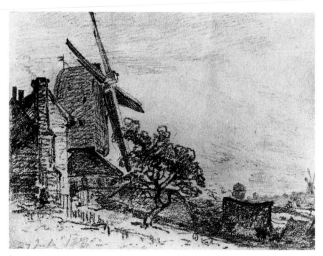

75 John Constable, *Windmill near Colchester*, 1816, pencil on wove paper 88 x
117mm (3 $^1/_2$ x 4 $^5/_8$ in). Hornby Library, Liverpool, Libraries and Inform-
ation Service

post-mill) is turned slightly towards the viewer.[7] When comparing
these last two drawings, it is interesting to see how Constable has
compacted the scene horizontally in the small sketch.

With the drawings of 1817 we arrive at Constable's full maturity
as a draughtsman. He never ceases to experiment and to extend
the range of the medium, but now there is absolute assurance, he
is fully aware of his powers and rejoices in exercising them. In
some respects, as in the present drawing, his work with the pencil
is again in advance of his painting. On canvas, it is not until the
1820's that he is to be found working with such freedom and
abandon, and able to respond so to natural forces, to movement,
fresh breezes and sparkling light.

Some years later, Constable returned to the subject of this mill,
this time to make a watercolour of it in its setting. This is only
known from a photograph (only possibly the original[8]); from a
copy by Mary Fisher, John Fisher's wife, that has remained with the
family (fig.76) ; and from a mezzotint engraved by David Lucas
several years after the artist's death.[9] In this watercolour, it is sur-
prising that Constable took as much from his first small sketch of
1816 as from the drawing of 9 August, 1817: depicting, for
instance, the mill turned slightly towards the viewer, as in the 1816
sketch, but sunlit, as he saw it in 1817. Until the true identity of the
mill depicted in no.40 has been established, it should perhaps
retain its earliest known title *Windmill near Colchester*.[10]

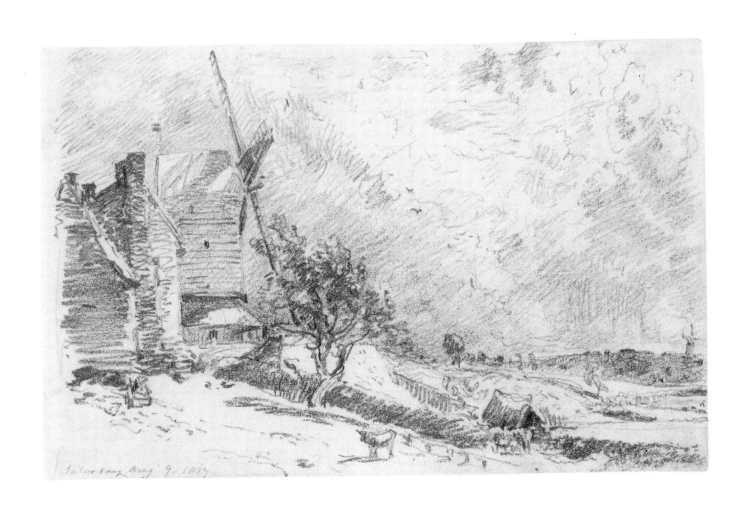

Saturday Aug 9. 1817

40

76 *Windmill near Colchester*, copy of a Constable watercolour by Mary Fisher, pen, brown ink and watercolour on wove paper 140 x 196mm (5 1/2 x 7 7/8 in). Private Collection

1 Whitworth Art Gallery, Manchester. See Fleming-Williams 1976, pl.20, p.57.

2 See no.26.

3 William Mason, a solicitor, had married Ann Parmenter, daughter of Golding Constable's eldest sister. Constable, some time later, had painted a portrait of their daughter Jane Anne.

4 See Reynolds 1984 17.11 and 17.12, pls 11 and 12.

5 Christchurch Mansion, Ipswich; see Fleming-Williams 1990, fig.232, p.257. This drawing was mistakenly inscribed by Constable 'Stanway Mill'. Although it stood on the western outskirts of Stanway village, it was in fact in the parish of Copford.

6 Private Collection; see *op.cit.*, fig.230, p.255.

7 This mill has been identified from the Constable drawing of 1817 by Mr Rowland W.Smith, as Copford (K.G. Farries, *Essex Windmills, Millers & Millwrights* Vol.5, 1988, addenda, p.121). However, this cannot be correct, as two drawings by Constable (the one of 26 July, 1816, and a later work, Reynolds 1984, 32.42) and the Chapman and André map of 1777 all show, the mill stood on the *north* side of the main Colchester/London road. In no.40 the mill is facing in a southerly direction and where the road should be, if this was Copford, the ground slopes down to a river. Neither, as has been suggested, can no.40 be of Greenstead mill, which Constable also drew on 26 July, 1816 and of which he later exhibited a watercolour (see, Tate 1991, no.329, repr.p.476). Greenstead mill had conspicuous 'braces' and a fence around it; neither features in either the drawing of 27 July, 1816 (fig.75) , or no. 40.

8 This is a photograph of a watercolour, then in a private collection, now untraced, that was shown in the Centenary Exhibition at Wildenstein's in 1937; no.165 in the catalogue.

9 See Leslie Parris, *John Constable & David Lucas,* Salander-O'Reilly Galleries, New York, 1993, pp.69-71.

10 See Shirley 1930, p.215.

41

Reapers on a Summer Evening 1817

Pencil on wove paper 112 x 178mm (4 1/2 x 7in), trimmed; inscribed in pencil '15 Aug^t 1817/6. to 7. Evening.' t.l.; watermark 'JOHN DICK/18'

PROVENANCE: By descent to Charles Golding Constable; Mrs A.M.Constable; Christie's 11 July 1887 (lot 14); Agnew; Sir Cuthbert Quilter; H.A.C.Gregory by 1948; Sotheby' s 20 July 1949 (lot 97); Tooth; Agnew; Mr and Mrs D.M.Freudenthal; Agnew 1979; Private Collection, England; acquired October 1993

A page from the 1817 sketchbook that contained so many magnificent drawings, no. 41 is one of four concerned with the harvest or with those who laboured on the land. It is different, however, from either the haunting drawing of 3 August, the so-called *Reaper passing a Cottage on a Lane at East Bergholt* (fig.77) or the sketch he made of reapers at work near Wivenhoe (fig.78), both of which are consciously pictorial in character and intent. No.41 seems to have been drawn for a different purpose, more as a plain record of the harvesting of a particular field. As such it poses a number of questions. Nowhere in the immediate vicinity of East Bergholt would Constable have been able to find a level field as large as this. It must have been somewhere in the plateau-like area to the east. But in that case from what sort of eminence was he able to look down on the scene?

It was general practice for wheat, reaped with the sickle, to be bound into sheaves which were stood up against each other into the stocks or stooks so familiar in paintings of harvesting before mechanisation. Oats or barley, on the other hand, were mown with a scythe and 'left loose; the neater method of binding into sheaves is not practised.'[1] In Constable's drawing the gang of harvesters is completing the middle third of the field with a smaller group starting on the remainder. If the crop is wheat, why has it not been stooked so late in the day and why have the sheaves been laid differently in alternate rows?[2] Constable apparently made his drawing in an hour, between six and seven in the evening. Are we witnessing one moment in the harvesting or two? Were men at work at both ends of the field at the same time, or were they at the far end when he began his drawing and had moved to the near end before he had finished?

Whatever reason he had for making this drawing and whatever

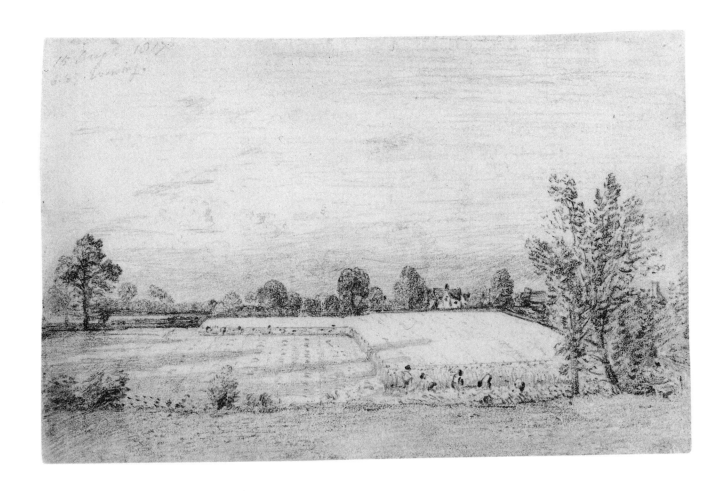

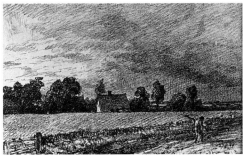

77 John Constable, *Cottage and Road at East Bergholt*, 1817, pencil on wove paper 115 x 186mm (4 $^1/_2$ x 7 $^3/_8$ in). Board of Trustees of the Victoria and Albert Museum, London

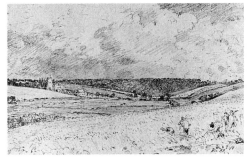

78 John Constable, *Churn Wood and Greenstead Church*, 1817, pencil on wove paper 116 x 187mm (4 $^1/_2$ x 7 $^3/_8$ in). Board of Trustees of the Victoria and Albert Museum, London

41 unanswerable questions it raises, as always, it is a living scene that Constable created with his pencil; a concern with practical details was secondary to his appreciation of the glory of that evening, with the low sun sending long shadows along the harvested field and up and across the still standing wheat (as it most probably seems to be). It will be noticed that he has achieved the effect of radiant light on the uncut corn by a subtle wash of graphite in the sky, slightly darker nearer the horizon, and with another complementary wash over the foreground field.

John Fisher or his wife,[3] made one of their copies of this drawing when it was still in its sketchbook. This – fig.79 – enables us to see that there was a slight loss on the left when no.41 was removed from the book.

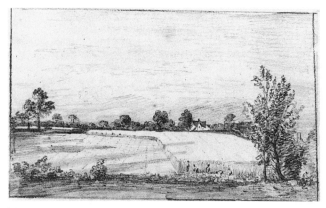

79 *Reapers on a Summer Evening*, copy by ?Mary Fisher of Constable's drawing, pencil on wove paper 140 x 230mm (5 1/$_2$ x 9 1/$_{16}$), image 113 x 188mm (4 1/$_2$ x 7 3/$_8$ in). Henry E. Huntington Library and Art Gallery, San Marino

1 Arthur Young, *General View of the Agriculture of the County of Suffolk*, 1813, ed. 1969, p.75.
2 From the varying attitudes of the men at both ends of the field, they seem more likely to be bending down with the sickle, i.e., reaping, than mowing with the scythe, and the crop therefore to be wheat.
3 Mary Fisher, née Cookson, was taught before her marriage by William Sawrey Gilpin, Drawing Master from the nearby Military School at Marlow, and on two occasions Fisher had asked Constable to lend sketchbooks so that his wife 'could copy the leaves of your mind.' Her mode of handling seems to have been less sensitive than her husband's, so fig.79 may well be one of her copies.

42

'Captain Allen' 1818

Pencil on wove paper 320 x 202mm (12 5/$_8$ x 8in); one half of a folded sheet; watermark 'FELLOWS 1812'; inscribed in pencil 'John Constable /London. Jan. 22d. /1818' b.r.

PROVENANCE:...; Christie's 16 November 1982 (lot 84, repr.)

As a portrait painter Constable is relatively little known, but, besides a number of his friends and family, nearly fifty of his commissioned portraits are listed. At an early stage in his career, when his prospects as a landscape painter appeared to be at a low ebb, he was 'much employed' painting life-size portraits – with a hand, three guineas, without, two guineas. 'This low price', he told Farington, 'affords the farmers &c to indulge their wishes and to have their Children and relatives painted.[1] Although later he would sometimes reluctantly accept a commission for a portrait, there were two years when he painted an unusual number: 1806, when seven members of the Lloyd family sat to him; and 1818, when he executed a further seven commissions. Some of the portraits, especially those of 1818, stand comparison with the work of any of his contemporaries. In that year he also copied a painting he had done of his two unmarried sisters for a relative, and in addition made the present pencil study of his cousin, presumably – as it is signed and dated – as a gift, perhaps for an anxious mother.

No.42 is traditionally held to be a portrait of a Captain Allen. This is entirely acceptable. It was while staying with the Allen family at Edmonton in 1796 that Constable first came into contact with a cultured circle with an interest in antiquity and the arts. Thomas Allen (1739-1831), the head of the family, husband of Constable's maternal aunt Jane, was a Fellow of the Linnean Society and the Society of Antiquaries and the owner, it is said, of a choice collection of prints. There were six children by the marriage, four sons and two daughters. All the sons entered the Services: John into the Navy, Thomas, David and James into the Army.[2] From what is known of his military career, David is likely to have been the sitter for the portrait as he was invalided out of the Madras Light Cavalry in 1825 with the rank of Captain and after his death in 1833 was referred to as 'that poor Captain David Allen'.[3] Furthermore, an occasion presents itself when the portrait may have been drawn. Constable's sister Ann wrote him an account of a visit to the Allens at Chelsea when she found her aunt

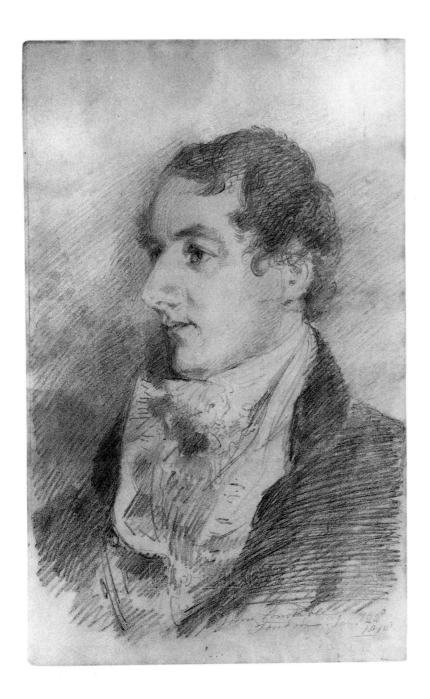

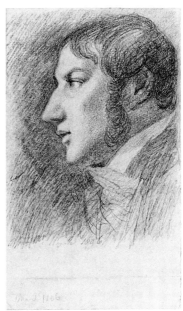

80 John Constable, *Self-portrait*, 1806, pencil on wove paper 237 x 145mm (9 $\frac{5}{16}$ x 5 $\frac{11}{16}$). Tate Gallery, London

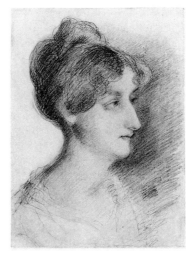

81 John Constable, *Priscilla Lloyd*, 1806, pencil on wove paper 431 x 332mm (17 x 13 $\frac{1}{16}$). Wordsworth Trust, Dove Cottage, Grasmere

42 'torn with anxiety, between parting with her Son David, who I understand leaves her, to return to India, in February'[4] and preparations for a move to Suffolk. What could have been more desirable for a distraught mother than a likeness of a son from whom she was about to be parted? Unfortunately, Ann's letter is dated 9 January 1817 and the drawing 22, January 1818. Could Constable have drawn his cousin before he left for India in February 1817, have completed the portrait later and signed and dated it in January 1818, perhaps when presenting it to his aunt? He certainly appears to have used a different pencil, a harder one, for the inscription.[5]

In 1806, when he drew himself in profile (fig.80) Constable also drew other portraits in pencil, including one of Priscilla Lloyd (fig 81) who later married William Wordsworth's younger brother, Christopher. His drawing of his cousin, no.42, however, is the only known pencil portrait from this later period. In most respects it is stylistically consistent with his current landscape studies: the sensitive delineation of eye, nostril and mouth with much of the detailing in *East Bergholt Church* (no.44), the dashing pencil-work of the open waistcoat and frilly stock with the free handling in his *Mill near Colchester* (no.40). Exceptional, in this case, are the passages where Constable has used his finger or thumb to smudge the graphite, and to emphasise thus the forward thrust of the stock and nonchalantly unbuttoned waistcoat.

1 Farington, 1 June, 1804, Vol.VI, p.2340.

2 I am most grateful to Jenny Spencer-Smith of the National Army Museum for supplying me with advice and information on the careers of Constable's army cousins. Thomas who fought at Waterloo, retired on half pay with the rank of Lieutenant when his regiment, the Ist Line Battalion, King's German Legion, was disbanded in 1816. James (1793–1859), who retired from the Indian Army in 1840 with the pension of a major, was not promoted to captain until September, 1818.

3 Mary Constable to her brother, the artist, 7 November 1833, JCC I, p.277. David Allen had died in Nullore than year, leaving a widow and two daughters.

4 Ann Constable, also to her brother, the artist, 9 January 1817, ibid., p.152.

5 There remains the possibility that the naval brother, John, could have been the sitter for the portrait. He had been given the command, as post captain, of the *Tyne*, of 24 guns, in 1815. See, JCC II, p.157 and n.3.

East Bergholt House and St Mary's Church 1818

Pencil on wove paper 102 x 127mm (4 x 5in), trimmed; inscribed in pencil '27th . Octr. 1818' t.l.

PROVENANCE: By descent from the artist; acquired August 1992

One of Constable's most effective pencil 'paintings', this sketch was the last he made of his birthplace, East Bergholt House. Golding, their father, having died two years before, Constable's unmarried brothers and sisters had decided that the place was too big for them, and it was the necessity to be present during the negotiations for the sale of the property that had brought him to East Bergholt that October. The fields he depicted in this drawing, still his family's, but shortly to be sold with the house, were for him rich in associations. It was here, down in the privacy of the little valley formed by the Ryber – the brook to be seen in the bottom left-hand corner of the drawing – that he and Maria had walked in the early days of their courtship. It was among these fields, that lay between his home and the Rectory, where Maria had stayed, that he had spent, he said, 'some of the happiest hours of my life.'[1]

Constable had been using the sketchbook in which no.43 was drawn since June of this year, and continued to do so the following year (see nos. 47–9). Several of the drawings it contained were of Putney and of scenes along the banks of the Thames. Three were done during an otherwise unrecorded visit to Windsor Castle. Only twice does he appear to have used it during his trip to Suffolk: on 26 October, when he rapidly sketched an old footbridge (fig.82) and on the 27th, when he made the present drawing.

No.43 repays close examination. East Bergholt House is seen in the distance to the right, just under the flighting birds. Left of centre may be discerned the low-pitched roof-line of St Mary's, with its little cupola, described by Constable in full in no.44. A comparison of this drawing with the slighter sketch made the day before (fig.82) enables one to appreciate more readily the remarkable fact that hardly anywhere in the former has Constable drawn a line. Almost every feature, the nearer trees in shadow, those in the distance less strongly indicated, the sunlit hedges and the sloping fields, is rendered without resorting to line. In places, such as the nearest hedge, it is difficult to see with what sort of movements and touches of the pencil-point he has managed to

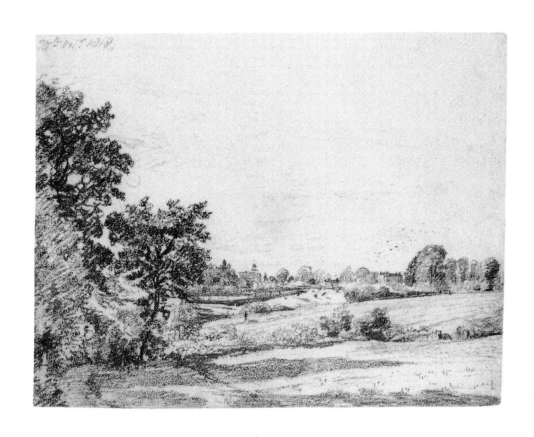

43

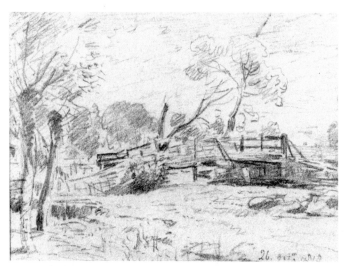

82 John Constable, *A Footbridge*, 1818, pencil on wove paper 102 x 127mm (4 x 5 in).
Private Collection

suggest such a variety of leafy forms. Much is said with minute touches: the gradient of the furthest field by the shadows cast by the cattle; space overhead by the flock of rooks (?) disappearing into the distance.

1 JCC II, p.132.

East Bergholt Church, with the Tomb of the Artist's Parents
1818(?)

Pencil on wove paper 200 x 320mm ($7^3/_4$ x $12^1/_2$ in); inscribed in another hand on an earlier mount 'East Bergholt Church. with the Tomb of Golding and Ann Constable, parents of J.Constable, by whom this was drawn Oct 28, 1818. Golding died aged 78. Ann died 1815 aged 67. By the side of their tomb are the tombs of Jas. Revans, his wife, and son and daughter. Revans was Golding Constable's faithful servant.'

PROVENANCE: By descent to Charles Golding Constable; Mrs A.M.Constable; Christie's 11 July 1887 (lot 22); Noseda; J.P.Heseltine; Sotheby's 25 March 1920 (lot 112); Agnew; Christie's 18 June 1928 (lot 58);Sir Robert and Lady Witt, by whom given to their son John; Sotheby's 19 February 1987 (lot 111, repr.)

St Mary's, in the middle of the village, was only a few doors away from the Constable home, East Bergholt House,and its priests, services and congregation played a central role in the life of the artist and his family. Viewed from one angle or another, the church features in forty of Constable's drawings and paintings. A perspective view of it, said to be a study for a painting, is amongst his earliest known drawings.[1] Four outstanding studies were made of the church in pencil; one of the south porch,[2] two of the partly ruined tower,[3] and no.44 the present drawing, of the east end with the parents' tomb in the foreground. In each case, Constable chose to make his drawing when the building was brilliantly lit by a low sun, a light that rendered up detail and surface texture with utmost clarity. Two of these studies, both of a pictorial character, were probably exhibited at the Academy, one, of the south archway of the tower[4] (fig.83) in 1815, the other, of the south porch, in 1818. Faintly ruled verticals in no.44 dropped from the apexes of nave and chancel, indicate that this drawing was a similarly planned and considered work. At some stage, to establish the hour, the shadow cast by the chancel roof was also edged with a ruled line.

No drawing in this exhibition better illustrates Constable's revelatory use of the pencil. Nowhere does he employ a contemporary calligraphy – the repetitious loopings of a Farington or

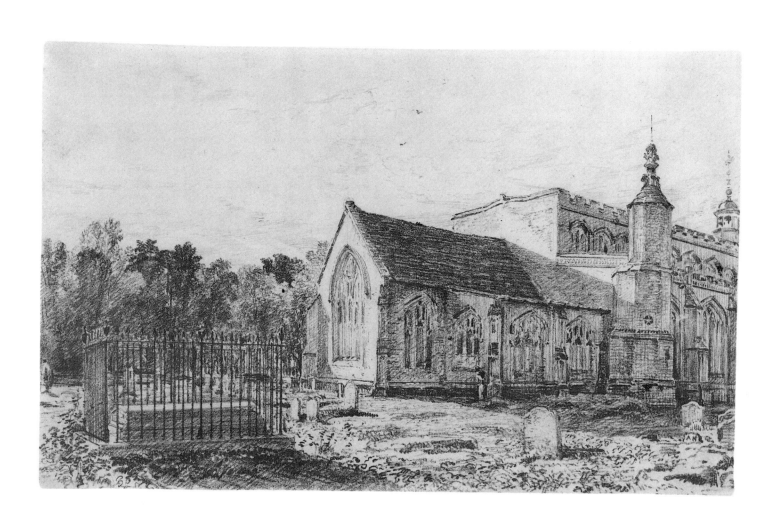

44 Girtin; only occasionally does he resort to outline. Instead, he works almost entirely with varying strengths of what, for lack of a better word, is termed shading, and with an overall, infinite variety of touches. Sometimes these touches detail individual plant or architectural features, but chiefly they serve to distinguish one material or surface from another: the stone coping of the chancel roof from the tiles, for example, or the inner smooth surface on the nave east wall from the rougher, outer corners that showed the chancel roof had at one time been higher. He achieves a great deal, too – the flood of sunlight and a sense of space – with varying pressures, from the merest light brushing of graphite in the sky, to the blacks of the little urns on the tomb railings.

Golding and Ann Constable's relationship with their devoted son, the artist, has been discussed elsewhere[5]. James Revans, referred to in the inscription, Golding's steward and business manager (and eventually one of his executors), is mentioned regularly in the family correspondence. On Christmas Day, Constable told Maria in 1813, no guests but his father's 'valuable and confidential servant Mr Revans and his family' were invited to join the family. 'Mr Revans,' he continued, 'used to *dance* me on his foot'.[6] Revans died in 1823, aged 73; his wife in 1841; his son in 1848. So the inscription on the mount (see above) must have been written after this last date. In his 1819 sketchbook Constable made three drawings in Bergholt churchyard:[7] a view, also dated 28 October, of the tomb and church from a few feet to the left of the viewpoint in no.44; a close-up of the tomb; and a detail of the stair-turret. It is odd that he should have drawn similar views on the same day in successive years. Could the '1818' in the inscription on the mount be a misreading of an original '1819' from which it was presumably copied?

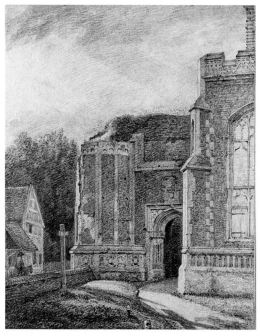

83 John Constable, *South Archway of East Bergholt Church Tower*, 1815, pencil on wove paper 269 x 207mm (10 5/8 x 8 1/8 in). Board of Trustees of the Victoria and Albert Museum, London

1 Reynolds 1973 no.15, pl.7. Possibly the work Constable told J.T.Smith about in a letter of 9 November 1796, 'I shall send you our Church, I was thinking of painting it in oil' (JCC II, p.6). Holmes,1902, p.238, lists an oil-painting of East Bergholt Church,which he dates 1798, in Leggatt Brother's 1899 exhibition at 77 Cornhill, no.55.
2 See Reynolds 1984 17.31, pl.31.
3 Ibid., nos 17.32, pl.32 and 17.33, pl.33.
4 Ibid., 17.33. For the suggested re-dating of this drawing, see Fleming-Williams 1990, p.127.
5 Fleming-Williams 1990, pp.150-55.
6 JCC II p.114.
7 See Reynolds 1984 19.28, pp.19 (pl.100), 23 (pl.102) and 25 (pl.103).

45

A House Seen Among Trees 1819

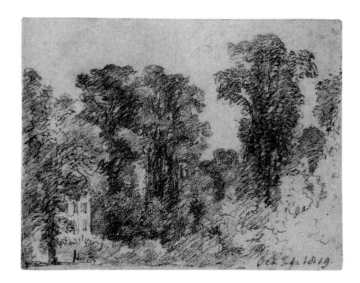

Pencil on wove paper 67 x 88mm ($2\,^5/_8$ x $3\,^7/_{16}$ in) trimmed l.& b.;
inscribed in pencil 'Oct . 1 . 1819' b.r.

PROVENANCE:...; Mary Christina, wife of Hugh Frederick Hornby;
by descent from Mrs Hugh Vaux, née Hornby; Lawrence Fine Art,
Crewkerne 19 April 1979 (lot HA 11, repr.)

Study of an Elm 1819

Pencil on wove paper 179 x 114mm (7 1/$_{16}$ x 4 1/$_2$ in); inscribed on the back of the mount 'Constable Hampstead 9[?0ct] 1819'

PROVENANCE:...; c.1900 E.C.Campbell; by descent to D.J.Ross; Sotheby's 7 July 1983 (lot 110, repr.)

On 19 July 1819, at no.1 Keppel Street, Bloomsbury, Constable's wife Maria gave birth to their second child, Maria Louisa. For some weeks Maria had been with her sister in Putney and was not looking forward to a return to 'hated London', her own words.[1] Knowing her need for country air, in September, Constable rented Albion Cottage, on the edge of Hampstead Heath, where she could breathe more freely. This initiated an annual summer migration to that village, high above London. Here he, too, found relief and was able to renew his practice of painting in oils direct from nature. For the next few years, while London-based, he therefore turned less frequently to his sketchbooks.

No.45 is one of two pages known to have come from a little sketchbook which is indistinctly inscribed on the inside of the back cover, 'Hampd /2/- Sept 9 1819', an inscription repeated inside the front cover. The book, from which many pages have been torn or cut out, now consists of twenty-eight leaves.[2] Many have been left blank. Several have been scribbled over by a child-ish hand. Only three are dated: no.45 (1 October 1819); p.23, a view of East Bergholt church (28 October 1819); and p.27 a sketch of a cedar tree at Putney (10 November 1819). Most of the draw-ings in the book – views, and sketches of donkeys and men at work with horses and carts – were done at Hampstead.

Constable made many studies of trees. One of his earliest, an exceptionally large pencil drawing, has only recently come to light (fig.84). Some of his finest were of trees he found at Hampstead. One of these, of fir trees in a neighbour's garden, he exhibited at the Academy of 1834.[3] When writing about his friend's love of trees, C.R.Leslie said that he had seen Constable 'admire a tree with an ecstasy of delight like that with which he would catch up a beautiful child in his arms.'[4] Leslie also recorded William Blake's exclamation on being shown a drawing by Constable of an avenue of fir trees, 'Why this is not drawing but inspiration', and Con-stable's dry response, 'I never knew it before; I meant it for draw-ing.'[5] The trees in no.45 with their outward curving branches, are clearly elms. These are matched by the pair in no.46 and could

well be a close-up of the same grove. Constable's varied treatment of the foliage in no.46 calls to mind a note Leslie found among his papers after his death. 'The world is wide; no two days are alike. nor even two hours; neither were there ever two leaves of a tree alike since the creation of the world'.[6]

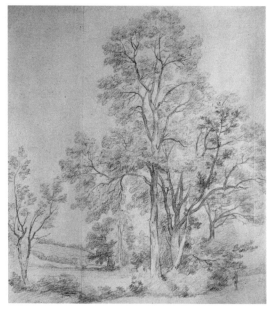

84 John Constable, *Study of a Tree*, c.1802, pencil on laid paper 500 x 450mm (19 11/$_{16}$ x 17 11/$_{16}$ in). Private Collection

1 JCC II, p . 250.
2 Originally there were forty leaves, made up of six sections, i.e., gather-ings of leaves. The following leaves are now missing, nos. 5,8,9,10,12,14,31,32,37,38,39 and 40. Pages 1, 3 and 7 are of horses and carts with men at work; page 5 is a view of Hampstead Parish Church where Constable and his wife were subsequently buried.
3 This was probably the study now at the Cecil Higgins Art Gallery, Bed-ford; see, Tate 1991, no.322, p.478.
4 Leslie 1951, p . 282 .
5 Ibid ., p . 280.
6 Ibid., p . 273.

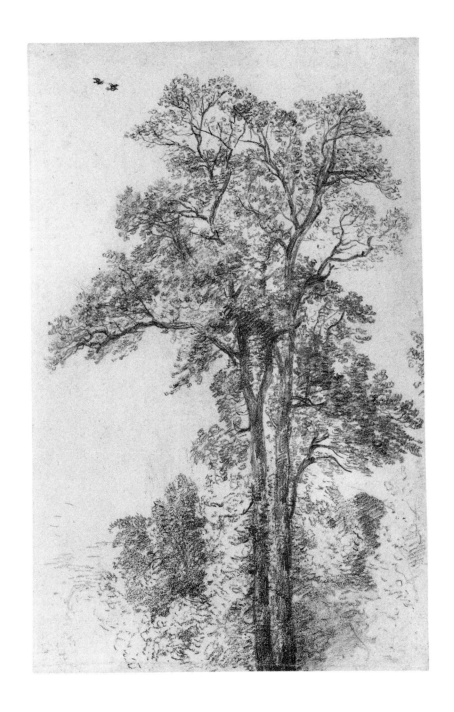

47

A States Yacht under Sail Off-shore, after W. van de Velde 1819

Pencil on blue-tinged wove paper 93 x 116mm ($3^5/_8$ x $4^9/_{16}$ in), trimmed; inscribed in pencil on the back 'W:V.Velde – British Gallery. July 13 – /1819 /1 foot $4^1/_2$ by 1 d.° $7^1/_4$ <Hozn> /Hor: 3 Inches /hight'

PROVENANCE: By descent to Charles Golding Constable; given by him to W. Caton-Thompson; by descent to his daughter, Miss G.Caton-Thompson; Christie's 20 March 1984 (lot 20, repr.)

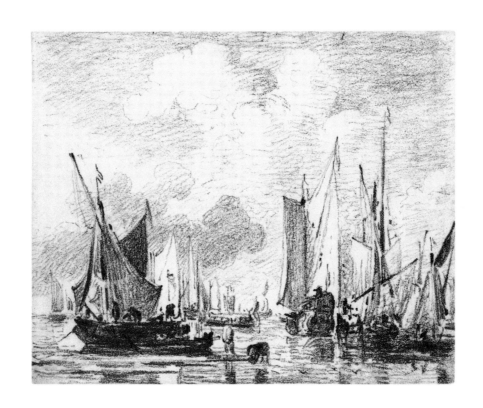

A States Yacht with Sail set close to the Shore 1819

Pencil on wove paper 99 x 117mm ($3^7/_8$ x $4^5/_8$ in), trimmed; inscribed in pencil on the back, parallel with the 117 mm edge 'W.V.Welde 1.11 by 24/Hight of Hor – 3.$^3/_4$ Hor -'; written independently of the above at right-angles

'2 feet 10-Inches by

3 feet-6-d° -

Hight of Horn

$9^1/_2$ Inch'

also on the back, a slight pencil drawing of masts and sails

PROVENANCE: By descent to Charles Golding Constable; given by him to W. Caton-Thompson; by descent to his daughter, Miss G.Caton-Thompson; Christie's 20 March 1984 (lot 21, repr.)

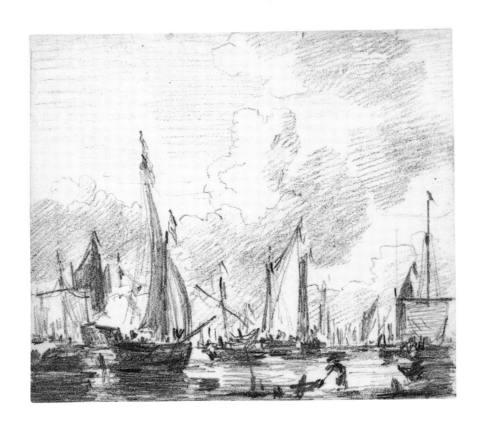

Landcape with a Cornfield, after J. van Ruisdael 1819

Pencil on wove paper 89 x 110mm ($3^1/_2$ x $4^3/_8$ in), trimmed; inscribed in pencil on the back 'V.W. -1 foot $4^1/_2$ 1 d.° $7^1/_2$ /hight of Hor 3 inches /Ruysdael /1 foot 6 /1 d.° $9^1/_2$ /British Gallery July 13. 1819'

PROVENANCE: By descent from the artist; acquired August 1992

Constable made copies of the work of other artists throughout his working life. Copying had been the accepted mode of learning for centuries, and pen and wash copies of engravings after Raphael and Claude are amongst his earliest surviving works.[1] Later, as a student at the Royal Academy Schools, he copied paintings by Claude and Wilson owned or loaned by Sir George Beaumont and Joseph Farington. While staying with Beaumont in 1823 (see no.63) he spent most of the time making copies and even in the 1830s he was still borrowing and copying in oils. [2] These later copies were, of course, made for the enjoyment they provided.

The three we are concerned with here – no.47, from a painting by van de Velde, no.48, from a seascape by an unidentified artist, and 49 from a painting by Ruisdael [3] – are part of a group that Constable made in 1819 at an exhibition of Old Masters[4], one of a series organised by the British Institution. He had already seen the show at an evening viewing on 28 June, but these sketches were made on July 13, after the exhibition had been closed to the public and made available to students to 'make copies or sketches from the original works.'[5]

Why this sudden practical interest in Old Master landscapes and marine paintings and why these carefully noted dimensions of their sizes and height of horizons?

Constable was currently beginning to work on a subject that would occupy him, on and off, until the completion of the final painting, his largest and most ambitious canvas, *The Opening of Waterloo Bridge* , which, when it was exhibited at the Academy in 1832, he titled 'Whitehall Stairs, June 18th, 1817'. He appears to have witnessed the event, the ceremonial embarkation of the Prince Regent for the crossing of the river to the southern end of the bridge for the actual opening, and he may even have sketched the scene at the time[6]. Later, in his 1817 sketchbook, he made some drawings of Whitehall Stairs and the landing-stage with the river traffic on a normal day.[7] One of these was taken at eye-level above the river. At some point, Constable came to regard this view as a subject suitable for a painting, quite apart from the other, the ceremonial Opening of 18 June. From this drawing at a low level he therefore made an oil-sketch [8] and then, on a 20 x 30 inch canvas, executed one of his more detailed and highly finished paintings (fig.85). It must have been with this subject in mind that he made such a close study of the ratio of sky to water in the paintings at the British Institution. The two marines and the Ruisdael that he measured (nos. 47, 48 and 49) had their horizons placed well down in the canvas and the first two were both titled 'A Calm' in the B.I.catalogue. Constable's painting, *The Thames and Waterloo Bridge*, is also a calm, and in none of his other pictures has he placed the horizon so low.

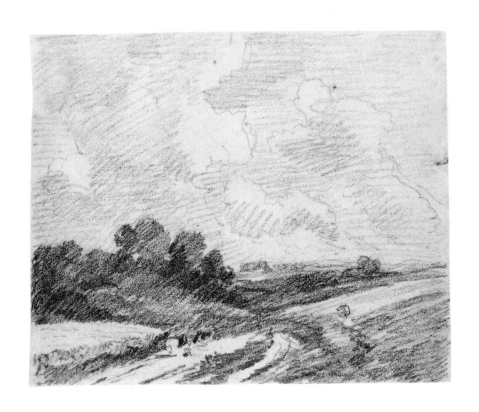

185

49

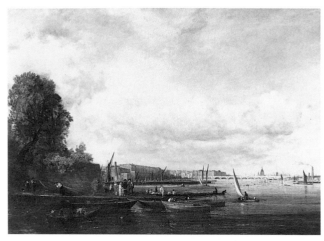

85 John Constable, *The Thames and Waterloo Bridge*, c.1820, oil on canvas 550 x
779mm (21 $^{11}/_{16}$ x 30 $^{11}/_{16}$ in). Cincinnati Art Museum, Gift of Mary Hanna

1 Three have recently come to light: a copy of an engraving after
 Claude's *Embarkation of Carlo and Ubaldo* (Christie's 7 April 1992, lot
 113, repr.); and copies of engravings after Raphael Cartoons *The Death
 of Ananias* and *The Blinding of Elymas* (Department of Prints and Draw-
 ings, the Art Institute of Chicago, accession nos 1922.2149 and 2150).
 The first two are signed and dated 1795.
2 In one of David Lucas's annotations to a copy of Leslie's *Life*, he
 records that Sir David Peel lent Constable a Ruisdael to copy (Tate
 1976 no.292, p.169) on condition that an alteration of some sort be
 made to distinguish copy from original. Constable added a dog. '... in
 all other respects the imitation was so perfect that ... only a few could
 detect any difference.' (JC:FDC, pp.61-2).
3 No. 47 is from a painting in the Royal Collection, *A Calm, a States Yacht
 under Sail close to the Shore*. See, Fleming-Williams 1990, fig. 150, p.166.
4 The other known copies are of two Cuyp landscapes with cattle and a
 Sea Port by Claude. Constable also noted the dimensions of a Ruisdael
 Waterfall and a Hobbema, so they, too, may have been copied.
5 *Repository of the Arts*, 1 May 1818, Vol VII, no. XLI, p.294.
6 The river subject is first mentioned in a letter to Fisher of 17 July 1819,
 four days after Constable's visit to the B.I. on students' day. 'I have
 made a sketch of my scene on the Thames – which is very promising'.
 JCC VI, p.45.
7 Reynolds 1984 17.5.6 and 7. pls 3, 4 and 7.
8 Ibid., 19.26, pl.89.

50

A Compositional Study for 'Stratford Mill' c.1820

Grey wash on dampened (?) paper 65 x 92mm (2 $^9/_{16}$ x 3 $^8/_8$ in),
trimmed

PROVENANCE:...; Mary Christina, wife of Hugh Frederick Hornby;
by descent to Mrs Hugh Vaux, née Hornby; a gift from her
husband Hugh Vaux (for cataloguing the Hornby Album) to
Peter Rhodes; Sotheby's 17 November 1983 (lot 105, repr.)

Most of Constable's earliest drawings were in pen and wash,
J.T.Smith's preferred medium. Wash, as well as watercolour, was
used again during Constable's tour of the Lakes in 1806, but since
then almost all his drawings had been in pencil. No.50 is an
unusual work, in that it marks a return to a use of wash, and also
because it seems to have played an important part in the develop-
ment of a major painting, *Stratford Mill*, the second of his six-
footers, the only work he exhibited at the Academy in 1820
(fig.86).
 Although the penultimate stage before tackling a six-foot canvas
for exhibition, a full-size compositional sketch, became Con-
stable's established pattern of working, he had no comparable
regular procedure in the initial stages.[1] The idea for *Stratford Mill*
(otherwise known as 'The Young Waltonians') began with an oil-
sketch he had made in 1811 of six anglers at the entrance to the
lock at Stratford St Mary, the next lock upstream from Dedham.
This was an upright, and only provided half of what was needed
for a 'landscape' composition. So, on a small canvas, he extended
the scene to the right with a view of the river stretching away into
the distance and, for further interest, introduced a barge against
the right bank with a figure in the bows, and a tow-horse close by
(fig. 87). Further changes were made when he came to paint the
composition again full-size, on a six-foot canvas now at the Yale
Center.[2] There were alterations to the figures and timbers in the
foreground, the horse was moved away to the right-hand edge of
the canvas and a new feature introduced down river on the left
bank, tall poplars and a sunlit, mysterious-looking wicket-gate.
 Where did our little wash drawing, no.50, come in this series of
sketches? The evidence strongly suggests third, after the small
composition, for it shares elements that are otherwise unique to
each of the oil-sketches: the lumpish barge (later to become low
and long) and the closely grouped foreground timbers to be seen

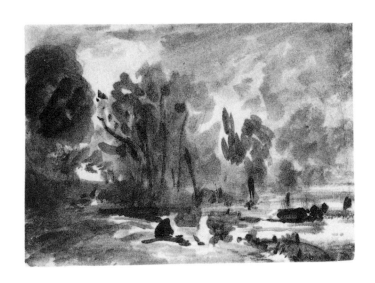

50

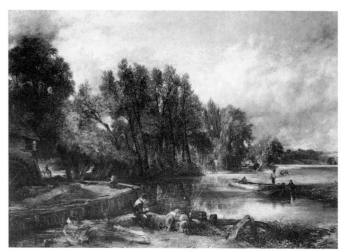

86 John Constable, *Stratford Mill ('The Young Waltonians')*, oil on canvas 1270 x 1829mm (50 x 72 in). The National Gallery London

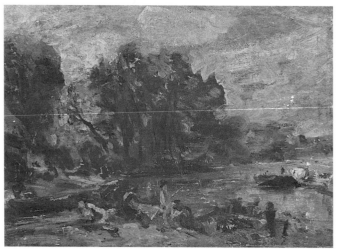

87 John Constable, *Sketch for 'Stratford Mill'*, c.1819, oil on canvas 305 x 426mm (12 x 16 9/16 in). Private Collection

only in the small sketch, (fig.87), the new group of trees with the poplars downstream and the repositioning of the horse only to be found in the big Yale sketch. In one respect it differs from both. Here, the standing figure is at the stern, not in the bows of the barge. As yet there is no sign of the sunlit wicket-gate. This seems to have been introduced after Constable came upon one of his early drawings, an upright pen and wash study, in the style of J.T.Smith, of a rickety shed door with poplars above a wall (fig.88).[3]

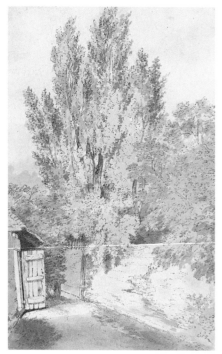

88 John Constable, *A Country Lane*, pen and brown ink with grey wash on wove paper 317 x 197mm (12 1/2 x 7 7/8 in), present whereabouts unknown

1 That is, apart from his habitual search among his sketchbooks and his earlier oilsketches for material.
2 See, Tate 1991 no.99, p.200.
3 *A Country Lane* ; untraced since its sale, Sotheby's 28 November 1974 (lot 64).

51

The Great Alder in Leadenhall Garden 1820

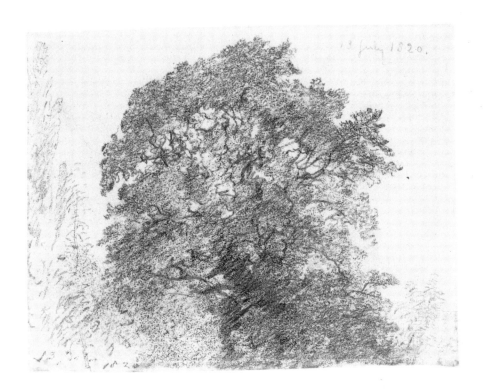

Pencil on wove paper 85 x 114mm (3³/₈ x 4¹/₂ in), trimmed; inscribed in pencil '13 July 1820' t.r., also in pencil '13 July 1820' b.l.

PROVENANCE:...; Dr H.A.C.Gregory; Sotheby's 20 July 1949 (part of lot 94 'Three studies of Trees'); Tooth; Agnew 1953; Mr and Mrs D.M. Freudenthal; Agnews; William B. O'Neal (promised to the National Gallery of Art, Washington); through exchange, December 1993

Salisbury Cathedral and Leadenhall Garden from the River Avon 1820

Pencil on wove paper 92 x 121mm ($3\,^5/_8$ x $4\,^3/_4$ in), trimmed; inscribed on the back in pencil '1820 Salisbury'

PROVENANCE:...; J.P.Heseltine; Sotheby's 23 March 1920; W.S. Corder; 20 September 1984, Neales of Nottingham (lot 808, 'two, Dedham Lock and Mill [see no.32]; Salisbury (?) from the river'); Anthony Reed

In 1811 and 1816, when visiting Salisbury, Constable had stayed at the Palace with the Bishop and his wife. In 1820 his host and hostess were John Fisher and his wife, who, the year before, had taken up residence in the Close. Their new home, Leadenhall, was attractively sited in the south-west corner with lawns running down to the Avon and with views westwards across the watermeadows towards Harnham Ridge. This, the only time at Salisbury when Constable had his wife and children with him, was a particularly happy visit; they stayed for six weeks. It was also a period of great productivity. Fisher, himself an enthusiastic amateur – two of his drawings of the distant cathedral are dated 1820[1] – had materially encouraged his friend by his purchase of *The White Horse*, Constable's first six-footer, shown at the Academy the previous year,[2] and was one of the few who could talk frankly with the artist about his work.

In these six weeks Constable painted nearly a dozen oils, most of them from inside the Cathedral Close. With his sketchbooks he went further afield (see nos 53 to 56) and was outdoors, drawing, on at least twenty-one of the days he and his family were at Salisbury. No.51 a sketch of a tree at the bottom of Leadenhall garden, that Constable called 'the great Alder',[3] was one of two drawings made on 13 July. The other, in a larger sketchbook, was a view from a river bank. These are the earliest dated drawings of the visit. In fig.89, an oil-sketch of the same tree, with a poplar on the left again just visible, we see rather more of the setting, this time with the river nearby and Harnham Hill beyond. The alder seems to have had a particular appeal, for it features again prominently in another drawing, no.52, a view from across the river, looking back towards the house and the cathedral. This appears to have been a preliminary study for one of Constable's larger oil-

sketches, the brilliant *Salisbury Cathedral and Leadenhall from the River Avon* in the National Gallery[4].

Both drawings are on a paper which takes the graphite in an unusually gritty fashion.

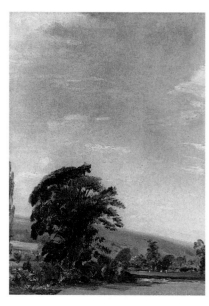

89 John Constable, *Harnham Ridge from Leadenhall Garden*, 1820, oil on paper 203 x 143mm (8 x $5\,^7/_8$ in). Mr and Mrs David Thomson

1 See Fleming-Williams 1990, figs.164 and 165, p.173. For further drawings by Fisher and a discussion of his friendship with Constable, see Fleming-Williams and Parris 1984, pp.181-194.

2 In Fisher's letter of 27 April 1820 (JCC VI, p.53) he describes the arrival of *The White Horse*: 'It is hung on a level with the eye, the lower frame resting on the ogee: in a western side light, right for the light of the picture, opposite the fire place. It looks magnificently. My wife says that she carries her eye from the picture to the garden & back & observes the same sort of look in both.' He concludes, 'I am quite impatient to see you here & wish that your young family would permit your wife to join the party.'

3 In a letter of 26 August 1827 to Fisher, describing a copy of the painting in the National Gallery (see n.4) by his assistant. 'John Dunthorne has compleated a very pretty picture of Your lawn & prebendal House – with the great Alder & Cathedral' (JCC VI p.232). Leadenhall was actually a canonical dwelling, but Bishop Fisher managed to collate his nephew as a prebendary to Leadenhall and then to have him admitted as canon residentiary.

4 See Tate 1991, no.137, p.254.

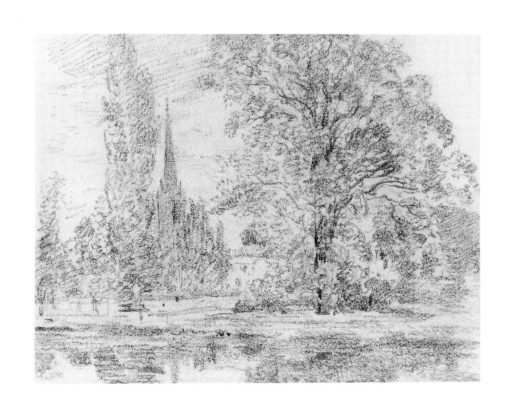

191

Salisbury Cathedral from beside the River Nadder 1820

Pencil on wove paper 114 x 184mm (4$^1/_2$ x 7$^1/_4$ in), slightly trimmed l., but stitchmarks still just visible; inscribed '18 July 1820' b.l.; on the back, in another hand 'M.L.C.47', i.e., Maria Louisa Constable 1847[1]

PROVENANCE: By descent to Maria Louisa Constable;...;L.G.Duke;...; Colnaghi; Edward Seago; Christie's 1 March 1977 (lot 55, repr.);...; Sotheby's 12 July 1984 (lot 83, repr)

This view of the distant cathedral was drawn on 18 July, 1820. It is the fourth of Constable's dated drawings done on that visit. The third is of Stonehenge, which he had drawn on the 15th, towards evening when the stones were casting long shadows.[2] In general, he seems to have preferred working in broad daylight, often when the sun was high – see nos 54 and 55. No.53, with the distant trees and cathedral silhouetted against the eastern sky, appears to have been drawn at sunrise – an exception to his normal practice.

One of Constable's stylistic characteristics is his sense of rhythm, to be seen in his management of the pencil itself across the paper surface, and also in the spacing and value of his accents. The rhythmic play of the pencil-point may be observed and enjoyed in the mass of foliage that forms the left-hand screen in no.53 – and in other drawings, such as the *Mill near Colchester* (no.40) and the *View on the Arun* (no.75). His innate sense of rhythmic interval and stress is most clearly marked out by the spacing of accents and their relative strengths in the central vignette of no.53, in the edge of the opposite bank, the watermeadows and the distant broken skyline.

1 Soon after the return from India in 1847 of Constable's eldest surviving son, Charles Golding, there was a division between the five surviving children – Maria Louisa, Charles Golding, Isabel, Alfred Abram and Lionel Bicknell – of their father's considerable store of work. Maria Louisa's initials on the back of no. 53 signify that this was one of the drawings she chose.

2 See Tate, 1991, no.291, p.445.

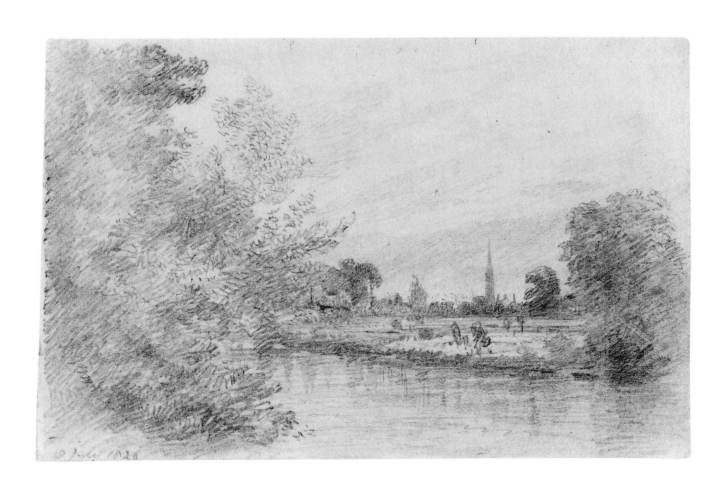

54

Salisbury from the Road to Old Sarum 1820

Pencil on wove paper 157 x 235mm (6 $^3/_{16}$ x 9 $^3/_4$ in), untrimmed, with stitchmarks down the left side; watermark '..ATMAN/18..'; inscribed in pencil '26 July 1820' b.l., and, probably in another hand 'Salisbury from the road leading from Old Sarum', t.l.

PROVENANCE: By descent to Isabel Constable; given by her to Dr. G.D.D'Arcy Adams; by descent, through his daughter Mrs A.M.Austin; acquired by private treaty from Sotheby's February 1984

Constable made seven 'finished' drawings of Salisbury cathedral from a distance during his stay in 1820. From the hills to the north and south, and from the watermeadows and river banks to the west, the cathedral in its setting is, of course, a most attractive subject. Constable certainly found it so. In 1829 he returned to it again and from another six drawings of the great church at a distance this time there resulted a major painting, *Salisbury Cathedral from the Meadows* , which he exhibited in 1831.[1]

No.54 was drawn from a viewpoint just below Old Sarum, on the road that runs north from Salisbury, a road Constable would have already travelled a few days before on his way to Stonehenge. Although the tower and spire of the cathedral is the obvious point of interest in this remarkable drawing, the real subject, one feels, is space and the almost vertiginous sense of depth achieved by contrast, the wide sweep of the fields under the immense sky, against the sharp perspective of the road zig-zagging into the distance. This theme was not new. In an earlier work, *Dedham from the South-East* (no.8) we were looking along an equally foreshortened road. But there a gentle light and cast shadows across the road had helped to create a spatial composition; here, under a clear afternoon sky the conditions were more stringent. Constable had to achieve his effect with line, a minimal amount of descriptive shading and an acute sense of scale. In this appreciation we should not overlook the part played by the judiciously placed wisps of cloud.

1 See Tate 1991, no 210 p.366.

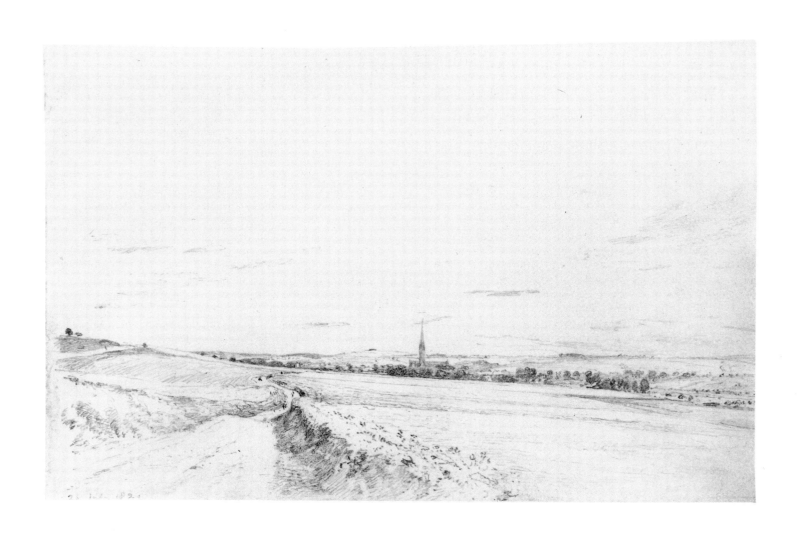

The Mound of Old Sarum from the South-East 1820

Pencil on wove paper 154 x 230mm ($6^{1}/_{16}$ x $9^{1}/_{16}$ in) trimmed; inscribed in pencil 'Old Sarum S E' t.l.; on the back in a later hand 'E.N.Mackinnon née Constable'

PROVENANCE: By descent to Ella Mackinnon (daughter of Constable's second son, Charles Golding); ...; Leggatt Brothers 1898;...; Alfred A.de Pass by whom given to the Royal Institution of Cornwall 1925; through exchange May 1985

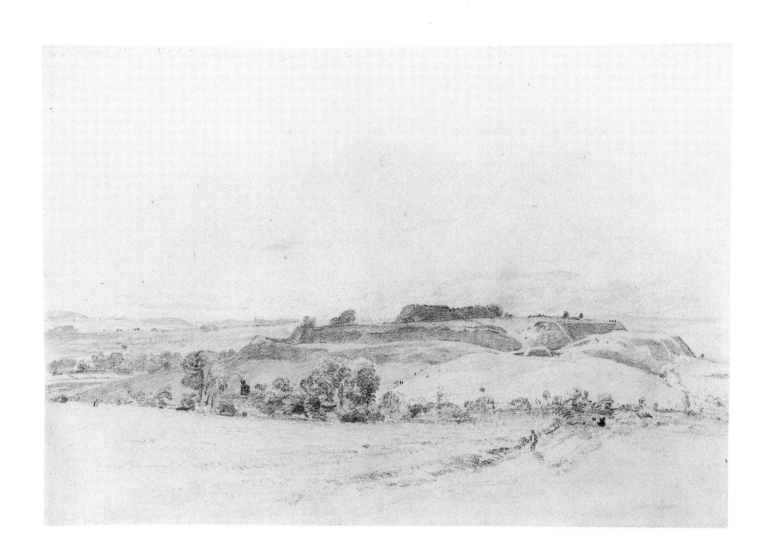

Salisbury from Old Sarum 1820

Pencil on wove paper 161 x 233mm (6 $^3/_8$ x 9 $^3/_{16}$ in), trimmed.

PROVENANCE:...; Sotheby's 15 March 1984 (lot 91, repr.)

An ancient site with centuries of history, Old Sarum was the subject of the letterpress for one of Constable's plates in his *English Landscape*. 'The present appearance of Old Sarum', he wrote, '– wild, desolate, and dreary – contrasts strongly with its former greatness. This proud and "towered city", once giving laws to the whole kingdom – for it was here our earliest parliaments on record were convened – can now be traced but by vast embankments and ditches, tracked only by sheepwalks: "The plough has passed over it".'

Originally an Iron-age hill-fort, by the middle of the 12th century there had stood within its encircling earthworks a castle on a new central mound and, inside an outer bailey wall, a cathedral, bishop's palace and associated outbuildings and dwellings. In Constable's time Old Sarum was still an impressive feature on the skyline to the north of Salisbury and on his first visit in 1811 he made two chalk drawings among its vast ramparts, one, a strikingly novel view of the distant cathedral (fig.90). During this visit of 1820, on June 26th, the same day that he made his drawing of the road to Salisbury, no.54, he also drew Old Sarum, this time from below[1]. The place continued to fascinate him. In 1829, during his last stay with Fisher, he made three more pencil sketches of it. From one of these he painted a small oil and later a large stormy watercolour which he exhibited in the Academy of 1834, with the title *The mound of the city of Old Sarum, from the south.* [2]

In no.55 a track with a figure leads the eye in towards the approaches to the deserted city, but unlike the road in no.54 it leads to a sculptural rather than a spatial theme, to an awareness of the size of this great earthen mass. In this drawing, Constable's sense of scale is again apparent. In his *Glaramara* of 1806, no.12,

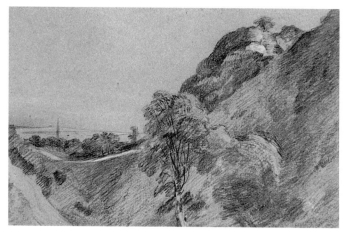

90 John Constable, *Old Sarum*, 1811, black and white chalk on grey paper 190 x 298mm (7 $^1/_2$ x 11 $^3/_4$ in). Oldham Art Galleries and Museums

two little trees in the far distance had served to register the immensity of the hills. Here, people establish scale: the figure on the path, then, further away, the pair to the left, and then the almost shockingly minute specks on the slopes leading up to Old Sarum's East Gate.

Salisbury from Old Sarum was drawn from the south-western side of the ramparts, a viewpoint now obscured by trees and bushes. Subsequent building has also considerably changed the view. In most of his depictions of Salisbury cathedral, the tower and spire are slightly elongated, presumably to convey the sensation of height that so often thrills; that seems to have thrilled Constable too when he saw the spire, fifteen miles away from Beckford's tower at Fonthill, darting 'up into the sky like a needle'.[3]

1 Reynolds 1984, 20.27, last recorded in the Leverhulme sale, Anderson Galleries New York, 2 March 1926 (lot 85).
2 Ibid., 29.17, 29.18, 29.45, 29.65 and 34.1.
3 JCC II, p.284.

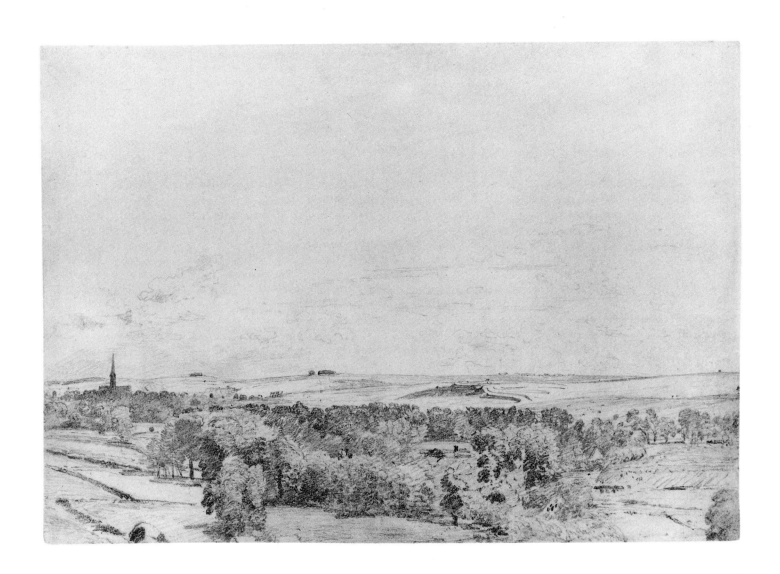

199

Workmen and Idlers Beside a Horse and Cart ?1818

Pencil on wove paper 100 x 133mm ($3\,^{15}/_{16}$ x $5\,^1/_4$ in), untrimmed
with stitchmarks down the left side; four pencil marks along the
top edge nearly equally spaced; inscribed in pencil '1818' b.1.

PROVENANCE:...; Christie's 21 March 1989 (lot 47, repr.)

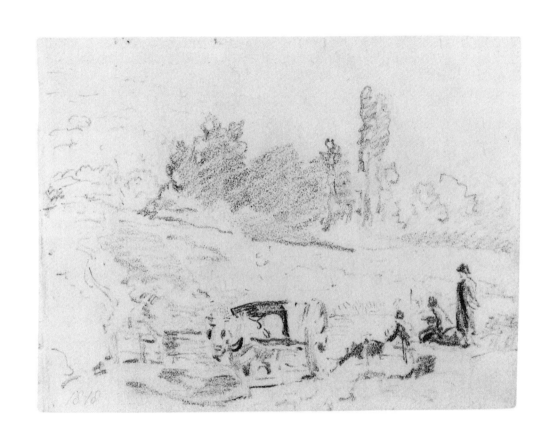

Seated Figures with a Horse and Cart ?1820

Pencil on wove paper 93 x 130mm ($3^7/_8$ x $5^1/_8$ in), untrimmed with stitchmarks along an irregular left side; inscribed in pencil '1820' b.l.

PROVENANCE:...; Christie's 21 March 1989 (lot 49, repr.)

Both of these drawings are slightly puzzling. They appear to have come from the same sketchbook, the one Constable used in 1818 (see no.43). The inscriptions seem to be in the artist's hand and the digits '18' and '20' are quite clear, yet they appear to have been written at the same time with the same pencil. Are these dates correct, and where exactly did he make the drawings?

After his return from Salisbury in 1820 Constable wrote to Fisher on 1 September, 'We had a pleasant journey to London – in truth we were made far more fit for such an exertion by the unbounded kindness and hospitality of yourself and Mrs. Fisher – & our good friends at the palace – indeed my dear Fisher my wife & myself feel quite at a loss to speak to you of those things.' He apologized for not having written sooner, and said he had found much to do, but had settled his wife & children comfortably at Hampstead 'I am glad to get them out of London'.[1]

On the Heath Constable made several pencil sketches of men at work, with their horses and carts; sometimes the workmen featured in his paintings of Hampstead. No.57 looks very like one of these sketches, but there is no record of him having been there in 1818. It was in the little 1819 sketchbook that he made his first drawings at Hampstead. No.58 on the other hand, is similar to some of the preparatory drawings he made for a painting in his 1814 sketchbook, a painting in Boston, a view of Dedham, which shows men at work at a dunghill (figs.91 and 92).[2] It may be recalled that he was at East Bergholt for the sale of the family home in the autumn of 1818, that is, at the very same time in the agricultural cycle, and could well have again witnessed 'muck-spreading'. But there is no evidence that he was there in 1820. He did occasionally confuse his months and even years. Could he have inadvertently reversed the dates on the two drawings?

1 JCC VI, p.56.
2 See Tate 1991, no.74, p.l58. Also no. 73 and figs.48-9 for detail and sketches of the work at the dunghill.

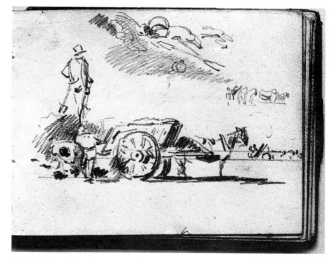

91 John Constable, *Men loading a Cart*, 1814, pencil on wove paper 80 x 108mm ($3^1/_8$ x $4^1/_4$ in), p.54 in the 1814 sketchbook. Board of Trustees of the Victoria and Albert Museum, London

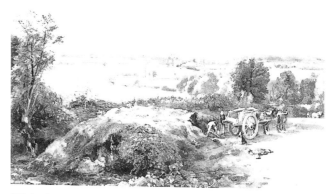

92 John Constable, *The Stour Valley and Dedham Village*, 1814-15, oil on canvas 553 x 781mm ($21^3/_4$ x $30^3/_4$ in). Museum of Fine Arts, Boston, Warren Collection

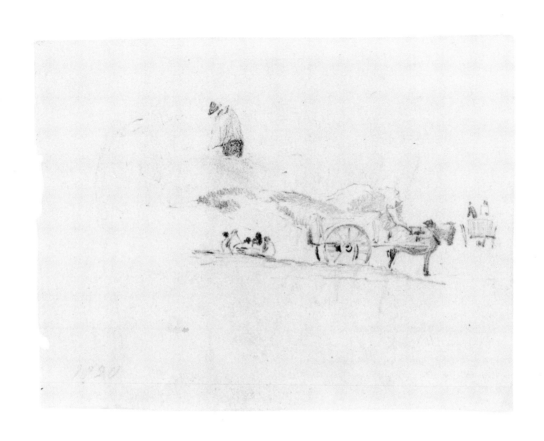

Greenham Lock 1821

Pencil on wove paper 175 x 248mm (6$^7/_8$ x 9$^3/_4$ in), trimmed; inscribed in ink 'Lock near Newbury/ June 5 1821' b.r.; on the back, down the right-hand edge, part of a river scene with trees (see below)

PROVENANCE: By descent to Charles Golding Constable; Christie's 11 July 1887 (lot 9); Noseda; J.P.Heseltine by 1902;...; Francis L. Berry; Christie's 12 June 1936 (lot 35);...;P.M.Turner 15 June 1936; by descent; Sotheby's 15 March 1984 (lot 89, repr.)

Fisher had written to Constable with the news of his recent installation as Archdeacon of Berkshire in December 1817, '...the emoluments are nothing; the honour something'[1]. In the execution of his duties in this office, Fisher was expected to make a tour each year of his four rural deaneries, Newbury, Reading, Wallingford and Abingdon. He had only just returned from his Visitation in 1820 when Constable and his family came to stay[2]. The Archdeacon proposed that Constable should accompany him on his next tour, in a letter of 6 March 1821, 'The first week in June I go my Visitation. Will you accompany me free of expence. I shall take Oxford in my way'[3]. The tour began in Newbury on 4 June and ended at Oxford on the 9th. Constable sketched at a remarkable rate, producing eighteen drawings in those six days, mostly from the banks of the Kennet and Avon canal and the Thames. On 5 June he made three drawings, including no.59, all of the canal downstream from Newbury.

All but five of the drawings are composed, carefully worked pencil studies. What was his purpose in making such drawings? Many of his pencil sketches, as we have seen, played an important part as source material for his paintings. But studies of a pictorial character such as these were seldom used. Nor, it seems, were they intended for exhibition. Primarily, of course, Constable drew outdoors whenever he had the chance because for him it was the most natural thing to do, and on this trip, while Fisher was engaged with his duties, he was able to work on a drawing as long as he liked. But apart from personal satisfaction there was the additional stimulus that such drawings would be most admired by members of his immediate circle. There are many references to his sketchbooks being passed around among his friends. They were also seen by total strangers. Fisher told Constable of a 'gentleman of property', an admirer of his art, who 'was first caught by a sketchbook of

yours which I had. Your pencil sketches always take people: both learned and unlearned. Surely it would answer to publish a few of them.'[4]

Throughout his working life, Constable's desire for public recognition, for the 'fame and gain' so often reiterated in his family's letters, was a strong motivation, and as he was a professional man, 'gain' was not necessarily the lesser aim. His practical viewing of the sketches he had made while accompanying Fisher, is echoed in his brother Abram's letter of 17 July, 'I am glad you had a pleasant ride & excursion, & as you hinted, it may be productive of profit one time or other.....fame is desirable & is what you aim at I know & admire.'[5]

In Constable's drawings of Shottesbrooke and Flatford (nos. 39 and 60), we have examples of him extending a sketch from one page of an open sketchbook to another. *Greenham Lock* was drawn on a right-hand page of his sketchbook. On the next right-hand page he made another careful study that day of one of the West Country barges moored alongside the bank. This he extended on the left-hand page, i.e., on to the back of no.59. So, to be able to read this Huntington drawing correctly, we have to include part of the right-hand edge of the back of *Greenham Lock*, as in fig.93.

93 John Constable, *Near Newbury*, 1821, pencil on wove paper 173 x 259mm (6$^{13}/_{16}$ x 10$^3/_{16}$ in), here shown with the drawing as continued on the back of previous page – ie. *Greenham Lock*, no.59. Henry E. Huntington Library and Art Gallery, San Marino

1 JCC VI, p.34.
2 Ibid., p.53.
3 Ibid., p.64.
4 FDC, p.118. See no.65 for Constable's response to a proposed publication.
5 JCC I, p.197.

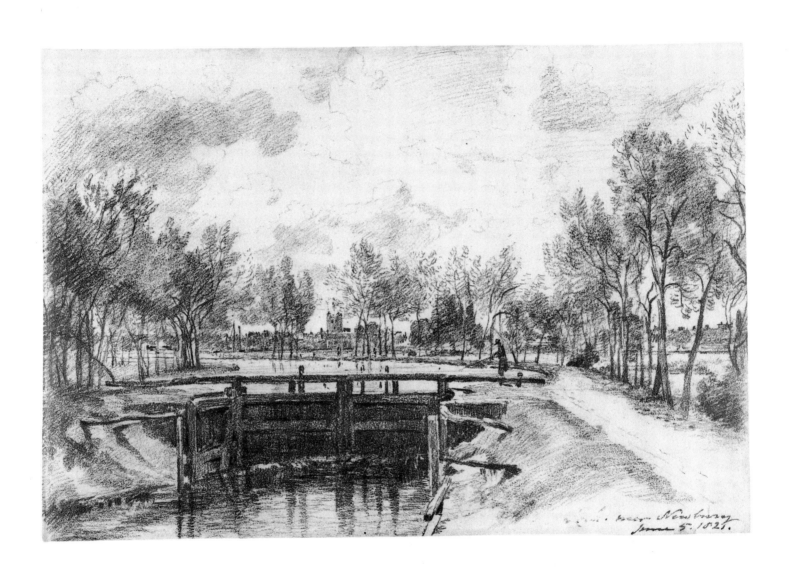

Lock near Newbury
June 5. 1821.

Flatford Lock 1823

Pencil and grey wash on two trimmed sheets of wove paper from adjoining pages of a sketchbook 172 x 50mm (6$\frac{3}{4}$ x 1$\frac{5}{16}$ in) and 172 x 267mm (6$\frac{3}{4}$ x 10$\frac{1}{2}$ in); inscribed in pencil 'Flatford 19 April 1823' b.r. and in another hand in faded ink 'April 19 1823'

PROVENANCE: By descent to Charles Golding Constable; given by him to A.J.Clark; by descent; Sotheby's 21 November 1985 (lot 118, repr.)

This is the first of three drawings done on successive days during a visit to Flatford in the spring of 1823[1]. It is not known for certain what had brought Constable there, but the trip may have had a dual purpose: to discuss his handicapped brother, Golding's employment as overseer of the Countess of Dysart's woods at Bentley, nearby, and to collect material for a painting he was working on.

A couple of months before, he had told Fisher that he had 'put a large upright Landscape in hand', which he hoped to have ready for that year's Academy.[2] This, it is generally agreed, must have been the painting, or the full-size sketch for it, which was in fact exhibited the following year, *The Lock* of 1824 (fig.94), an upright of the entrance to Flatford lock viewed from the same spot as no.60. The entrance to the lock as he finally depicted it, and may so have envisaged it when planning the work, was in a fairly dilapidated state, some of the timbers rotting, the bank overgrown with water-side plants. It was four years, however, since he had been to Flatford and there had been changes; the lock was not as he may have remembered it and even, perhaps, drawn it.[3]

For some years his brother Abram, who managed the mill and the family business, had been concerned about the condition of the lock. In 1815 he had complained to the Stour Navigation, the body responsible for the upkeep of the canalized river, 'that Flatford Locks are in a ruinous state, that the upper Gates thereof cannot be opened without the assistance of an Horse'.[4] Although it was ordered that 'the same be repaired compleatly within nine months' nothing apparently was done. So in May 1820 Abram again complained, stating that 'Flatford Locks are in a ruinous state and in great decay and the bank of the River in a very dangerous state.'[5] This time it was ordered that the lock should be repaired in one month. The order was carried out. In no.60 we can see that there is a new brace against the nearest upright, that

bolts had been re-sited, boards at the entrance renewed and the bank rebuilt. In the painting (fig.94) the lock is as it had been. Constable evidently preferred it in its 'ruinous state'.

Our wash drawing, no. 60 is from a sketchbook that he had partly filled during his Berkshire tour with Fisher two years before (see no.59). Bringing this book with him, rather than a more convenient one that he could slip into a pocket, suggests that collecting material for his picture had been the prime purpose of this visit to Flatford.

With the pages of a sketchbook open before him, Constable, as we have seen (nos. 39 & 59), would sometimes extend a drawing over on to the left-hand page. This is what must have happened when he was sketching the lock. It is unfortunate that there was a slight loss when the pages were removed from the book, so that the edges are not correctly contiguous.

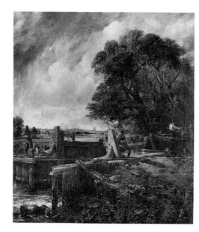

94 John Constable, *The Lock*, 1824, oil on canvas 1422 x 1207mm (56 x 47$\frac{1}{2}$ in). Thyssen-Bornemisza Collection

1 The others, of the Boathouse at Flatford and a farm at Bentley, were both fully detailed pencil studies (see, Reynolds 1984 23-9 and 10, pls 398 and 9).
2 JCC VI, p.112.
3 It is possible that he had had an early drawing to work from, a drawing now missing but similar to one he had used for his painting *Boys Fishing* of 1813. See, Tate 1991 no.57 and fig.37, p.131.
4 East Suffolk Record Office, EI 1 394/1, Minute Book, Stour Commissioners.
5 Ibid.

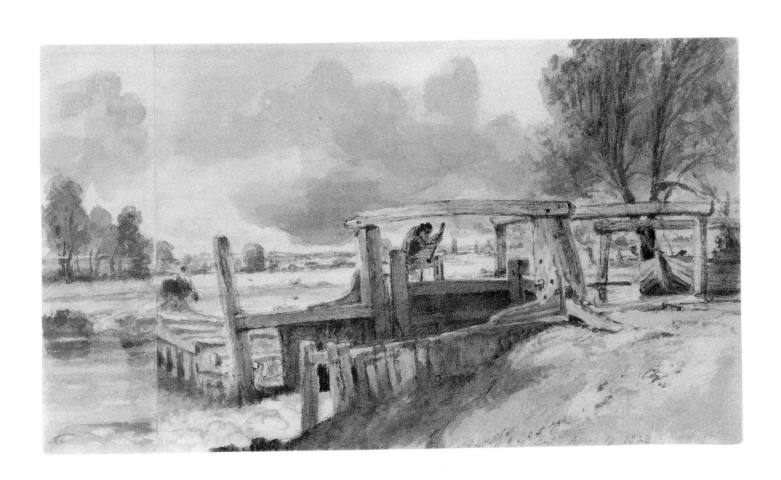

A Wooded Lane 1823

Pencil and grey wash on wove paper 168 x 252mm (6$\frac{3}{8}$ x 9$\frac{7}{16}$ in); inscribed in pencil 'June 27. 1823' b.l.; on the back, a small pencil sketch of a woman and two children

PROVENANCE:...; acquired later 1950s; by descent; Sotheby's 11 April 1991 (lot 41, repr. col.)

In June 1823 Constable again took a house at Hampstead for his family, chiefly for the sake of his wife's health. This time it was Stamford Lodge, only a short distance from the Heath and the Vale of Health. On 21 June, at nine o'clock in the evening, to celebrate his release from the confines of his house in Charlotte Street, he made two beautiful pencil studies of trees[1]. On the 26th he painted a watercolour of the Lower Pond (fig. 95) and the following day, this time in plain grey wash, no.61, an unusual work with its soft cabbagey trees, a view less readily identifiable as a Hampstead subject. The somewhat generalised forms suggest that this was done from memory, rather than made on the spot.

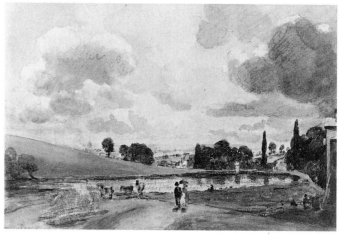

95 John Constable, *The Lower Pond , Hampstead*, 1823, watercolour on wove paper 169 x 253mm (6$\frac{5}{8}$ x 10in). British Museum, London.

1 See Reynolds 1984, 23.11 and 12, pls 400 and 401.

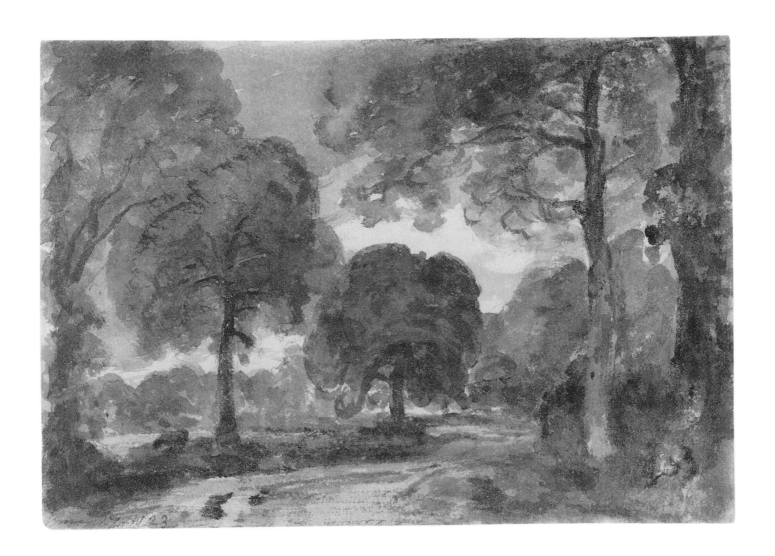

209

Fonthill Abbey from the Road 1823

Pencil on wove paper 177 x 258mm (7 x 10^1/$_{16}$ in), trimmed; inscribed in pencil 'Augt. 22. 1823' t.l.; on the back in pencil 'Sherborne Collegiate church / September 2. 1823'

PROVENANCE: By descent to Charles Golding Constable; Christie's 17 February 1877 (lot 171); Ellis; ...; Sotheby's 30 March 1983 (lot 142, repr.)

The inscription on the back of no.62 refers to a drawing Constable made of Sherborne Abbey Church on the next page of his sketchbook.[1] These two drawings were preceded by a sketch of Salisbury Cathedral dated 20 August, the first to be made in this new sketchbook[2].

In May 1823, Fisher took his leave of Osmington and moved his family to Gillingham in Dorset. Straightway he started making plans for Constable to visit him there. Constable was willing to join him as he had a commission to paint an old mill nearby. When Fisher tempted him with further picturesque mills, Constable replied 'you think "three mills" irresistable. but it is you I most want.' Fisher drove to Salisbury to meet Constable off the coach and on the 22nd they set off for Gillingham, twenty or so miles to the west, '...we came another Road to Gillingham from Salisbury', Constable told Maria,'- by. Mere – we passed Fonthill Gate – it is strange that such a building (so fairy like) & so truly by every standard a model of taste & elegance should be standing alone in these melancholy regions of the Wiltshire Downs'.[3]

It is understandable that Constable should call Fonthill 'so fairy like', but curious that he should do so in this letter, for he talks of having passed the gate, and from there it is unlikely he would have been able to see the house. He and Fisher returned there, however, a few days later when there was a viewing of a sale of pictures.

The previous October he had written to Fisher about the place when pressure of work had prevented him from getting away. 'I do not regret not seeing Fonthill. I never had a desire to see sights – and a gentleman's park – is my aversion.'[4] These much-quoted sentiments were quite forgotten when he wrote to Maria the day after his visit to 'that extraordinary place'. He had climbed to the top of the 225-foot tower and seen how Salisbury 'at 15 miles off darted up into the Sky like a needle – & the magnificence of the wood & lakes a wild region of the downs to the north', and was also quite won over by the interior. 'The entrance and when within is truly beautifull Imagine the <Cath> inside of the Cathedral at Salisbury or indeed any beautifull Gothick building magnificently fitted up with Crimson & Gold antient pictures in almost every nitch statues – large massive Gold Boxes for relicks &c &c beautifull & rich carpets Curtains & Glasses – some of which however spoiled the effect – but all this makes it on the whole a strange – Ideal romantic place – quite a fairy land.'[5] A colourful description, sharply at odds with the bleak view of the distant towers that he had obtained when driving by with Fisher on the road to Gillingham.

Constable appears to have made his drawing from beside the road about a mile and a half from Hindon. This is confirmed by his precise noting of the position of the tower of the Abbey in relation to its two small turrets. Fonthill Abbey was cruciform in plan, the 'nave' running approximately north and south, with the tower on the crossing and the two turrets at the end of the east 'transept'. Constable could see the northern turret, but the other was almost hidden by the tower. This establishes his viewpoint securely, as having been north-west of the Abbey, i.e., on the road to the west of Hindon, now the B3089.

1 Reynolds 1973, no.257, pl. 194.
2 Ibid., no.256, pl.195.
3 JCC II, p.283.
4 JCC VI, p.98.
5 JCC II, pp.284-5.

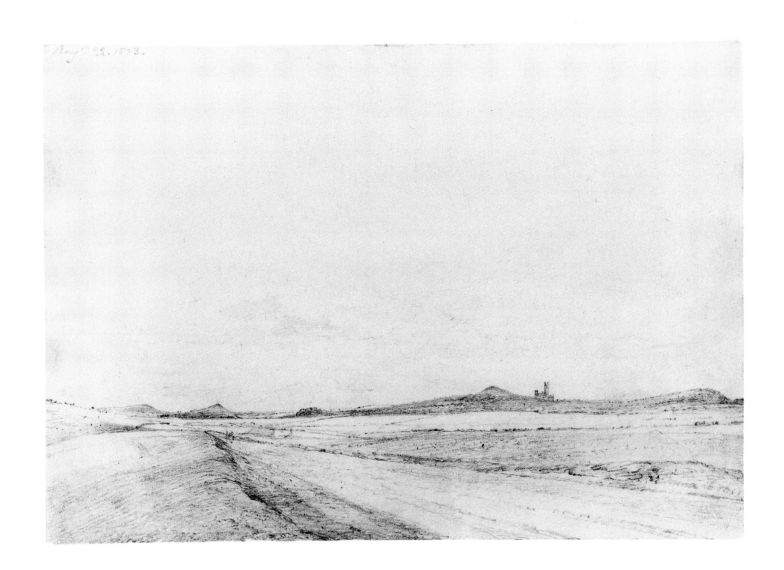

Aug.t 22. 1823.

211

A Path through a Wood, after Sir George Beaumont 1823

Pencil on wove paper 170 x 250mm (6^3/$_4$ x 9^3/$_4$ in), trimmed; inscribed in pencil 'Coleorton. 23d Oct. 1823' b.l.; 'East Bergholt/ tuesday Aug 5 / 1790' b.r.; on the back in pencil 'From a drawing by Sir George Beaumont, Bart Done at Coleorton Nov.1.1823 J.C.'

PROVENANCE:...; P.M.Turner; by descent; Sotheby's 10 March 1988 (lot 42, repr.)

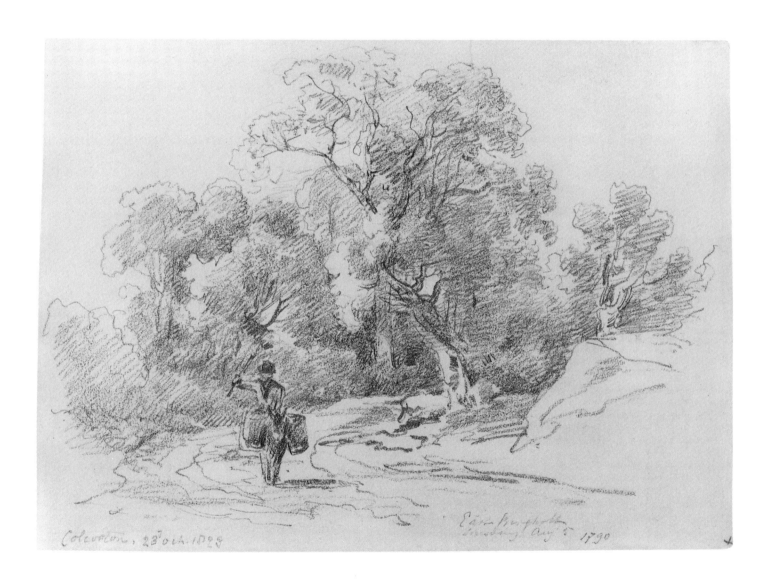

Colerton, 23ᵈ Oct. 1823

Edinburgh
Tuesday Aug 5 1790

64 Sir George Howland Beaumont,Bart.

A Path through a Wood 1790

Pencil on wove paper 170 x 250mm (6$\frac{3}{4}$ x 9$\frac{3}{4}$ in), trimmed; inscribed in pencil 'East Bergholt GHB. 1790 /Tuesday Aug 5'

PROVENANCE:...; P.M.Turner; by descent; Sotheby's 10 March 1988 (lot 42)

In the autumn of 1823 Constable spent nearly six weeks as a guest of Sir George and Lady Beaumont at their Leicestershire home, Coleorton Hall. Hitherto, as Constable's acknowledged superior in rank, Beaumont had been the kindly but condescending mentor. The recent success, however, of the big six-footers Constable had been exhibiting seems to have wrought a change in their relationship, and the hours they worked happily together upstairs in the painting room at Coleorton were spent in friendship, almost on equal terms. Beaumont urged upon his guest the necessity for exercise; he, himself always rode out in the afternoon 'fine or foul'. So, at two o'clock the horses were brought to the door and, Constable told Maria, 'Lady Beaumont hunts us both out.'[1]

With so many fine paintings in the house – works by Claude, Poussin, Wilson, Cozens and Swaneveldt – Constable was at the summit of his earthly ambitions. 'You would laugh', he told Maria, 'to see my bed room. I have draged so many things into it. books portfolios – paints canvases – pictures &c. and I have slept with one of the Claudes every night'[2]. It was the Claudes that kept him at work, copying, during the day.[3] In the evening, Sir George or his wife would read a play aloud, and a portfolio of his work would be brought out for inspection. 'I amuse myself Evgs', Constable said in a letter of 18 November, 'making sketches fr Sir Gs drawings about dedham &c – I could not carry all his sketchbook[s] – he has filled so many'.[4]

About half a dozen of Constable's Beaumont copies have been identified, but so far only in the present pairing, nos.63 & 64, do we have both the original and the copy.[5] There is something to be learned from comparing them. A prolific draughtsman, Beaumont seldom seems to have pondered long in front of the motif.

Constable endeavoured to ape his easy-going manner and succeeded up to a point, but was unable to conceal his own rhythmic energy and more profound experience of landscape. Beaumont drew the bank on the right with a few indecisive strokes; Constable with one or two vigorous lines. The road, rendered somewhat vaguely in Beaumont's drawing, is the means by which Constable firmly establishes his ground plane. Without prior knowledge, one might be forgiven for assuming Beaumont's work to be the copy; Constable's, the original.

1 JCC II, p.292.

2 Ibid. p.296.

3 See Reynolds 1984, 23.36, pl.424 for Constable's copy in the Art Gallery of New South Wales of Claude's painting in the National Gallery, *Landscape with Goatherd and Goats*. Constable also copied a painting, then attributed to Claude, *Landscape: the Death of Procris*, now also in the National Gallery, but catalogued as a copy, probably of the eighteenth century.

4 JCC II, p.302. Leslie, in his biography (*Life*, 1951, p.114), retelling what one imagines Constable must have told him, has this little exchange in his account of the Coleorton visit. 'Sir George recommended the colour of an old Cremona fiddle for the prevailing tone of everything, and this Constable answered by laying an old fiddle on the green lawn before the house', a retort that has been called the most famous in art history. Although Lady Beaumont took lessons on the organ later in life, neither she or her husband were musical and it seems unlikely that there was 'an old fiddle' so conveniently to hand. Perhaps Constable had made his point verbally, 'If I place a violin on the lawn...', and when retold the incident acquired a little local colour.

5 For the other copies, see Reynolds 1984, 23.27 (pl.415), 23.34 (pl.422), 23.75 (pl.461), 23.76 (pl.462) and 23.79 (pl.463).

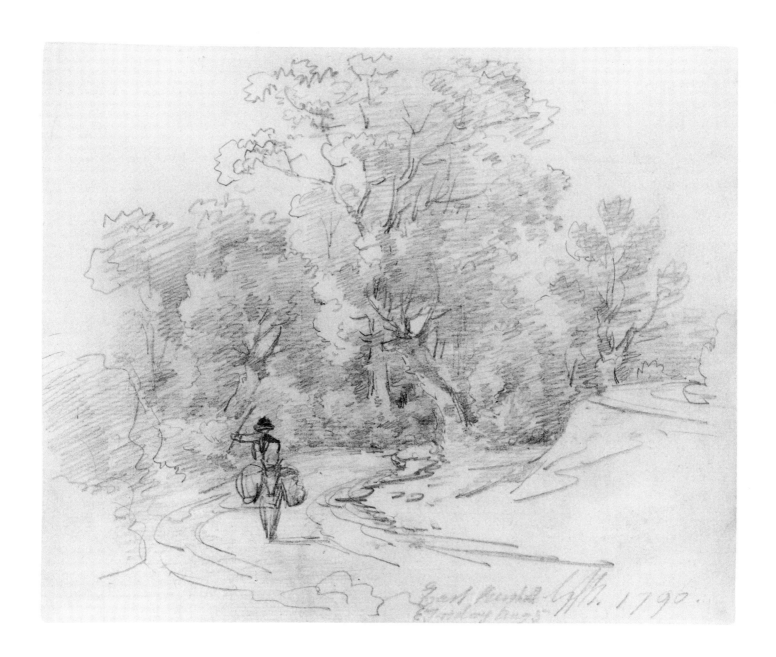

215

Worthing 1824

Pencil, reed or quill pen and wash on wove paper 178 x 259 mm
(7 x 10 3/16 in), trimmed; inscribed with pen 'Worthing/
Wednesday 22 Sep^r. 1824' b.l.; also, in pencil, vertically 'Goring'
t.r.[1]

PROVENANCE: By descent to Charles Golding Constable; Mrs
A.M.Constable; Christie's 11 July 1887 (lot 35); Noseda;
J.P.Heseltine; P.M.Turner 1935; by descent; Sotheby's 15 March
1984 (lot 92, repr.)

In May 1824, concerned at the state of his wife's health ('...this
warm weather has hurt her a good deal'),[2] Constable took Maria
and the children down to Brighton, choosing lodgings for them in
Western Place on the edge of the town, close to the front and to
open country. She stayed there with the children until November.
He joined them for a week in June and then for a long stay – July
to October.

In June he only had time for a few oil-sketches. In July, however,
he brought several works to be completed, and throughout that
and the following month was busy with his paint-box out of doors,
sketching life on the shore and in the nearby fields in all sorts of
weather conditions. Then, suddenly, he seems to have abandoned
oils and to have spent September and October on a series of draw-
ings of a character unique in his oeuvre – beach scenes most care-
fully worked in pen and wash over pencilled outlines. In almost all
these drawings Constable took as his main theme the long-shore
fishing fleet and the men who worked it, mostly with the vessels
beached, their sails and nets drying. In all, with associated pencil
drawings and studies of anchors and trawling gear, some thirty
such drawings of Brighton shore have been listed.

Constable's purpose in making the more formal pen and wash
compositions – such as his beach scene with Brighton Pier (fig.96)
and the signal station at Worthing (no.65) – is unclear, but he may
have had it in mind to prepare a group for publishing. In Dec-
ember they were seen by a French dealer, John Arrowsmith, who
had already bought *The Hay Wain* and *View of the Stour*, two of Con-
stable's major paintings, and he engaged him to prepare twelve of

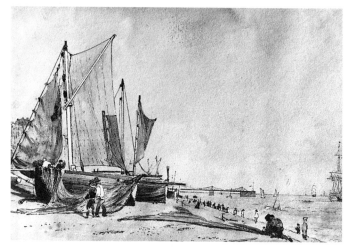

96 John Constable, *Brighton Beach with Fishing Boats and the Chain Pier*, 1824, pen, pen-
cil and watercolour 178 x 259mm (7 x 10 1/4 in). Board of Trustees of the Victoria and
Albert Museum, London

the Brighton views for the engraver, to be published in Paris.[3]
Fisher approved; 'Your sketch books', he wrote, 'would I guess
engrave well'.[4] But nothing more is heard of the scheme.

Worthing , dated 22 September, is the only one of the series to
have been drawn away from Brighton. With its complementary
sweeping curves of cloud and shore in a scene otherwise almost
bereft of incident, it is one of the most original drawings of the
series.

1 Goring, in Constable's time, was a village by the sea of some 500 inhab-
itants, 2 1/2 miles west of Worthing. It is not known why he should have
chosen to write its name in pencil thus, unless it was as a reminder of
some sort.
2 JCC VI, p.157.
3 Ibid., p.184.
4 Ibid., p.188.

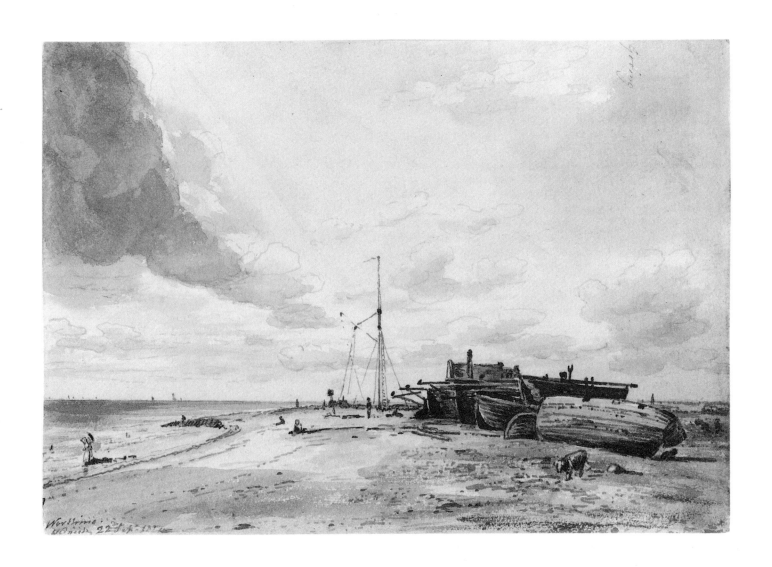

217

Colliers on Brighton Beach 1825

Pencil on wove paper 114 x 184mm (4$\frac{1}{2}$ x 7$\frac{1}{4}$ in), trimmed; inscribed in pencil 'Brighton / Oct. 14. 1825' b.l.

PROVENANCE:...; Sotheby's 16 July 1987 (lot 132, repr.)

In 1825, the summer at Hampstead had not provided the climate Constable's ailing wife and young children needed, so he took them down again to Brighton and found lodgings, this time in Russell Square. 'I am not happy apart from them even for a few days or hours', he wrote to a friend, 'and the Summer months separate us too much – and disturb my quiet habits at my Easil'[1]. They stayed on until the spring of 1826, he endeavouring to join them as often as work permitted.

In October, on one of his short visits, Constable made three drawings of colliers from the beach. Two, no.66 and a more distant view, fig.97, are dated the 14th. The third, fig.98 is not so inscribed, but is plainly of the same group of vessels. These coal brigs that supplied the increasingly prosperous resort with fuel, were a familiar sight, off-shore or beached. For Constable they were of special interest. The Suffolk coal trade had been an important part of the family business and, besides a fleet of barges, his father had built and managed sea-going vessels to ply between his wharf at Mistley, at the mouth of the Stour, and London. The previous year, among Constable's many drawings of beach scenes, four had been of coal brigs unloading when high and dry at low tide.[2] Normally these colliers appear to have arrived off Brighton and to have beached there at low tide in threes. In no.66 there is clearly a fourth vessel at the back, lying further off-shore. She apparently did not stay, for in neither of the other two drawings is she to be seen, unless that is her in full sail in the distance near the right-hand edge in fig.97.

In these drawings one can but marvel at the amount of information Constable manages to convey with minimal notation. Much of what he was sketching was in motion: in one, the pen and wash drawing, fig. 98, the vessels were still afloat and rocking to and fro, yet he gives a remarkably full account of their rigging; in no.66 he had little time to observe and note the men rowing out in their boats, yet how effectively has he caught the oarsmen and the figure in the stern of the nearest one, with his arm raised. With the slightest of touches Constable suggests so much, the wetness of the beach in fig.97 for instance, with five small strokes of the pencil under the nearest figure on the shore. So quick was his eye, sometimes he caught nature almost literally on the wing with his sketches of birds – a heron in flight at Flatford,[3] house-martins or swallows skimming over the river at Harnham Bridge,[4] or sand-martins, perhaps, in the bank of a sunken lane at Fittleworth, see no.81.

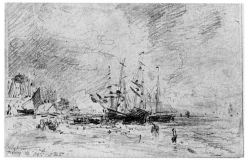

97 John Constable, *Brighton Beach with Colliers Ashore*, 1825, pencil on wove paper 115 x 185mm (4$\frac{1}{2}$ x 7$\frac{1}{4}$ in). Courtauld Institute Galleries, (Witt bequest 1952), London

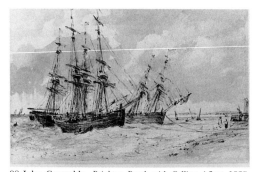

98 John Constable, *Brighton Beach with Colliers Afloat*, 1825, pencil on wove paper 115 x 178mm (4$\frac{1}{2}$ x 7 in). Private Collection

1 To Francis Darby of Coalbrooke Dale, 29 August 1825, JCC IV, p.99.
2 Reynolds 1984, 24.34, pl.506 and 24.47-9, pls 518-20.
3 Ibid. 27.30, pl.659.
4 Ibid. 20.55, pl.176.

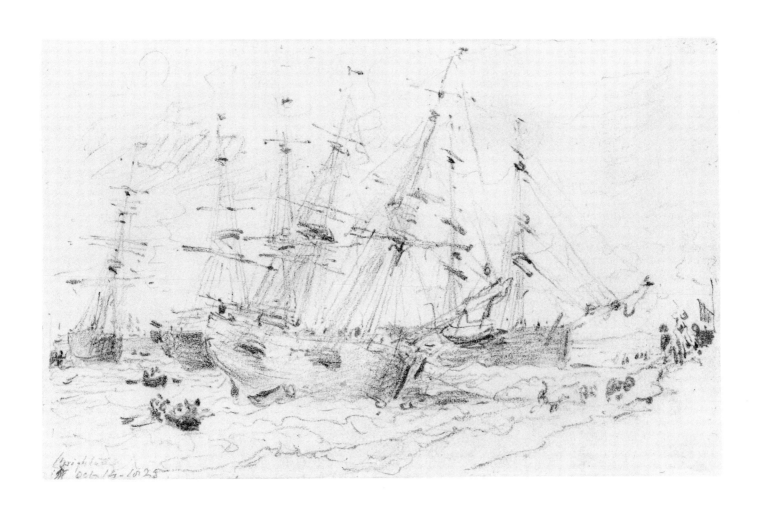

67

The Schooner Malta on Brighton Beach 1828

Pen and ink and grey wash over pencil 112 x 189 mm (4$^{7}/_{16}$ x 7$^{1}/_{8}$ in), trimmed; inscribed in pencil 'May 30. 1828' t.l.; on the back, an inscription in ink by Charles Golding Constable 'Brighton, Wreck of a schooner lying on the beach. May 30 1828 / J.C. made 4 other sketches of this wreck on the same day. And on the 29th. (the day previous), he likewise made 4 of her in different vie[ws]'; also inscribed on the back in ink by C.G.Constable's wife 'I certify this to be the work of my / late Father-in-law / J. Constable R.A. / A.M. Constable / May 18th 1877'

PROVENANCE: By descent to Charles Golding Constable ; his widow, Mrs A.M.Constable (later, Mrs Edward Ashcroft);...; Berkely Fase; by descent to a grandson; Phillips 30 April 1984 (lot 94, repr.)

Very different in character from the careful studies discussed under no.65, Constable's sketch of the schooner *Malta* beached at Brighton belongs to another unique series of drawings, a series recording a sequence of events he witnessed over a period of forty-eight hours.

On 29 May 1828, this stretch of the coast was swept by an unseasonably severe gale. The fishing fleet suffered the loss of many nets and some of the coastal vessels were driven ashore. Two of these were coal-laden, the *Shepherd*, further along the coast at Hove, and a schooner, the *Malta*, from Sunderland.[1] It was the fate of the latter, on the beach at Brighton, that Constable followed so closely. According to Charles's inscription on the back of no.67 his father had made nine drawings of the *Malta*, four on 29 May and five the next day. Five (with a possible sixth) dated 30 May are known, but so far only one of the scene on the 29th has come to light, a hasty pencil sketch of the schooner stranded, with a man aloft and a heavy sea breaking around her (fig.99).

The unusual sight of a vessel so high up the beach and the subsequent attempts to refloat her attracted a lot of attention from the townsfolk. No.67 is the only drawing in which there are no crowds around the stricken *Malta*. In the other four (two in pencil, two in wash) we see the schooner from close to, from the east – with the *Shepherd* aground in the distance – and from afar, a viewpoint to the west.[2] In no.67, the *Malta* is still aground, with shorelines to prevent her from listing over further; her fellow sufferer,

99 John Constable, *The Schooner Malta Ashore*, 1828, pencil on wove paper 115 x ?180mm (5$^{7}/_{8}$ x ?7$^{7}/_{16}$ in). Private Collection

the brig, is setting her sails and preparing to leave on the rising tide.

This was Constable's last season at Brighton. Maria's condition was steadily worsening, the hoped-for benefits of sea air having been of no avail. He reported her 'very sick' on 23 July and they returned to Hampstead the following week. The efforts to save the *Malta* were successful and she was floated off on 12 June. Constable's stricken wife did not recover. She died in his arms on 23 November.

1 Details of the storm and the stranded vessels are found in issues of the Brighton *Herald* and *Gazette*. On 12 June the *Gazette* reported that the attempts to get the *Malta* off 'having hitherto proved unsuccesful. A large concourse of spectators assembled on Sunday evening [the 8th] to witness the efforts then made; but owing to a rope breaking, the task was abandoned until the return of the spring tides.'
2 All the relevant drawings are reproduced in Fleming-Williams, 1990, figs 198-203, pp.215–9.

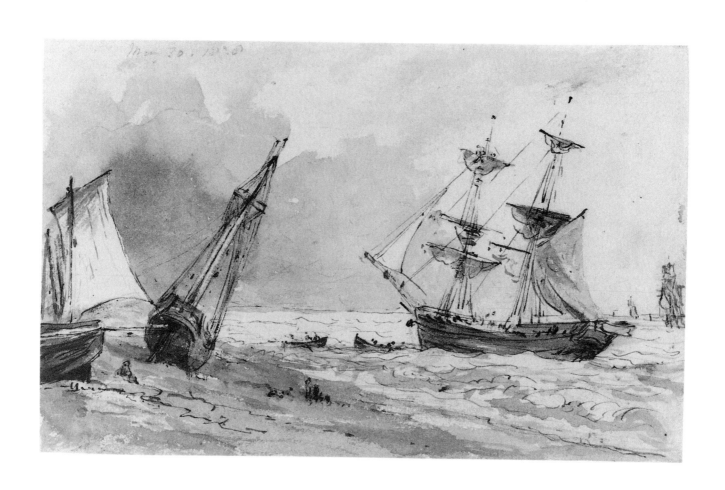

Study for 'Hadleigh Castle' 1828/9

Pen and iron-gall ink on wove paper 101 x 166 mm (4 x 6 $\frac{1}{2}$ in), the paper of a brownish hue due to action of the iron gall

PROVENANCE: By descent to Isabel Constable; given by her to Dr. G.D.D'Arcy Adams; by descent, through his daughter Mrs A.M.Austin; acquired by private treaty from Sotheby's February 1984

When in need of an idea for a major painting, Constable would generally turn for inspiration to his sketchbooks and early oil-sketches. For his sole exhibit of 1829 he found what he needed in a tiny pencil sketch of 1814 (fig.100), a view of Hadleigh Castle in Essex which he had described in a letter to Maria, of 3 July 1814, as 'a ruin of a castle which from its situation is a really fine place – it commands a view of the Kent hills – the nore and north foreland & looking many miles to sea.'[1]

His wife's death, though, as he said, long looked for, had overwhelmed him, leaving a void in his heart 'that can never be filled again in this world.'[2] A cloven tower standing in the midst of a ruin was therefore an understandable choice as the subject for his next exhibit.

It is not known when Constable began to develop the composition, but by February 1829 it was sufficiently advanced for his brother to refer to it as the 'Picture of the Nore.'[3] The first stage seems to have been a small squarish (8 x 9 $\frac{1}{2}$ inch) oil, almost a direct translation from the drawing of 1814.[4] Our pen and ink drawing, no.68, appears to represent a re-think. Along the top of one of the pages in his 1814 sketchbook Constable had drawn a minute panorama of the view across the Thames towards Sheerness and the Nore. [5] By extending the scene to the right, as in no.68, he was able to use this drawing, to make the great estuary and its shipping more of a feature and to achieve a better balance, a cantilever composition, as it were, with the tower as a fulcrum. There does not seem to have been a further stage, a work between this pen and ink composition and the six-foot sketch, now at the Tate, a canvas on which he appears to have vented to the fullest extent his pent-up grief (fig.101).

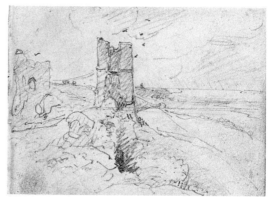

100 John Constable, *Hadleigh Castle*, 1814, pencil on wove paper 81 x 111mm (3 $\frac{3}{16}$ x 4 $\frac{3}{8}$ in). Board of Trustees of the Victoria and Albert Museum, London

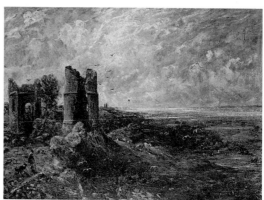

101 John Constable, *Sketch for 'Hadleigh Castle'*, 1828-9, oil on canvas 1125 x 1674mm (48 $\frac{1}{4}$ x 65 $\frac{7}{8}$ in). Tate Gallery, London

1 JCC II, p.127.
2 JCC IV, p.282.
3 JCC I, p.255.
4 Reynolds 1984, 29.3, pl.706.
5 Reynolds 1973, no.126, pl.100.

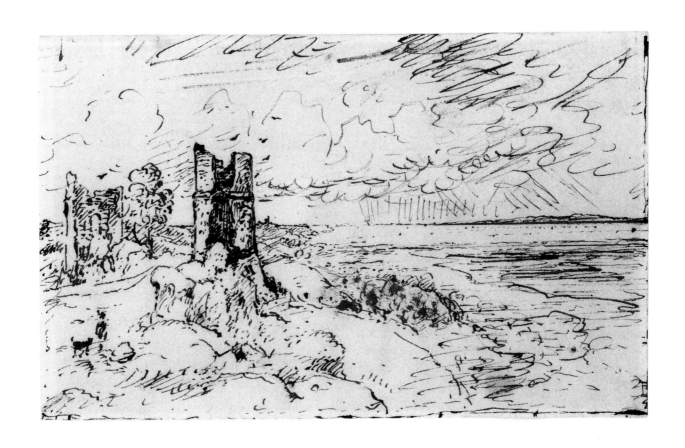

223

A Wooded Coastal Landscape 1829

Pencil on wove paper 114 x 183 mm ($4^1/_2$ x $7^1/_{16}$ in); inscribed in ink 'July 1829. Salisbury Close' b.l.

PROVENANCE: Presumably given by Constable to Archdeacon Fisher; by descent; Christie's 18 June 1980 (lot 40, repr.)

Three sketchbooks have survived containing drawings by John Fisher. In 1980 no.69 was a loose sheet in one of these, the 'Salisbury' sketchbook,[1] a book containing watercolours by Fisher and copies by him of Constable drawings and of etchings by the Dutch artist, Waterloo. One of these is inscribed 'J.F. 1822 a bad copy of a good Waterloo'.

Constable's final visit to Salisbury was in November 1829. No.69 was drawn when he and his two eldest children spent some three weeks with the Fishers there in July. It was another fruitful visit. Some of the sketches he made were of the cathedral from the banks of the river, material for his next great canvas *Salisbury Cathedral from the Meadows*[2]. Constable was an avid collector of prints and engravings. When his collection was sold after his death, the greater part of 5,000 items listed under 530 lots consisted of painters' etchings and engravings after the Old Masters.

This was a three-day sale.[3] No etchings by van Goyen were catalogued as such, but three days later there was a sale of Constable's own works with forty lots of paintings by Old and 'Modern' Masters, including two by (or attributed to) van Goyen.

From their description,[4] neither of the van Goyens bore any resemblance to the drawing under discussion, which seems to have been Constable's own invention, comprising van Goyen-like elements – the cottage, distant church (with a centre spire), riverbank and sailing boats – but with a very un-Dutch figure and with trees bending before a very un-Dutch, almost rococo wind. Constable may have been remembering, even talking about a van Goyen painting when he was making this drawing, but plainly it was never his intention, as it sometimes had been, to attempt a facsimile.

1 See Fleming-Williams and Parris 1984, p.185 n.*.
2 His main exhibit at the R.A. in 1831.
3 Fosters, 10-12 May 1838.
4 Lot 2 *A Landscape with travellers in a cart*; lot 13 *A Landscape with waggons descending a hill.*

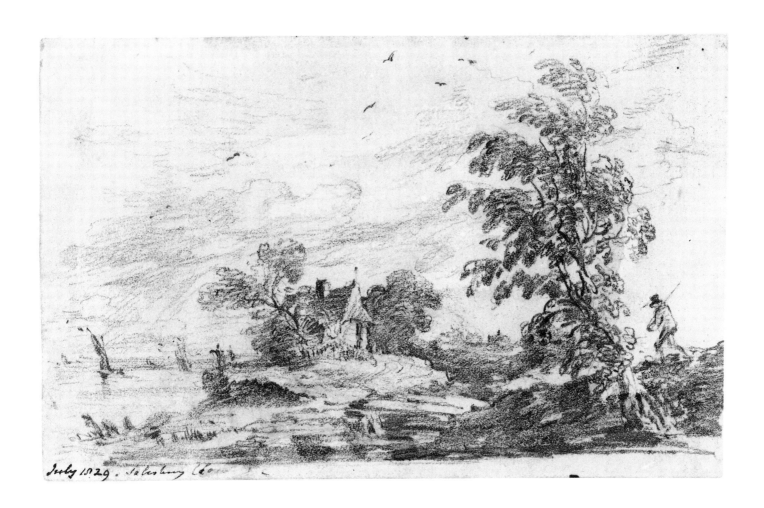

July 1829. Salisbury &c

Stoke-by-Nayland c.1830-35

Pencil and iron-gall ink wash with white heightening on wove paper 122 x 165mm ($4^{3}/_{16}$ x $6^{1}/_{4}$ in), irregularly trimmed; inscribed in pencil on the back '...I will no long omit[..] to you – I find [——]Stoke' and in a later hand in pencil 'R Thompson Esq from Isabel Constable'

PROVENANCE: By descent to Isabel Constable, by whom given to R.A.Thompson;...; Sydney Cowper; by descent; Sotheby's 16 July 1987 (lot 133, repr. in col.)

Situated on high ground a few miles up the Stour valley, Stoke-by-Nayland's 120-foot tower is seen quite often on the skyline in Constable's drawings and paintings of the views from East Bergholt, looking westwards – in nos 29 &30, for example. He also sketched the tower and church a number of times from the road below. This was the subject he chose for one of the mezzotints in his *English Landscape* and also for a late painting, a work now in the Art Institute, Chicago. The present drawing, no.70, relates to both the mezzotint and the painting, but how, exactly, is by no means clear.

The *English Landscape*, Constable's offering to the public of what Leslie Parris has called 'an epitome and justification of his life's work'[1] consisted of twenty-two mezzotints after a variety of his works, issued in five parts between June 1830 and July 1832. 'Stoke by Neyland', as he spelt it, appeared in the second part in January 1831, but a proof in the Metropolitan Museum (fig.102) with the rainbow touched in with white, is dated September 1830.

As we have seen in the little study for *Stratford Mill* (no.50), behind such seemingly free, somewhat 'blottesque' wash drawings, there is a greater degree of intent than might first appear to be the case. Were it not for the broken shadows in the right foreground and one or two other slight differences, one might assume that this wash drawing of Stoke-by-Nayland was a composition that preceded the dated proof in which Constable first introduced the rainbow. But these shadow shapes remind us that in 1835 he was contemplating another painting of the subject. He talks about the projected work in a letter to an amateur artist friend. 'What say you to a summer morning? July or August, at eight or nine o'clock, after a slight shower during the night, to enhance the dews in the shadowed part of the picture, under "Hedgerow elms and hillocks

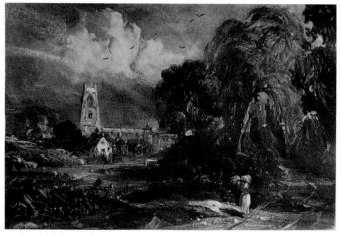

102 David Lucas after Constable, *Stoke-by-Nayland*, 1830, mezzotint on wove paper, plate mark 180 x 250mm ($7^{1}/_{16}$ x $9^{7}/_{8}$ in). Metropolitan Museum of Art, New York, Harris Brisbane Dick Fund

green"'. Plough, cart, horse, gate, cows, donkey, are then all listed as 'good painting material for the foreground'[2], and all but the donkey are to be seen in the foreground of the Chicago painting (fig.103).[3]

Parris lists three oil-sketches of this subject.[4] All three depict the lane moving into deep shadow with the light source to the right; in two, the woman with the bundle on her head figures prominently. None, however, conclusively matches the engraving. Constable appears to have given Lucas, his engraver, some other sketch to work from. The addition of a rainbow in the touched proof (fig.102) created an anomaly, for only when the sun is behind the viewer will a rainbow appear. This was partially remedied in the published state. In the Chicago painting the sunlight is pouring through the translucent leaves of the main tree, as it may well have done at nine o'clock on a summer morning, and consequently there is, of course, no rainbow.

Constable does not seem to have given much thought to the position of the sun in no.70 but it may have been the unintended effect of light coming through the branches of the main tree here

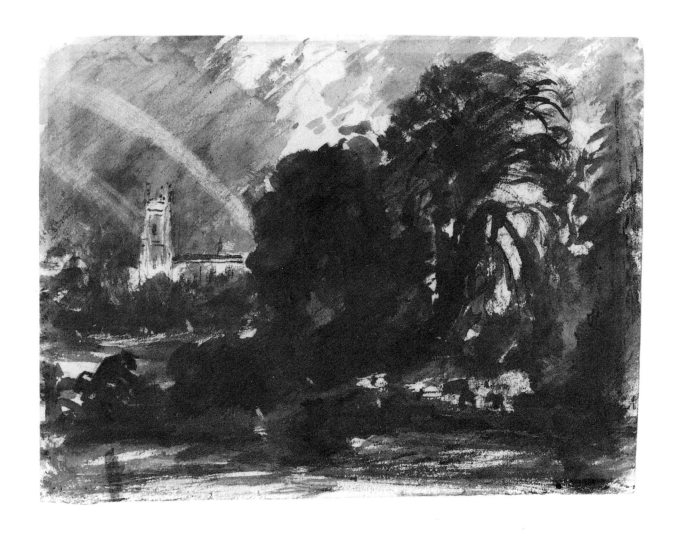

70 that gave him the idea of early morning sunlight for the picture he was planning. That, in other words, this wash drawing, no.70, was a preparatory work for the Chicago painting, rather than for an intermediate stage in the development of the mezzotint, and should be assigned therefore to 1835 rather than to 1830.

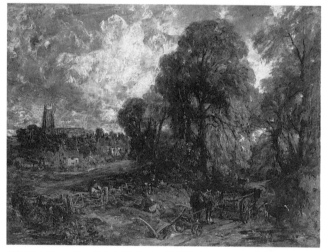

103 John Constable, *Stoke-by-Nayland*, c.1835-7, oil on canvas 1258 x 1685mm (49 1/2 x 66 3/8 in). Art Intitute of Chicago, Mr and Mrs W. W. Kimball Collection

1 *Tate Gallery Catalogue of Acquisitions 1984-86* , 1988, p.23.

2 A letter to William Purton, a Hampstead resident, which R.B.Beckett dates 1835, possibly July, JCC V, p.44. Purton's dates have not as yet been ascertained, but he gave invaluable help with the children after Constable's death; visited the East Bergholt area with C.R.Leslie in 1840; and was the author of two works on *Picturesque Beauty* , 1864 and 1865, in which he talks of having been for some years 'in constant intercourse' with Constable.

3 Leslie (*Life* , 1951, p.251) says that 'the large picture of "Stoke" was never painted', but in an unpublished article Charles Rhyne has argued cogently that this need not present a problem if the idea is accepted that the Chicago painting is a full-size sketch, not an unfinished picture.

4 Parris 1981, no.11 (p.61), figs 1 and 6, pp.60 and 63.

Dedham Vale from Langham 1830

Pen and iron-gall ink wash on wove paper 57 x 84 mm (2 1/2 x 3 1/2 in); inscribed in ink '23ᵈ De.ʳ 1830'; watermark '/ATMAN/ URKEY/3'; on the back in pen 'Stok/Noon/Sea be[each]/Old S[arum]', i.e., titles for the *English Landscape*

PROVENANCE:...; Sotheby's 19 November 1987 (lot 28, repr.)

In December 1830, the second number of the *English Landscape* was ready for publication and the third was in preparation. So far, proofs for this number had been taken for two of the titles, *Summer Evening* and *A Heath*. For the mezzotint he called *Summer Evening* Constable had chosen a painting exhibited in 1812 of a sunset seen from a field at East Bergholt, with Langham hills in the distance dark against the glowing sky.[1] No.71 provides the first evidence that Constable was then contemplating a view in the opposite direction as the subject for a new mezzotint, a view from the fields below Langham church, with the Stour winding its way past Dedham towards the open water of the distant estuary.

Constable had four paintings of this subject to choose from: three early sketches and a later work, a much larger unfinished canvas.[3] David Lucas, Constable's young engraver, began working from the version now in the Victoria and Albert Museum, but elements from all four paintings, as well as cattle from drawings and pencil outlines, seem to have been incorporated in the final published state.[4] No.71 is closest to the sketch in the Ashmolean Museum (fig.104) with its balanced composition of trees on either side, but what part the little drawing played in the development of *Summer Morning* it is really not possible to say, unless at this early stage Constable wished to see how this subject might look in monochrome – as a mezzotint.

1 See Tate 1991, no.33, p.101.

2 The 'Morning', as such, is first referred to in a letter to David Lucas of 19 February 1831, JCC IV, p.342.

3 All four paintings are reproduced in Tate 1991, nos 17-20, pp.79-82.

4 Op.cit., pp. 337-42.

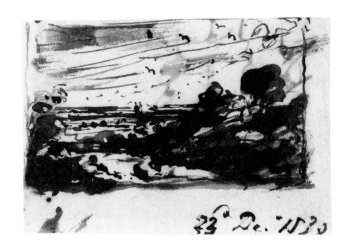

104 John Constable, *Dedham from Langham*, 1812, oil on canvas 190 x 220mm
(7 1/2 x 8 5/8 in). Ashmolean Museum, Oxford

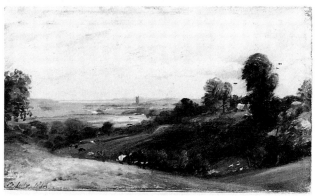

The Small Salisbury 1832

Mezzotint on wove paper with grey wash and white heightening 225 x 284 mm (8 $^7/_8$ x 11 $^3/_8$ in); plate 176 x 252 mm (6 $^{15}/_{16}$ x 9 $^{15}/_{16}$ in); image 137 x 213 mm (5 $^3/_8$ x 8 $^3/_8$ in)

PROVENANCE:...; P.D.Colnaghi; R.L. Murphy; Christie's 5 November 1985 (lot 96, repr.)

Constable involved himself closely with the engraving of the plates for his *English Landscape*. David Lucas sent proofs at each stage and Constable expected the young engraver to execute promptly any changes he thought necessary. Instructions for alterations or additions were sometimes sent by letter, but more often by the return of a touched proof, that is an impression on which he had worked with pencil or wash and occasionally with white heightening.

The original for the *Small Salisbury* was an oil sketch that Constable had painted from a drawing of 1829 of the cathedral from Longbridge, on the outskirts of the city.[1] The mezzotint had at one time been intended for the fifth and final part of the *English Landscape*, but it had given trouble. With his own paintings Constable was finding it increasingly difficult to let well alone, and would often work and re-work a canvas, sometimes, one feels, almost to its death. This restless spirit was expressed in the seemingly endless changes he demanded for some of the mezzotints, and is also found in his correspondence with Lucas, which occasionally was of an explosive nature.

The *Salisbury* is first mentioned in a letter of 1831 '...& how is the first proof of the "Salisbury from the Meadows?" '.[2] On 3 October Lucas is asked to bring a proof by 3 o'clock the next day, 'and then we shall have light enough to touch the *"Title"* & the *"New Sarum"*'.[3] In December Constable was crippled by a severe attack of rheumatism and, confined to his bed, was unable to write. Letters were dictated. However, by the middle of January 1832, though still in great pain, he was able to work on a proof, on no.72, which appears to have been the ninth state of the Longbridge view. Two days later his eldest, fourteen-year-old son took down the following note for Lucas.

> Dear Sir
> Papa desires me to say that he is anxious to see you as soon as possible for – *he has cut you out a week's work* on the Salisbury
> I am yours truly
> John C.Constable
> Sunday evening; January 15th 1832 [4]

Work on the plate continued but by the end of February Constable decided to call a halt. 'I really consider the state of the Salisbury plate is so utterly hopeless', he wrote on the 28th, 'that I have come to the determination to abandon it'.[5] And on 3 March told C.R.Leslie that 'Lucas & myself have contrived to spoil the little Salisbury between us – so you must value the early proof which I now send.'[6] The story does not end here though, for, after the publication of the final part of the *English Landscape* Constable had plans for an appendix, for the use of some of the abandoned plates, including the *Salisbury*. 'What a pity I did not let well alone', he told Lucas in September, 'it is beautiful'.[7] Although there was another series of proofs, this scheme came to nought and the small *Salisbury* was only finally published in 1838, after the artist's death.

Only a few small areas of the proof remain untouched in no.72 – it is in fact almost entirely a work of Constable's hand. In fig.105, reproducing a proof similar to the one the artist worked on, we can see some of the changes wrought by the bed-ridden Constable, such as the increasingly threatening sky and the overall darkening of the lights, darks that must have reflected only too well his state of mind at this difficult time.

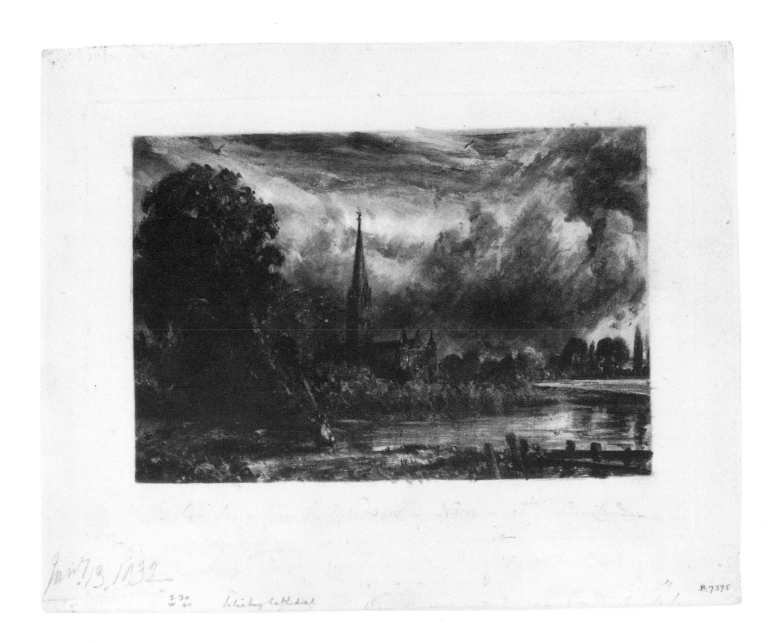

Jan.y 13. 1832

S 30
W 40 Salisbury Cathedral

231

72

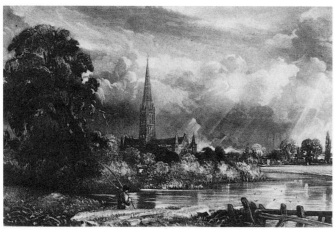

105 David Lucas after Constable, *The Small Salisbury*, 1832 progress proof mezzotint on wove paper, plate mark 175 x 250mm (6 7/8 x 9 7/8 in). Fitzwilliam Museum, Cambridge

A Landscape Composition with Horse and Rider c.1832

Pencil and brown wash on wove writing paper 94 x 134mm (3 11/16 x 5 1/4 in), irregularly trimmed; on the back a slight pencil study of a sky with a rainstorm and a roughly sketched-in foreground

PROVENANCE:...; Christie's 12 July 1988 (lot 33, repr.)

1 See Tate 1991, no.206 and fig.105, pp. 360 and 361.
2 JCC IV, p.349.
3 Ibid., p.356. The '*Title*' was the frontispiece for the *English Landscape*, a view of the back of East Bergholt House, his birthplace.
4 JCC IV, p.364.
5 Ibid., p.367.
6 JCC III, p. 63.
7 JCC IV, p.381.

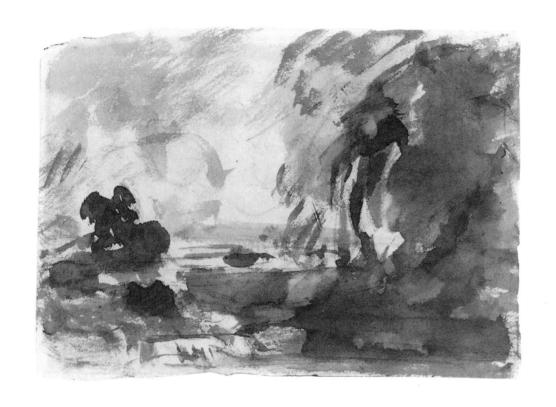

On the Stour c.1832

Pencil, pen and brown ink and brown wash on wove paper 114 x 187 mm (4 $^1/_2$ x 7 $^3/_8$ in); watermark '/TMAN/31'

PROVENANCE:...; Mary Christina, wife of Frederick Hornby; by descent from Mrs Hugh Vaux, née Hornby; Lawrence Fine Art, Crewkerne, 19 April 1979, (lot HA14 repr.)

At first sight no.73 appears to be a study, in reverse, for Constable's painting *The Leaping Horse* [1], which has a boy rider urging a tow-horse over one of the jumps that kept cattle from straying along the banks of the Stour. But it is much more closely associated with no.74; with a watercolour Constable made on a visit to East Bergholt in 1832 (fig.106) and, less directly, with one of an often reproduced pair of wash compositions that are generally given a later date (fig.107).

Constable's first six-footer, *The White Horse* [2] of 1819, depicted a barge being manoeuvered across the Stour from one towpath to the other, with a grey tow-horse (the 'White Horse') standing in the bows. In fig.106 we appear to have another crossing, but this time the water is shallow and there is no need for the horse to be ferried over. Presumably the boy is dismounting, for in no.74 he is clearly scrambling up on to the bank to join his charge. Here, just in front of the horse, is an example of a 'jump' over which the boy may have to take his steed. In design, the two drawings, no.74 and fig.106 are curiously static. Constable does not often present his barges so, frontally, as if for a stage set, nor, as in no.74 with the barge seeming so uncomfortably long.

In the vertical wash composition (fig.107) it is just possible to make out the boy and horse in the river with the bow of the barge close by. The mass of trees on the right and the horse and rider are common to all four drawings. It is not clear, however, whether Constable was envisaging a barge in the bottom right-hand corner of no.73. Free of all constraint, spatially this is perhaps the most exciting drawing of the group, with its whirling tonality, the leaping horse dark against the glistening distance and the contrasting, sharp little touches suggesting an animated foreground.

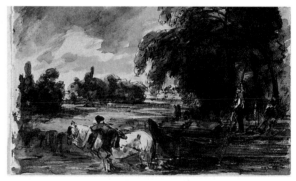

106 John Constable, *A Barge on the Stour*, 1832, pencil, pen and brown ink and watercolour, 115 x 192mm (4 $^1/_2$ x 7 $^5/_8$ in). Board of Trustees of the Victoria and Albert Museum, London

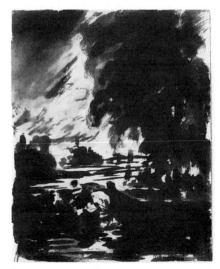

107 John Constable, *Trees and a Stretch of Water on the Stour*, c.1832-6, pencil and brown wash on writing paper 205 x 162mm (8 x 6 $^3/_8$ in). Board of Trustees of the Victoria and Albert Museum, London

1 See Tate 1991, no.162, p.295 and a detail facing p.283.
2 Ibid., fig.65, p.194.

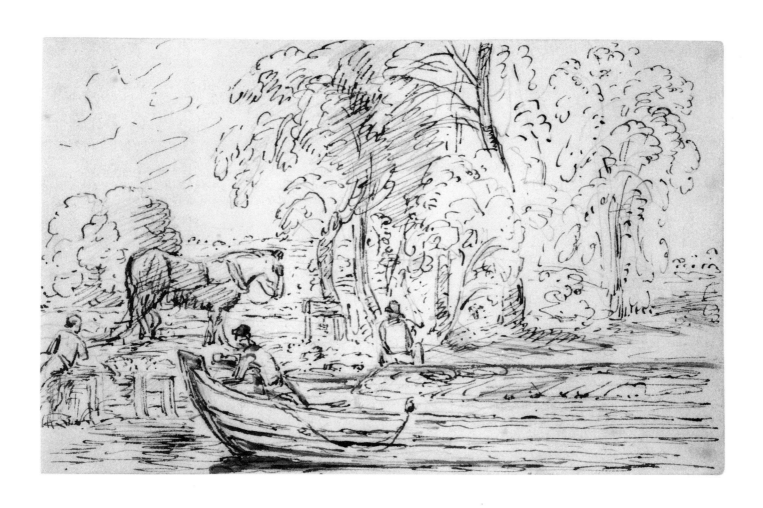

235

On the Arun 1834

Pencil on wove paper 136 x 230mm (5³/₈ x 9 in), trimmed; inscribed in pencil 'July 19 1834.'

PROVENANCE:...; Mary Christina, wife of Frederick Hornby; by descent from Mrs Hugh Vaux, née Hornby; Lawrence Fine Art, Crewkerne, 19 April 1979, (lot HA15, repr.)

'An extremely interesting portion of Constable's works [C.R.Leslie wrote in his *Life*] is known only to his intimate friends – I mean the contents of his numerous sketchbooks ... and in looking through these books one thing is striking, which may be equally noticed of his pictures, that the subjects of his works form a history of his affections.'[1]

Leslie goes on to list Bergholt, Salisbury, Osmington, Hampstead, Gillingham, Brighton and Folkestone (where his boys were at school) and scenes in Berkshire when he was with Fisher. Through another friend there was a final renewal of outdoor sketching in 1834 – 35,[2] that produced around fifty drawings and watercolours, and almost filled another four sketchbooks.

Constable's new friend was George Constable (no relation) a prosperous brewer in Arundel, who had been shown the *English Landscape*, was fulsome in its praises, and had immediately written to ask the price. They met – in December 1832 – and, most unusually, Constable appears to have taken a liking to him straightway, but it was not until the summer of 1834 that he was able to accept an invitation to stay with the brewer and his family in Sussex.

During this ten-day visit in July, Constable made drawings of some of the places to which he was taken – Bignor Park, Petworth, Chichester, etc. But the subject of no.75 he found near at hand, on the edge of the town. The drawing was given its present title when it came to public notice in 1979, but although the masts on the left of the drawing clearly belonged to a vessel on the Arun (see fig.108), the barge must have been in a creek, or, more probably, in view of the water-wheel against the building, a tidal mill-pool.

Constable made two drawings on 19 July, no.75 and a view of the castle from the east.[3] This was his first sketch of the Duke of Norfolk's recently rebuilt residence, an imposing silhouette from this angle. During his second visit, in July of the following year, he made a number of preparatory studies of the castle. It was on the

painting from these studies, *Arundel Mill and Castle*,[4] that he was working on the day he died, 30 March 1837. No.75 exemplifies the increasingly fluent and inventive manner that Constable was developing in these last years. In a number of the Sussex drawings the almost frenetic pencilwork must surely signify haste, perhaps because he was keeping his friends waiting, but he had written ecstatically about the scenery around Arundel: 'I never saw such beauty in *natural landscape* before'[5], and the vigorous handling in the briefest sketches as well as in drawings such as no.75 surely reflect his excited response to the Sussex landscape. Much of it was of a character entirely new to him, but obviously it was for the familiarity of its ingredients – the windmill on the right, the barge, the water-mill and even the men at work on the sail up aloft – that Constable chose to draw this rural backwater. Barges, so much part of his early life, caught his eye wherever he went.[6]

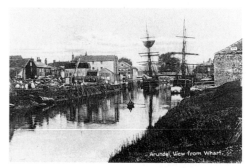

108 *Arundel Docks*, photograph taken c.1870. Arundel Museum and Heritage Centre

1 Leslie 1951, p.288.
2 There is no evidence that Constable drew or painted out of doors after his trip to Worcestershire in the autumn of 1835.
3 Reynolds 1984, 32.24, pl.933.
4 Ibid., 37.2, pl.1087.
5 In a letter to C.R.Leslie of 16 July, 1834, JCC III, p.111.
6 Two of his last drawings from nature were of barges on the banks of the Severn, see fig.65 and Reynolds 1984, 35.28, pl.1037.

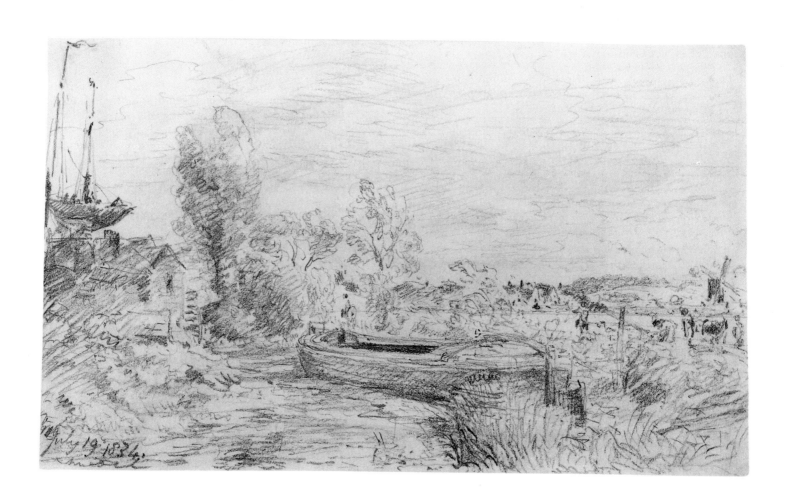

July 19 1824

Cowdray Castle 1834

Pencil on wove paper 206 x 271mm ($8^1/_8$ x $10^5/_8$ in), slightly trimmed l.; inscribed on the back in pencil 'Petworth/Cowdray Castle', also on the back a slight sketch of a man and a cow

PROVENANCE:...; Christie's 12 July 1988 (lot 21, repr.)

Constable had met Lord Egremont for the first time when he visited Petworth with his Arundel host and hostess in July. The Earl had then warmly invited Constable to stay, an invitation which, in September, he had eventually been persuaded to accept. Leslie, a fellow guest tells how

> Lord Egremont, with that unceasing attention which he always paid to whatever he thought would be most agreeable to his guests, ordered one of his carriages to be ready every day, to enable Constable to see as much of the neighbourhood as possible. He passed a day in company with Mr. and Mrs. Phillips[1] and myself, among the beautiful ruins of Cowdray Castle, of which he made several fine sketches.[2]

Leslie's 'several' sketches consisted of no less than six large pencil drawings and three watercolours, a remarkable day's work.[3]
From Petworth, Cowdray would have been little more than half an hour's drive. One of the watercolours was a view of Cowdray from a distance as Constable would have first seen it among dense woodlands, with the South Downs behind (fig.109). Roofless since a disastrous fire in 1793, Cowdray was built in the middle of the sixteenth century to replace a moated stronghold of the Bohuns. When Henry V111 visited it in 1538 his host was William Fitzwilliam, Earl of Southampton, whose portrait by Holbein was subsequently lost in the fire of 1793. Now – and when Constable saw it – neither the north nor the south ranges, that originally enclosed a courtyard, are standing. Four of his drawings were of the gate-house, two from inside the courtyard, two, including no.76 from a distance to the west.
On 12 September, two days before the Cowdray visit, Constable had made a drawing of the Rother valley encircled by wooded slopes, the hanging woods he so admired. In these last years there was still a need to make a drawing such as this view of Cathanger (fig.110), to revert to precise delineation and rich tonality.

109 John Constable, *Cowdray Park*, 1834, pencil and watercolour on wove paper 207 x 272mm ($8^1/_8$ x $10^3/_4$ in). Board of Trustees of the Victoria and Albert Museum, London

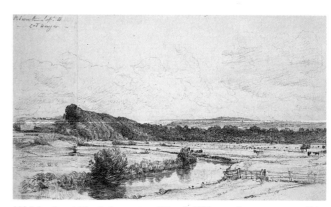

110 John Constable, *Cathanger, near Petworth*, 1834, pencil on wove paper 204 x 345mm (8 x $13^9/_{16}$ in). Collection of Mr and Mrs Eugene V. Thaw

1 Thomas Phillips R.A. (1770 – 1845), a life-long friend of Lord Egremont.
2 Leslie, *Life*, pp.235-6.
3 Reynolds 1984, 34.32-8,34.40, pls 941-8 and 950.

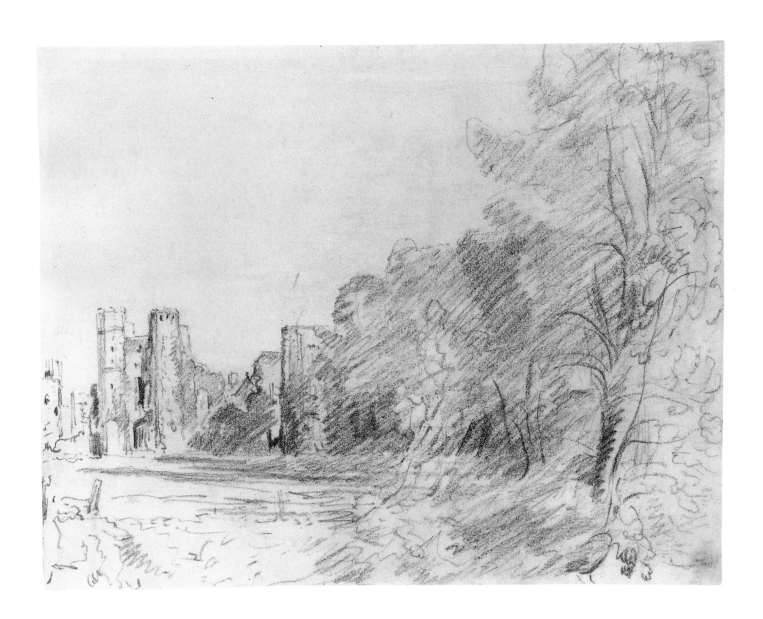

Study for Jaques and the Wounded Stag 1835

Pen and iron-gall ink with white heightening on writing paper that
has been folded as for a letter 228 x 185mm (9 x 7$^1/_2$2 in); in-
scribed in ink 'The Lords', l. and 'Jaques' b.; on the back 'Designs
for "Jaques" ' and vertically in another hand 'Mr/Constable/
Charlotte St', both in ink

PROVENANCE:...; Professor J. Isaacs;..; Christie's 14 June 1977 (lot
93, repr.)

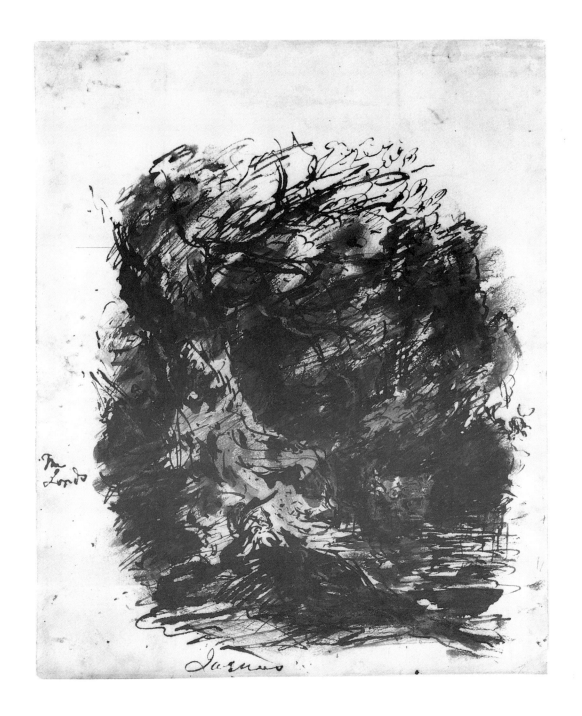

77 B

Study for Jaques and the Wounded Stag 1835

Brush and iron-gall ink on irregularly edged writing paper 105-
114 x 104-6mm ($4\,^1/_8 - 4\,^1/_2$ x $4\,^1/_2$ in); on the back part of a draft
for a letter.

...some paper by Joan
I hope Your friend will
profit by our lectures – for
Your sake [?lent] him one for
the whole season – so this I hope
he will not [?...] & [?with]
[?...] when he feels [?...]

PROVENANCE:...; Christie's 14 June 1977 (lot 94, repr.)

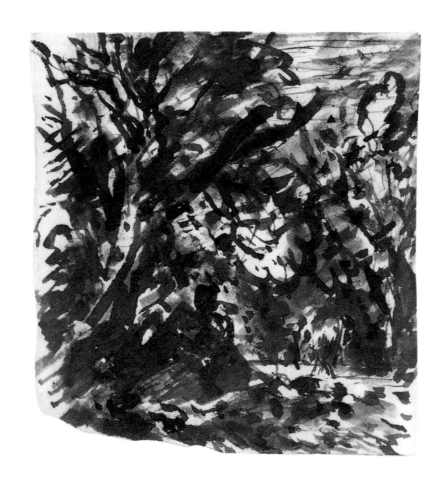

Study for Jaques and the Wounded Stag　1835

Pen and iron-gall ink and wash with white heightening on writing
paper 228 x 185mm (9 x 7 $^1/_2$ in)

PROVENANCE:...; Christie's 12 July 1988 (lot 24, repr.)

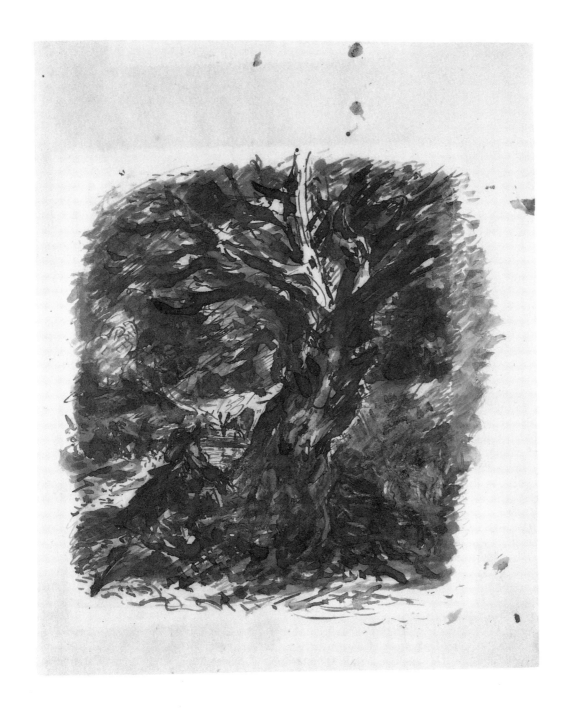

Study for Jaques and the Wounded Stag 1835

Pen and iron-gall ink on writing paper, top right-hand corner missing 145 x 101mm (5 $^{11}/_{16}$ x 4 in)

PROVENANCE:...; Christie's 12 July 1988 (lot 25, repr.)

In 1834 Constable's friend John Martin, the bibliographer (1791–1853), had published an edition of Gray's *Elegy* with, among others, three wood-engravings after designs by Constable. Later editions included a fourth, as frontispiece. Encouraged by the success of this little work, Martin next planned a *Seven Ages of Shakespeare* with twelve illustrations, each by a different artist. *As You Like It* was a favourite play of Constable's and in 1832 he had exhibited a watercolour at the Academy of the scene described in Act II when two of the courtiers banished to the Forest of Arden with the Duke espied Jaques as he lay under an oak watching a wounded stag at a brook (fig.111).

It is therefore not surprising that he chose the same scene for *The Seven Ages*, but remarkable if true, that, as Martin said in his Introduction, Constable 'made nearly twenty sketches for the "melancholy Jaques" '. Too many it seems, for it was left to C.R.Leslie after the artist's death to select the design 'he judged most appropriate' and transfer it on to the wood-block. How he managed it is hard to imagine, if the design was like any of those that have survived. Perhaps the difficulty experienced by the engraver Samuel Williams in interpreting the design is reflected in the result (fig.112), a poor thing by any standard.

The present group, nos 77 A – D, represents four of the ten that have so far come to light. Here, they have been arranged in order of acquisition; there is no way of telling how they relate to each other chronologically. Only once, in a cryptic sentence of Leslie's is the project mentioned: 'Martin was here today [10 February 1835], with his seven ages, he is pleased with my idea of the fates'.[1] But at a guess, judging by apparent changes of mood and technique, Constable worked on the series over a period of time. The number of sketches he made may indicate a failure to find a satisfactory answer to the problem of how to place Jaques and the stag at a credible distance from each other in an upright vignette – sometimes, as in C, he was far from arriving at a solution – but this proliferation may equally well have been fulfilling a need for the release of pent-up creative energy.

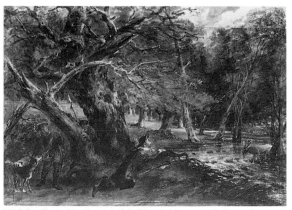

111 John Constable, *Jaques and the Wounded Stag*, pencil, (?) reed pen and brown ink and watercolour on wove paper 201 x 313mm (7 $^{15}/_{16}$ x 12 $^{5}/_{16}$ in), extended on all four sides to 230 x 328mm (9 $^{1}/_{16}$ x 12 $^{14}/_{16}$ in). Mr and Mrs David Thomson

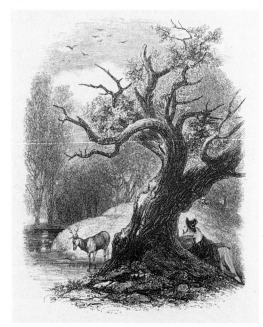

112 Samuel Williams after Constable, *Jaques and the Wounded Stag*, wood engraving illustration for John Martin's *Seven Ages of Shakespeare*, 1840. British Museum, London

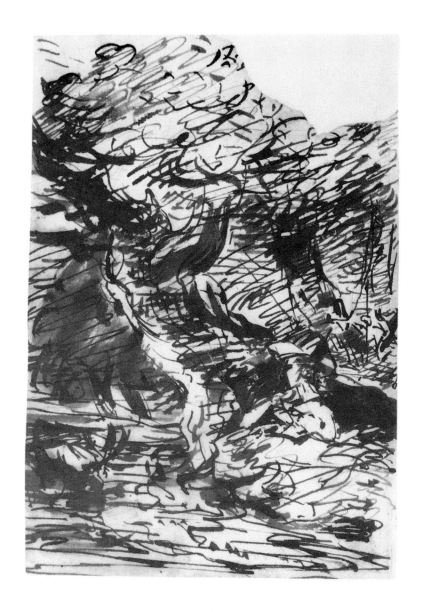

77D Technically, some of the Jaques designs are quite extraordinary. In A there are faint tracings of graphite and the composition may initially have been sketched in with pencil (only one of the ten is entirely in pencil, fig.113), but this soon disappeared under washes of diluted iron-gall ink applied wet and drily with a brush – possibly a square-tipped one – and also, as may be seen around the drier edges, with a finger or thumb. Over this, with undiluted ink and an assortment of pens, he drew the figure of Jaques, the oak and the forest beyond with a storm of swirling dots and squiggles. Finally, while some of the ink was still wet, he heightened a few passages with white chalk.

C and D are a contrasting pair. With the former Constable appears to have had most trouble. It is heavily overworked, especially to the right of the tree where there is a mass of chalking mixed up with the ink, and he has rather indecisively made an attempt to shape the right-hand edge with pale wash, seemingly as an afterthought. D is a relatively straightforward pen and brush drawing over some pencilling. To the modern eye B, the work of brush and finger only, the most consistent of our four examples, is perhaps the most satisfying.

It may only be a coincidence, but, as Anne Lyles has pointed out, no.77 D bears a very strong resemblance to a pen drawing by Joseph Farington, *Scene in a Wood, with Figures* , in the Oppé Collection (fig.114).

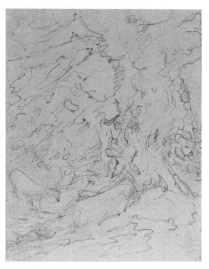

113 John Constable, *Study for 'Jaques and the Wounded Stag'*, 1835, pencil on writing paper 130 x 102mm (5 $^1/_8$ x 4 in). Mr and Mrs David Thomson

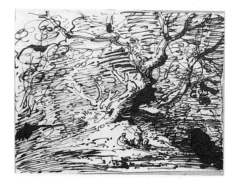

114 Joseph Farington, *Scene in a Wood with Figures*, pen and ink on wove paper 140 x 197mm (4 $^1/_2$ x 7 $^3/_4$ in). Private Collection

1 JC:FDC p.242.

A Sunken Lane at Fittleworth 1835

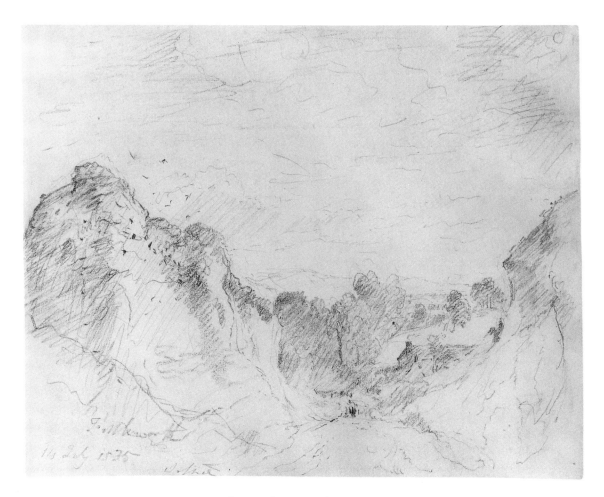

Pencil on wove paper 222 x 285mm (8³/₄ x 11³/₁₆ in), almost
untrimmed, stitchmarks just visible down left side; watermark 'J
WHATMAN 1833'; inscribed in pencil 'Fittleworth / 14 July 1835'
b.l.; on the back 'L.C [Lionel Constable] 80'

PROVENANCE:...; Christie's 12 July 1988 (lot 21, repr.)

A Wooded Landscape with a Cottage 1835

Pencil on wove paper 222 x 285mm (8 3/4 x 11 3/16 in); inscribed in pencil in the sky t.l. 'Mellow / Clouds'; on the back in ink 'This drawing by John Constable, R.A. bought from / Messrs Leggatt of 77 Cornhill at the exhibition of Constable's / Pictures and Drawings on November 22nd 1899, the first day of the exhibition'

PROVENANCE: By descent to H.G.Constable; Leggatt Brothers 1899; Th.Batterbury;..,Sotheby's 10 July 1985 (lot 110, repr.)

Constable's second and last visit to Arundel took place in July 1835. 'I long to be amongst your *willows* again', he had written to his friend George Constable, 'in your walks and hangers, among your books of antiquities &c, &c, and to enjoy your society – all as I did before without reserve, restraint, coldness & form, which belongs to "no friendship", and "great houses" '.[1] During his stay of some twelve days, Constable filled one sketchbook (now intact, with twenty-one drawings, in the Victoria and Albert Museum[2]) and made eleven more drawings and watercolours, including nos.81 and 82 , in a larger book.[3]

Constable had discovered Fittleworth water-mill when staying at Petworth in September 1834 and had then made two pencil sketches and a watercolour of it. From Arundel, Fittleworth was further away, about eight miles, but the place seems to have had a particular appeal, for he returned there on three successive days to draw the mill, the church and the village, and the sunken lanes. On 14 July he took two sketchbooks with him. In the smaller, intact book he drew the village street and church; in the larger one a close-up of the water-wheels at the mill and a view down the steep perspective of the sunken lane, no.78. Two days later he returned yet again to make three more pencil sketches of the lane (fig.115). Perhaps he was comparing it with one he knew so well, the lane down to Flatford.

For rapid notations of landscape such as nos 78 and 79 Con-

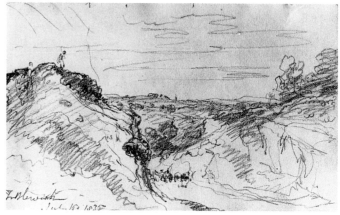

115 John Constable, *A Sunken Lane at Fittleworth*, 1835, pencil on wove paper 115 x 188mm (4 1/2 x 7 3/8 in), p.31 from an intact sketchbook. Board of Trustees of the Victoria and Albert Museum, London

stable was developing a kind of ideographic style that enabled him to record the scene with minimal means, yet with a freedom that must have given immense satisfaction. In his earlier work his aim often seems to have been to lose himself in the contemplation of the natural world; now, he appears to find the keenest pleasure in the performance itself, in the infinite variety of touches he could make with his pencil, from flowing, rippling movements to sharp dots and stabs, from a soft brushing of graphite to the deepest darks, performing as if he were both conductor and full orchestra.

A curious feature in no.78 is the depiction of the sun in the top right hand corner, a feature that only this ideographic manner permits. The evening before, in the smaller sketchbook, he had also drawn the sun as a plain circle, this time low down between some trees, just before setting.

1 JCC V, p.23.
2 Reynolds 1973, no.382, pls 278-89.
3 See Reynolds 1984, nos 35.9 to 35.18, pls 995-1003.
4 Ibid., 35.19 (p.19), pl.l014.

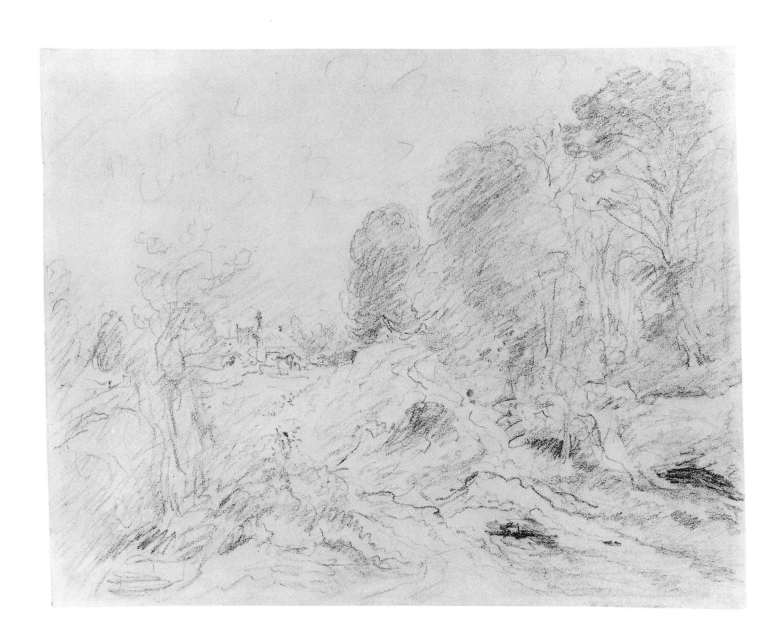

251

Worcester Cathedral from the South 1835

Pencil on wove paper 220 x 280mm (8 $\frac{1}{4}$ x 11 in); watermark 'WHATMAN/1833'; inscribed in pencil 'Worcester 6 Oct 1835' t.r.

PROVENANCE:...; Cyril Drummond; by descent; Sotheby's 16 July 1992 (lot 104, repr.)

Constable had been to Worcester once before, in December 1811, to see Maria Bicknell, then staying with her half-sister at Bewdley where her parents had sent her to be away from him (see no.81). The purpose of this visit in 1835 was to deliver three lectures on the history of landscape to the recently formed Worcester Institution for Promoting Literature, Science and the Fine Arts, lectures that were to be an extension of two he had given previously at Hampstead. Final arrangements had been made with the Secretary, Edward Leader Williams, in a letter of 29 September:

> It will be more agreeable to myself to lecture in the morning, as my tables[1] and specimens can be better seen, and I hope it is now so planned. But I am very desirous, if not too late, that my second and third lectures should follow without a break...I have taken a place on the Sovereign Co[ach], and I shall be with you on Monday, but so late as not to be able to unpack my things, but I shall not want much at first; only we must be early in the morning on Tuesday, so that we can get the room ready and a cloth hung up. My four sheets of double elephant[2], about ten feet in height, and a few things besides.

Constable had not given such a series before and was somewhat nervous about it. 'I feel myself in the situation of the lobster as very pleasant at first, but as the water gets hotter and hotter, was sadly perplexed.'[3]

If Constable gave the first lecture on the morning of Tuesday the 6th, as planned, then no.80 must have been drawn latish that afternoon, as the light on the cathedral suggests.

During his stay at Worcester he made three other drawings: on the 10th, the day after his first lecture, a view of the cathedral from upstream on the west bank of the Severn[4]; a view of the distant city taken two days later from a hill to the north;[5] and a slighter, undated sketch of the cathedral beyond some willows (fig.116).

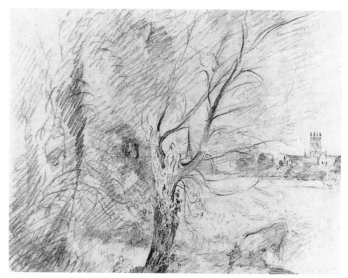

116 John Constable, *Worcester Cathedral from the Meadows*, 1835, pencil on wove paper 220 x 285mm (8 $\frac{5}{8}$ x 11 $\frac{3}{16}$ in), present whereabouts unknown

No.80, a comparatively recent discovery, was drawn from a meadow on the west bank of the river, just a stroll from Bromwich Lane where he may have been staying with Edward Leader Williams and his family.[6] A markedly serene work, no.80 is very different from the others made on this trip. His lectures, we know, were a great success. Was the tranquil mood of the drawing an expression of the relief he felt after having lectured well, at having escaped the sad perplexity of the lobster?

At some early stage Constable ruled a faint horizontal line across his paper. This he strengthened along the top of the cathedral nave and chancel roof. It was not unusual for him to rule such a line across a page on which he was about to make a drawing, but we cannot be certain why he did so. Sometimes it established his eye level, as in no.75, *On the Arun*, but this was not always the case. Perhaps these lines helped him to construct the work. Drawing from nature, whatever the subject, requires a keen aware-

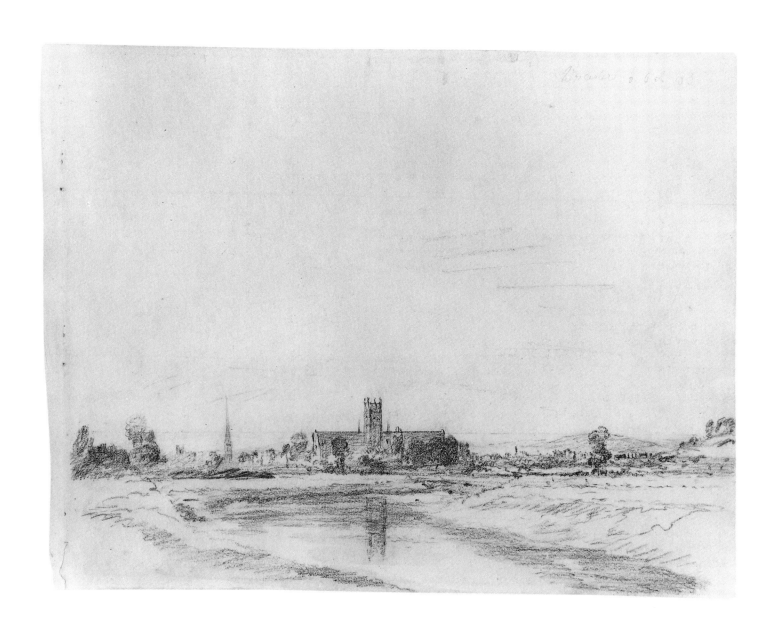

80 ness of relative distances and angles. The latter can only be seen against basic horizontals and verticals. These may be actually drawn, forming an irregular grid (as in Constable's Lake District sketch of 1806, no11), they may be merely held in the mind as a concept, or reduced, as in our drawing of Worcester cathedral, to a single horizontal ruled across the page. From this, Constable would have been able to judge the acute angles of the river banks and the slight rise of the hills, and along its length space the intervals between the distant trees and buildings.

1 Tables, in this case, appears to have referred to the list of painters that he is known to have displayed, along with the 'specimens', copies of the Bayeaux Tapestry and various representations of landscape by the Old Masters.

2 Double elephant, a size of paper – i.e. 26 1/2 x 40 inches.

3 Lord Windsor, *John Constable R.A.*, 1903, pp.129-30.

4 See Tate 1991, no.341, p.486.

5 See Reynolds 1974, no.383, pl.275.

6 Leader Williams, father of Benjamin Williams Leader, R.A., was Chief Engineer to the Severn Navigation Commission. In 1841 the Williams family, as shown in the census, were residents of Bromwich Lane, west of the Severn, but, possibly in his role as Chief Engineer, Williams also appears to have lived at Diglis House, just south of the cathedral and not far from the lock where the Worcester/Birmingham Canal debouches into the Severn. In 1834 Constable had sent two works to the exhibition of contemporary art organised by the Worcester Institution. Next year, 1835, he sent five paintings, including *The Cornfield*. In a letter of 27 April (JCC V,p.62) Williams warned him that there would be a stoppage on the canal after 11 May and suggested he should send the pictures off before that date. Constable is not otherwise known to have had his pictures transported to a provincial exhibition by water.

81

Dowles Brook 1835

Pencil on wove paper 218 x 278mm (8 3/8 x 11 in), trimmed; inscribed in pencil 'Dowlis Brook / Oct 15 1835' b.r.

PROVENANCE:...; C.Bostock; Sotheby's 26 June 1946 (lot 71, part of an album); Agnews;...; Mrs Young;...; Sotheby's 14 March 1985 (lot 87, repr.)

The last dated sketch Constable was to make from nature, no.81 was drawn at the end of his Worcestershire visit, when he stayed at Spring Grove, near Bewdley, with Sarah, his wife's half-sister, whose second husband, Joseph Fletcher, was rector of St Andrew's, Dowles, the distant church seen in the drawing. Constable's previous visit to Bewdley, in December 1811, had been momentous. Maria Bicknell, not long after the start of their correspondence, had written from Spring Grove begging him to cease writing – his only link with her – as her parents disapproved.[1] This he could not bear. Desperate to see her, he took coach for Worcester and arrived on the doorstep at Spring Grove, unannounced. His impetuosity saved the day – and the lady. Since his wife's death he had almost lost touch with the Worcestershire relations, but the opportunity to re-visit the place where, so long ago, he said he had spent some of the happiest hours of his life,[2] was not to be missed.

 Six or seven drawings were made in and around Bewdley; none, however, of the hallowed spot Spring Grove itself, where he was staying. Two are dated 14 October, a group of cottages, probably on what was known as Venus Bank (fig.29), and a detailed study of a plough.[3] Two are of barges on the banks of the Severn; on one sketch he noted that the barge had a red tiller[4], the other barge is a wreck, lying in two halves (fig.117). Who knows what was in his thoughts as he made these drawings? 'What you say of "Spring Grove" ', his sister Mary wrote in reply to his account of the trip, 'is a link in the chain of your benefits which connects you with your greatest blessings on Earth.'[5]

 No.81 is of a watersplash through which the old Bewdley/ Bridgenorth road passed. The view is now obscured by a stone bridge that carries the metalled B4194 over Dowles Brook. We could end with no better example of Constable's mode of drawing at the end of this, the last of his sketching years; a mode that

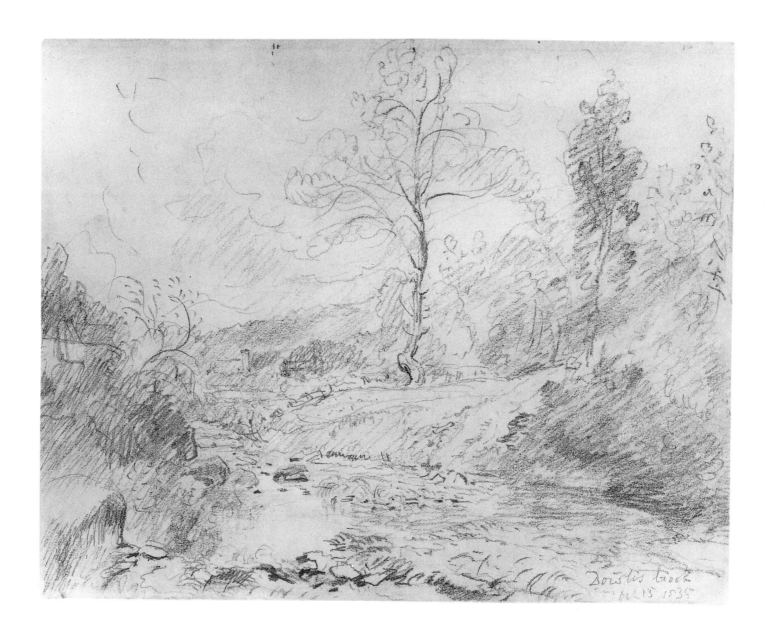

Dowles Brook
Feb 15 1835

255

81 allowed extremes of handling, from soft areas of shading to flicks
 of the pencil-point, from the most delicate of touches to heavy
 chiselled darks; a system in which often only the most cursory ref-
 erences were made to figuration, but in which every mark in con-
 text was rich with meaning; a mode that enabled him there, beside
 Dowles Brook, to embrace the full experience of landscape.

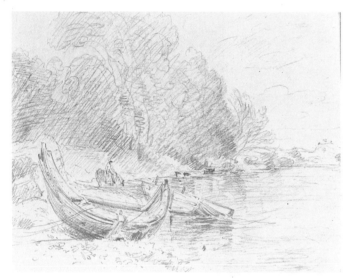

117 John Constable, *Boats on the Severn at Worcester*, 1835, pencil on wove paper 218 x
280mm (8 ¹/₂ x 11in). National Gallery of Scotland, Edinburgh

1 In her letter of 17 December 1811, Maria had written: 'I never can con-
 sent to act in opposition to the wishes of my Father, how then can I con-
 tinue a correspondence wholly disapproved of by him?' JCC II, p.55.

2 In the letter he wrote to Maria on 24 December, on his return to
 London. '...I may now say that some of the happiest hours of my life
 were passed at Spring Grove mixed as they were with moments of unut-
 terable sadness. Ibid., p.57.

3 See Reynolds 1984 35.24, pl.1033.

4 Ibid., 35.28, pl.1037.

5 In a letter of 25 October 1835, JCC I, p.294.